CONTENTS

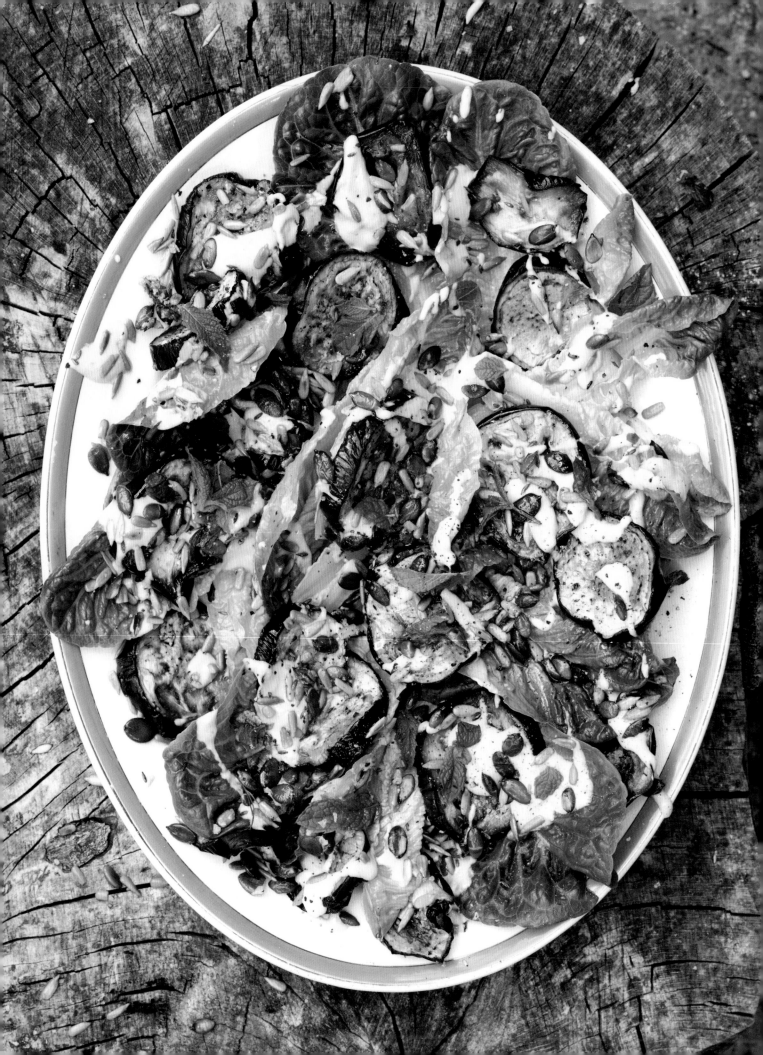

TAKING TIME TO LIVE WELL

LISA SYKES

FIREFLY BOOKS

A FIREFLY BOOK

Published by Firefly Books Ltd. 2016
Text Copyright © 2016 Iceberg Press Ltd.
Photos copyright as listed on page 255

All rights reserved. No part of this publication may be
reproduced, stored in a retrieval system, or transmitted
in any form or by any means, electronic, mechanical,
photocopying, recording or otherwise, without the prior
written permission of the Publisher or a license from
The Canadian Copyright Licensing Agency (Access
Copyright). For an Access Copyright license,
visit www.accesscopyright.ca or call toll free to
1-800-893-5777.

First printing

Publisher Cataloging-in-Publication Data (U.S.)
A CIP record for this title is available from the
Library of Congress

Library and Archives Canada Cataloguing in Publication
A CIP record for this title is available from Library and
Archives Canada

A Cataloguing in Publication record for this book is
available from the British Library

Published in the United States by
Firefly Books (U.S.) Inc.
P.O. Box 1338, Ellicott Station
Buffalo, New York 14205

Published in Canada by
Firefly Books Ltd.
50 Staples Avenue, Unit 1
Richmond Hill, Ontario L4B 0A7

Editorial Supervision: Sydney Loney
Page Production: Cassandra Pilon

Printed in China

INTRODUCTION

The Simple Things first appeared on British newsstands in the autumn of 2012, and it offered readers a simple promise: "to celebrate the things that matter most." It was a magazine about slowing down, living in the moment, enjoying the company of friends and family and making simple food for informal gatherings. Although I wasn't the editor then, I became an avid reader. For me, each issue was a monthly reminder of how good life can be when you remember to take the time to live it well – an idea we adopted as our slogan when I joined the editorial team at the end of that first year.

It was in 2014 that two friends and I decided to plough into our savings and borrow the rest to set up our own publishing company – we'd discovered that we believed in *The Simple Things* so much, we wanted to run it ourselves. Our efforts have been rewarded with a growing readership, and so many requests for back issues of the magazine that we started to sell out. This sparked an idea: what if we collected the best of *The Simple Things* in an anthology?

Choosing what to leave out was the hardest part. I wanted to show that it doesn't matter where you live or how busy you are, there are always opportunities to learn something new, to do something well, to revel in the outdoors and to share good food with the people you enjoy the most. Because these values underpin the whole magazine, we could have selected almost any article, but I hope the final curation reflects how growing, cooking, making and sharing are both timeless and infinitely worthwhile. Think of this as your handbook for happiness.

As this book went to press, we published the 50th issue of *The Simple Things* for our subscribers and followers worldwide. It seems there's something universal about swapping a 'to do' list for a 'could-do' list, and I sincerely hope our *Best of The Simple Things* inspires you to start yours.

Lisa

Editor,
LISA SYKES

thesimplethings.com

🐦 @simplethingsmag
📷 @simplethingsmag
📘 facebook.com/thesimplethingsmag
📌 pinterest.com/simplethings

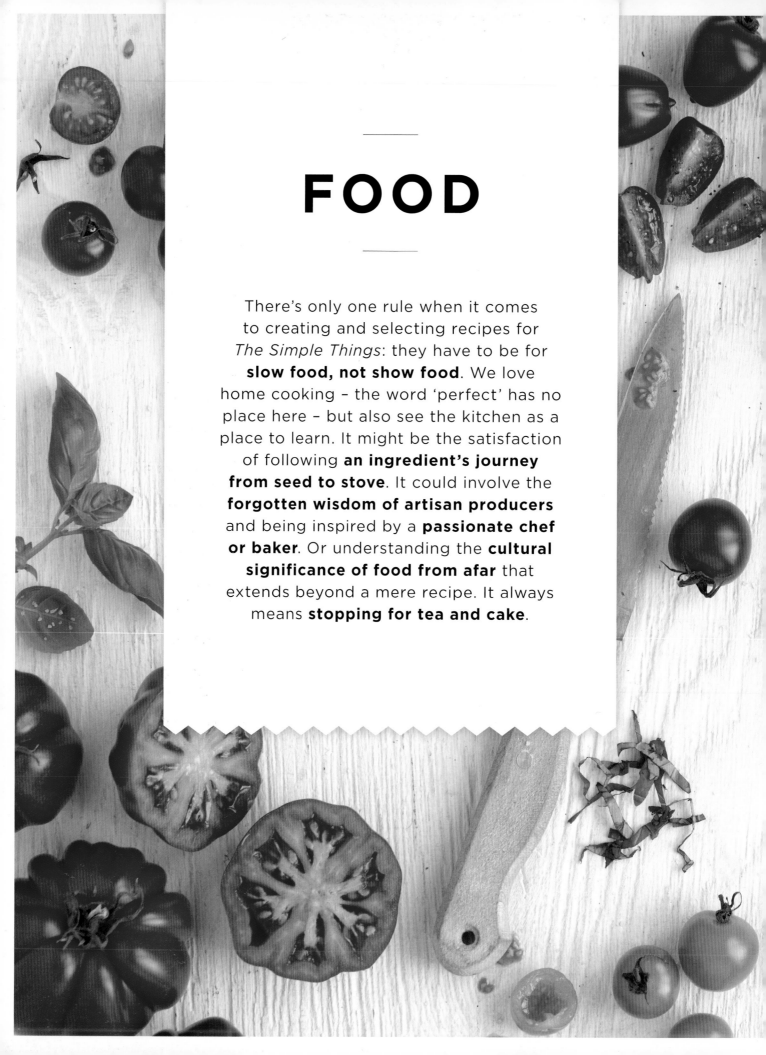

FOOD

There's only one rule when it comes to creating and selecting recipes for *The Simple Things*: they have to be for **slow food, not show food**. We love home cooking – the word 'perfect' has no place here – but also see the kitchen as a place to learn. It might be the satisfaction of following **an ingredient's journey from seed to stove**. It could involve the **forgotten wisdom of artisan producers** and being inspired by a **passionate chef or baker**. Or understanding the **cultural significance of food from afar** that extends beyond a mere recipe. It always means **stopping for tea and cake**.

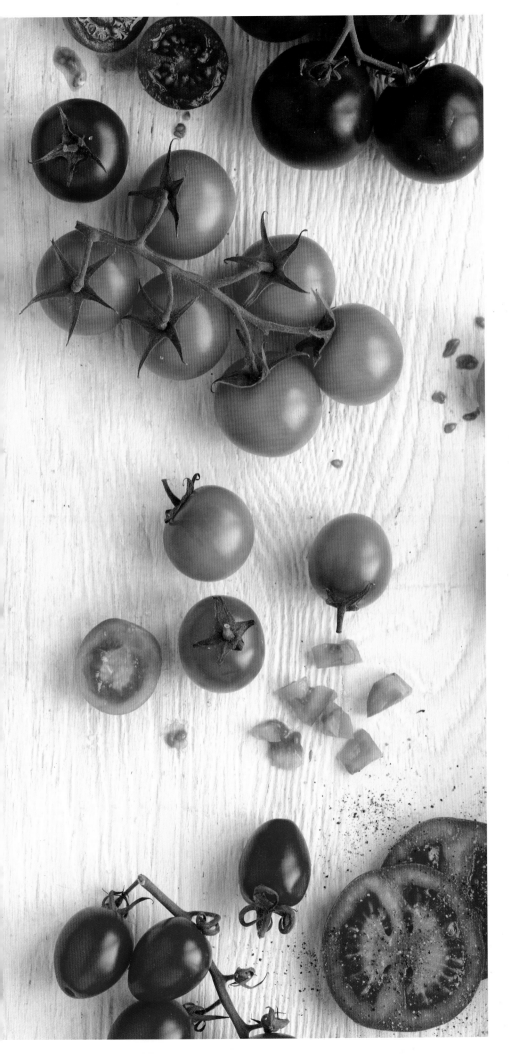

SEED *to* STOVE
RHUBARB TIME

PINK AND JUICY, RHUBARB BRINGS
A SWEETNESS TO PLOT AND POT
WHEN IT'S MOST NEEDED

Lia Leendertz

Winter's grip is truly relaxing now. An early fluff of blossom has suddenly softened the bare, dark damson tree branches, and newly awoken shoots are appearing above the ground. The soil is still too cold for seeds – they will just rot away if sown this early – but those crops that need a long season can and should be started now, on windowsills and in heated propagators.

Get chillies going quickly, and towards the end of the month make a sowing of tomatoes. But one of the best things you can do on the plot at this moment is to prepare the soil. Planting-out time feels like it is an age away, but it will suddenly be upon us, and then we will have windowsills stuffed with plants and nowhere to put them. Clear the ground of weeds, and be as ready as you can be when the big rush hits. This is the lull before the storm...

There is a freshness in the air and that thrilling feeling of days lengthening, but still most of the useable crops are those that have been in the ground all winter: sturdy beetroots, long-standing cabbages. Everything is starting to look a little too familiar. There are a few delicate new shoots coming from the perennial plants though, those plants that die down and then re-sprout from a permanent root system year by year. This is their moment, as they have a great head start on annuals, which need to be sown afresh each spring. Sorrel is now up, and I cut handfuls of its bright green lemony leaves to collapse into melted butter and stir into potatoes. But my favourite of the perennials is rhubarb, so sweet, pink and fruity, just when those qualities are lacking on the plot.

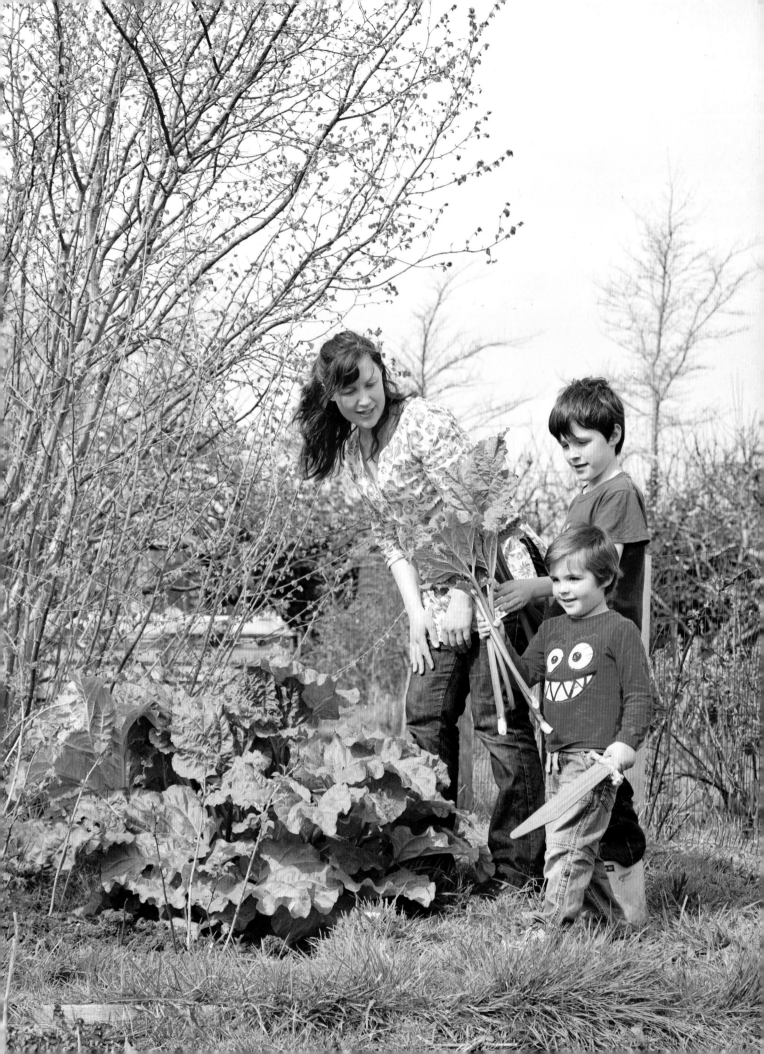

Rhubarb and ginger pavlova

THE TWO MAIN COMPONENTS REQUIRE PLENTY OF OVEN TIME AT DIFFERENT TEMPERATURES, SO PLAN ACCORDINGLY

Serves 8

FOR THE MERINGUE

6 egg whites

300g soft brown sugar

1 tsp red wine vinegar

50g crystallised ginger, sliced thinly

FOR THE TOPPING

3 sticks rhubarb

3 tbsp honey

Zest and juice of one orange

1 vanilla pod, split

3 Chinese star anise

1 vanilla pod

500ml double cream, to serve

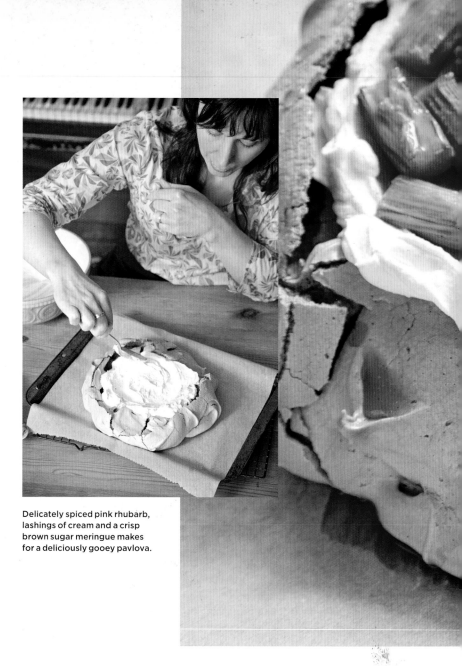

Delicately spiced pink rhubarb, lashings of cream and a crisp brown sugar meringue makes for a deliciously gooey pavlova.

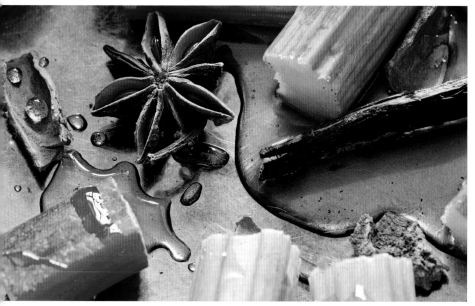

TO MAKE THE MERINGUE

1 Preheat the oven to 180°C/Fan160/350°F. Cover a baking sheet with parchment paper; set aside.

2 In a perfectly clean bowl, whisk the egg whites until they form peaks, then slowly whisk in the sugar a tbsp at a time. It will turn sepia-coloured and shiny. Sprinkle in the vinegar and the crystallised ginger, then carefully fold in until combined.

3 Spoon and smooth the mixture into a circle approximately 23cm across on the lined baking sheet. Place in the oven and reduce the heat to 150°C/Fan130/300°F. Bake for 1 hour 15 minutes, or until it is dry and crisp on the outside. Turn off the oven, open the door slightly, and leave to cool completely.

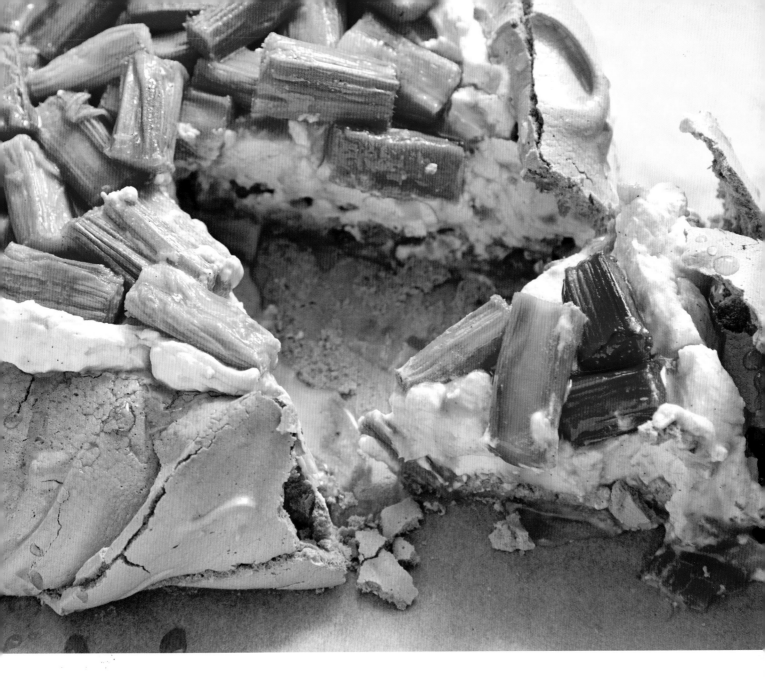

FOR THE RHUBARB TOPPING

4 Preheat the oven to 180°C/ Fan160/350°F. Slice the rhubarb into 2-inch pieces and place in a deep-sided baking dish. Pour over the honey and orange juice. Scrape the beans out of the vanilla pod into the juices, then add the pod along with the Chinese star anise.
5 Bake for around 30 minutes, until the rhubarb is tender but still holding its shape. Remove from the oven and leave to cool.
6 Whip the cream and spread it generously over the cooled meringue base. Spoon the rhubarb carefully onto the top, dribbling over some of the juices, and serve immediately.

Red wine vinegar is a secret tip of Nigella Lawson's, which makes the middle of the meringue soft and chewy.

This rhubarb relish is to be eaten up rather than saved – which is unlikely to be a problem.

Tempura mackerel with rhubarb relish

THE SHARPNESS OF THE RHUBARB
CUTS THROUGH THE OILINESS OF
THE FISH AND PROVIDES A WONDERFUL
SWEET-SOUR BALANCE

Serves 2 as a starter

FOR THE RELISH

1 tsp coriander seeds

Sunflower oil, for frying

1 onion, finely diced

3 cloves garlic, minced

2 stalks rhubarb,
finely diced

½ inch fresh root ginger,
peeled and grated

2 tbsp white wine vinegar

1 tbsp caster sugar

FOR THE TEMPURA
MACKEREL

Sunflower oil, for frying

1 mackerel, filleted

50g plain flour

50g cornflour

Salt

150ml ice-cold water

1 Start by making the relish. Heat a frying pan and then dry-fry the coriander seeds for a few minutes, or until they emit a delicious toasty scent. Add the oil and gently fry the onion until translucent and browning slightly.
2 Add the garlic, rhubarb and grated ginger. Cook for a few minutes and then add the vinegar and sugar. Cook gently for a minute or two; set aside for later.
3 For the mackerel: fill a small saucepan one-third full of sunflower oil and place over a high heat. Slice the mackerel into pieces a couple of inches across.

4 Make your batter. Put the flours and salt into a large bowl and whisk in the iced water until the mixture is just about smooth (don't worry about a few lumps).
5 Check the oil is hot enough by dropping a small cube of bread into it. If it sizzles, it's ready. Dip each piece of fish into the batter, then lower it into the oil. Cook just three or four pieces at once, and flip over after a minute or two. Lift out and onto kitchen roll and repeat until all the fish is cooked. Serve immediately, with the relish.

Dusty pink lady

WHEN SHAKEN WITH THE SYRUP AND ALCOHOL, THE EGG WHITE BECOMES LIKE A SWEET, ALCOHOLIC MERINGUE

Makes 2 cocktails
FOR THE RHUBARB SYRUP
2 sticks rhubarb, roughly chopped
2 cups water
Approx. 2 cups caster sugar
Chinese star anise

FOR THE DRINK
Ice
100ml gin
100ml rhubarb syrup
1 egg white

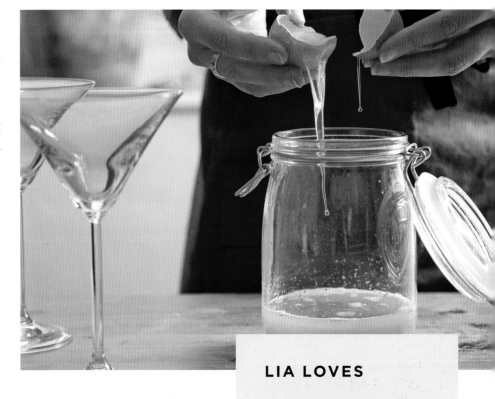

1 To make the rhubarb syrup, place the rhubarb and Chinese star anise in a saucepan with the water. Bring to the boil and simmer for around 10 mins, until it has disintegrated into a mush. Leave to cool, then strain through a muslin into a bowl. For the clearest syrup, don't squeeze the muslin; just let the juices drip through.

2 Measure the juice back into a clean saucepan and add the same amount of sugar by volume. Heat the mixture until the sugar crystals have dissolved and the syrup is clear. Leave to cool.
3 Put the ice into a cocktail shaker (or lidded jar), add the other ingredients, shake and serve.

No need for a cocktail shaker. A preserving jar wil shake up an equally thick and frothy tipple.

LIA LOVES

Rhubarb is one of the easiest plants to grow and just reappears year after year, with very little effort on the gardener's part. It is tolerant of most soils and will put up with being planted in your shadiest corner. It can be 'forced' to grow early by covering the crowns in late winter.

CHAMPAGNE
This is a favourite of mine, as the stems are so beautifully pink. It is an early variety, so you can grow it naturally, but if you need it earlier it also works as a 'forced' variety.

VALENTINE
This is a particularly sweet-tasting variety with lovely red stems. It is vigorous, but not prone to bolting.

STOCKBRIDGE ARROW
One of the varieties used in Yorkshire for forcing, with distinctive arrow-shaped leaves. Cover with a forcing pot or upturned dustbin for early, tender, pale pink stems.

THE EXPERT: CHEESE

JOIN US ON A TASTE ADVENTURE WITH ANN-MARIE DYAS OF THE FINE CHEESE CO, WHERE SHOPPING AND SELECTING IS EVERY BIT AS ENJOYABLE AS CONSUMING

Jenny Dixon

Walking into a specialist shop is exciting and maybe even overwhelming. You stand faced with a huge array of what the store has to offer – more than 150 artisan cheeses, in the case of The Fine Cheese Co. With no particular recipe in mind, your turn comes all too quickly and the pressure is on for a quick choice. British manners mean we don't feel happy to hold up the queue while we taste and ponder. But that's exactly what a cheesemonger wants us to do.

Think of a cheesemonger as your personal shopper. After a few questions about the flavours and textures you enjoy, you'll soon be tasting happily. Ann-Marie Dyas is the ideal guide. She's loved cheese all her life, and has been a cheesemonger for more than 20 years.

"I export British artisan cheese all over the world from Australia to America," she says. "But I'm most proud of our success in getting the French to respect and appreciate English cheese." Ann-Marie fiercely maintains that she won't let you leave her shop until she's found the thing you love.

Why should I come to a specialist cheese shop?
You need to buy from someone who is around cheese every single day. When I train my team, I ask them to know their cheese in their heads, in their stomachs and in their hearts – they need the full connection.

In England we don't eat cheese every day. Unlike in France, it doesn't make an automatic appearance at the end of the meal. So there isn't the same familiarity and comfort about choosing cheese – it tends to be more of an adventure. So if cheese is something that's more of a treat for the weekend, at least make sure you buy it from someone you can trust. Even better, make it part of a regular weekly habit and build your appreciation. It's so much fun as well as being delicious.

The choice is so overwhelming — how can I choose?
I want everyone to feel passionate about cheese and not feel as if they need a PhD in cheese to shop with us. So many people say they are interested in cheese, but they aren't confident about it. My team handle and taste cheese every day. They know what is good, and they know how to help a customer narrow their search and find a cheese that will really make them smile.

Can I taste before I buy?
Always ask to taste, even if you know a cheese well – cheeses change. Let the cheese warm in your mouth to release its flavour. The first taste should develop into greater complexity, particularly in the case of unpasteurised cheese as there's so much more going on.

What is a soft cheese?
Soft cheese is a broad heading. These cheeses tend to be younger and have a pliable texture, although they don't always have a gentler flavour. Some possess what I call an 'ice-cream texture', whipped-up but firm; they don't 'give' when pressed, but instead they melt in the mouth. Then there are those with a more supple, semi-soft texture, such as Brie or

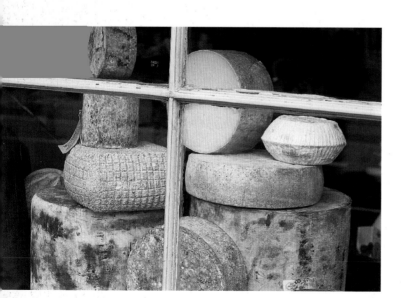

The Fine Cheese Co shop window, groaning with artisan cheeses. "It's a huge amount of history, people and love you're looking at," says Ann-Marie Dyas.

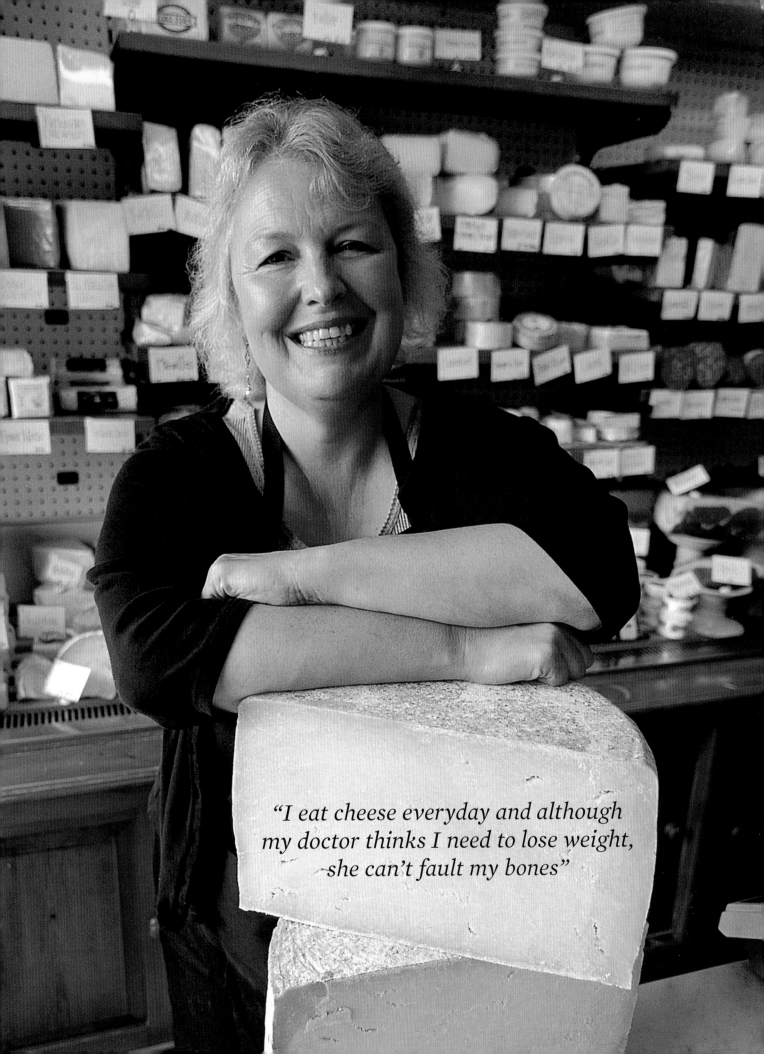

"I eat cheese everyday and although my doctor thinks I need to lose weight, she can't fault my bones"

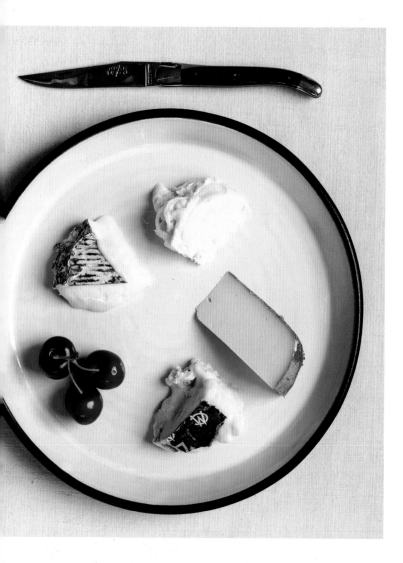

A handsome Italian collection on what Ann-Marie calls a "dreamboat plate" (clockwise from the top): La Tur, Pecorino Rosso, Gorgonzola Dolce, Carboncino.

In the case of goats' milk cheese, even if you don't think you like the taste, try to keep an open mind. Start with a cheese such as Perroche. It is very fresh, just a few days old, and its taste hasn't really developed. It is lemony and delicate with a texture so soft that you could spread it with a knife.

What affects the flavour?

Many, many things influence the flavour of an artisan cheese. It's a handmade product and depends on every factor from the season and the diet of the animal to the conditions in which the cheese is matured. Flavour depends on the culture used, and particularly how it is treated once made. Soft and semi-firm cheese may be 'wash-rinded'. This practice of brushing the rind with a brine solution, cider or even *eau de vie* changes the colour and creates a pungent aroma – although the bark isn't always as strong as the bite! The sign of a washed-rind cheese is the colour, which will be some degree of orange, from the faintest blush to a deep shade.

How do I know if a cheese is ripe?

You don't want chalk in your Brie, or soft cheese that is still brick-hard. Ask the cheesemonger; their experience comes from the fact they handle cheese a lot.

How long should I keep cheese?

It all depends on the cheese. Best-before dates are a guide, but a cheese can be over the top, or even be nowhere near ripe. Trust your cheesemonger and yourself on this. If it tastes horrible, don't eat it! Always remember that once a cheese is cut, it starts to die. It will only continue to ripen if it's whole. Also don't be put off by mould; if it appears on the cut surface, pare it. Remember, mould is cheese's bedfellow; it wants to grow a coat on its surface to protect itself.

What's the best way to store it?

Wax paper is good for wrapping. Don't use cling film, as this draws moisture from the cheese; foil is better. Store cheese in the salad drawer, as this is the warmest place in the fridge. In general, a fridge is too cold for cheese, as it has to be set low to chill meat, fish, and so on. The atmosphere is also too dry, which is why your Parmesan Reggiano goes like wax. A clean, wrung-out tea towel thrown over a cheeseboard will keep cheese hydrated.

Can I prevent it from smelling?

You can't, it's natural. I once opened the mini-bar in a French hotel to find a sign that read: 'No Camembert!'

Camembert. Give the cheese a little press to test if it is ripe. If it's in a box, take it out. Flavour can vary hugely, starting with the delicate 'triple cream' varieties. Most people will know Vignottes, but try instead the farmhouse Delice de Bourgogne, Brillat Savarin or Jean Grogné — they are all delicious. Then you step up in texture and taste to Reblochon. It, too, is gentle and mild, with a texture that has a bit of spring in it.

Camembert is a stronger cheese – though a Brie de Meaux will give it a run for its money! Look for the key words: *au lait cru* (unpasteurised) and *moulé a la louche*; this will tell you it's a true artisan Camembert. It reads 'made with the ladle', meaning the mould is filled by hand. These cheeses tend to be straw-coloured and have an undulating surface.

What should I look out for?

Choose unpasteurised. A typical Somerset Brie (or '60% Brie') is pasteurised and mass-produced. The taste will be creamy, but with no 'fruitiness'. Go for a Brie de Meaux; it is always made with raw milk.

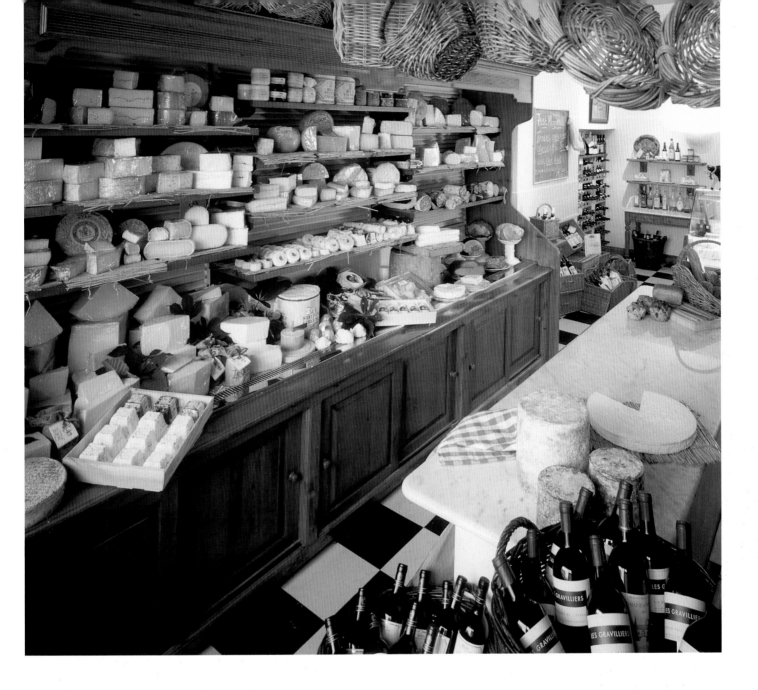

They knew the fridge would never recover from tourists buying their rounds of Camembert to take home.

What's the best way to serve it to guests?
Marble keeps cheese cool, wood looks natural, but with slate you can write the cheese names on with chalk, so you don't forget what you are serving. Remember to bring out the cheese when you bring out the red wine. Cheese should be chambréd to bring it to room temperature.

Is there any cheese etiquette I should know about?
There's no worse insult than slicing the nose off a cheese! You should take a thin sliver from the side. There is also special etiquette for pyramids – always cut from the centre in wedges, and baby Stiltons and Cheddar truckles – never spoon the cheese, but cut small wedges from the round. You should also have more than one knife if you are serving a blue cheese.

A ritual of cheese shopping with a specialist will soon increase your repertoire. "It's like being a child learning to taste all over again," says expert Ann-Marie.

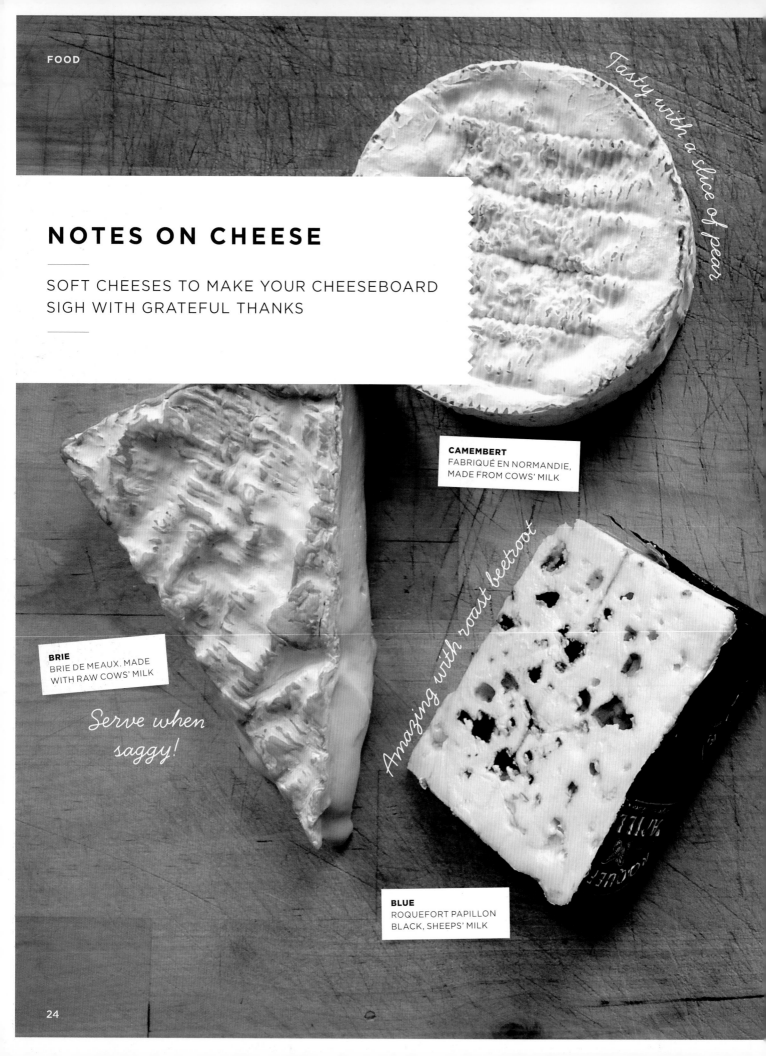

NOTES ON CHEESE

SOFT CHEESES TO MAKE YOUR CHEESEBOARD
SIGH WITH GRATEFUL THANKS

Tasty with a slice of pear

CAMEMBERT
FABRIQUÉ EN NORMANDIE,
MADE FROM COWS' MILK

BRIE
BRIE DE MEAUX, MADE
WITH RAW COWS' MILK

Serve when saggy!

Amazing with roast beetroot

BLUE
ROQUEFORT PAPILLON
BLACK, SHEEPS' MILK

If you like it a little salty

FETA
MADE WITH
GOATS' MILK

*Your crumbly
friend in salads*

TOMME
MADE WITH RAW
GOATS' MILK

*Brilliant when
the bread's
still warm*

TRIPLE CREAM BRIE
BRILLAT SAVARIN,
MADE WITH COWS' MILK

Choosing for a cheeseboard is
very personal, but as a guide,
try to balance your flavours and
textures – even soft-cheese lovers
will appreciate a firm contrast.

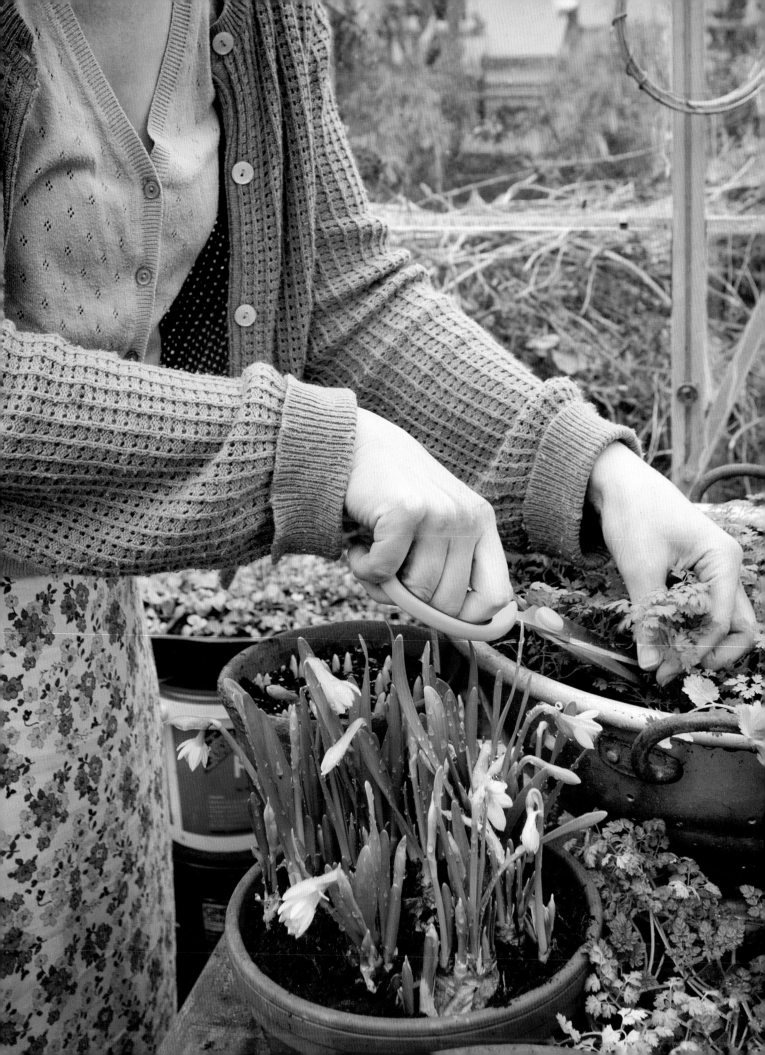

SEED *to* STOVE
HERBAL REMEDY

FILLING THE GAP IN YOUR VEGETABLE CROP WITH HANDFULS OF FRAGRANT HERBS

Lia Leendertz

Spring is always slow to spring on my allotment. It may be on a south-facing slope, giving the sun every possible chance to warm up the soil, but that soil is dense clay and so clings to cold wintry moisture far longer than suits me. I want to get sowing, but I know that a seed placed into this inhospitable environment will sulk like a teenager. And so I spend a lot of hours in my greenhouse at this time, where I can provide seeds with a fairly constant temperature and some nice, welcoming compost.

In here I'm sowing trays of beetroots, carrots and lettuces, to prick out into the ground as soon as it's warmed up a little, and I'm still nurturing some overwintered broad beans and sweet peas to plant out shortly too, for what I hope will be sweet little beans, as early as possible.

We're now deep into the 'hungry gap' – the period of time between the stored crops running out and the new crops beginning. Of course nowadays we can just pop to the supermarket, but if you want something fresh and lovely from the allotment, pickings are currently rather lean. To fill this gap with taste, if not with bulk, I keep a trio of wintry annual herbs on the go. Coriander, parsley and chervil are all a pain to grow in the summer — coriander in particular running to seed in a couple of weeks – but they seem to like winter and early spring cool, and will keep on producing fresh, tasty leaves, particularly if given a little protection from the elements. I sow my seeds across wide, shallow containers and keep them in the greenhouse. I've been harvesting leaves from them all winter, and they're still going now.

Chervil soup*

A WARMING DISH THAT GIVES THESE DELICATE LEAVES A WELCOME CHANCE TO SHINE

Serves 4

1 litre stock
20g unsalted butter
1 tsp vegetable oil
1 onion
1 large potato
1 large bunch chervil
150ml single cream
Salt and pepper

1 Dice the onion finely. Melt the butter in a large pan, add the oil and the onions and turn the heat to its lowest setting.
2 Put the lid on and cook the onions very slowly. You want them to turn translucent and not to brown.
3 Peel and cube the potato and add it to the pot once the onions are cooked, then pour on the stock.
4 Boil for 10 mins or so until the potato is soft, then throw in the chervil and whizz everything up with a hand-held blender.
5 The uncooked chervil will at first float on the surface, but as it softens it will become suspended in the soup.
6 Take it off the heat instantly and add cream, salt and pepper to taste.

As chervil is such a delicate and easily lost flavour, a dribble of concentrated chervil oil helps this soup to sing. Take a small bunch of chervil and remove all of the stems, putting only the feathery leaves into a pestle and mortar. Pour on a little oil and some crunchy sea salt, and start pounding and grinding until the oil turns green and thick. Dribble it onto the soup before serving.

Chervil loses its flavour when heated too much, so it needs to be added at the very end of cooking.

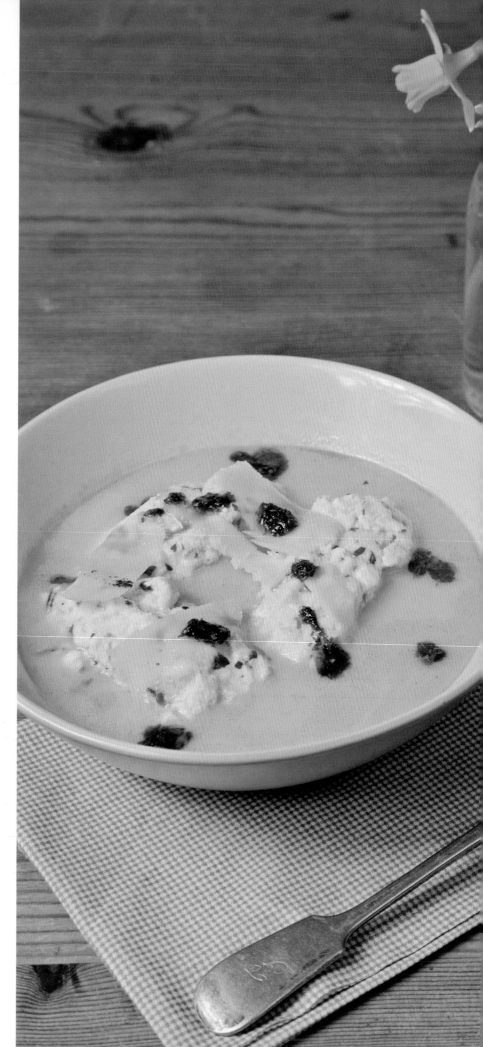

Ricotta, a mild cheese made using whey, is a key ingredient in the soup's dumplings.

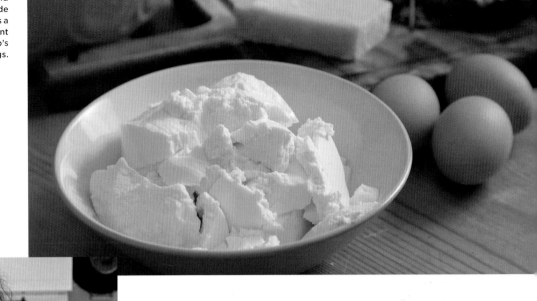

Ricotta & herb dumplings

NOT YOUR TRADITIONAL HEAVY BRITISH DUMPLINGS, THESE ARE LIGHT AND FLUFFY

Makes 8-10 dumplings

500g ricotta cheese

Handful of parsley (you can substitute other herbs at other times of the year)

60g Parmesan, finely grated

6 tbsp plain flour

3 eggs

Salt and pepper

1 In a large bowl, beat the drained ricotta with the Parmesan, salt, pepper and eggs.
2 Finely chop the herbs and stir them in, then add the flour, a tablespoonful at a time.
3 Set a pan of water boiling, salt it well and then turn it down to a simmer. Make a quenelle (a small ball) of the mixture between two spoons, then lower it into the water. It should stay whole and drop to the bottom of the pan. If it breaks up, you need to add a little more flour and try again.
4 Cook a few dumplings at a time. Once they're cooked they'll rise to the surface, and can be fished out with a slatted spoon. Eat while hot in the soup, sprinkled with more freshly grated Parmesan.

Winter herb salad

GO HEAVY ON THE HERBS.
THIS MIDDLE EASTERN-STYLE
DISH IS PACKED WITH
PUNCHY FLAVOURS

Serves 4
1 large bunch flat-leaved parsley
1 large bunch coriander
5 cauliflower florets
A handful of radishes
5 spring onions

FOR THE DRESSING
Zest and juice of half a lemon
30ml extra-virgin olive oil
Salt and pepper

1 Roughly chop the herbs and the
radishes and slice the spring onions,
and put them together into a large
bowl. Take the central stems out of
the cauliflowers to break them up
into tiny florets. Add to the salad.
2 Put all of the dressing ingredients
into a jar and shake them together,
then pour over the salad and mix well.

** **Pittas** are ready when they've risen and are just starting to turn brown. Remove them
from the oven and place on a clean tea towel, then cover with another tea towel to keep them
soft and warm while you make the others. Ideally, you'll want to serve and eat them as soon
as possible. They'll be fluffy and doughy and like no shop-bought pitta you've ever eaten!*

To make Middle Eastern
Labneh cheese, tip natural
yoghurt into a cheese cloth
and suspend over a bowl for
24 hours. The yoghurt will
set like a soft cheese.

Pitta

HOME-MADE PITTA IS
PILLOWY AND FLOURY AND
SOFT. YOU'LL NEVER GO
BACK TO SHOP-BOUGHT

Makes 8 small pittas
500g plain white flour
1 tsp easy-blend yeast
1 tbsp caster sugar
1 tsp salt
2 tbsp olive oil
325ml warm water

1 Mix the flour, yeast, sugar and salt,
then start to add first the oil and then
the water, until you've made a sticky
dough. Knead it for 10 mins.
2 Leave the dough in a warm place
until it's doubled in size.
3 Heat the oven to 250°C/Fan230/
482°F, gas 9. Once hot, put a baking
tray into it. Leave for at least 15 mins.
4 Tip the risen dough onto a floured
surface and knead lightly. Divide into
eight portions, roll into balls in your
hands and use a rolling pin to roll each
flat. When you have a few ready, take
the hot tray out of the oven, add some
flour and the pittas, and place the
tray back into the oven.
5 In about 8 mins the pittas will have
risen and be ready to serve.*

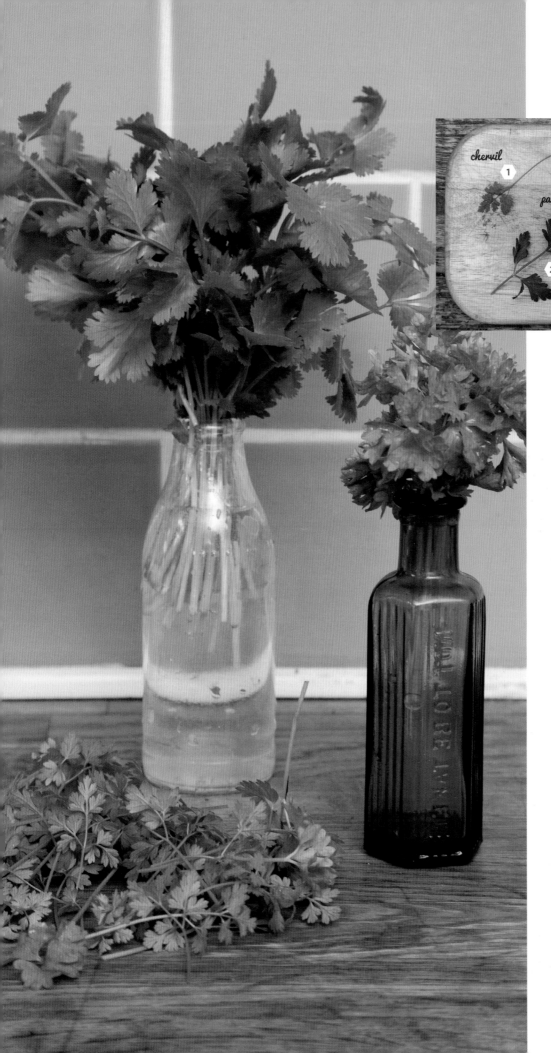

chervil
1
parsley
3
2
coriander

LIA LOVES

In winter, feathery herbs offer a bite of aromatic flavour in place of summer-growing leaves

CHERVIL

(1) Chervil is a little like parsley but has a far daintier appearance and a beautiful, feathery leaf, a little like a young carrot top. The taste is far subtler than parsley, too, a sort of delicate aniseed flavour that works particularly well with fish and eggs.

PARSLEY

(2) Some dislike the texture of curled parsley – such as 'Moss Curled' – but I find that the taste is stronger, so I use this wherever the texture is irrelevant, such as chopped finely in a parsley sauce or simmered in a stock. It will stand through hot summer weather better than flat leaved. With smooth, flat leaves in a beautiful bright green, 'Plain-leaved Italian' is the variety I use if making a salad that contains a high percentage of herb leaf.

CORIANDER

(3) 'Calypso' is slower to bolt than most coriander varieties and suits being grown as 'cut and come again'. Each plant will give three or four crops of leaves if you cut just above the growing point each time you harvest.

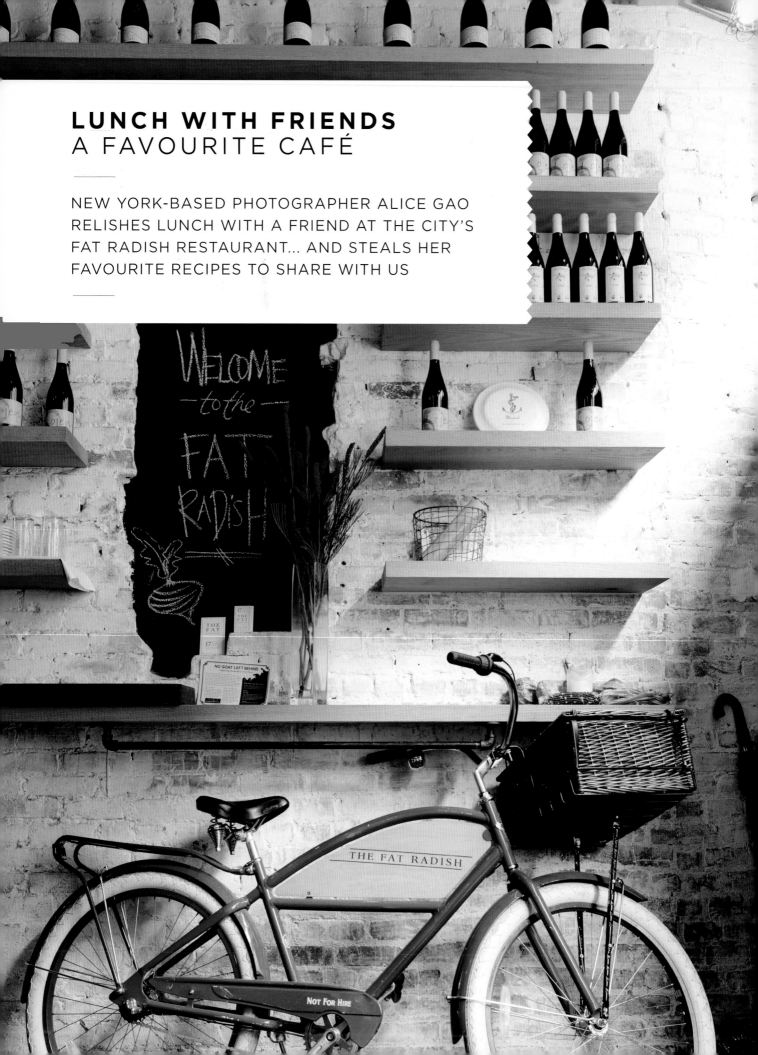

LUNCH WITH FRIENDS
A FAVOURITE CAFÉ

NEW YORK-BASED PHOTOGRAPHER ALICE GAO RELISHES LUNCH WITH A FRIEND AT THE CITY'S FAT RADISH RESTAURANT... AND STEALS HER FAVOURITE RECIPES TO SHARE WITH US

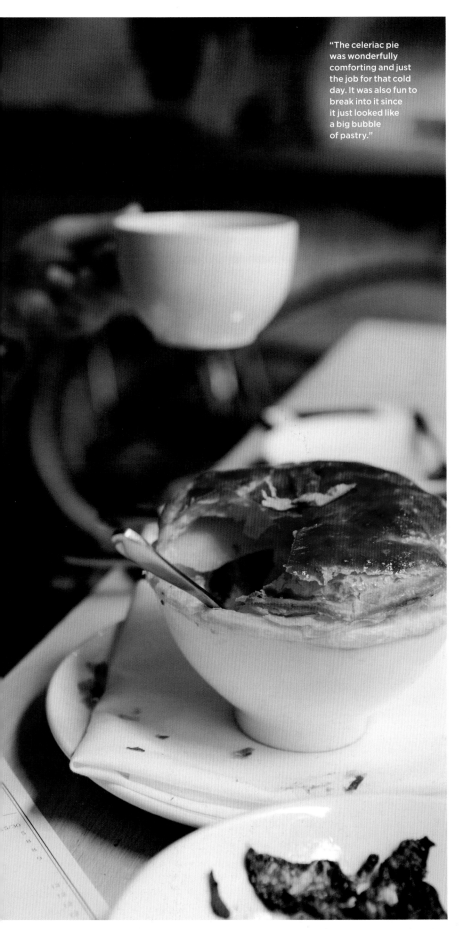

"The celeriac pie was wonderfully comforting and just the job for that cold day. It was also fun to break into it since it just looked like a big bubble of pastry."

Celeriac Pie

DIG INTO A COMFORTING PIE OF ROASTED VEGETABLES AND BLACK GARLIC IN A SWEET, CREAMY SAUCE

Makes 1 large or 2 individual pies

2 medium celeriac (about 900g peeled)

1 red onion, diced

1 head of black garlic, chopped

1 small stalk of celery, chopped

100g brioche croutons (cube the brioche, toss in olive oil and seasoning, then brown in oven for 10 minutes at 180°C/Fan160/350°F, gas 4)

1 apple, peeled and chopped

3 allspice berries

1 bay leaf

1 tsp parsley, chopped

1 tsp chives, chopped

100ml single cream

500ml milk

2 tbsp butter

50g grated Gruyère cheese

Salt and pepper

One 320g sheet puff pastry

1 egg

1 Peel and dice the celeriac. Place about 200g in a saucepan, add the apple, allspice, bay leaf and milk. Simmer until the celeriac is soft.
2 Toss the remaining diced celeriac in 3-4 tablespoons of vegetable oil and spread on a baking tray. Roast for 35-40 minutes at 230°C/Fan210/450°F, gas 8. Toss the onion in a little vegetable oil, place on a separate tray and roast for 25-30 minutes.
3 Blend the soft celeriac and apple (removing the bay leaf and allspice) until smooth with the cream, butter and some cooking liquid. It should be a soup-like consistency.
4 In a large bowl combine the roasted celeriac and onions, raw celery, black garlic and croutons.
5 Add the celeriac purée to the mix until you reach the desired consistency, and then season with salt and pepper, parsley and chives.
6 Place the mixture in one large or two small pie dishes and top with grated cheese.
7 Cut a circle from puff pastry slightly bigger than your dish. Brush with egg and press on the dish.
8 Bake for 25 minutes at 180°C/Fan160/350°F, gas 4 until the pastry has risen.

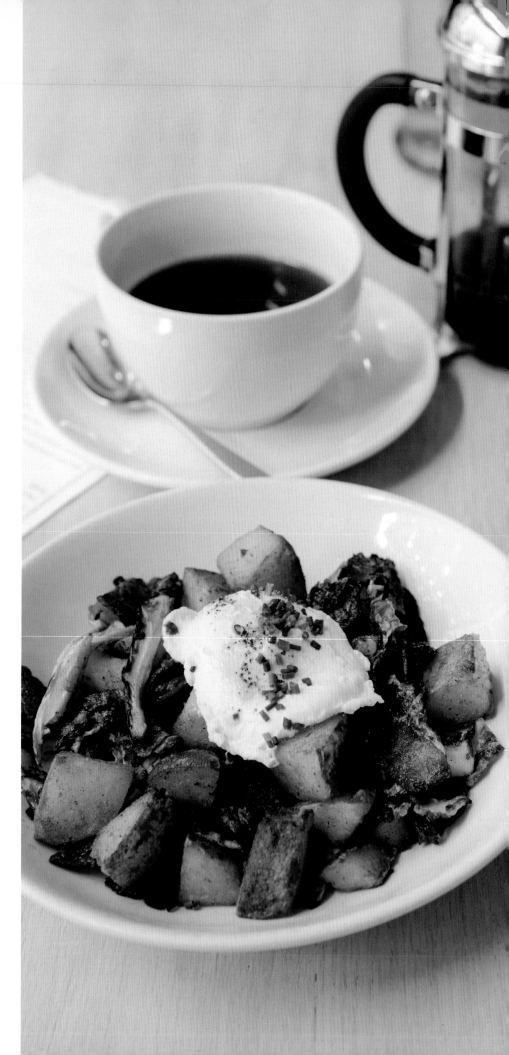

"The potatoes in the bubble and squeak were nice and crunchy, which I really like. I just love Brussels sprouts, and these were expertly wilted but still a little crispy."

Bubble and squeak

NO LEFTOVERS? NO WORRIES. YOU CAN STILL ENJOY THIS CASUAL CLASSIC FOR BRUNCH OR LUNCH

Serves 2

2 russet potatoes (approx 400g)

Handful Brussels sprouts, shredded

Handful Swiss chard, chiffonaded (roll the leaves up into a cigar shape and slice thinly into strips)

6 rashers of streaky bacon

Salt, fresh ground pepper and nutmeg to taste

Butter to fry

1 Cut the potatoes into cubes and roast in the oven at 200°C/Fan180/400°F, gas 4 for 30-40 minutes.

2 While the potatoes are cooking, grill the bacon until crisp. Drain off any excess fat and then chop the bacon into 3cm lengths.

3 Heat a teaspoon of vegetable oil in a hot frying pan. Add the Brussels sprouts and Swiss chard, and keep stirring constantly until the greens are just cooked. Add the bacon and stir through.

4 Remove the potatoes from the oven and let cool briefly.

5 Melt butter in a non-stick frying pan and add the potatoes, greens and bacon. Fry these over a moderate heat until lovely crispy bits form – around 15 minutes.

6 A tasty addition to the dish is a softly poached egg. Sprinkle with chives to serve.

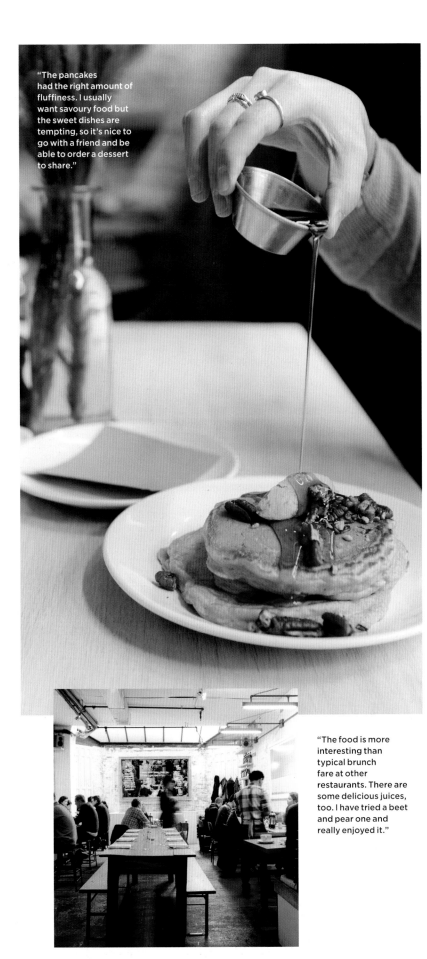

"The pancakes had the right amount of fluffiness. I usually want savoury food but the sweet dishes are tempting, so it's nice to go with a friend and be able to order a dessert to share."

"The food is more interesting than typical brunch fare at other restaurants. There are some delicious juices, too. I have tried a beet and pear one and really enjoyed it."

Pumpkin pancakes

PILE UP FAT, FLUFFY PANCAKES TWO OR THREE AT A TIME, SPRINKLE AND POUR YOUR FAVOURITE TOPPINGS AND DIVE IN

Makes 8

125g flour

1^1/$_2$ tsp baking powder

A pinch of salt

1 egg

1 tbsp sugar

150ml buttermilk (if you can't find buttermilk, add 1/$_2$ tbsp of lemon juice to 150ml of milk, stir and leave to stand for a couple of minutes before using)

40g butter, melted

225ml pumpkin purée*

1 Stir together the flour, baking powder, salt and sugar. Add the egg, buttermilk, pumpkin purée and melted butter, and whisk to combine.
2 Pour the pancake mixture into a jug. Heat up a small heavy-based frying pan on the stove. If you were given a blini pan for Christmas, now's the time to use it!
3 Pour the mix into the hot pan. You want each pancake to be about 8cm in diameter. Once the top of the pancake starts to bubble, flip it over and cook the other side for about a minute.
4 Serve with a generous drizzle of maple syrup, a sprinkling of your favourite nuts and a scoop of ice cream.

** If you don't have pumpkin, you can substitute butternut squash purée. Cut squash in half, remove seeds and cook in a 200°C/Fan180/400°F, gas 6 oven until soft. Scoop out flesh and blend with a knob of butter until smooth.*

NOTES ON TEA

BE IT STRONG, HERBAL OR CAFFEINE-FREE, IF TEA RULES YOUR LIFE, FILL THE KETTLE AND ENJOY EIGHT OF THE BEST

DARJEELING EARL GREY
LEAVES FROM THE FOOTHILLS OF THE HIMALAYAS COMBINE WITH ITALIAN BERGAMOT (OIL FROM THE RIND OF AN ORANGE) TO CREATE A FRAGRANT TEA THE RAJ COULD ONLY DREAM ABOUT

Harvested for just two weeks a year, at dawn!

SILVER TIPS WHITE
THE PUREST, MOST EXCLUSIVE TEA YOU CAN FIND. MADE OF FRESH YOUNG TEA BUDS BEFORE THEY'VE UNFURLED. DELICATE IN FLAVOUR AND LOW IN TANNIN AND CAFFEINE

CHAMOMILE
A RELAXING, SOOTHING AND SOPORIFIC HERBAL DRINK. CHOOSE ONE THAT USES WHOLE FLOWERS, NOT GROUND-DOWN BITS. WILL ALSO LIFT THE COLOUR OF BLONDE HAIR WHEN USED AS A RINSE!

Little sticks of detoxifying delight

LEMONGRASS
EXCELLENT FOR DIGESTION, AND SWEETER AND MORE CITRUSSY THAN YOU MIGHT IMAGINE. YOUR NEW FAVE HANGOVER CURE

YERBA MATE
LOVED BY CHE GUEVARA AND PRONOUNCED 'YERBA MAH-TEY', THIS HOT DRINK DERIVED FROM HOLLY IS SUCKED FROM A GOURD THROUGH A SILVER STRAW KNOWN AS A BOMBILLA

MATCHA GREEN
USED IN JAPANESE TEA CEREMONIES FOR HUNDREDS OF YEARS, AND RELIED ON BY MEDITATING BUDDHIST MONKS, THIS POWDER ED GREEN TEA IS NOW A HEALTH CRAZE

Hugely healthy...

TUNG TING OOLONG
ALSO KNOWN AS DONGDING, OR BLUE TEA, THIS STRONG, PART-FERMENTED TAIWANESE TEA IS CONSIDERED TO BE GOOD FOR GENERAL HEALTH

ROOIBOS
POPULAR WITH THOSE KEEN TO DITCH THE CAFFEINE, THIS DISTINCTIVE REDDISH-BROWN DRINK IS ADORED FOR ITS SLIGHTLY NUTTY, MALTY TASTE

Sweeten up lemongrass with a smidge of honey

SUMMERHOUSE KITCHEN

THE GARDEN AT RIVER COTTAGE, BRITAIN'S PREMIER COOKERY SCHOOL, IS FULL OF TOMATOES, AUBERGINES AND COURGETTES IDEAL FOR LUNCHTIME SALADS

Gillon Meller

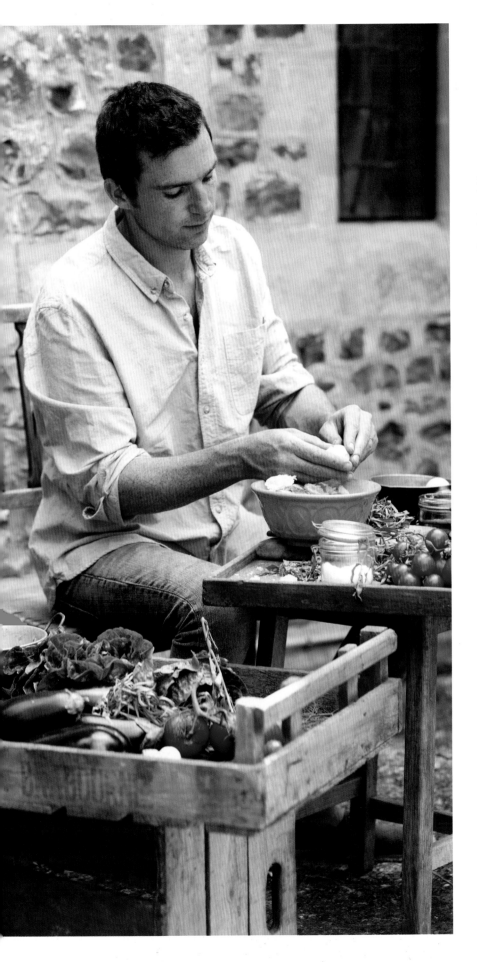

River Cottage is based at Park Farm in a valley of 65 acres on the Dorset/Devon border. Here you'll find the farm and cookery school where I work daily as the head chef, either in the busy kitchen or teaching a cookery class.

It's an amazing place to be, especially in summer when the gardens are full of produce. We harvest every morning and menus are built on what's available and good that day. It's the best way to cook and the only way when there's such abundance. I find it pushes creativity, particularly when there are gluts to work with.

This month, I'm making three super simple salads using three high-summer favourites you will know well – tomatoes, aubergines and courgettes.

Each year, through mid-to late summer, we grow aubergine plants at River Cottage – they do really well in the poly tunnels. Aubergines are great when they are firm and fresh. I like them thickly sliced and chargrilled, served with lamb or grilled fish.

Unlike aubergines, courgettes grow happily out of doors down here in the southwest. Just two or three plants could produce dozens over several weeks. When courgettes are small and fresh I like them raw, thinly sliced with lemon juice and mint. With slightly larger courgettes, slice and slow cook on the hob in a little oil with garlic and dill for well over an hour. They turn hopelessly soft and rich. Spooned onto toast or turned through pasta with crumbled goats' cheese or feta, this makes a really comforting lunch.

In late autumn, I like to roast the last of the tomatoes with tarragon, anchovies and garlic. The combination is wonderfully fragrant, sweet and comforting, but during the summer I make a generous salad using the freshest tomatoes I can find.

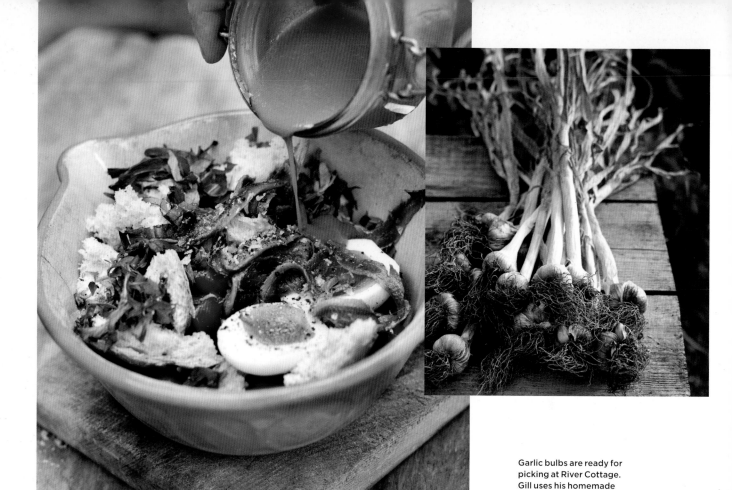

Garlic bulbs are ready for picking at River Cottage. Gill uses his homemade red wine vinegar to make the vinaigrette.

Tomatoes with anchovies, tarragon, eggs & sourdough

THIS COMBINATION OF TOMATOES, TARRAGON, BREAD AND RED WINE VINEGAR IS FULL OF THE WARMTH OF SUMMER

Serves 4

4 free range eggs

800g ripe tomatoes

Small loaf of sourdough or country bread, a few days old

12–14 anchovy fillets

Leaves from 1 small bunch tarragon, chopped

Leaves from 1 small bunch basil, chopped

FOR THE DRESSING

3 tbsp good olive oil

2 tbsp red wine vinegar

$^1/_2$ tsp sugar

1 tsp mustard

Salt and freshly ground black pepper

1 Bring a small pan of water to the boil, add eggs and cook for 6$^1/_2$ mins. Run eggs under cold water to stop them cooking – the yolks should have a softish centre.

2 Peel the eggs, halve them and set aside.

3 Cut the tomatoes into bite-sized pieces and place in a large salad or mixing bowl. Take about 150g bread and tear it into chunky pieces and add to the tomatoes.

4 Add the anchovy fillets, soft-boiled eggs, herbs and half the dressing. Season well with salt and pepper, then carefully, using clean hands, turn everything together. You don't want to break the eggs up, so use a light touch.

5 Allow salad to stand for 10–15 mins before turning once more; it will taste all the better for it.

6 Divide the salad between four plates and drizzle with the remaining dressing.

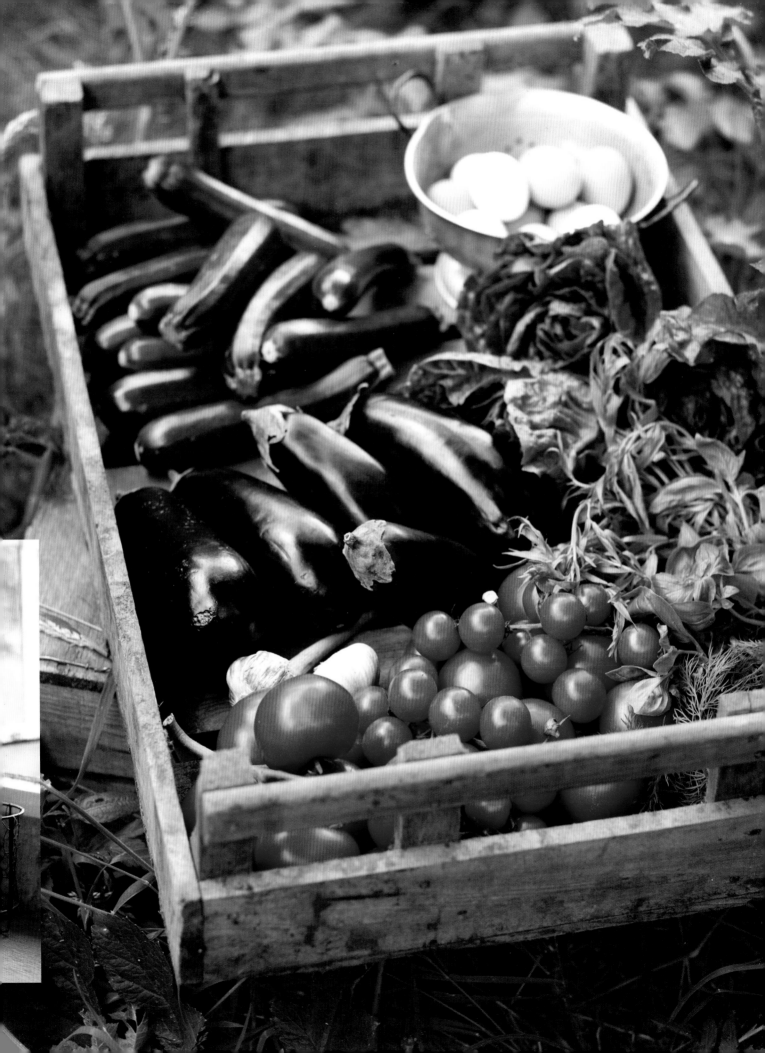

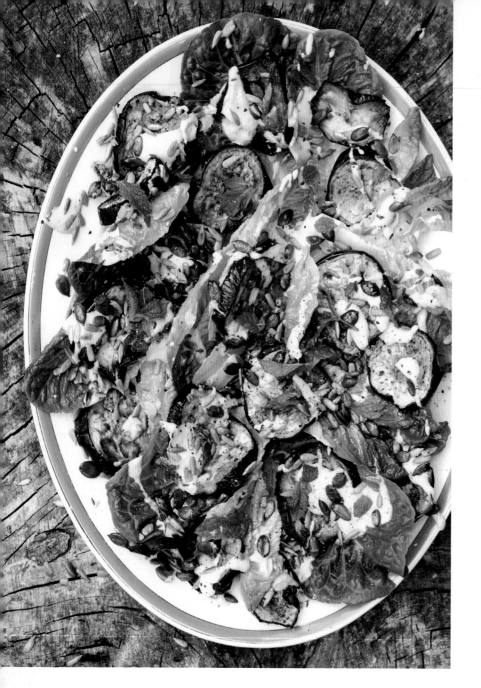

Roast aubergines with toasted seeds & lettuce

GARLICKY ROASTED
AUBERGINES WITH SALAD
LEAVES AND A TAHINI
AND YOGHURT DRESSING

Serves 4

2–3 medium aubergines

3 tbsp olive oil

2 cloves garlic, peeled and bashed

2 small Cos or Little Gem lettuces

Small handful mint leaves, chopped

FOR THE DRESSING

2 tbsp tahini

1/2 clove garlic, crushed or grated

Juice and zest of one lemon

2 tbsp natural yoghurt

2 tsp runny honey

3 tbsp olive oil

FOR THE TOASTED SEEDS

2 tbsp pumpkin seeds

2 tbsp sunflower seeds

2 tsp cumin seeds

1/2 tbsp olive oil

1/2 tsp sugar

Good pinch of salt

1 Pre-heat the oven to 180°C/Fan160/350°F.
Slice the aubergines into rounds about
1cm thick. Place in a bowl and trickle over
the olive oil. Season well and add the bashed
garlic. Toss the whole lot together, then
lay the aubergine out on a baking tray
in a single layer.
2 Cook for 30–35 mins, turning the slices
once, halfway through.
3 Meanwhile, place a small frying pan over
medium heat. Add the seeds, oil, sugar
and salt and toss together as they toast.
Cook for 2–3 mins until fragrant and begin-
ning to pop a little. Set aside to cool.
4 Put the tahini in a small bowl with the
garlic, lemon juice and zest, yoghurt,
honey and oil. Whisk with a fork until thick
and creamy. If too thick, add water.
5 Cut the base from each lettuce and dis-
card any damaged outer leaves. Separate
the lettuce leaves, wash and spin dry.
Arrange leaves over a large platter; top
with aubergine slices, then spoon over
the dressing.
6 Finish with a scattering of toasted seeds
and some chopped mint.

Chopped dill or fennel tops are fragrant accompaniments for torn roast chicken and grilled courgettes.

Courgettes with dill, spring onions, mint and chicken

I'M USING LEFTOVER CHICKEN, BUT SHARDS OF ROASTED LAMB WOULD ALSO WORK

Serves 4, or 2 as a main course

4 medium-size firm courgettes

2 tbsp olive oil

1 clove garlic, finely chopped

Leaves from small bunch mint, chopped

1 bunch of spring onions, sliced

Small bunch of dill, chopped

Juice of 1 lemon

300g leftover chicken

1 Slice the courgettes into rounds as thick as a £1 coin. Place in a bowl and add olive oil, garlic, salt and pepper. Tumble together, then lay out in a single layer over a large baking tray.
2 Pre-heat the grill to high and cook for about 6–10 mins on each side until golden.
3 Return cooked courgettes to the bowl. Add chopped mint, spring onions, dill and lemon juice. Combine well.
4 Tear the chicken into pieces and turn through the warm courgettes.
5 Finish with a glug of olive oil and season.
6 Serve the salad while still warm with some sprigs of dill or fennel tops to garnish.

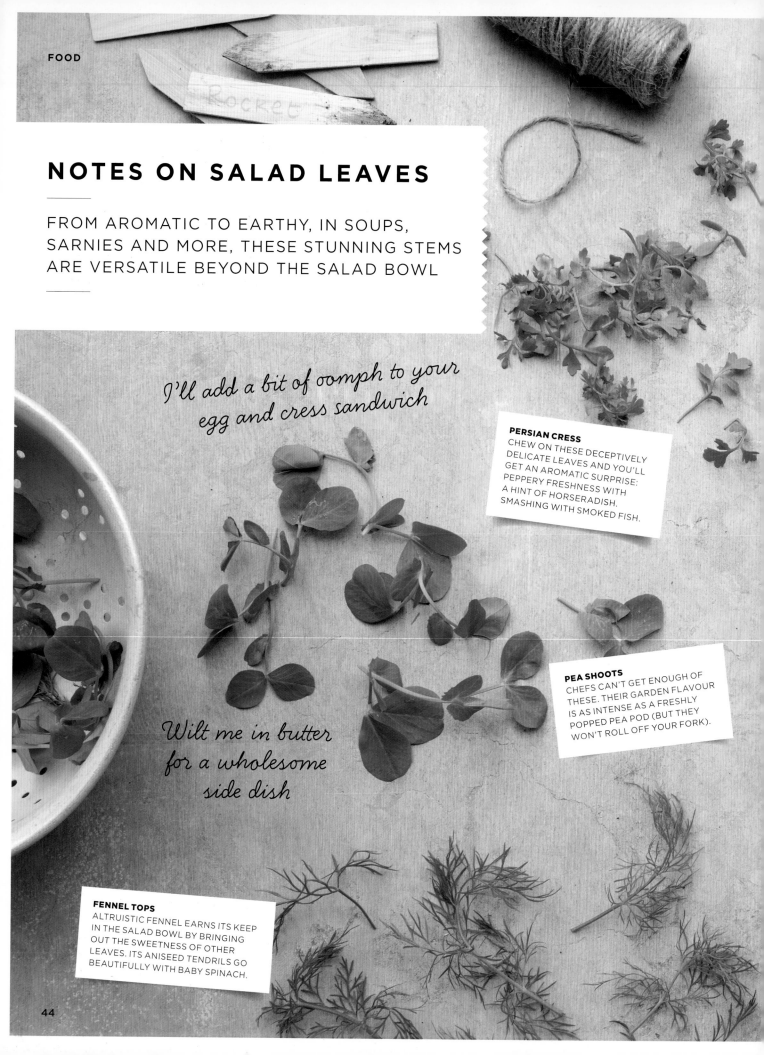

NOTES ON SALAD LEAVES

FROM AROMATIC TO EARTHY, IN SOUPS, SARNIES AND MORE, THESE STUNNING STEMS ARE VERSATILE BEYOND THE SALAD BOWL

I'll add a bit of oomph to your egg and cress sandwich

Wilt me in butter for a wholesome side dish

PERSIAN CRESS
CHEW ON THESE DECEPTIVELY DELICATE LEAVES AND YOU'LL GET AN AROMATIC SURPRISE: PEPPERY FRESHNESS WITH A HINT OF HORSERADISH. SMASHING WITH SMOKED FISH.

PEA SHOOTS
CHEFS CAN'T GET ENOUGH OF THESE. THEIR GARDEN FLAVOUR IS AS INTENSE AS A FRESHLY POPPED PEA POD (BUT THEY WON'T ROLL OFF YOUR FORK).

FENNEL TOPS
ALTRUISTIC FENNEL EARNS ITS KEEP IN THE SALAD BOWL BY BRINGING OUT THE SWEETNESS OF OTHER LEAVES. ITS ANISEED TENDRILS GO BEAUTIFULLY WITH BABY SPINACH.

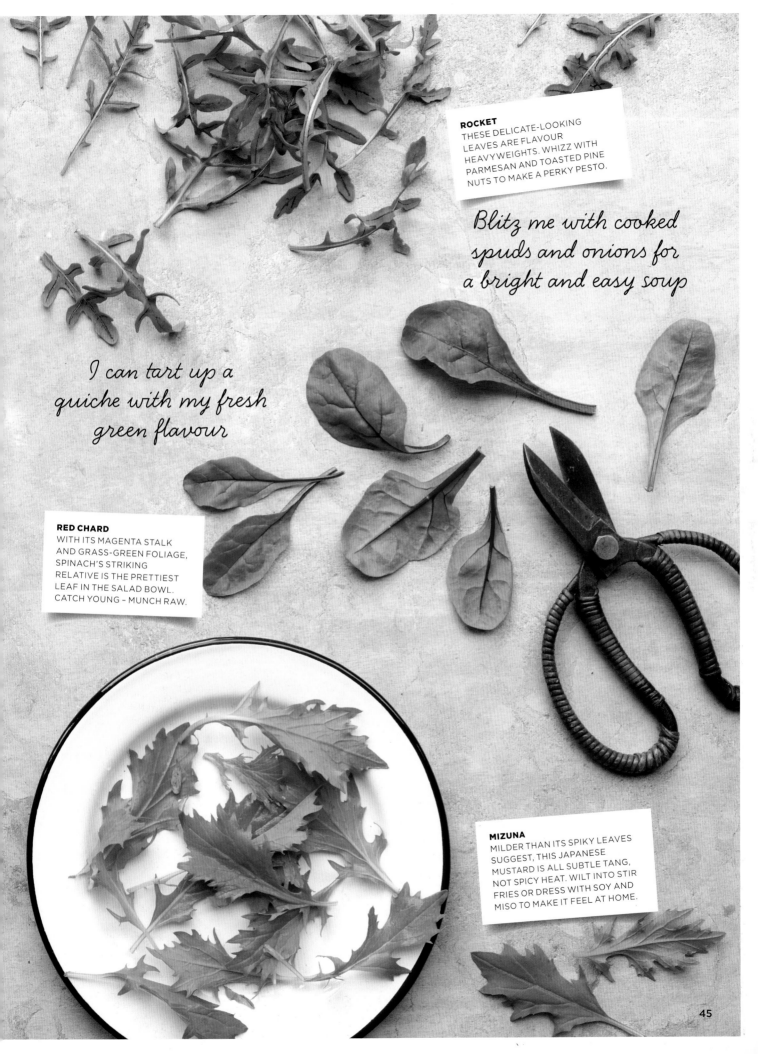

ROCKET
THESE DELICATE-LOOKING LEAVES ARE FLAVOUR HEAVYWEIGHTS. WHIZZ WITH PARMESAN AND TOASTED PINE NUTS TO MAKE A PERKY PESTO.

Blitz me with cooked spuds and onions for a bright and easy soup

I can tart up a quiche with my fresh green flavour

RED CHARD
WITH ITS MAGENTA STALK AND GRASS-GREEN FOLIAGE, SPINACH'S STRIKING RELATIVE IS THE PRETTIEST LEAF IN THE SALAD BOWL. CATCH YOUNG – MUNCH RAW.

MIZUNA
MILDER THAN ITS SPIKY LEAVES SUGGEST, THIS JAPANESE MUSTARD IS ALL SUBTLE TANG, NOT SPICY HEAT. WILT INTO STIR FRIES OR DRESS WITH SOY AND MISO TO MAKE IT FEEL AT HOME.

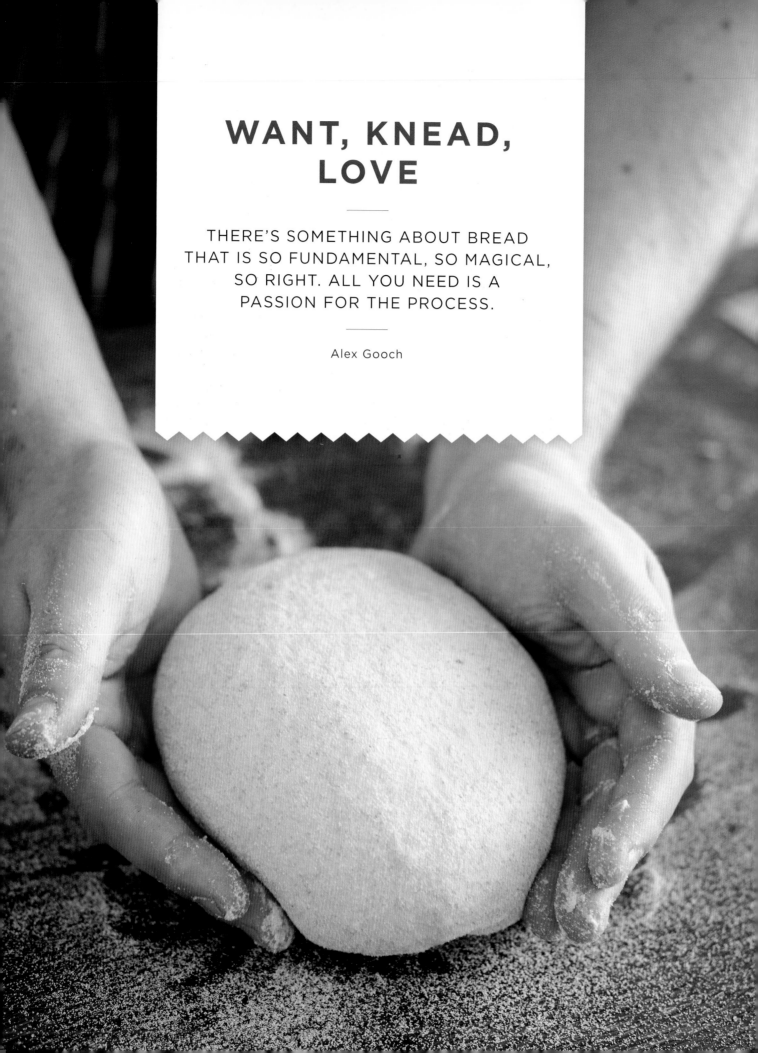

WANT, KNEAD, LOVE

THERE'S SOMETHING ABOUT BREAD
THAT IS SO FUNDAMENTAL, SO MAGICAL,
SO RIGHT. ALL YOU NEED IS A
PASSION FOR THE PROCESS.

Alex Gooch

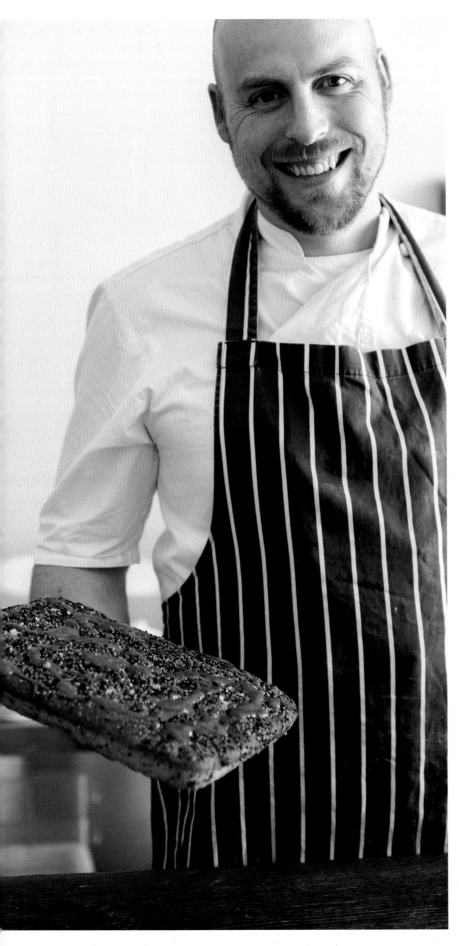

Good bread takes patience, passion and instinct. Making it brings you into the moment completely. It stimulates all of the senses, whether it be the feel of the dough, the sweet smell of the baking bread, or the crackle as you squeeze a ciabatta.

When I was growing up, my brothers and I ate toast, toast and more toast! And that was about as close to bread as I got, until I started as a kitchen porter when I was doing my A-levels.

I loved the camaraderie of the kitchen and felt at home there. They offered to train me, so I ditched the idea of college and settled into the chef's life of long hours and a surrogate family of fellow foodies.

I liked baking bread, and worked at a few Italian restaurants where I mastered focaccia pretty well and at hotels where I made plenty of pastry and croissants. But it was while at Penrhos Court in Herefordshire that I started experimenting, encouraged by chef Daphne Lambert (who I named my first sourdough starter after). In 2007 she let me take over one of the kitchens at night, and this was my first bakery. I began selling bread and jams at farmers' markets and food festivals; the following year I opened my bakery, called Alex Gooch Artisan Baker, in Hay-on-Wye.

There are so many possibilities with bread: rye sourdough, mixed grain, ciabatta, brioche. But one of the things that keeps me excited and inspired is following the seasons, and letting them dictate the bread I make. It turns out that pink fir apples make the most scrumptious potato and onion bread, and the magical cep makes a mind-blowing garlic and cep foccacia with herb oil.

Baking is a hard job – pulling all-nighters, and the need to step up a gear when things are busy. But baking at home is different: one of the reasons I think it is now so popular is because the results are so rewarding. The process is so enjoyable, too. It is very natural; you can listen to the radio or chill out for a while – bread is at its best when it is left to rest a lot.

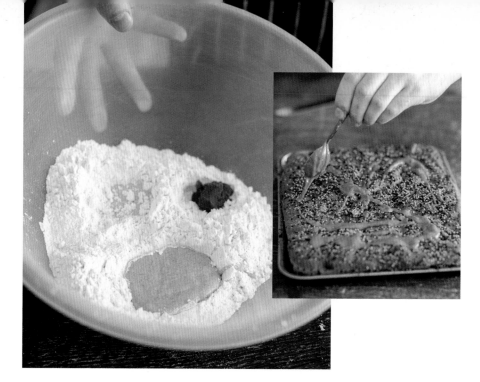

Cavolo nero is kale's Italian cousin and has a pleasant, tangy flavour.

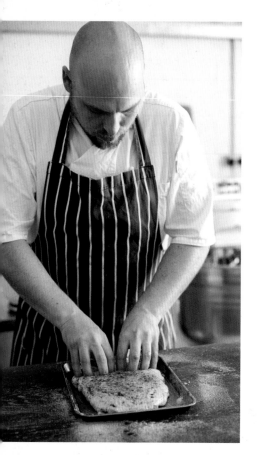

Black garlic flatbread with sesame, nigella and a kale-miso dressing

THIS FLATBREAD IS GREAT ON ITS OWN. THE RAW KALE DRESSING ADDS FRESHNESS AND VIBRANCY

400g strong white flour
270g water
40g Gooch's sponge (pg. 53)
20g miso (1 heaped tsp)
4g dried quick yeast (6g fresh yeast)
10g sesame seeds
10g nigella seeds
1 large clove of black garlic
30g extra-virgin olive oil

FOR THE DRESSING
30g cavolo nero (or rapini or spinach)
30g extra-virgin olive oil
10g miso

1 Mix the flour, water, sponge, miso and yeast in a bowl to form a dough with no loose bits of flour left. Knead in the bowl for 2 mins using a timer. Turn the dough out onto the table and leave it to rest for 2 mins. You can use a little semolina if the dough seems excessively moist.
2 Knead the dough for 2 mins using a timer, and then rest for 2 mins; knead for another 2 mins, shape into a ball and place into a lightly oiled bowl. Cover it tightly using cling film or place the bowl in a plastic bag, and seal it to create a greenhouse effect.
3 Leave to prove for two hours until well risen.
4 Oil a baking tray that is roughly 30x24cm; make sure all of the tray is oiled, including the sides. Sprinkle semolina or polenta all over the oil.
5 Turn the bowl upside down and let the dough fall onto the baking tray. Arrange it evenly with a roughly 3cm gap all the way around the outside that the dough can be stretched into a bit later.
6 Crush the black garlic in a pestle and mortar with the olive oil, until a smooth consistency is formed. Scrape out the black garlic mix onto the top of the dough and rub it all over, including around the edges.
7 Put all ten of your fingers into the dough until they touch the tray and stretch it out to fill the tray, making clearly defined holes with your fingers. Sprinkle the sesame and nigella seeds over the top of the flatbread and leave to prove for 45 mins, with a bowl on top or another cover which does not touch the surface as it is proving.
8 Bake for 15 mins at 240°C/Fan 220/475°F. Remove from oven and leave to cool on the tray it baked on.
9 For the dressing, blitz the ingredients in a blender for a few seconds until smooth and, with a spoon, flick the dressing all over the top of the now room-temperature flatbread.

GOOCH'S GLOSSARY

WILD YEAST
As opposed to baker's yeast (fresh or dried): this just exists in flour, in grain, in the environment, it just is. Baker's is what you buy, a cultivated form of fast-acting yeast.

KNEADING
This mixes the ingredients and aids the forming of gluten: the gluten in the bread is what holds the CO_2 in the bread and makes it lighter. CO_2 is released by the yeast as they feed on the natural sugars in flour.

DOUGH
Flour, water, salt, yeast. It may on occasion contain other things, like butter, but these are incidental.

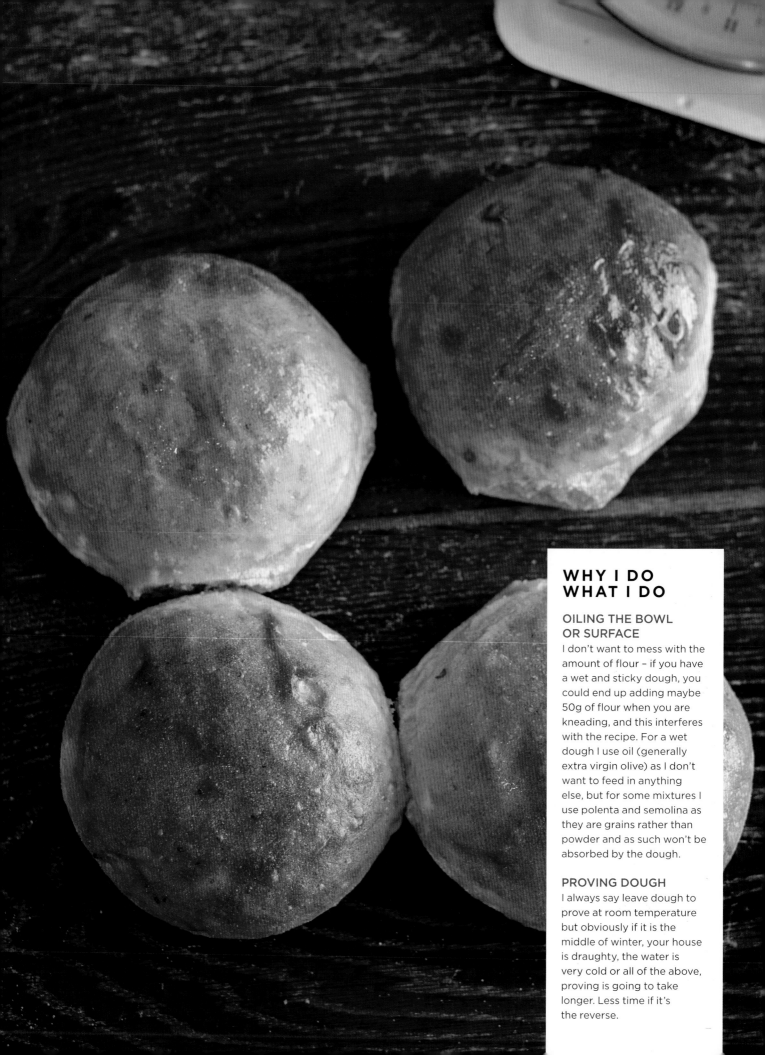

WHY I DO WHAT I DO

OILING THE BOWL OR SURFACE

I don't want to mess with the amount of flour – if you have a wet and sticky dough, you could end up adding maybe 50g of flour when you are kneading, and this interferes with the recipe. For a wet dough I use oil (generally extra virgin olive) as I don't want to feed in anything else, but for some mixtures I use polenta and semolina as they are grains rather than powder and as such won't be absorbed by the dough.

PROVING DOUGH

I always say leave dough to prove at room temperature but obviously if it is the middle of winter, your house is draughty, the water is very cold or all of the above, proving is going to take longer. Less time if it's the reverse.

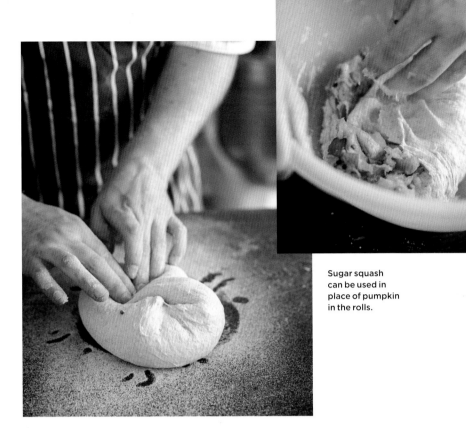

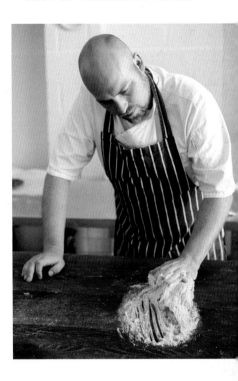

Sugar squash can be used in place of pumpkin in the rolls.

Roast pumpkin and apple rolls

GREAT FOR MAKING SANDWICHES, OR TOASTED WITH POACHED EGGS

500g strong white flour

300g water

50g Gooch's sponge

10g sea salt

5g dried quick yeast (7g fresh yeast)

75g pumpkin

75g eating apples

1 tsp coriander seeds

1 Cut your pumpkin and apple into small pieces (4–5cm cubes) and keep them separate. Place your pumpkin on a baking tray and sprinkle with olive oil, salt, pepper and the coriander seeds. Roast at 220°C/Fan 200°C/425°F for 15 mins. Add the apple, tossing with the pumpkin, and roast for a further 10 mins.

2 Leave to cool, then crush the pumpkin and apple up in your hands; different-sized chunks are desirable.

3 Mix the flour, water, sponge, salt and yeast in a bowl to form a dough. With the dough still in the bowl, mix in the pumpkin and apple. Knead in the bowl for 2 mins using a timer. Turn the dough out and leave it to rest for 2 mins.

4 Knead the dough for 2 mins using a timer, and then rest for 2 mins; knead for another 2 mins, shape into a ball and place into a lightly oiled bowl. Cover it tightly using cling film, or place the bowl in a plastic bag and seal it to create a greenhouse effect.

5 Leave to prove for 2 hours.

6 Sprinkle semolina or polenta onto the table, and turn your bowl upside down and let your dough fall out onto it. Divide into four equal pieces and shape into balls. If the dough is sticking, use a little semolina to help you shape them.

7 Oil a baking tray and then sprinkle semolina onto the oil – it creates a nice crust on the bottom of the rolls. Place your four rolls on the tray and cover with a bowl or something that will not stick to them (make sure it is airtight so that a skin does not form on top of the rolls as they rise). Prove for 1 hour 15 mins.

8 Bake for 20 mins at 220°C/Fan200/ 425°F. Remove from the oven and brush tops with extra-virgin olive oil. Leave at least an hour before serving.

Plum and ginger bread with a cider and honey glaze

THIS BREAD IS EFFECTIVELY A YEASTED CAKE, ONLY WITH MUCH LESS SUGAR THAN MOST CAKES

400g strong white flour

240g water

40g Gooch's sponge

8g sea salt

4g dried quick yeast (6g fresh yeast)

20g fresh ginger, peeled and grated

4 tsp runny honey

1 tsp vanilla extract

25g sugar

250g de-stoned plums, cut into eight

FOR THE GLAZE

3 tbsp runny honey

30ml cider

1 tsp vanilla extract

1 Mix the first eight ingredients (up to vanilla extract) in a bowl until they form a dough. Knead in the bowl for 2 mins. Use a timer. Turn the dough out onto the table and leave it to rest for 2 mins.

2 Knead the dough for 2 mins using a timer, and then rest for 2 mins; knead for another 2 mins, shape into a ball and place into a lightly oiled bowl. Cover it tightly using cling film, or place the bowl in a plastic bag and seal it to create a greenhouse effect.

3 Leave to prove for 2 hours.

4 Generously butter two 500g bread tins, and then sprinkle semolina or polenta all over the inside of the tins.

5 Lightly oil your work surface, and turn your bowl upside down and let the dough fall onto the oiled area. Weigh the dough into two equal portions and cut each portion into ten pieces (they don't have to be exactly the same size).

6 Sprinkle the sugar over the dough, ensuring each little piece is covered with it. Place four pieces of the dough in the bottom of each tin and push down so the base is covered. Divide half the plums between the two tins, then top each loaf with another four pieces of dough. Layer the rest of your plums on top and finish each loaf with the last two bits of dough and press gently.

7 Leave to prove for 1 hour 15 mins. Place in a preheated oven for 28 mins at 220°C/Fan200/425°F.

8 Mix glaze ingredients and brush all over the top of your two loaves as soon as they're out of the oven. Leave your loaf for at least one hour before eating.

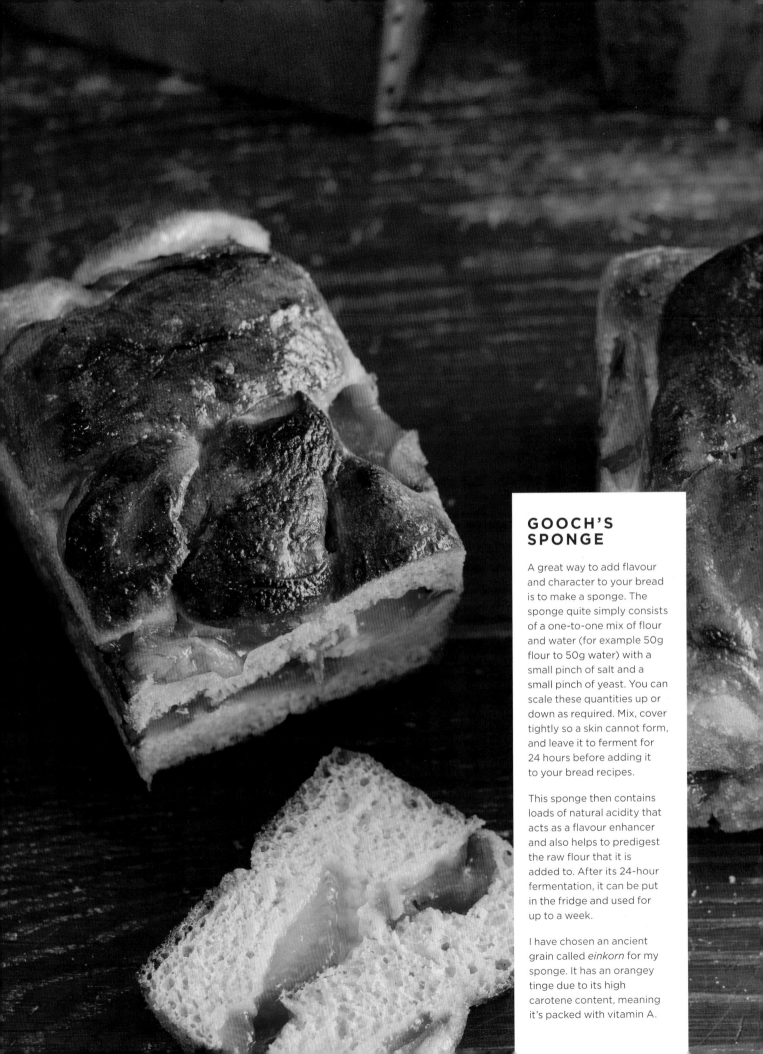

GOOCH'S SPONGE

A great way to add flavour and character to your bread is to make a sponge. The sponge quite simply consists of a one-to-one mix of flour and water (for example 50g flour to 50g water) with a small pinch of salt and a small pinch of yeast. You can scale these quantities up or down as required. Mix, cover tightly so a skin cannot form, and leave it to ferment for 24 hours before adding it to your bread recipes.

This sponge then contains loads of natural acidity that acts as a flavour enhancer and also helps to predigest the raw flour that it is added to. After its 24-hour fermentation, it can be put in the fridge and used for up to a week.

I have chosen an ancient grain called *einkorn* for my sponge. It has an orangey tinge due to its high carotene content, meaning it's packed with vitamin A.

NOTES ON OILS

CHOOSE THE RIGHT OIL AS A FOUNDATION OR DRESSING, AND YOU'LL BE ANOINTED WITH PRAISE

AVOCADO
MADE FROM THE FLESH, NOT THE STONE, AND SIMILAR TO OLIVE OIL. KNOWN FOR ITS SKIN-SOFTENING PROPERTIES BUT ALSO LOVED BY SALADS

Infuse with lime for a killer dressing

Keep away from the hob!

Add a spoonful to your smoothie

PUMPKIN SEED
DARK GREEN/LIGHT BROWN IN COLOUR, THIS INTENSE, NUTTY OIL MAKES A REAL IMPACT DRIZZLED ON SALADS, TOSSED WITH PASTA AND SPLASHED ON SEAFOOD, BUT CAN ALSO PRODUCE AMAZING GREEN SPONGE CAKES

LINSEED
ALSO KNOWN AS FLAXSEED, THIS OIL HAS BEEN DOING PEOPLE GOOD SINCE ANCIENT GREECE. DELICATE ENOUGH TO STIR INTO ANYTHING

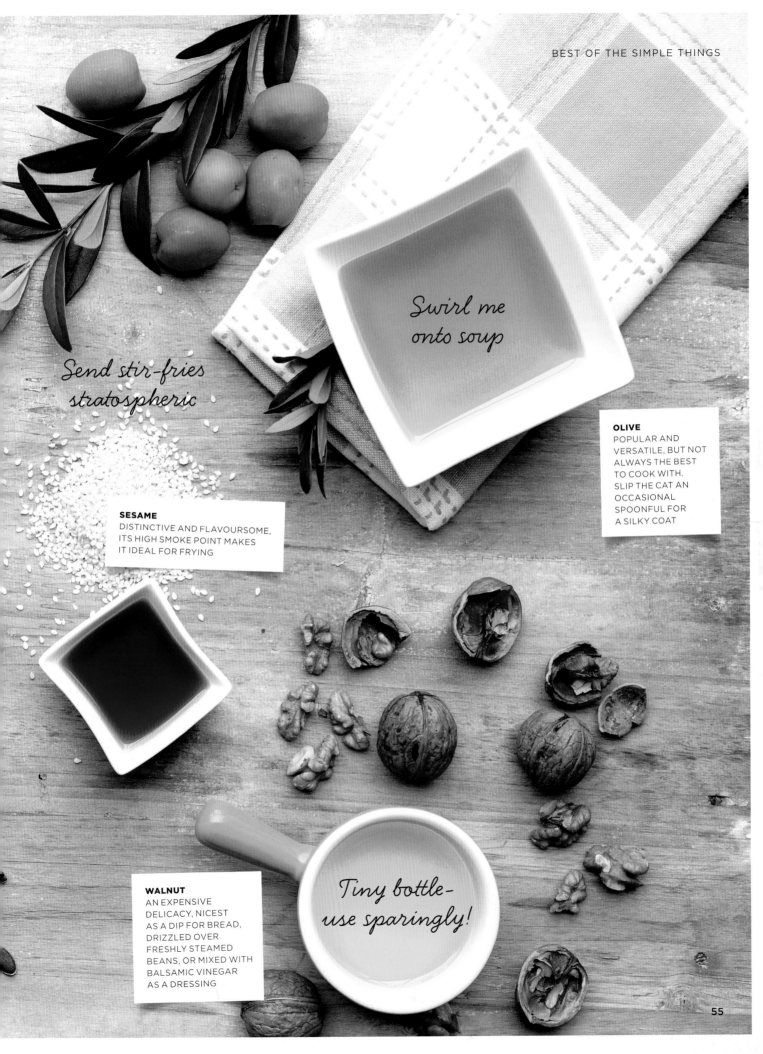

Send stir-fries stratospheric

Swirl me onto soup

SESAME
DISTINCTIVE AND FLAVOURSOME, ITS HIGH SMOKE POINT MAKES IT IDEAL FOR FRYING

OLIVE
POPULAR AND VERSATILE, BUT NOT ALWAYS THE BEST TO COOK WITH. SLIP THE CAT AN OCCASIONAL SPOONFUL FOR A SILKY COAT

WALNUT
AN EXPENSIVE DELICACY, NICEST AS A DIP FOR BREAD, DRIZZLED OVER FRESHLY STEAMED BEANS, OR MIXED WITH BALSAMIC VINEGAR AS A DRESSING

Tiny bottle – use sparingly!

THE EXPERT: TOMATOES

THE TOMATO STALL'S PAUL THOMAS TELLS US HOW TO TAKE THIS VERSATILE FRUIT FROM THE VINE TO THE PLATE

Lorenzo Bacino

From canned-in-juice to fresh-off-the-vine, dainty cherry to chunky beef, the humble tomato has made itself indispensable in our kitchens. It's the bedrock of soups and sauces, salads and sandwiches. Our pizzas and Bloody Marys would be nothing without it. One man who knows more than most people about this great and versatile fruit is Paul Thomas. Growing up on the Isle of Wight, he worked in kitchens from the age of 14 and ended up a tomato expert almost by accident. Returning from a long trip with no clear job prospects, he found himself driving a van-load of tomatoes around London.

"It was just at the time when farmers' markets were becoming popular," he says. "I used to pitch up with these fabulous tomatoes from our Isle of Wight tomato nursery and people were going crazy for them. I had no idea what to expect, but pretty soon I was doing more than 20 farmers' markets in London and elsewhere. I still trade at many of them."

That was about a decade ago. Now Paul heads The Tomato Stall, which remains part of the same Isle of Wight tomato company and today also offers its own range of ketchups, sauces and juices. With years of tomato expertise under his belt, he's our great guide to the little fruit that thinks it's a vegetable. We asked him to tell us everything we need to know.

What are the main types of tomatoes?
I think it's best to think in terms of family categories. So you've got large vine tomatoes, beef tomatoes, cherry-on-the-vine, baby plums, yellow baby plums, and medium cocktail on-the-vine. They're about the size of a golf ball and you typically get about eight to a vine.

Which are nicest to eat raw?
Depending on what your palate is and if you prefer something sweet, I'd go for a cherry-on-the-vine or a piccolo cherry-on-the-vine. They're the sweetest ones we grow. If you want something a bit meatier or juicier, then beef tomatoes are the way to go. We also grow a baby plum type which is close to the Italian san marzano variety and has a zingy sweet taste.

What are the best types to cook with?
The plum varieties. They've got quite a lot of flesh on them, so when you cook them down, there's very little water, and the flesh makes them thicken nicely. What happens when they're not fleshy enough is that you end up cooking a third of the body away. Lots of tomatoes are great in flavour, but hold quite a lot of water. When you cut open a san marzano tomato, for example, you can see it's really thick and has a lot of flesh to it and not much water. Most plum varieties are similar in texture.

What should you look for in a tomato?
I choose tomatoes based on colour and appearance, and they don't have to look flawless to have a good flavour. I'd look for on-the-vine, and always check the vine is healthy and hasn't gone too green or brittle – that means it's still quite fresh. The longer the tomatoes stay on the vine, the longer they'll continue to draw nutrients from it. If the vine is brittle it means the tomato has got all it can, so it'll be getting on a bit in terms of age. The tomato itself needs to be a deep colour in appearance and have a nice shine. That's a really good indication of a nice tomato.

How does flavour change according to colour?
Yellow tomatoes are less acidic and sweeter than red ones. They have a more citrus flavour to them. We also have green tomatoes, which are slightly bitter. We have red tiger tomatoes with a harder skin. You really need to cook them

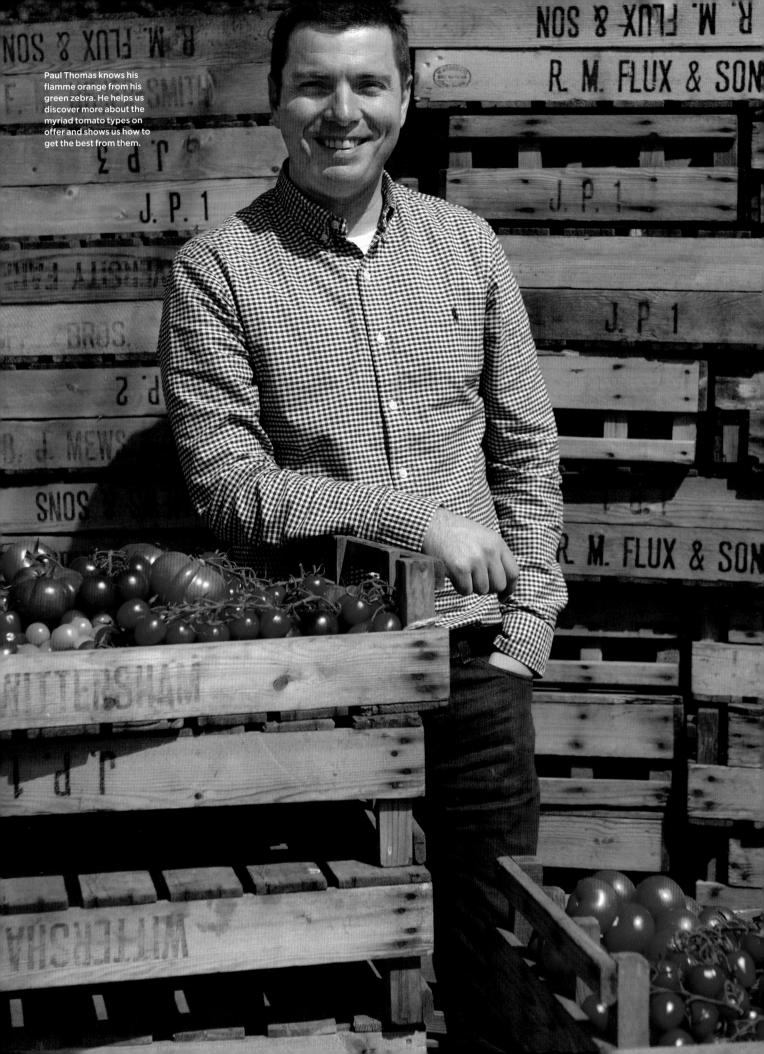

Paul Thomas knows his flamme orange from his green zebra. He helps us discover more about the myriad tomato types on offer and shows us how to get the best from them.

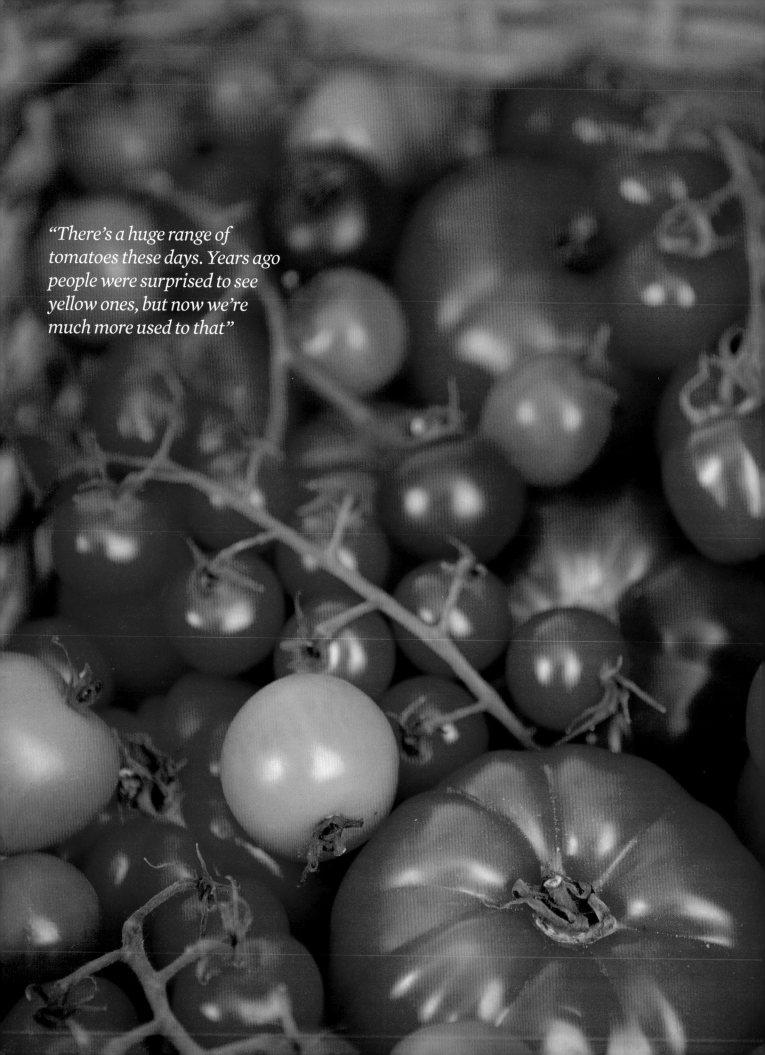

"There's a huge range of tomatoes these days. Years ago people were surprised to see yellow ones, but now we're much more used to that"

Tomatoes like the sun, and there's nothing tastier than a warm fruit fresh from the veg patch. At home there's no need to keep them in the fridge.

down to get the best out of the flavour. And we do pink tomatoes, too! They're really sweet and have a nice shine to the skin. They aren't bitter at all. There's a huge range these days. Years ago people were surprised to see yellow ones, but now we're much more used to that. We've got orange and chocolate cherry tomatoes in the warehouse. They're an off-brown colour and not as sweet as the reds, but they still have a nice taste.

What can you do with the green variety?
They make great classic chutney, but, you can also use them to make gazpacho and balance the bitterness with the coriander and the lime and chili.

How should they be stored?
The best thing is to store them in a brown paper bag in the fruit bowl at room temperature. As long as they're on the vine, they'll continue to ripen a little bit. Never put them in the fridge. With vine tomatoes, you'll notice those at the top are a deep red colour as they've ripened first, and towards the bottom they're still slightly orange. Give it a few days, and they'll go dark red, too, as they get the nutrients from the vine.

Does organic make any difference to flavour?
In terms of flavour, there's no difference as the varieties are the same. Organic ends up being more of a lifestyle choice, to my mind.

What can you do when they get over-ripe?
You can make a good gazpacho with over-ripe juicy tomatoes. Blitz them up and add some lime juice, a bit of chilli and some ice. It has a lovely watery freshness.

Canned or fresh?
I'd go for fresh in season, but in winter canned is fine as a good consistent product. But fresh is always best.

Can you freeze them?
I wouldn't recommend it. They're sub-tropical, so they hate the cold and it won't enhance them at all. You could make a sorbet with the essence and the juice, I guess!

What about drying them?
Yes, definitely. Cut them in half or quarters depending on the size and put them skin-side down on a tray with the exposed area on the top. Add a drizzle of oil and a bit of seasoning, and put them in a low oven at about 70-80°C and let them sit there for a few hours. A fan-assisted oven is good as the air flow helps to dry them out. As they dry down slowly, it'll caramelise the natural sugar in the tomatoes. You can use them straight away or put them in a jar with a bit of oil covering them. Pop them in the fridge and they'll last you about a month. You can do that with any type, not just the red ones. Just make sure the oil covers them and keeps the air out.

What partnerships will bring out the flavours?
There are always the traditional Italian, Spanish and Greek olive oil combinations and the basil. But I'd say thyme's a good one to marry with tomatoes. Tarragon works really well, too. Salsa verde and chilli somehow bring out the flavour well in terms of balance between sweetness and heat.

Some more adventurous ideas to try?
At The Tomato Stall we're experimenting with making a range of jams. Tomatoes are a fruit, but people don't think of them as being good for jams – but it works. They give jam a really sweet flavour. We want to encourage people to use them in a different kind of way, too.

People are roasting cherry-on-the-vine tomatoes and stuffing the beefy ones. I saw a Raymond Blanc recipe for tomato fondue, which looked great, too. About three years ago we had so many yellow tomatoes we didn't know what to do with them, so we juiced them, and now our yellow tomato juice is one of our bestsellers. It's a lot sweeter and less acidic than standard red tomato juice.

Also, a baker friend made a carrot cake and replaced the carrot with tomatoes. He made tomato icing using tomato juice and icing sugar. It tasted really great. I think it may take a while to catch on though!

What's the most unusual dish you've made?
Last year we went to a music festival and we made tomato ice lollies. It's always best when you don't tell people what it is immediately. When we told them it was tomato they were pleasantly shocked.

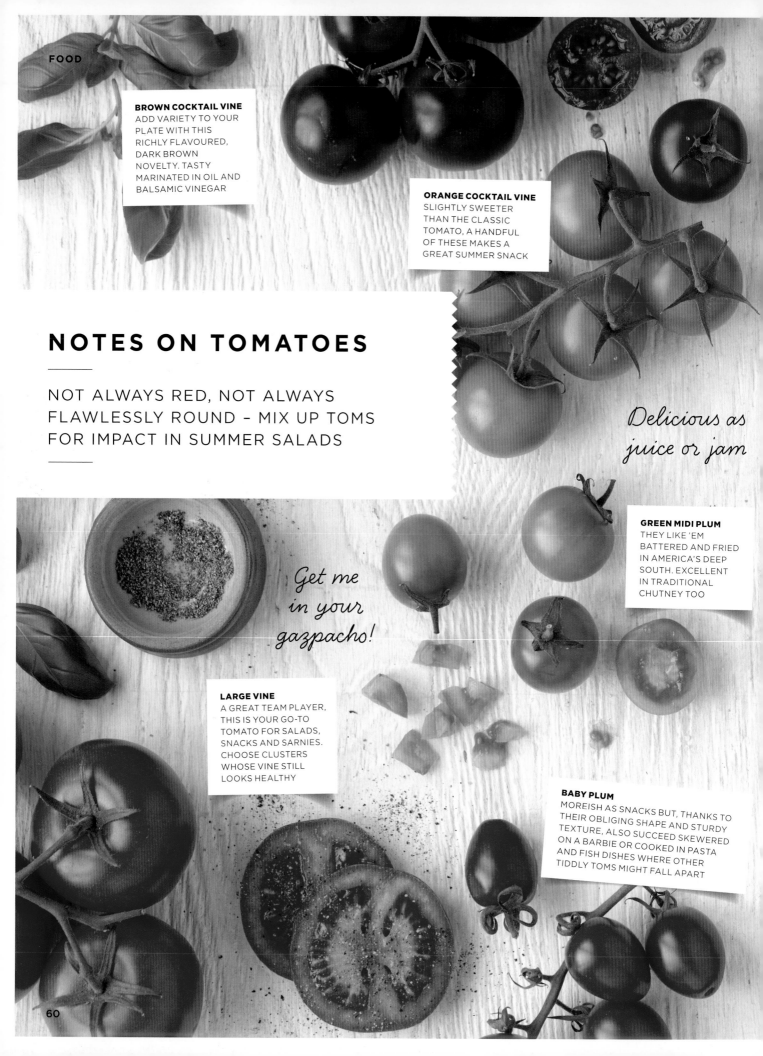

BROWN COCKTAIL VINE
ADD VARIETY TO YOUR PLATE WITH THIS RICHLY FLAVOURED, DARK BROWN NOVELTY. TASTY MARINATED IN OIL AND BALSAMIC VINEGAR

ORANGE COCKTAIL VINE
SLIGHTLY SWEETER THAN THE CLASSIC TOMATO, A HANDFUL OF THESE MAKES A GREAT SUMMER SNACK

NOTES ON TOMATOES

NOT ALWAYS RED, NOT ALWAYS FLAWLESSLY ROUND – MIX UP TOMS FOR IMPACT IN SUMMER SALADS

Delicious as juice or jam

Get me in your gazpacho!

GREEN MIDI PLUM
THEY LIKE 'EM BATTERED AND FRIED IN AMERICA'S DEEP SOUTH. EXCELLENT IN TRADITIONAL CHUTNEY TOO

LARGE VINE
A GREAT TEAM PLAYER, THIS IS YOUR GO-TO TOMATO FOR SALADS, SNACKS AND SARNIES. CHOOSE CLUSTERS WHOSE VINE STILL LOOKS HEALTHY

BABY PLUM
MOREISH AS SNACKS BUT, THANKS TO THEIR OBLIGING SHAPE AND STURDY TEXTURE, ALSO SUCCEED SKEWERED ON A BARBIE OR COOKED IN PASTA AND FISH DISHES WHERE OTHER TIDDLY TOMS MIGHT FALL APART

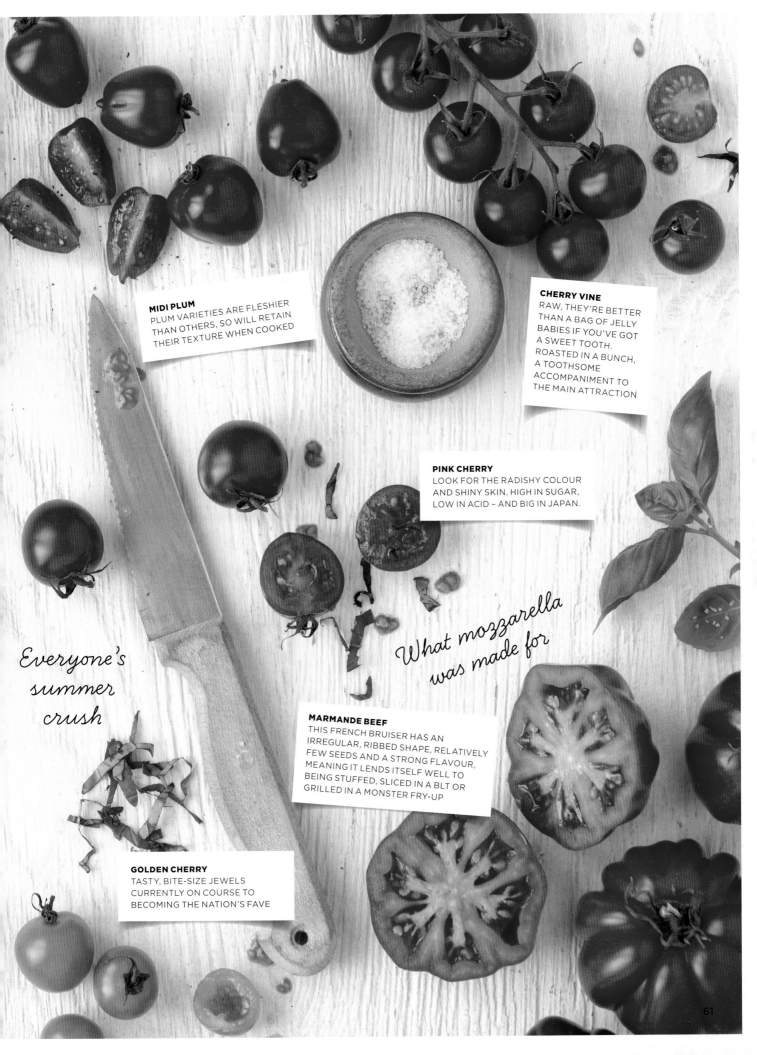

MIDI PLUM
PLUM VARIETIES ARE FLESHIER THAN OTHERS, SO WILL RETAIN THEIR TEXTURE WHEN COOKED

CHERRY VINE
RAW, THEY'RE BETTER THAN A BAG OF JELLY BABIES IF YOU'VE GOT A SWEET TOOTH. ROASTED IN A BUNCH, A TOOTHSOME ACCOMPANIMENT TO THE MAIN ATTRACTION

PINK CHERRY
LOOK FOR THE RADISHY COLOUR AND SHINY SKIN. HIGH IN SUGAR, LOW IN ACID – AND BIG IN JAPAN.

What mozzarella was made for

Everyone's summer crush

MARMANDE BEEF
THIS FRENCH BRUISER HAS AN IRREGULAR, RIBBED SHAPE, RELATIVELY FEW SEEDS AND A STRONG FLAVOUR, MEANING IT LENDS ITSELF WELL TO BEING STUFFED, SLICED IN A BLT OR GRILLED IN A MONSTER FRY-UP

GOLDEN CHERRY
TASTY, BITE-SIZE JEWELS CURRENTLY ON COURSE TO BECOMING THE NATION'S FAVE

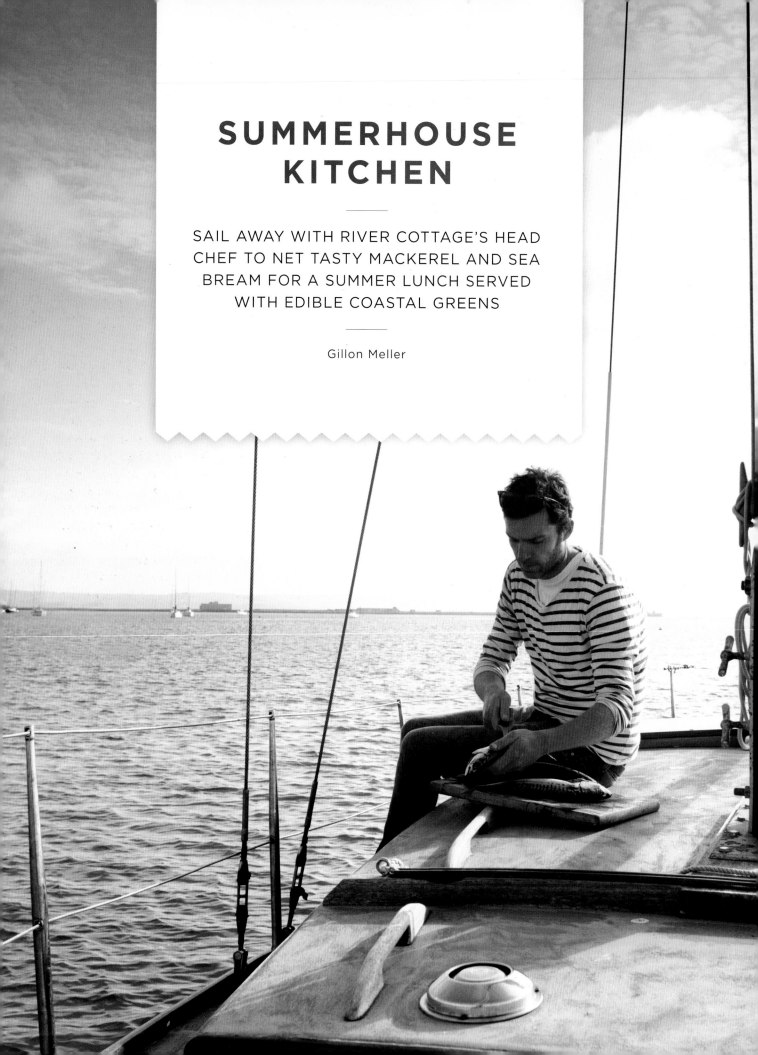

SUMMERHOUSE KITCHEN

SAIL AWAY WITH RIVER COTTAGE'S HEAD
CHEF TO NET TASTY MACKEREL AND SEA
BREAM FOR A SUMMER LUNCH SERVED
WITH EDIBLE COASTAL GREENS

Gillon Meller

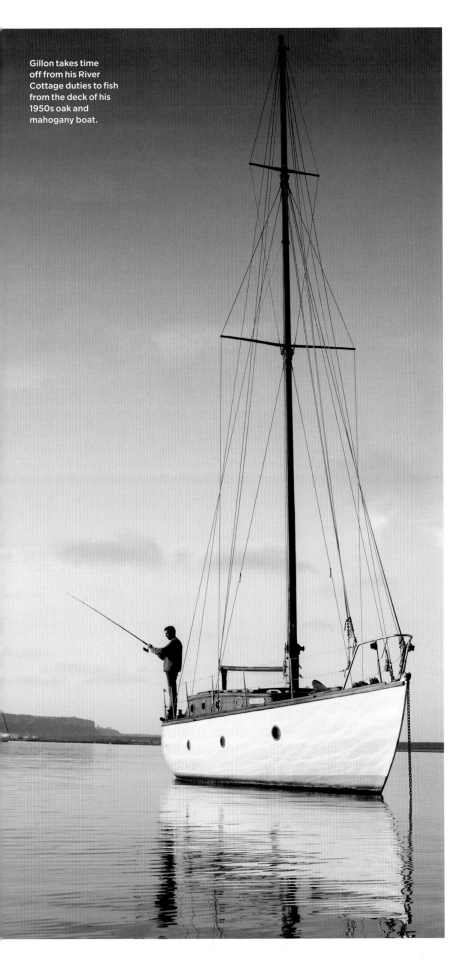

Gillon takes time off from his River Cottage duties to fish from the deck of his 1950s oak and mahogany boat.

Over the summer months I try to get out on our boat as often as I can. She was built in 1950 from mahogany and oak. My dad built wooden boats and has sailed them most of his life, but he didn't build this boat; we bought her from a lady who kept her moored at Restronguet in Cornwall. She is simple to sail, fine and seaworthy – she's certainly not glamorous like some classic boats, but more a workaday east-coaster.

There are always a few fishing rods on board, as well as some hand lines for trolling along behind her stern as we tack around the bay. We regularly land mackerel, plus the odd larger, predatory fish like sea bass or bream on occasion. Catching fish while we are sailing, or even when we are still on the mooring, is great fun and means we can be sure we'll get to eat well that day.

The fish is often cooked in our well-ordered galley, but it's also nice to take the dinghy ashore and do some cooking on the beach. There are two edible coastal wild greens growing along the rocky foreshore. Sea beet, a particular favourite of mine, is similar to spinach but its glossy, pointed leaves are fleshier and more flavoursome. Sea beet cooks in the same way as our more familiar cultivated greens, like chard and kale, and is delicious simply simmered, seasoned and buttered. You'll find it growing in late spring through to early summer, and it is at its best before it flowers.

Rock samphire belongs to the carrot family. It has antler-like fronds and can be found growing in patchy clumps along cliffs, around sea defences and on rocky outcrops. Its flavour is met with mixed reactions – some people find it too strong, but I like the taste. Rock samphire is traditionally pickled, but I simply serve it with sea beet.

Fresh mackerel looks firm, bright-eyed and colourful. If you can't fish for your own, look out for these characteristics when you buy it.

Mackerel with ginger, sesame, honey and coriander

MACKEREL IS A VERSATILE FISH AND WHEN IT'S REALLY FRESH, IT IS DELICATE, TENDER AND SUBTLE

Serves 2

2 tsp sesame oil

2 mackerel, filleted

2 garlic cloves, peeled and thinly sliced

Half a finger-sized piece of root ginger, peeled and thinly sliced

Half or 1 whole fresh red chilli, deseeded and thinly sliced

2 tbsp tamari sauce

1 tbsp sesame seeds

2 tsp runny honey

2 tsp cider vinegar

2 tbsp water

1 bunch of coriander, chopped

2 limes, to serve

Sprouted lentils, to serve

1 Heat a large, non-stick frying pan over a medium high heat. Add the sesame oil, followed by the mackerel fillets, skin side down.
2 Cook for 1-2 mins, then add the garlic, ginger and chilli to the pan, scattering these ingredients around the fillets so that they start to cook quickly – give them a minute or so of sizzling before you flip the fillets over.
3 Add the tamari, sesame seeds, honey, cider vinegar and water. At this point the mackerel will be cooked through, so carefully transfer it to warmed plates.
4 Continue simmering the sauce for a further 30-40 secs. Add the coriander to the pan, then remove the pan from the heat. Spoon the sauce over the fish.
5 Serve with limes to squeeze over the fish and sprouted lentils or rice.

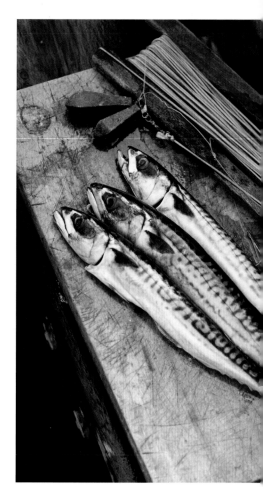

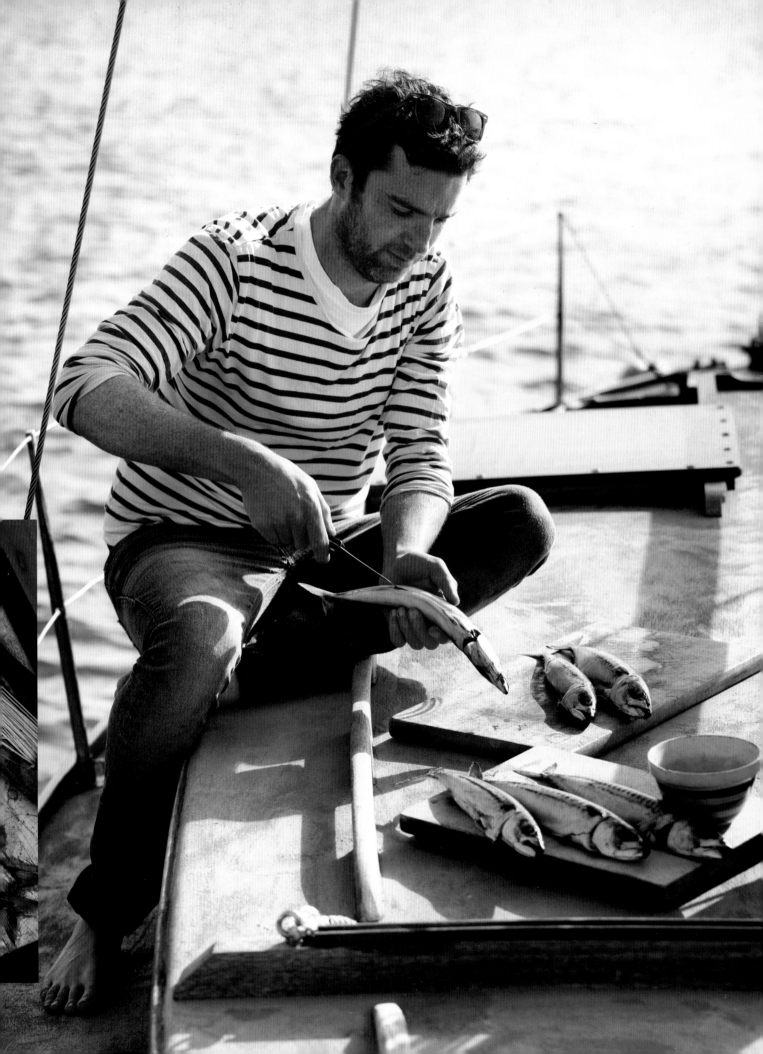

Black bream sashimi

BLACK BREAM IS LOVELY
IN THIS RECIPE, BUT
SEA BASS OR MACKEREL
WOULD WORK WELL, TOO

Serves 4-6

1 large, very fresh black bream or wild
sea bass, or two large mackerel

1-2 tbsp English or Dijon mustard

3-4 tbsp soy or tamari sauce

1 Using your sharpest knife, fillet and
skin the fish. Remove the central line
of pin bones from the fillet by slicing
down each side of the bone line, or
use a pair of pin-boning tweezers to
remove each bone individually. You
should be left with four boneless,
skinless fillets.

2 Slice very thin pieces of fish from
the fillets and arrange them on plates.

3 Use the tip of the knife to spread
a small amount of mustard on the
fish. Add a scant splash of soy
sauce, then serve.

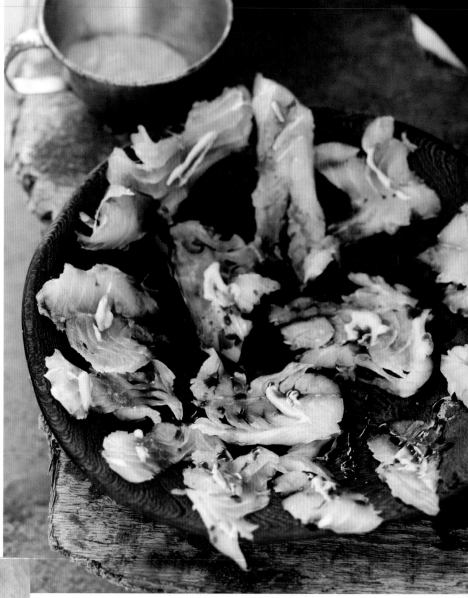

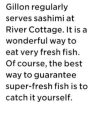

Gillon regularly
serves sashimi at
River Cottage. It is a
wonderful way to
eat very fresh fish.
Of course, the best
way to guarantee
super-fresh fish is to
catch it yourself.

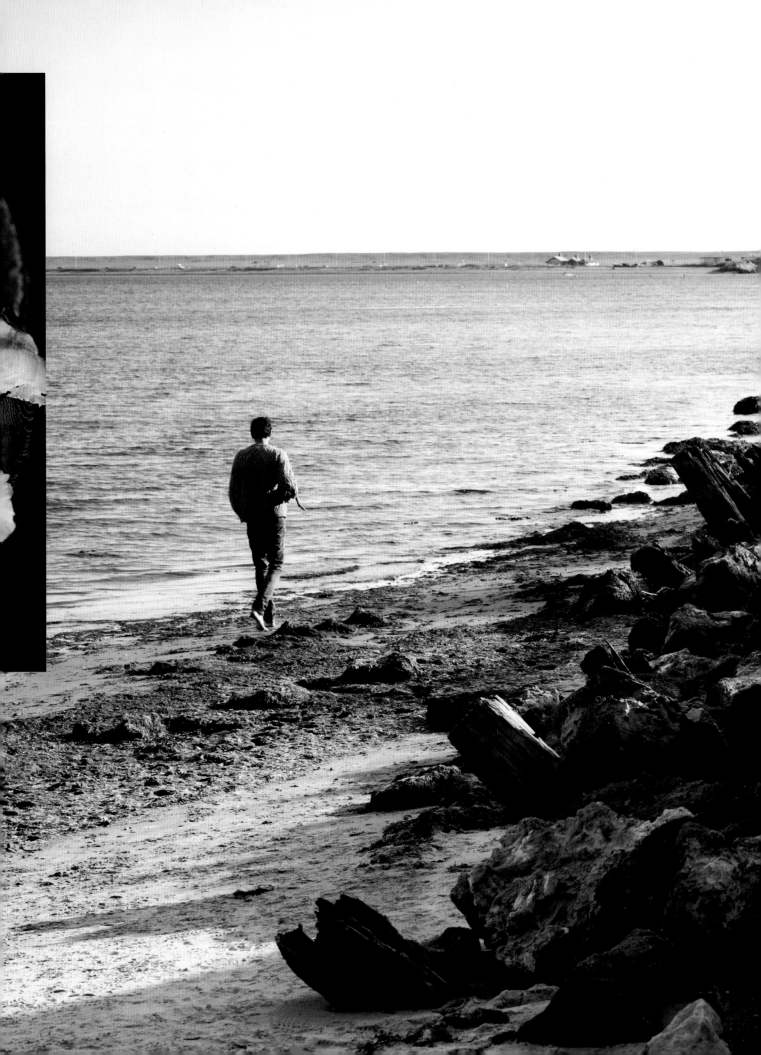

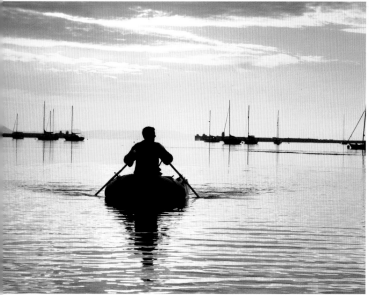

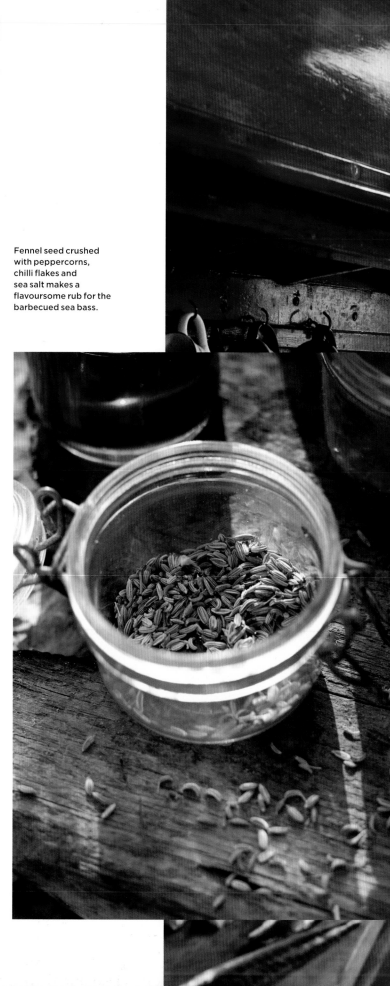

Fennel seed crushed with peppercorns, chilli flakes and sea salt makes a flavoursome rub for the barbecued sea bass.

Barbecued wild sea bass with fennel seed, black pepper and chilli

IF THE WEATHER'S NOT GOOD, COOK THE FISH IN A HOT OVEN RATHER THAN A BARBECUE

Serves 4

1 large wild sea bass
1 tbsp fennel seeds
2 tsp black peppercorns
2 tsp chilli flakes
3 tsp sea salt
2 tbsp olive oil

1 Gut and scale the fish. Place it on a large board and, using a sharp knife, cut four 2cm-deep slash marks on both sides – this will help the flavours of the dry rub seasoning to penetrate the fish flesh. It will also allow the heat from the barbecue to reach the centre of the fish more quickly.
2 Use a pestle and mortar to crush the fennel seeds, peppercorns, chilli flakes and salt together.
3 Trickle the fish with olive oil and rub this in, together with the fennel seed mixture – make sure it gets into the slash marks and in and around the belly cavity.
4 Place the fish on the grill of a hot barbecue and cook carefully for 5-10 mins on each side. If the barbecue is too hot you'll burn the fish, so watch the heat closely. You can always take the fish off and allow the embers to die back a little.

Buttered sea beet and rock samphire

GO EASY ON THE SEASONING, AS ROCK SAMPHIRE IS ALREADY IMBUED WITH SALT

Serves 2-4

3-4 large handfuls of sea beet leaves

1 handful of rock samphire leaves

Large knob of butter

1 tbsp good-quality olive oil

Salt and freshly ground black pepper

1 Remove the coarser stems from the sea beet and the samphire. Wash the greens well, then drain.
2 Bring a large pan of water to the boil, add the sea beet and samphire, and allow to simmer for 4-5 mins.
3 Drain the sea beet and samphire and return to the pan with the butter, olive oil and some salt and black pepper. Toss and serve.

SEED *to* STOVE
THE JOYS OF JARS

FILL YOUR LARDER WITH PICKLING PEARS, TANGY TOMATO RELISH AND NUTTY LIQUEUR

Lia Leendertz

September on the allotment can very quickly turn faintly ridiculous. The season is reaching its finale and suddenly everything is maturing at once, demanding attentive hands and mouths. Wherever I look, fruits and nuts are ripening, bountiful, going over. After a summer of hard work this is the pay-off, and it is hard to keep up. September is a wonderful time for eating and sharing, but there are actually only so many ripe and dripping tomatoes you can eat, as it turns out. When I have eaten my fill, it is time to knuckle down to making something useful of the glut. With the lean months not far off, this is the time to start stowing produce away, to stack my cupboards full of preserved bounty that can be pulled out when the plot is bare and forbidding, to remind me of better days past and those to come.

Home-grown tomatoes are rarely the summer treat we want them to be. In summer they are a trickle, and only in September do they become a deluge. Despite enjoying plenty of them fresh from the vine, I also have enough to make chutneys, relishes and ketchups for winter. Pears and apples are ripening now, and almost always in greater abundance than can be sensibly eaten. Hazelnuts are now taking on their hard, brown coats and nuttiest flavour. They don't have to be preserved, of course – they will do the job themselves, sitting patiently in a bowl until the nutcracker comes out at Christmas – but I have enough from my three coppiced bushes to make some into a special liqueur that might also go down well come December.

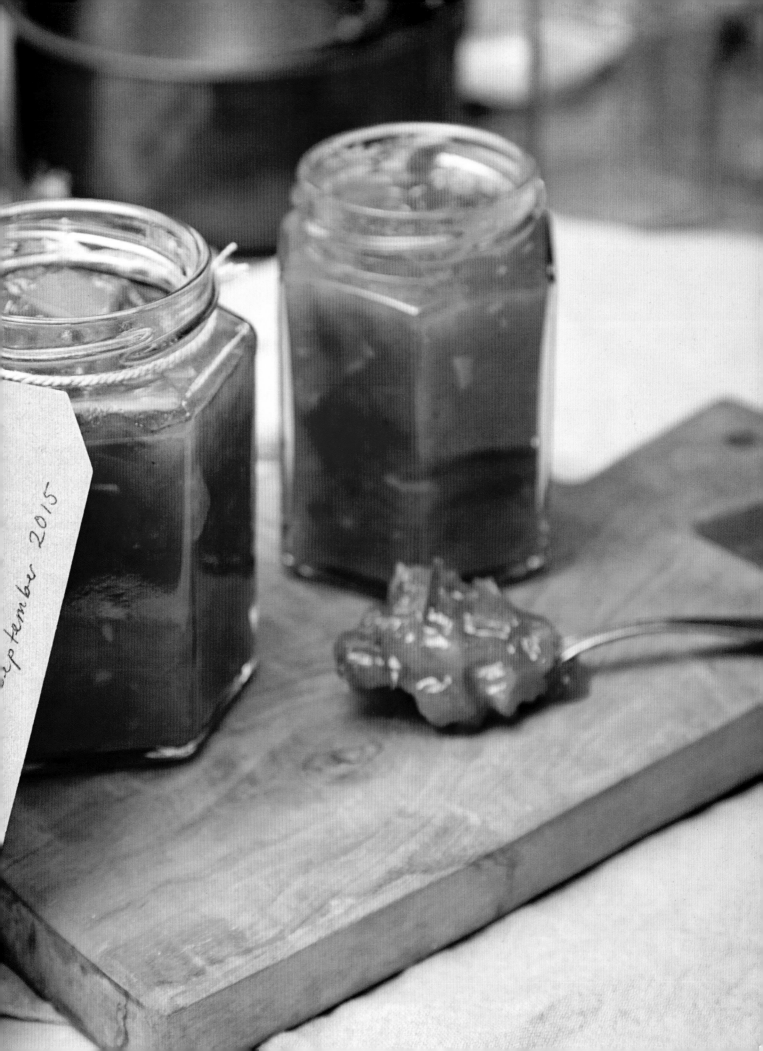

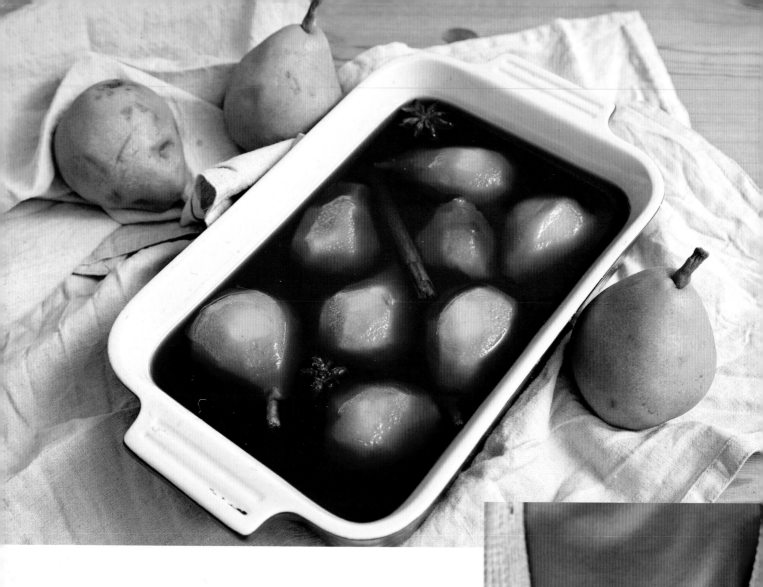

Spiced pickled pears

SWEET ENOUGH FOR A
PUDDING WITH CREAM
AND AMAZING WITH
CHEESE OR COLD MEATS

700g pears
225g soft dark brown sugar
175ml red wine vinegar
1 cinnamon stick
3 star anise

1 Preheat the oven to 160°C/
Fan 140/325°F.
2 Put the sugar, vinegar and
spices into a pan and warm
gently, until all the granules have
dissolved. Then turn up the heat
and simmer for a minute or two.
Remove from the heat.
3 Meanwhile peel, halve and
core the pears and lay them cut-
side down in an oven-proof dish.
4 Pour the warm syrup over the
pears, cover the dish with a lid
or silver foil and bake in the
oven for around 40 minutes.
5 Sterilise two 1-litre jars (or sev-
eral smaller ones) and pour in
pears and juices while they and
the jars are still warm. Seal. They
will keep for several months,
sealed, or a for few weeks in
the fridge after opening.

Smoked garlic and tomato relish

SMOKED GARLIC GIVES THIS RELISH A GENTLE SMOKY TASTE, BUT IT WORKS WELL WITH ORDINARY GARLIC, TOO

Makes 4 jars

1 onion

6 smoked garlic cloves, sliced

Oil for frying

1 green chilli, seeds removed, finely chopped

800g chopped tomatoes, seeds removed

200ml red wine vinegar

200g sugar

50g capers, rinsed

1 In a large pan, heat a little oil and gently fry the onions until they start to soften. Add the garlic and chilli and slowly soften these, too.

2 When the onion is turning translucent add the tomatoes, stir, and cook gently for a few minutes. Then pour in the vinegar and the sugar.

3 On a low heat, stir to dissolve the sugar, then bring to a simmer. Simmer and stir for about 40 to 50 minutes, or until the mixture turns jammy. It is ready when you can draw a brief line across the bottom with a wooden spoon.

4 Allow to cool slightly, then stir in the capers and add plenty of salt and pepper to taste. Pour into warmed jars and seal.

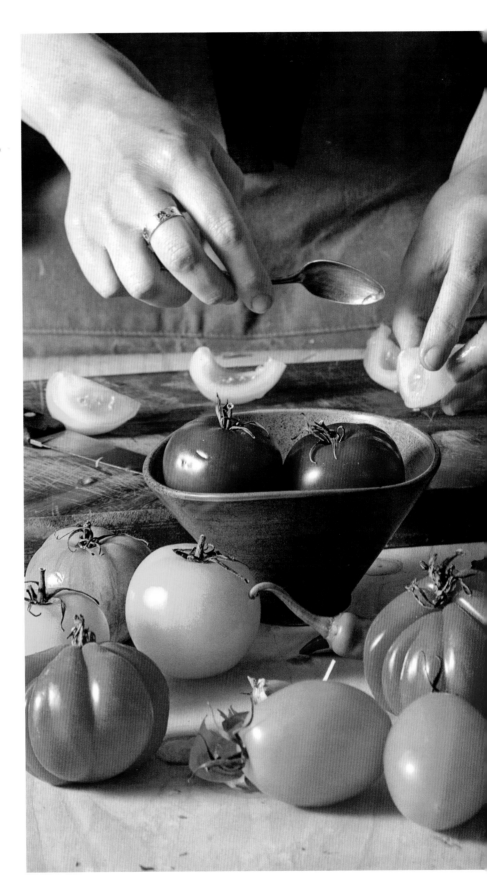

Gianduja liqueur

LITTLE BOTTLES OF
THIS CHOCOLATE AND
HAZELNUT LIQUEUR
MAKE WONDERFUL
CHRISTMAS PRESENTS

450g hazelnuts
200g cacao nibs
750ml vodka (40% proof)
300ml simple syrup* (you can
buy this but it's easy to make,
see below)

1 In a large, dry frying pan, toast the
hazelnuts until they start to take colour,
then tip them into a cloth and rub off
as many of the skins as you can easily
get to come off.
2 Pour the cacao nibs into the
frying pan and toast briefly, until
the aroma hits your nose. Tip out
into a cool bowl.
3 In batches, grind hazelnuts and cacao
nibs in a food processor until they are the
texture of coarse sand (you could use a
pestle and mortar instead, but this will
obviously take some time). Tip every-
thing into a large, sealable jar and pour
on the vodka. Stir well and store away.
4 After around ten days, strain the mix-
ture into a sterilised and cooled jar. Use
a colander lined with muslin, and when
the bulk of the liquid has passed
through, suspend the muslin above the
jar and let it drip through for an hour
or so. Don't squeeze or press on the
mixture to extract more liquid, as this
will cloud the liqueur.
5 Stir in the cooled simple syrup
and it is then ready to drink, or to
store for up to a year.

To make the
simple syrup

1 I always use American 'cups'
measurements for making syrup,
because you need an equal volume
of water and sugar and this is the
most straightforward way to mea-
sure them. You will need around
1¼ cups each of sugar and water.
But if you prefer, this equates
to around 300ml water and
about 200g sugar.
2 Put the sugar and water into
a saucepan and warm through
gently until the sugar has dis-
solved, then turn up the heat and
simmer for a minute. Take off
the heat and allow to cool.

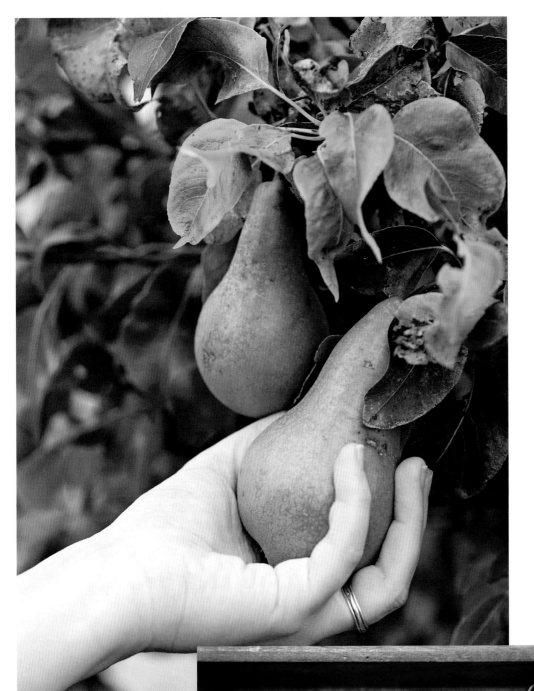

LIA LOVES

This is a good time to order pear trees for late autumn planting. Ask your nursery what the potential size of your tree is and whether it is self-fertilising. If not, it will need to be paired with another one to pollinate it.

CONFERENCE PEAR

A great all-rounder pear that ripens in October. Can be used hard for pickling or later as a dessert pear.

WILLIAMS BON CHRETIEN PEAR

A particularly delicious dessert pear with soft, sweet, buttery flesh. Ripens in September.

BLACK PEAR OF WORCESTER

A beautifully flavoured cooking pear that's ideal for pickling or baking. It ripens late, in about February.

NOTES ON PRESERVES

FROM SWEET CURDS TO MUSTARDY PICKLES, THESE STORE-CUPBOARD KEEPERS ADD PIZZAZZ TO SAUCES, STEWS, BAKES AND MORE

REDCURRANT JELLY
NO LUMPS, NO BUMPS, JUST PURE FRUITINESS. USE IT TO LIFT AND DEEPEN DISHES LIKE LAMB STEW AND CHINESE PORK HOTPOT – GRAVY, TOO.

TOMATO CHUTNEY
SUMMER PLENTY IN A JAR. ITS JAMMY SWEET-AND-SOURNESS MAKES IT A PIQUANT PARTNER TO HARD CHEESES; IT ALSO ADDS OOMPH TO PIZZA TOPPINGS AND PASTA SAUCES.

PASSIONFRUIT CURD
SPREAD A LITTLE SUNSHINE ON YOUR AFTERNOON TEA. THIS TROPICAL TAKE ON AN ENGLISH CLASSIC BRIGHTENS SANDWICH CAKES AND MERINGUES. ALSO GOOD STRAIGHT FROM THE JAR.

Eat me quick, I don't last long

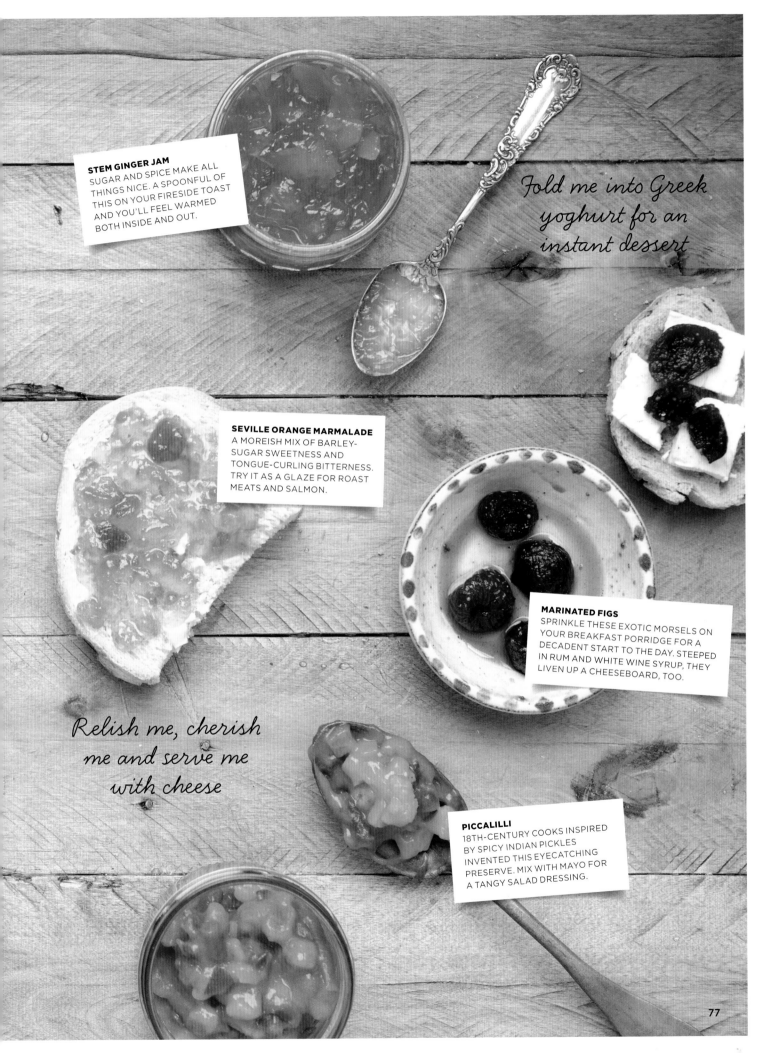

STEM GINGER JAM
SUGAR AND SPICE MAKE ALL THINGS NICE. A SPOONFUL OF THIS ON YOUR FIRESIDE TOAST AND YOU'LL FEEL WARMED BOTH INSIDE AND OUT.

Fold me into Greek yoghurt for an instant dessert

SEVILLE ORANGE MARMALADE
A MOREISH MIX OF BARLEY-SUGAR SWEETNESS AND TONGUE-CURLING BITTERNESS. TRY IT AS A GLAZE FOR ROAST MEATS AND SALMON.

MARINATED FIGS
SPRINKLE THESE EXOTIC MORSELS ON YOUR BREAKFAST PORRIDGE FOR A DECADENT START TO THE DAY. STEEPED IN RUM AND WHITE WINE SYRUP, THEY LIVEN UP A CHEESEBOARD, TOO.

Relish me, cherish me and serve me with cheese

PICCALILLI
18TH-CENTURY COOKS INSPIRED BY SPICY INDIAN PICKLES INVENTED THIS EYECATCHING PRESERVE. MIX WITH MAYO FOR A TANGY SALAD DRESSING.

FOOD FROM AFAR
BAKLAVA*

YOU CAN'T KEEP an empire going for 600 years without pudding. And, my, did the Ottoman Empire know how to do pudding. Honed over centuries, baklava is as sweet as victory and addictive as power itself.

The best baklava can make Western patisserie look a bit toothless. It crackles when you bite into it, puts up just enough of a fight against your teeth to feel really satisfying, and sticks gratifyingly to the roof of your mouth for just the right amount of time.

Scoffed all around the Eurasian border countries – from Greece, Cyprus and Turkey to the Balkans, Middle East and former Soviet countries – baklava has its roots in several regional specialities of the 14th century. The 'modern' variety involves filo pastry, melted butter and chopped nuts (usually pistachios, almonds, hazelnuts or walnuts) layered in a pan, sliced into diamonds, triangles and rectangles and covered in a syrupy mixture of honey and rosewater, or orange flower water, before baking. It's then served at room temperature – often with a nutty garnish – as a dessert or with coffee.

Theories abound as to the decline of the Ottoman Empire. Baklava wishes you to note it's not named in any of them.

Possibly derived from the Mongolian 'bayla-', 'to tie, wrap up, pile up'. Though no one is sure.

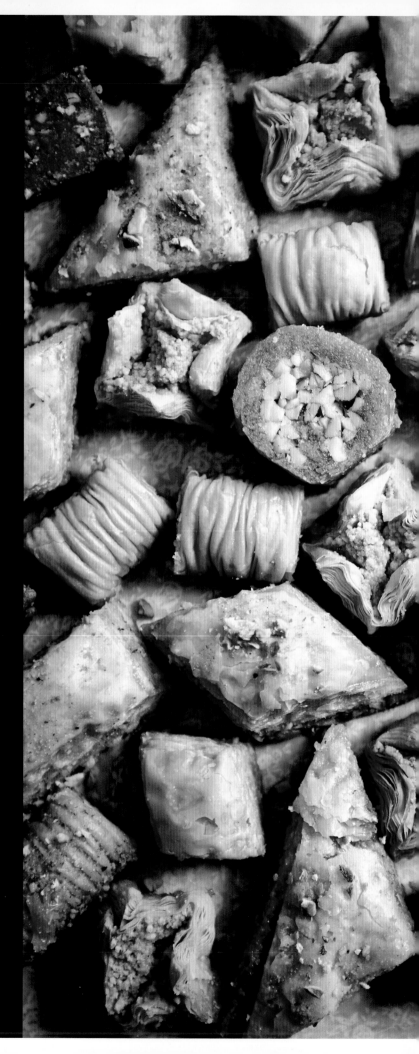

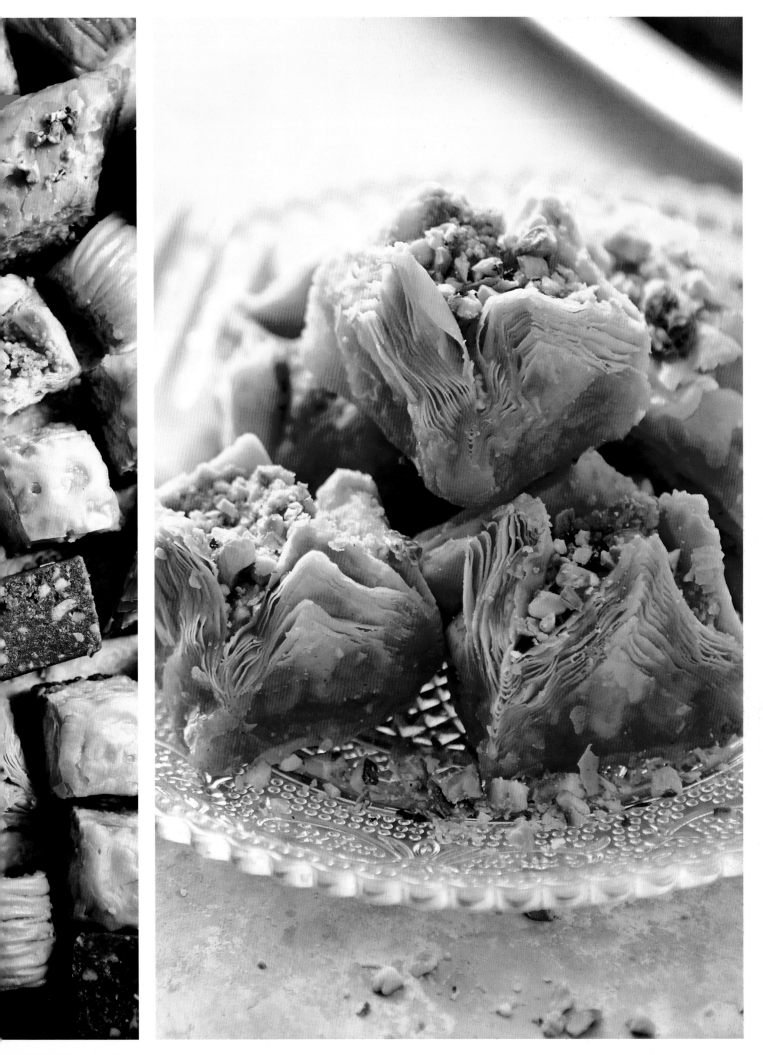

FIKA

FALL IN LOVE WITH FIKA. It's a noun ("Time for fika"), a verb ("Shall we fika?") and possibly the most versatile, informal, connotation-free communal snacking custom observed anywhere in the world. You see, "I had fika with your sweetheart today" is no more loaded a statement than "I saw your sweetheart at the traffic lights". Fika-ing with your boss suggests to no-one that a promotion's in the air. And you can dunk! In fact, some fika treats are designed with dunking in mind.

Broken down, we're talking nothing more complicated than a drink and a snack. Normally the former is coffee or tea and the latter some sort of baked good – especially cinnamon buns, cookies, croissants or an open sandwich, preferably served up on a doily.

Buddies and kin of all ages make great fika companions, but so do co-workers – indeed, some companies set aside a whole *fikarum* for your all-important daily departmental *fikapaus*. In Scandi crime drama *The Bridge*, an entire investigation team downs tools to fika in the middle of the night (because that's another great thing – it can happen at any time of day).

Fika: straightforward, egalitarian and rather beautiful. Much like the typical Swede.

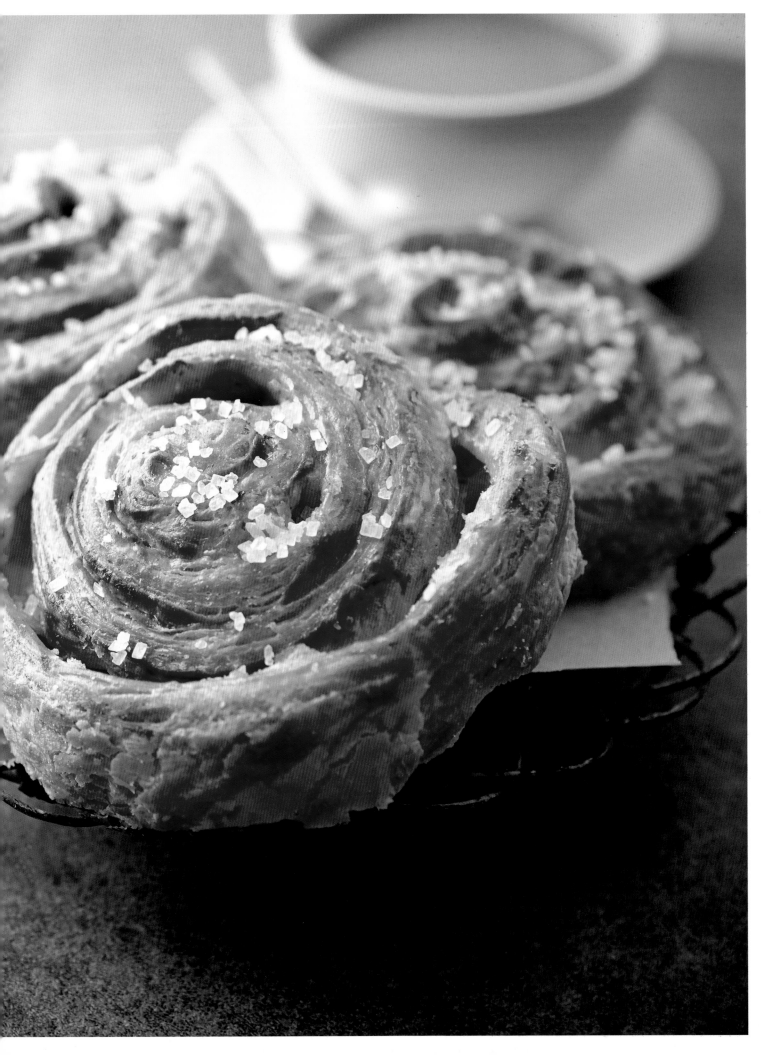

TURKISH DELIGHT*

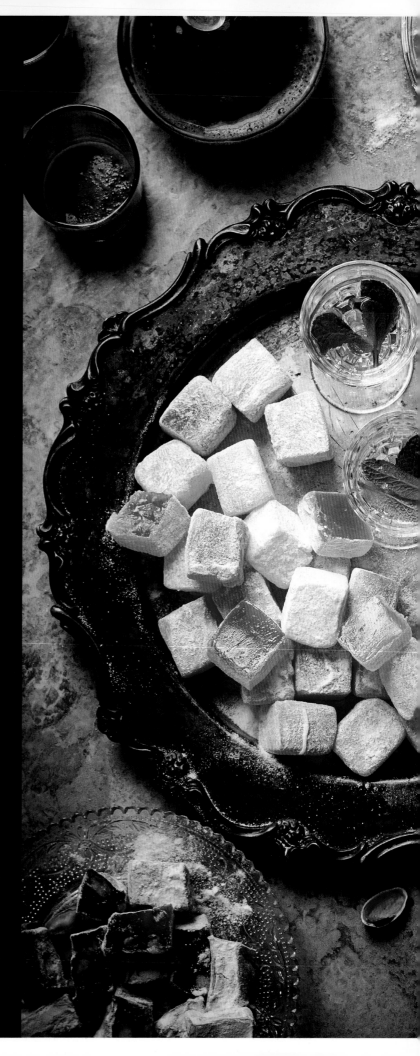

IF ANY CONFECTIONER today sold something called 'lumps of delight', you wouldn't be able to place your order for sniggering. Back in less potty-minded times, however, this was what sweet-toothed Victorians called Turkish delight.

First created in the 18th century – reputedly to keep an Ottoman sultan's harem happy – it was brought to Britain about a century later. Made properly, the delicacy remains a chewy, sticky, exotic work of art – sugar-and-corn starch flavoured naturally with rosewater, mastic resin, cinnamon, mint, orange or lemon, mixed with nuts and dried fruit, cubed, then dusted with icing sugar. It could pass for fairy food. Little wonder C.S. Lewis chose it as the White Witch's choice of bribe in *'The Lion, The Witch and the Wardrobe'* – indeed, sales of the stuff soared in the West when the feature film came out a few years ago.

Undelightfully, Turkish delight has become a pawn in the long-running huffiness between Greeks and Turks. The Greeks say their (pretty much identical) version, loukoumi, is better, and in 2007 a Greek-Cypriot firm audaciously pipped rivals across the Aegean to win EU trademark protection for their product. Ouch.

The only thing both nations agree on is how divinely it goes with thick, black coffee. One lump or two?

Or 'lokum', from the Arabic words luqma(t), meaning morsel and mouthful, plural luqum.

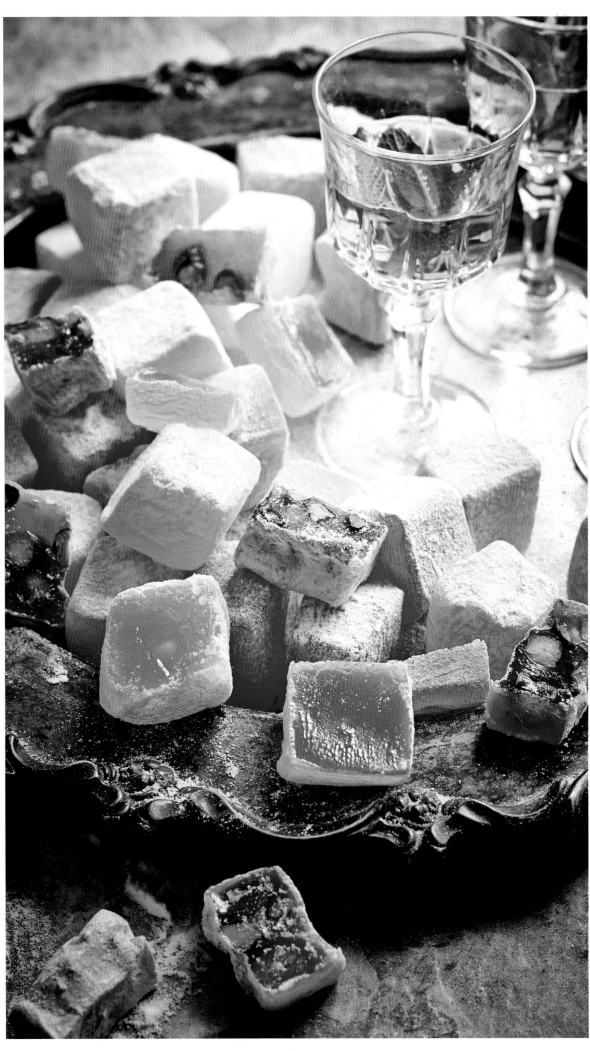

HOME

We have a theory at *The Simple Things*: If you really want to switch off, there's no better way than **making something yourself.** Being absorbed in a **weekend project** seems to put real life on hold for a while, and there's nothing quite like **the satisfaction of a job well done**. Proudly homemade cushion covers, plant holders, stationery – if it can be **beautiful and useful,** then we'll give it a whirl. A little **inspiration** can go a long way, so each issue we talk to **collectors, designers and makers** about what they love and why. We like our own homes to **reflect the seasons**, bringing flowers into the house and **decorating with natural finds.**

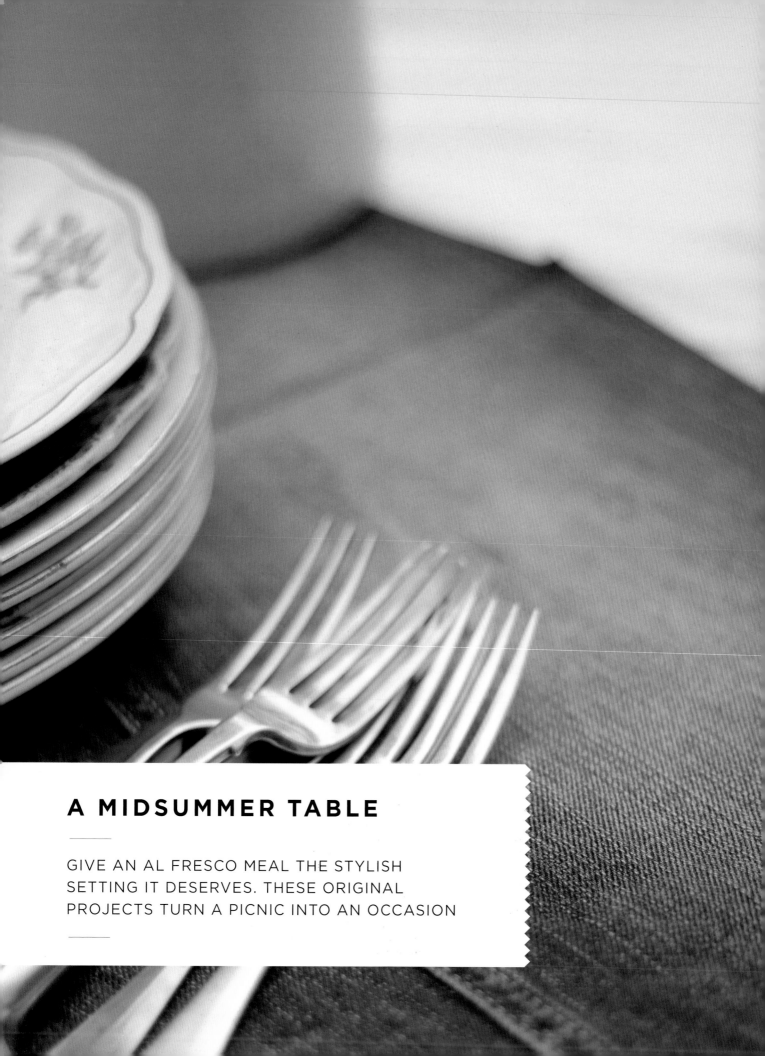

A MIDSUMMER TABLE

GIVE AN AL FRESCO MEAL THE STYLISH
SETTING IT DESERVES. THESE ORIGINAL
PROJECTS TURN A PICNIC INTO AN OCCASION

Midsummer's Day may mark the height of long evenings, but it's the real start of lazy summer days spent lolling on the lawn, ice cubes chinking in drinks, as the kids run squealing through the sprinkler. It's the time to enjoy the smell of freshly mown grass mingling with aromatic barbecue smoke.

And with all this summer-solstice revelry comes the promise of al fresco meals. This year, instead of a picnic eaten on your knees (fun, but after the tenth glass of wine spilt on the lawn, you'll yearn for a flat surface), set up an outdoor table and decorate it with these clever projects.

Our concrete planters are also a bit edgy, and their rough colouring and texture are a great match for a variety of flowers. Make plenty of the painted candlesticks to ensure twinkly, late-night magic, encouraging guests to linger into the small hours. After all, these summer days (and nights) are where memories are made.

HOW THE FINNS DO THE SOLSTICE

With its short, often non-existent nights, midsummer in Finland is a sociable celebration. Many Finns head into the countryside for bonfires (called kokkos), cookouts, saunas and parties.

Finnish folklore regarded midsummer as a very potent time, particularly for those seeking suitors or wishing to boost their fertility. By the light of the midnight sun, maidens would gather seven different flowers and place them under their pillow in the hope of dreaming of their future husband, or they would stare into wells – while naked – hoping to get a glimpse of their suitor's reflection.

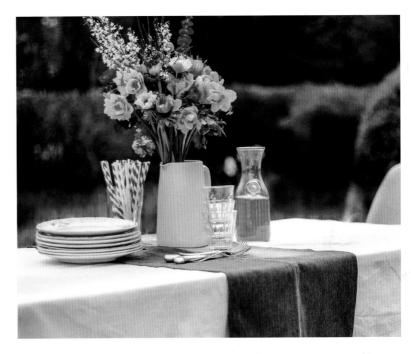

Upcycled jeans runner

Heather Young

JUST RUMMAGE FOR OLD JEANS AND BEGIN. MAKE THE DENIM RUNNER TO WHATEVER SIZE YOUR TABLE DICTATES

The upcycled denim runner will add a contemporary edge and a welcome antidote to the saccharine sweetness of picnic pastels.

SUPPLIES
Old pair of jeans
Fabric scissors
Sewing machine
Thread

1 Cut the legs off a pair of jeans (as far up towards the crotch as possible) using fabric scissors.
2 Cut down the inside-leg seam to open each leg out and then iron them.
3 Now hem each edge using your sewing machine.
4 Hem the cut edge at the end of one of the jean pieces, then hand-sew or machine-sew it on top of the other piece.

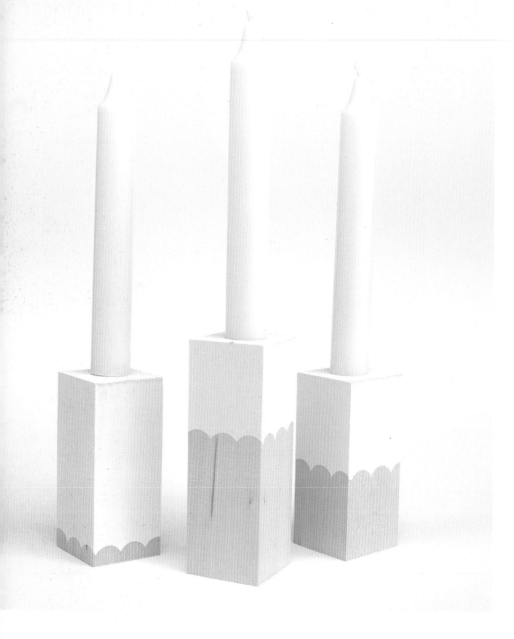

Painted candlesticks

Erin Loechner

WHO WOULD HAVE
THOUGHT SIMPLE
BLOCKS OF PAINTED
WOOD COULD BE MADE
TO LOOK SO ELEGANT?

SUPPLIES
**Square blocks of wood
at various lengths**
**7/8in drill bit (or one that
matches the size of candles
you choose to use)**
Dot stickers
Crafter's acrylic paint
Paintbrush

1 Mark the centre of one end of a
block of wood. Using the drill bit,
make a hole in the wood, about
12.5cm deep.
2 Using the dot stickers, create
a pattern where you want the wood
to remain visible. Press the stickers
firmly in place. Paint the wood,
going over the stickers. To ensure
full coverage, paint 2-3 coats and
allow to dry completely.
3 Once the paint is dry, gently
peel off the stickers to reveal your
design. Get your candles ready
and light them.

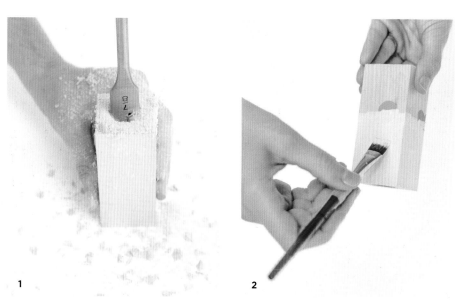

1

2

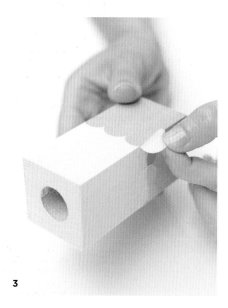

3

Concrete centrepieces

Jen Huang

THESE CONTAINERS
HOLD CUT FLOWERS
OR PLANTS AND CAN
BE LEFT OUTSIDE
ALL SEASON LONG

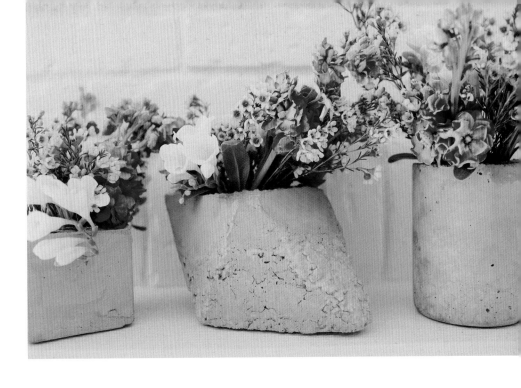

SUPPLIES

Scissors

Bottles of various shapes (try milk cartons or cola bottles. Think outside the box for fun shapes!)

Cardboard boxes

Duct tape

Plastic sheet

Quikrete concrete mix

Large bucket

Mixing stick (or anything to mix your concrete)

Sharp knife

1 Cut the bottles in half.
2 Trace out your shapes on cardboard and tape together with duct tape. Leave an opening in your cardboard shapes for the concrete to be poured in.
3 Lay out the plastic sheet to mix the concrete on, to prevent any mess.
4 Mix your concrete in the bucket, as per the instructions. Pour the concrete into your shapes.
5 Take halved ends of the water bottles and push into each shape's top to create a hole for your flowers. Allow to set for the instructed time.
6 Peel or cut off the cardboard and plastic (you will need to use a knife to get the plastic off) to reveal the concrete vases. Cut your water bottle halves away from the top of the concrete. Insert flowers.

Double secure the duct tape on the cardboard shapes to ensure there are no leaks.

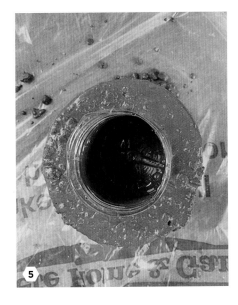

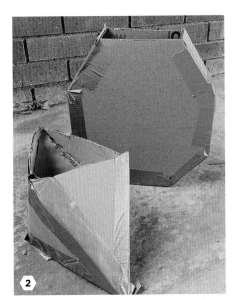

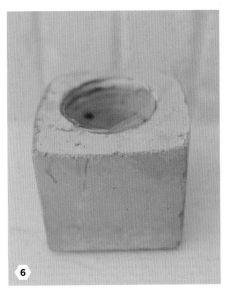

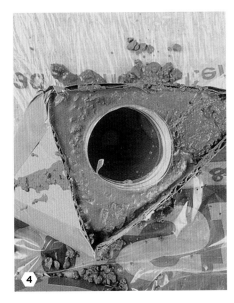

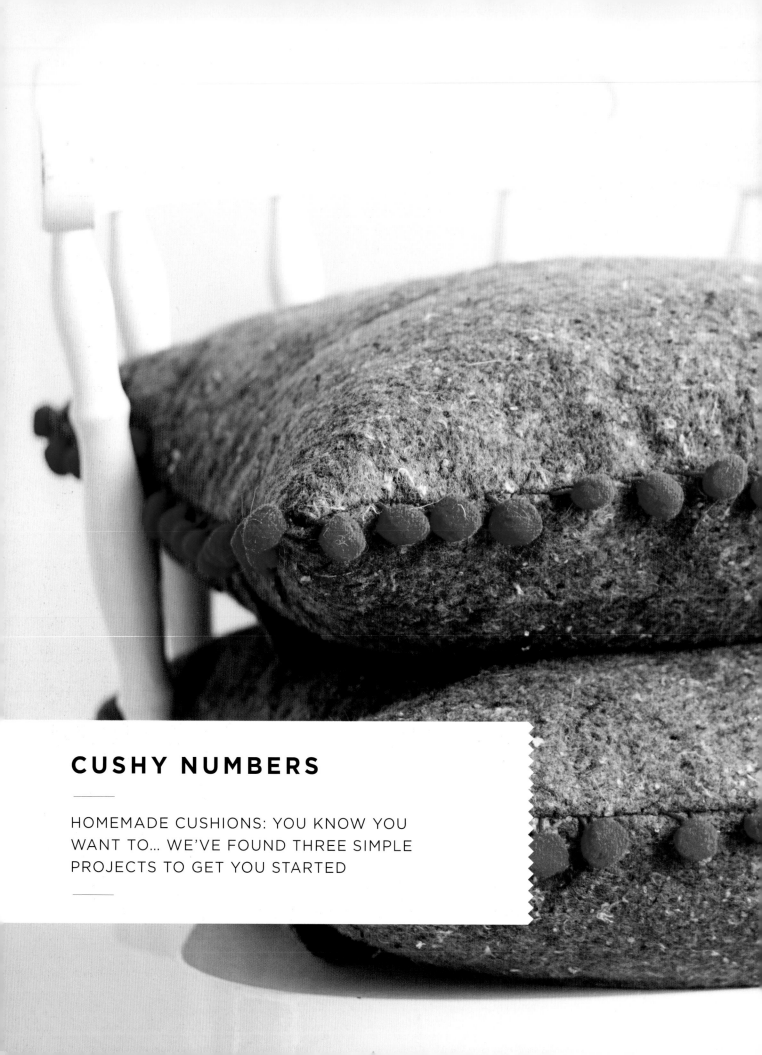

CUSHY NUMBERS

HOMEMADE CUSHIONS: YOU KNOW YOU
WANT TO... WE'VE FOUND THREE SIMPLE
PROJECTS TO GET YOU STARTED

Simple cushion cover

Victoria Haynes

Cushions are a good launch pad for those of us wanting to dip into a bit of sewing for the first time since school.

T here are many reasons to love cushions – for their affordability, for their skill in tying a room scheme together, for their downright cuddliness. Minimalists may want to look away but, for the rest of us, a bare stick of furniture is made infinitely more inviting by the addition of something soft and comfy.

Cushions also happen to be a good launch pad for those of us wanting to dip into a bit of sewing for the first time since school. Fashion a simple, square cushion cover and you'll be pleating curtains in no time. Maybe. And if one cushion is the beginning and end of your career as a seamstress, at least you'll be able to plump up your homemade pillow with pride. It's a great way to get the look you're after, too. Our three projects have something for every level of stitcher.

NO ZIPS OR BUTTONS REQUIRED, JUST A BIT OF FOLDING AND STITCHING

SUPPLIES
Iron
Fabric of your choice
Tape measure
Ruler
Tailor's chalk or a pencil
Dressmaking pins
Sharp scissors
A sewing machine
Cushion pad

1 You'll need enough fabric to cover the cushion generously. Iron out any creases.

2 Measure the width of your cushion pad, then add roughly 2cm to each side for a seam allowance. Do the same for the length, if your pad isn't square.

3 Measure this distance (width + 4cm) from one edge of the fabric and mark with the tailor's chalk. From this mark, measure and mark again. From this second mark, measure downwards and mark the length of the cushion, including seam allowance. Join all the marks up with a ruler. Cut along the lines carefully.

4 Place fabric face up. Sit your

cushion pad on top of the fabric, in the centre.

5 Wrap the cushion pad so that it is completely covered with fabric with a good overlap and trim excess if needs be.

6 Unwrap the cushion and fold one short edge of the fabric over by roughly 1cm. Fold this over again to hide any rough edges. Iron in place. Pin, then repeat for the opposite edge. Stitch along each of the pinned seams, then remove pins.

7 Place your fabric face up. Sit your cushion pad in the middle. Mark the cushion edges with pins, leaving enough room, where the two seamed edges meet on top, to manoeuvre cushion.

8 Remove pad and sew alongside pins; remove pins. Fasten off and snip corners at a diagonal.

9 Turn the cushion cover right side out. Iron out any creases and press the edges so they're neat and tidy.

10 Pop your cushion pad inside.

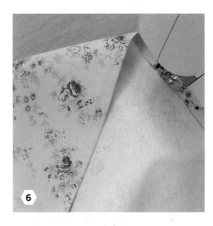

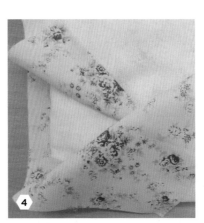

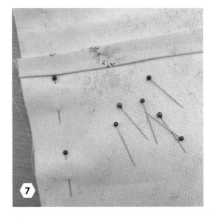

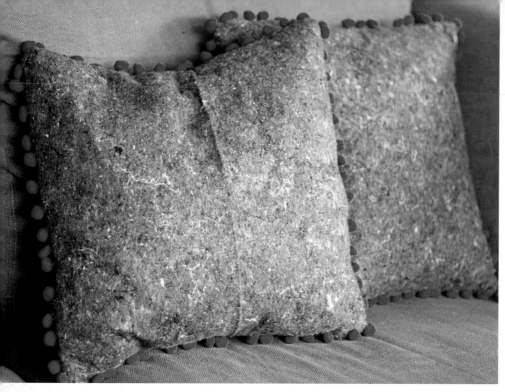

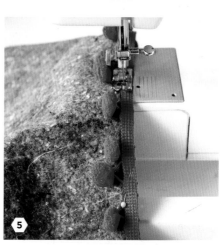

Pompom cushion cover

Lana Red

POMPOMS ADD A DASH OF COLOUR AND JOLLINESS TO ANY CUSHION

SUPPLIES
Iron
Fabric of your choice
Pompom ribbon
Scissors
Thread
Sewing machine
Cushion pad

1 Measure your cushion pad, and cut one piece of fabric 2cm larger on each side (so 54x54cm for a 50x50cm cushion).
2 Cut two pieces of fabric two-thirds the cushion size, plus 2cm on each side (in our example, each would be 54x35cm).
3 Fold 2cm of longer edge of one of the smaller pieces over, and stitch in place. This will be the overlapping part on the back. Repeat with other smaller piece.
4 Pin pompom ribbon around all four edges of the bigger piece of fabric, facing inwards, fabric right side up.
5 Sew in place and remove pins.
6 Lay big piece face up; on top, lay two shorter pieces face down, aligning the longer edges (the shorter pieces' seamed edges towards the centre).
7 Pin and sew unseamed edges together, keeping pompoms facing inwards. Turn right side out and insert cushion pad.

Colour block cushion

Kelly Cheesley

USE TWO (OR MORE)
DIFFERENT FABRICS
TO CREATE A CUSHION
OF CONTRASTS

SUPPLIES

Iron

2 pieces of fabric of your colour
choice

Sewing machine

Thread

Scissors

Tape measure

Pins

Cushion pad (approx. 40x40cm)

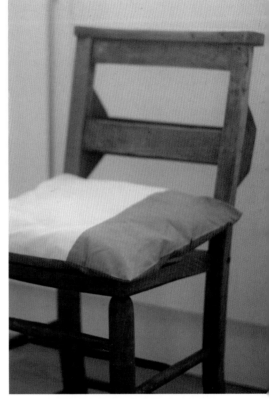

1 Iron the fabric and cut each piece
into 42x56cm rectangles. Lay fabrics
on top of each other, right sides
facing inwards.
2 Place the edge of your sewing-
machine foot along the raw edges
of the fabric as a guide and sew
a seam down one short edge.
3 Iron the seam, flattening the
seam allowance towards the darker
fabric so it will not be seen from
the other side.
4 Wrap the fabric around the cushion
pad to decide which colour looks
best at the front. Trim a 8cm-wide
strip of the fabric down the short side
of the colour you want less of on the
front of the cushion.
5 Fold over one short edge by
a cm. Press. Repeat a second time,
and press again. Repeat for the
other short side.
6 Sew both of these hems, using the
edge of your foot as a guide again.
7 Lay the fabric right sides up with
the shorter colour on the right.
Starting with the shorter colour,
measure 13cm along the bottom
edge from the middle seam and pin.
Repeat on top edge.
8 From the pin at the bottom edge,
measure 41cm to the left and add
another pin. Repeat for top edge.

9 Using the pins as a guide, fold
over one side. Repeat on the other
side so you create an envelope shape
(the fabric at the back will overlap).
Pin along the edges and remove
pins in the corners.
10 Sew each edge, taking care to
catch all the layers and get a straight
seam. Remove pins and use pinking
shears to trim the seam allowances
to prevent fraying. (You could also
do this using a zigzag stitch on
your sewing machine.)
11 Turn cushion cover right sides out
and press. Insert your cushion pad.

THE COLLECTOR: TEA TOWELS

ENGLISH CHEESES, METRIC TO IMPERIAL CONVERSIONS, A GUIDE TO MANOEUVRES OF THE RED ARROWS... AMANDA GOODE'S TEA TOWEL COLLECTION ENCOMPASSES THEM ALL

Helen Powell

Back in the 1970s and 1980s, in the days before you could simply ask Google, where could you turn if you needed to make metric to imperial conversions or wanted to know how to carve a turkey? If you were a well-organised domestic goddess, you might perhaps have looked to the most humble household items – the tea towel or, more specifically, the infographic tea towel.

Over the past seven years, Amanda Goode has amassed a collection of more than 100 vintage tea towels. They offer advice on 'How to arrange the church flowers', celebrate 'The little trains of Wales' and even suggest 'Cakes to eat according to your birth sign'. Most are instructional in some way, informing or educating using a limited number of words.

"They're almost like a textile version of Twitter," she observes, "a little bite-sized version of what somebody wants to say about something. I think they represent an ideal of past domesticity. A world where everything appears to be well ordered, simple and very self-contained."

Amanda admits to using some of them occasionally, and likes to put one or two on display in her kitchen. As a textile designer and lecturer herself, she says she's drawn to them because they aren't especially design-conscious, but offer instead a visual celebration of the everyday.

"They're unrestrained by the creative goal of trying to appear aesthetically pleasing," she says. "They're almost an antidote to many of today's more design-led things. They pay lip service to design, but they're much more of the people. They aren't prohibitively expensive and I suppose they're something that most people can just pick up along the way."

Does she see them as kitsch, then?

"Yes, perhaps, but I think they're something even beyond kitsch. Sometimes kitsch things are a bit knowing, but the tea towels aren't at all. Often they're quite innocent, and their appeal actually lies in the fact that they're so badly considered. I have one with an illustration of Fergie and Prince Andrew at their wedding and the drawing is just terrible."

The tea towels in Amanda's collection depict a diverse and entertaining range of British places, pastimes and pursuits, offering a sometimes revealing glimpse into the nation's psyche. She resists the temptation to include examples from other countries, but has noticed that Australia and Cyprus in particular also "produce a good line of tea towel".

Amanda recognises that times have changed, but would love to see a range of instructional tea towels that reflect our current-day concerns: "How to repair your false nails,

1: English folk dances, 1970s

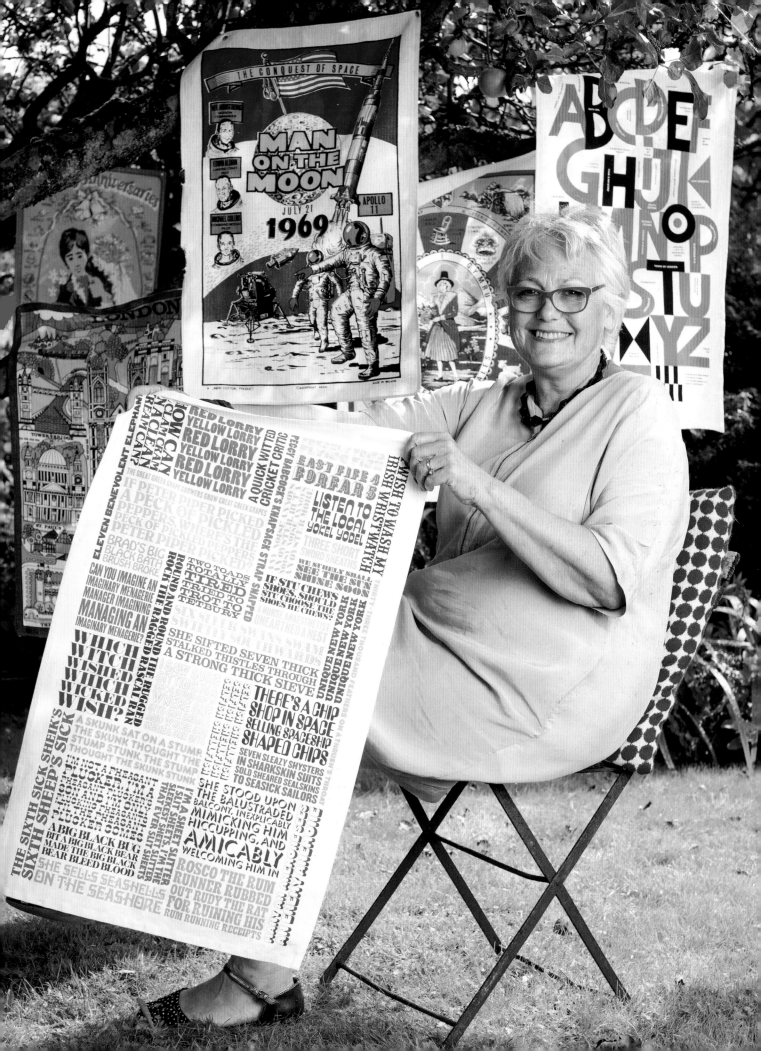

perhaps?" She's looking forward to seeing what contemporary offerings her students come up with when she launches the brief for a tea towel design competition later this year.

Amanda has shown her collection in an exhibition at Bath Spa University, and has plans for a book, but she also intends to allow the tea towels to take on an even more interesting and unusual role as a random generator of things to do. She plans to undertake some of the activities described on them – walking the Pennine Way, for example, or visiting all the little railways of Wales and recording the process through a series of YouTube videos.

Amanda emphatically admits that she likes the idea of doing random things.

"When I was a little girl I loved to watch a television programme called Picture Book," she explains. "The reason it was my favourite programme was because in every episode, when the presenter turned over the pages of the book, it was always something different, and you never knew whether it was going to be a poem or whether it might be a little play or whatever. And that's really how I like to lead my life – every day when you turn over the page it's something different."

She concedes, however, that some of the activities may be easier to arrange than others. "I may only be able to watch the Red Arrows display team, and I possibly won't make it onto the moon either – but you never know!"

②

"They're unrestrained by the creative goal of trying to appear aesthetically pleasing"

2. Guide to floral arrangements, late 1980s
3. Seven days of childhood commemorative, early 1980s
4. Racecourses of Britain, 1980s
5. Wedding anniversaries, 1970s
6. England's local festivals and customs, 1980s
7. Eclipse commemorative, 1999
8. Daz advertising, 1970s
9. Red Arrows manoeuvres, 1980s
10. English cheeses, 1970s
11. Man on the Moon commemorative, 1969
12. A balanced diet guide, 1970s
13. Cake recipes, 1990s
14. Royal wedding commemorative, 1986
15. Decimal currency conversion, 1970
16. United Nations flags, 1991

③

④

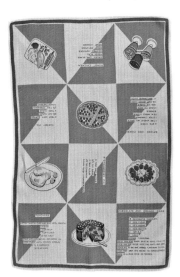

5

6

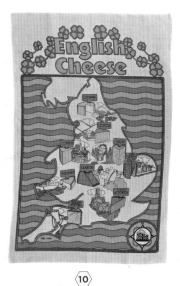

7

8

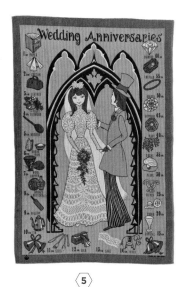

9

10

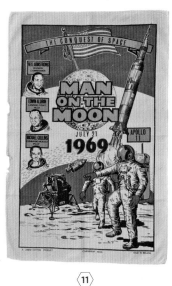

11

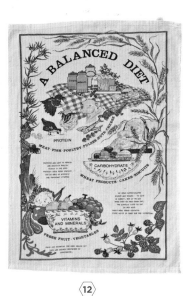

12

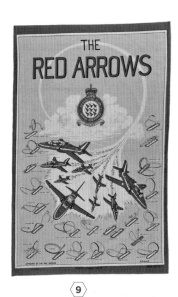

13

14

15

16

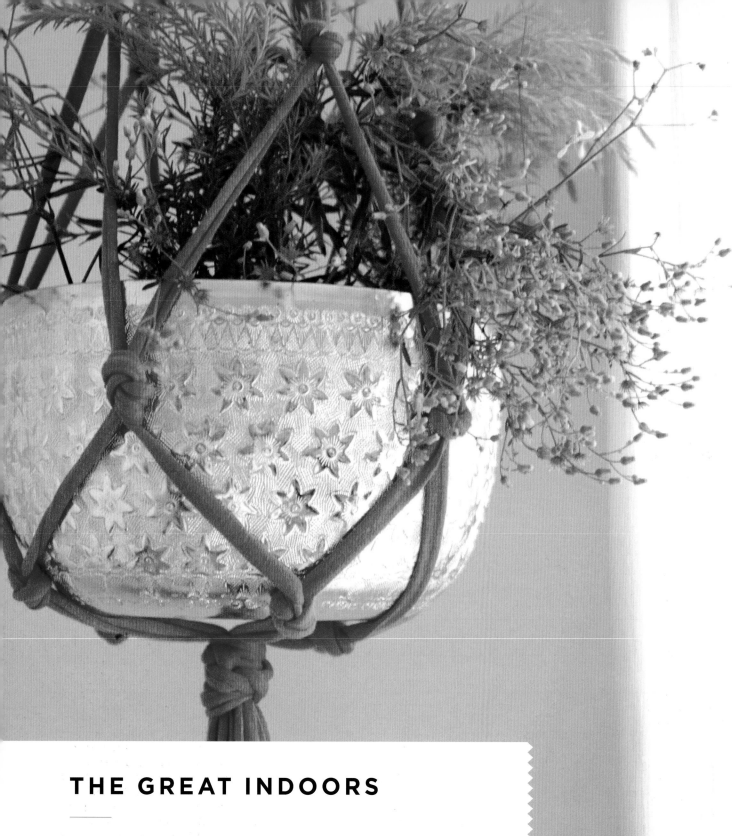

THE GREAT INDOORS

PROJECTS TO PERK UP THE PLANT LIFE IN
EVERY CORNER OF YOUR HOME

Creative gardening need not be restricted to the outdoors. Or, indeed, to off-the-shelf plant pots. Making a terrarium or a hanging plant holder is a craftier way to display greenery, and both are great projects for anyone finding themselves low on either time or space.

Be warned, though – these two projects come with a major flashback warning. Macramé and building terraria are both revivals of past crazes, which – hopefully much like your plants – have refused to die.

A BLAST FROM THE PAST

The ancient craft of macramé was a hit with the Victorians, although it's most associated with 1970s homespun style. Plant hangers are back, given a colourful – and, dare we say, tasteful – makeover. You can, of course, buy one if all that knotting brings back painful memories.

Terraria mania was also originally at its height in Victorian times. We have Dr. Nathaniel Bagshaw Ward to thank for the miniature worlds of the terrarium (originally known as the 'Wardian case'). Back in the 19th century, he discovered that his beloved ferns grew much better encased in glass, where they were protected from pollution. Decorative but low maintenance, it's easy to see how they have retained their appeal two centuries on.

Hanging plant holder

Laetitia Lazerges

MACRAMÉ IS BACK – BELIEVE IT OR KNOT

SUPPLIES
Textile yarn
Scissors
2 plant pots, ideally already containing a plant

1 Cut five pieces of the textile yarn, each about 4m long, and one more of about 40cm (you can adjust the measurements to your desired length).
2 Fold each of the longer pieces of yarn in half. Group all the folds together, then create a loop by wrapping the smaller piece of yarn around the grouped threads several times and tying firmly.
3 Divide the 10 pieces of hanging yarn into five pairs.

4 About 20cm below the top loop, take the first two threads and knot them together. Repeat for each of the pairs.
5 Then, take the right hand thread from the first pair and, further down, knot it with the left hand thread from the second pair. Repeat for each thread until each piece of thread is tied to another.
6 Repeat the process down the length of the yarn. The bigger you make the gap between the knots, the more space you'll have for the pot, but you'll need to make the knots closer together to hold the bottom of the pot.
7 Test for size with your plant pot, before tying a secure knot underneath the pot with the threads.
8 To add a second pot, repeat under the bottom knot using exactly the same knotting system.
9 Finish with a large knot containing all the yarn and neaten the ends with scissors.

Terrarium

HERE'S HOW TO MAKE YOURS THE BEST IN GLASS

SUPPLIES

Glass container

Plants of your choice

Small stones

Potting soil suited to the types of plant you are trying to grow (succulents will need sand)

Activated charcoal (available from pet shops or health food stores)

Chopsticks

Tweezers

Pebbles and bark for decoration

1 Wash your container.
2 Cover the bottom of the vessel with just under 4cm of stones to create a drainage layer.
3 Add a layer of activated charcoal to cover your rocks (you can skip this step if your terrarium will be open).
4 Add your soil layer, deep enough to take the roots of your chosen plants. Ideally you want ones that don't grow too tall and with a variety of leaf shapes and colours. Sealed terraria will work with tropical plants that like hot and humid conditions. For an open terrarium, cacti and succulents work better. Plants such as Irish moss, *Sagina subulata*, provide good, dense coverage.
5 Use chopsticks to create wells for the plants in the soil. Remove them from their containers and place into the terrarium. Once satisfied with the arrangement, build up the soil around the plants to support them.
6 Decorate with pebbles and ornamental items of your choice. This is where the tweezers come in handy.
7 Place the terrarium in a warm spot, away from direct sunlight.
8 Mist with water a few times a week, or as often as required.

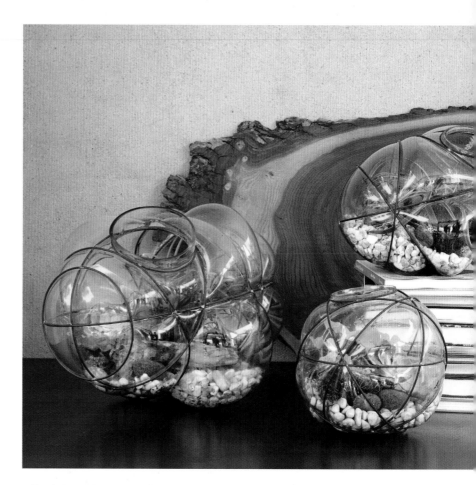

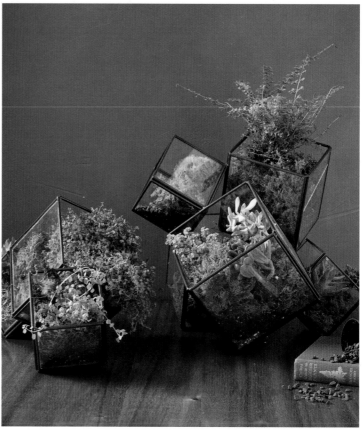

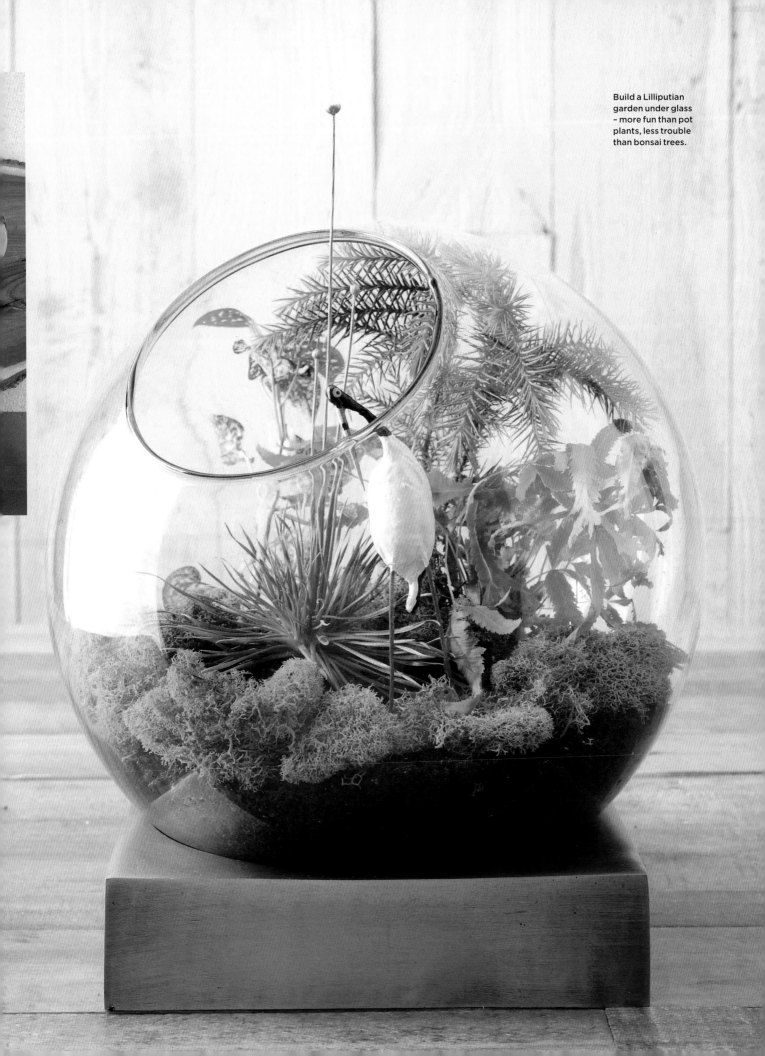

Build a Lilliputian garden under glass – more fun than pot plants, less trouble than bonsai trees.

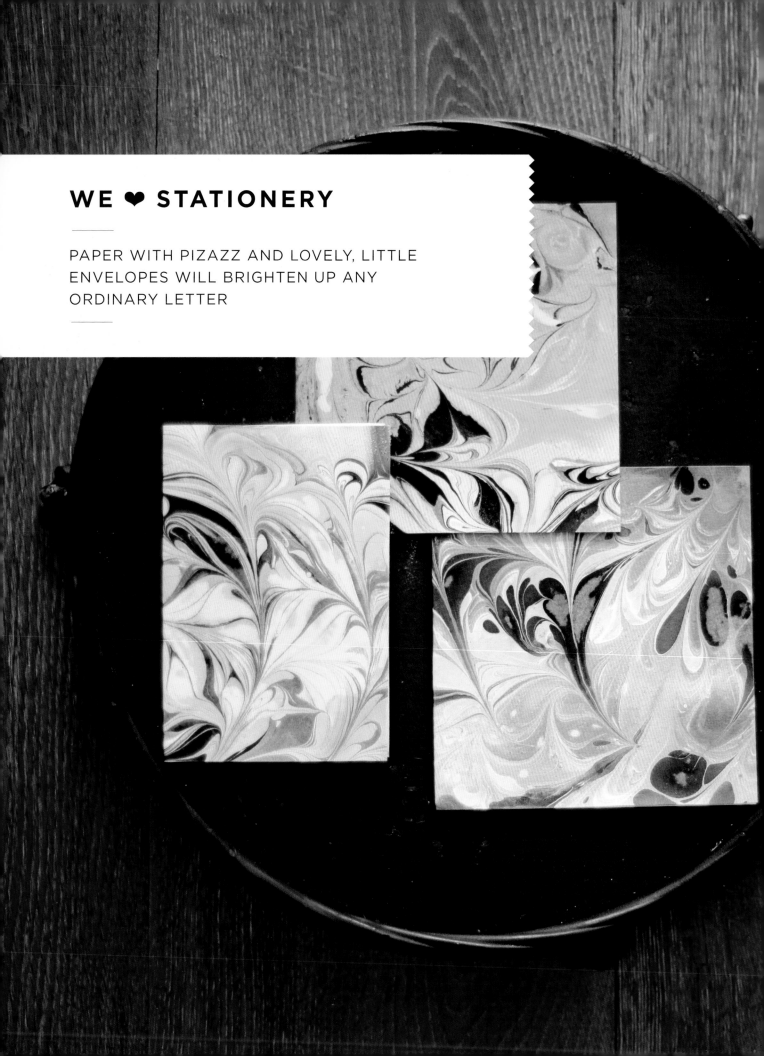

WE ♥ STATIONERY

PAPER WITH PIZAZZ AND LOVELY, LITTLE
ENVELOPES WILL BRIGHTEN UP ANY
ORDINARY LETTER

It's reassuring, in a world of technological devices, that stationery has never been more popular—it seems that we can't get enough of multicoloured paper clips, ring binders and hole punches. Lucy Edmonds of cool online stationers Quill London puts this down to an increase in home working: "People are giving more thought to their home office spaces, which means they're willing to spend a little bit more on stationery they'll enjoy using and that won't get pinched." She also suggests it's an opportunity to accessorise: "Stationery is a great little everyday vehicle for design, pattern and colour," she says. "Whether it's a patterned notebook in your handbag or a brass pencil-holder on your desk."

Marbled paper

Mollie Costley

YOU'LL NEED TO BUY A FAIR FEW SUPPLIES, BUT ONCE YOU'VE PREPARED YOUR MATERIALS, YOU CAN PLAY FOR HOURS

SUPPLIES
Alum
Shallow plastic tub
Paper of your choice
Plastic bucket
Methocel
Distilled water
Clear ammonia
Whisk
General purpose craft paint
Fabric paint
Paper cups
Dispersant
Straws and skewers
(one for each colour)
Clothesline
Paper towels

1 In the plastic bucket, mix 3 tbsp of alum powder per litre of hot tap water. Brush the solution onto the paper, then let dry flat. This mixture can be reused for up to a week.
2 To prepare the size (the surface of thick cellulose solution to float your paints colours on), mix 4 tbsp methocel and 1 tbsp ammonia per 4.5 litres of distilled water in the shallow plastic tub. Whisk vigorously, and then allow all of your bubbles to dissipate.
3 To prepare the paint, squirt about a tablespoon of each colour into separate plastic cups. Add one or two drops of dispersant and slowly add water until the paint has the same smooth consistency as whole milk. If the paint is too thick, it will just fall to the bottom. You can test the consistency in a separate pot with a bit of size to see which paints need thinning and which aren't quite concentrated enough yet.
4 Lay or drip the first paint colour onto the size using a straw or eyedropper. The colour will float on top and spread out a few inches. Keep in mind how you want your design to look once it's finished.
5 Add additional colours on top. Some paints will spread quickly and move others out of the way. The colours don't usually mix, which allows for lots of potential in the end product – just remember that the way you lay your paints on top of each other will affect the look of the fin-

ished piece. As you add each new colour, the ones added before will deepen and change as they're pushed together.
6 Using a pointed skewer, draw in the paint and create swirls, stripes and shapes of all kinds, as you like.
7 Now take your piece of paper and lay it flat down on the paint. Lay the middle down first, then let the ends roll out onto the surface so that no air is trapped beneath. Leave it for between two to five seconds before lifting off.
8 Make sure you get all the air bubbles out by patting gently. Hold two corners of the paper and pick it up, allowing the extra size and paint to drip off.
9 Go straight to the sink, or a bucket of cold water, and rinse gently until the size is washed away. Hang or lie flat to dry.
10 After each print, you can either add more paint or clear the surface with newspaper and start a new design. Reuse the size for a few days by simply lifting the remaining paint off with paper towels. If you're not using your size again, place it in a container filled with kitty litter, paper scraps or sawdust and let it dry before throwing away.
11 Now you can go to town with your newly made paper, turning it into cards, writing paper or even bespoke artwork.

Denim pencil case

Harri Wren

IF YOU DON'T HAVE A
SEWING MACHINE, JUST
USE A NEEDLE AND
THREAD – THERE'S NOT A
LOT OF STITCHING TO DO

SUPPLIES

20 x 15cm piece of denim

Lining fabric

Pins

Scissors

20cm long dress zip

1 Cut two pieces of lining fabric and two pieces of denim the length of the zip (20cm) and 10cm deep.

2 Place lining fabric right side up, with zip (also right side up) along top edge.

3 Place outside fabric face down on lining fabric. Pin along zip's top edge.

4 Sew along pinned edge, taking pins out as you go. Use a zipper foot if you have one – if not, sew as close to the edge as possible.

5 Place the other piece of lining fabric underneath, right side up, so that the zip lines up with it. Place denim fabric on top of the zip face down and pin into place. Sew along the other edge of the zip.

6 Lay all your sewn pieces flat. Fold along zip so that outside fabric is face down. Pin along sides, allowing for a seam allowance.

7 Sew together, turn inside out. Your pencil case is ready to fill.

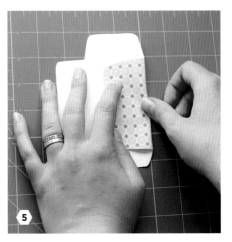

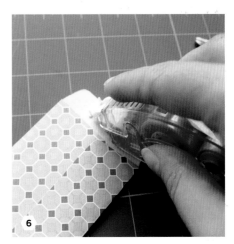

Tiny envelopes

Ruth Bleakley

REPLICATE ANY
ENVELOPE THAT YOU
ALREADY HAVE TO
HAND, SO THERE'S NO
MEASURING INVOLVED

SUPPLIES

Interestingly shaped envelope
A bowl of water
Cardboard to make your template
Paper to make your new envelope
Glue tape roller or glue stick

1 Choose an existing envelope of a
pleasing size and shape. Soak it in
a bowl of lukewarm water for about
one minute, or until the glue
releases from the paper easily
(it won't take long).
2 Pat the now unfolded envelope dry –
it doesn't have to be completely dry,
just not drippy – and trace it onto a
thin piece of cardboard like a cereal
box. Try to be accurate at this stage
and trace neatly.
3 Cut the template out with a pair of
scissors. Label it for future reference.
4 Use a pencil to trace your new
template on an attractive sheet of
paper: gift wrap, maps, magazines,
old calendars all work. Trace on the
inside so the marks won't show.
5 Cut out the shape with scissors.
Fold it, sides first. Use the folded sides
as a guide to fold the top and bottom.
6 Use a glue tape roller or glue stick
to stick your envelope together.

THE COLLECTOR: VINTAGE FABRICS

THE JOYFUL COLOURS AND PLAYFUL PATTERNS OF OLD TEXTILES ARE IRRESISTIBLE FOR RACHEL MANSI

Lottie Storey

As pets and their owners often resemble each other, so do collectors and their collections. Take Rachel Mansi. Dressed in a psychedelic-print skirt and bright blue T-shirt, she sits in her studio surrounded by fabric as colourful as she is. She offers me a cup of tea as the stereo blares 70s disco, and I step into her rainbow vintage world. It's deeply nostalgic.

"I had a colourful upbringing," she tells me. "My mum and I moved a lot, and wherever we lived she would hang a piece of Heal's fabric on the wall. It made a new place feel like home. Years later, she gave me the fabric and I decided to find out more about it. One day, I saw a piece on eBay and the collecting bug took hold."

Rachel started to look out for more Heal's designs and, along the way, found other designers that caught her eye. Her knowledge grew with her collection. "I'm always particularly excited when I track down a fabric that I've seen in a book," she says. "One of the first was 'Petrus' by Peter Hall for Heal's – I still have my first piece of that mounted on a canvas in the living room. And I love it when I find a piece that the V&A doesn't have in its archive. Take 'Prince of Quince' by Juliet Glynn Smith for Conran, sold in the first Habitat shop in Chelsea – I have it in purple, white and green, but I've never seen the green referenced anywhere." It's not just the rare and highly regarded that interest Rachel – like the best collectors, she only buys what she really loves. "It doesn't matter if a fabric is considered an iconic design – if I don't love it, there's no place for it on my shelves."

There could be a danger that Rachel's collection might stay stuck in the past. Rachel, however, has plenty of ideas to keep her love of vintage fabric alive. "Initially, I intended to make cushion covers and lampshades from vintage fabric to sell," she says. "I gradually realised, however, that to make a profit, I'd either need to work very fast or charge a lot. I also knew that my favourite part of the process was sourcing the fabric. So, I built up a large collection of good-quality fabric in every colour of the rainbow, and I set up a blog, a Facebook page and got onto Instagram. As well as showing people what new stock is coming in, I share moments from my life." By doing this, potential customers get to know more about Rachel and recognise that she's a person with genuine enthusiasm and knowledge. "I can give people a more personal service," she says."They can contact me to discuss custom orders or just to chat about fabrics."

Rachel has also made many friends in the vintage fabric community. "Many of those I meet are makers who love using the fabrics I find, though I think of them as friends first and customers second. One of the loveliest things about fabric is that, unlike other collectable items, it can be shared easily. I can send a piece to a friend and keep a bit for myself."

1. Dutch geometric fabric by Dekoplus

The only piece of fabric in Rachel's collection that she wouldn't part with is a piece of Dutch fabric printed with rows of tulips and daisies (number 14). "I love it partly because it's just so cheerful, and partly because I didn't expect to find it," she tells me. "An online friend found it in a charity shop in Ireland and messaged me to ask me if it was vintage. I nearly fell off my chair because I'd been looking for that particular design for years. We did a swap: she sent me half the fabric and I sent her some squares of vintage sheets to make a quilt."

Rachel's fascination is partly about history, partly about domesticity and partly about glamour, she says. "Fabric is passed from generation to generation," she says, "in the form of clothing, blankets, and quilts. It is a source of warmth, comfort, and self-expression. It can be made into something domestic or glamorous – a tea towel or a silk scarf, a curtain or a ballgown. Uniquely, it can be repurposed again and again – an out-of-style dress can be altered and restyled, or a treasured baby blanket can be reincarnated as a quilt."

What's next for Rachel? "I'd like to start selling at vintage and textiles fairs because it's a lovely way to meet other enthusiasts and collectors face to face," she says. "I also plan to do more sewing and to make a start on my dream quilt using a square from every fabric in my collection. The only problem is, how will I ever finish it if I'm always collecting more?"

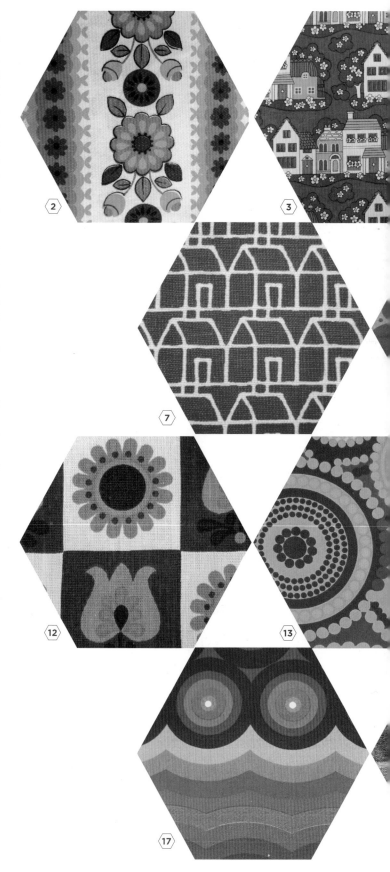

2. 1960s English floral barkcloth
3. 'Daisy Walk', 1970s furnishing fabric by Jonelle
4. 1960s Dutch floral fabric by Dekoplus
5. Swedish 'Folklore' fabric by Göta Trägårdh
6. 1960s 'Petrus' cotton crêpe by Peter Hall for Heal's
7. 1970s 'Casa' by Conran Fabrics
8. 1960s 'Mykero' by Saini Salonen for Borås
9. 1970s Scandinavian fabric featuring buildings, birds and elephants
10. 1960s 'Frequency' by Barbara Brown for Heal's
11. 1960s 'Prince of Quince' by Juliet Glynn Smith for Conran
12. Dutch chequered floral fabric by Dekoplus
13. 'Glimminge' by Mona Björk
14. 1970s German stylised floral fabric
15. 1960s Dutch tulip and daisy fabric (Rachel's favourite)
16. 1960s British mod floral barkcloth
17. 1960s 'Ebb Tide' by Barbara Brown for Heal's
18. 1970s 'Cherry Orchard' by Irmgard Krebs for Heal's
19. 1960s 'Pastoral' by Regina Moritz-Evers for Heal's
20. 1960s 'Verdure' by Peter Hall for Heal's
21. 1960s American mod floral linen

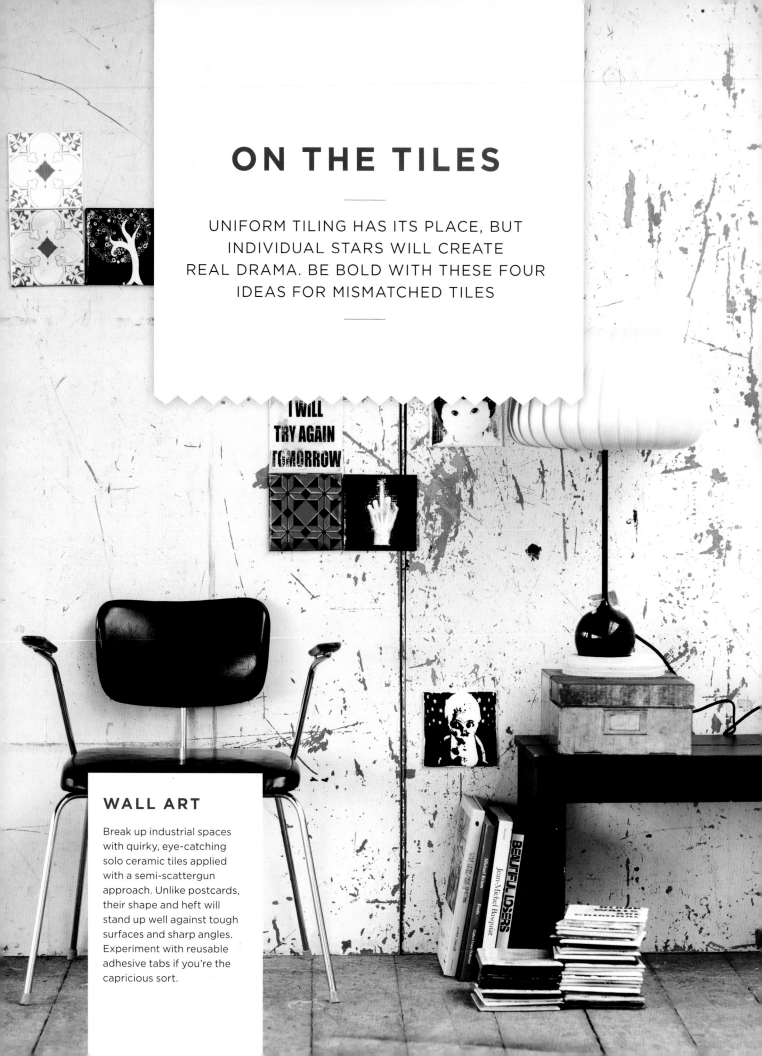

ON THE TILES

UNIFORM TILING HAS ITS PLACE, BUT
INDIVIDUAL STARS WILL CREATE
REAL DRAMA. BE BOLD WITH THESE FOUR
IDEAS FOR MISMATCHED TILES

WALL ART

Break up industrial spaces
with quirky, eye-catching
solo ceramic tiles applied
with a semi-scattergun
approach. Unlike postcards,
their shape and heft will
stand up well against tough
surfaces and sharp angles.
Experiment with reusable
adhesive tabs if you're the
capricious sort.

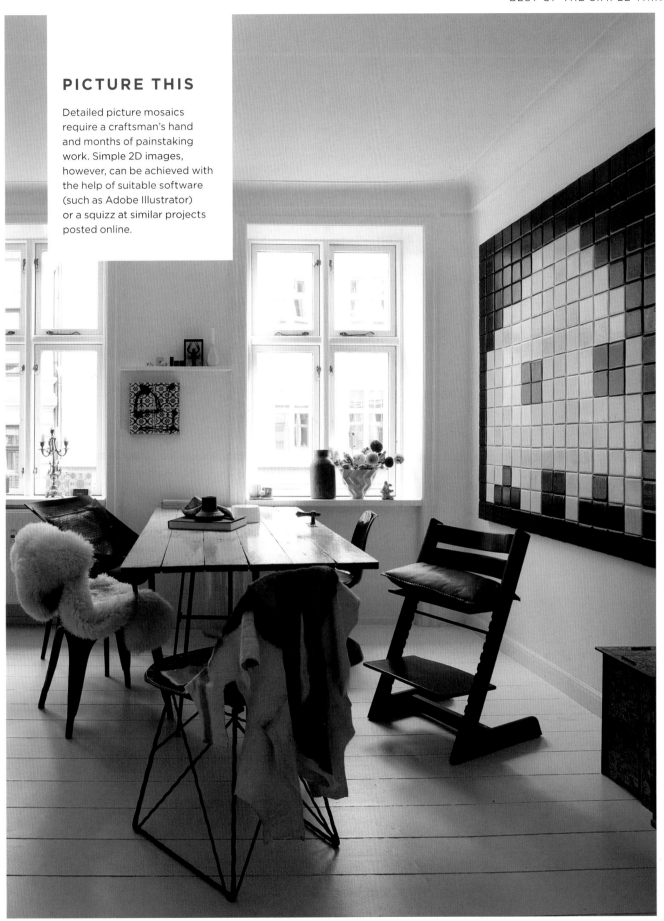

PICTURE THIS

Detailed picture mosaics require a craftsman's hand and months of painstaking work. Simple 2D images, however, can be achieved with the help of suitable software (such as Adobe Illustrator) or a squizz at similar projects posted online.

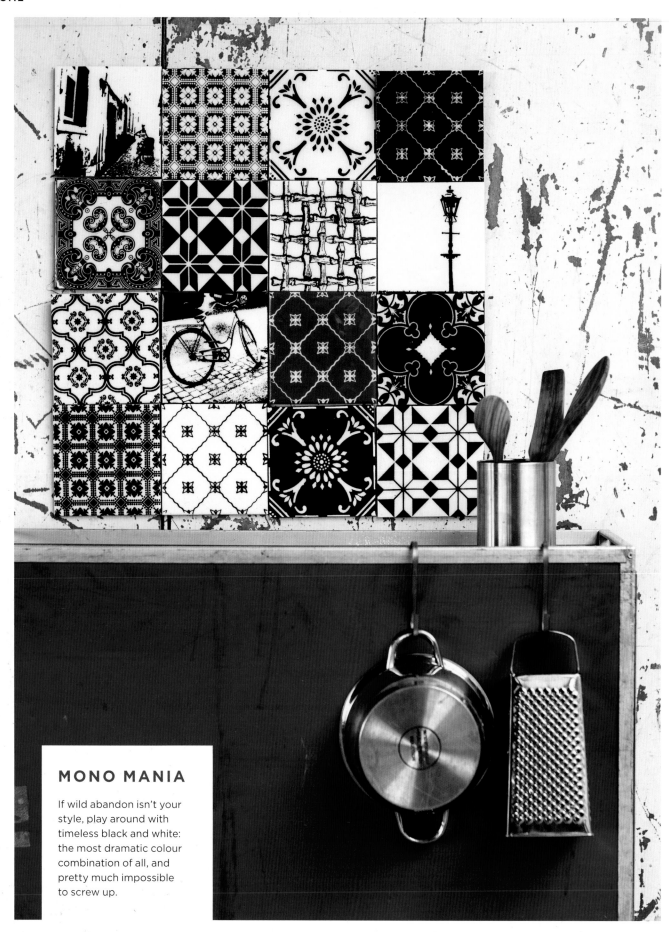

MONO MANIA

If wild abandon isn't your style, play around with timeless black and white: the most dramatic colour combination of all, and pretty much impossible to screw up.

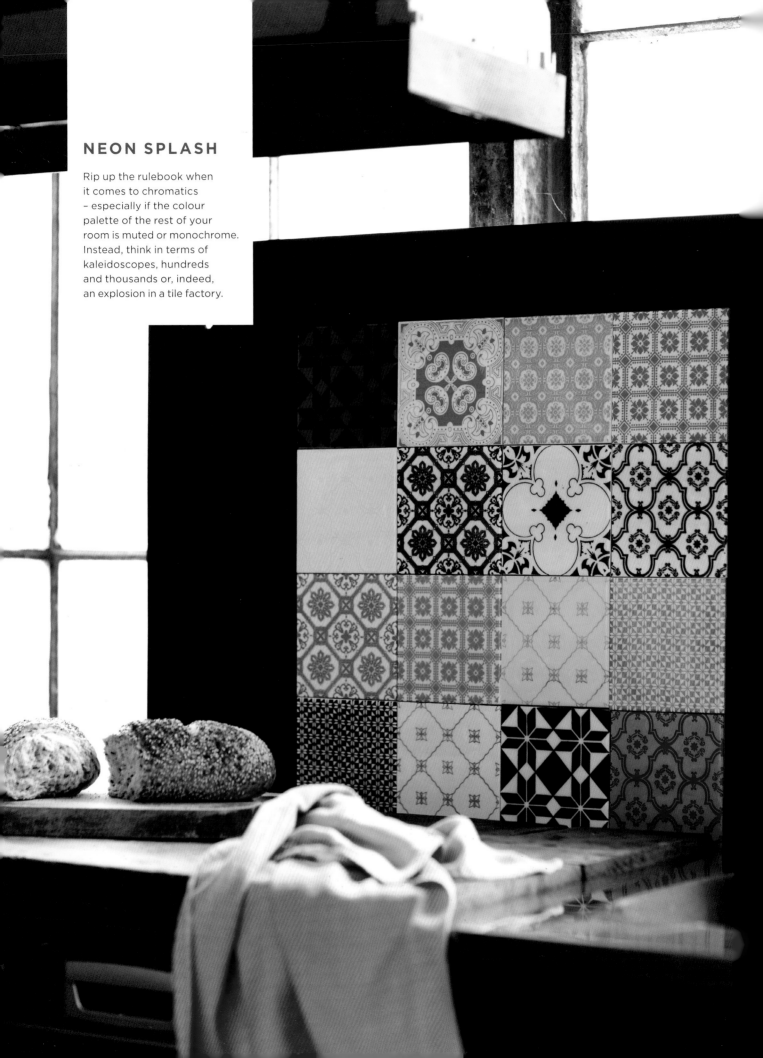

NEON SPLASH

Rip up the rulebook when it comes to chromatics – especially if the colour palette of the rest of your room is muted or monochrome. Instead, think in terms of kaleidoscopes, hundreds and thousands or, indeed, an explosion in a tile factory.

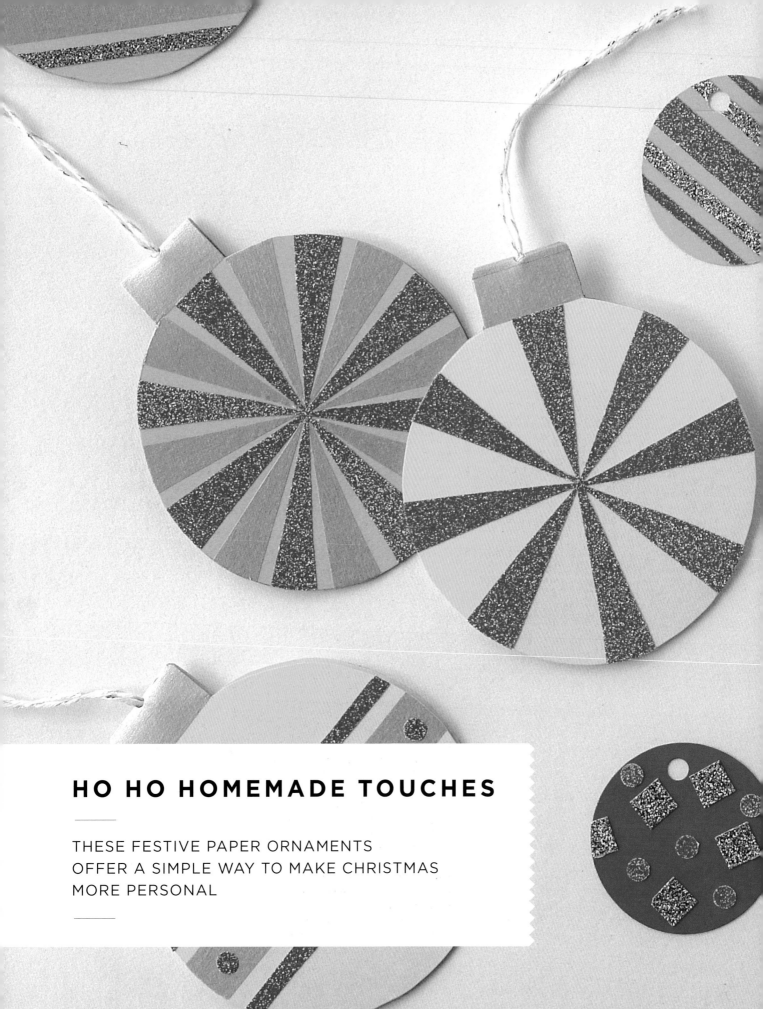

HO HO HOMEMADE TOUCHES

THESE FESTIVE PAPER ORNAMENTS
OFFER A SIMPLE WAY TO MAKE CHRISTMAS
MORE PERSONAL

Duringg the build-up to Christmas, spare a thought for the postie with his bag full of cards. The British send more per person than any other country, so it's not surprising that we were the originators of the first commercial Christmas card in 1843. We have a fine tradition of making cards, too – even Queen Victoria had her kids at it.

And the Queen was spot on: making your own cards is a satisfyingly easy way to add personality and sparkle (depending on how liberal you are with the glitter) to your Christmas. It will even save you some money, too. These clever cards can be adjusted to size to allow for any desired festive greeting, whether it's a to-the-point 'Merry Christmas' or a lengthier salutation. They can also double as gift tags or ornaments.

While you've got your scissors out, the pretty paper wreath over the page can be made in under an hour and offers a crafty take on the traditional wreath.

Ornament cards

Marisa Edghill

CARD, PRETTY TAPE AND A BIT OF RIBBON ARE ALL YOU NEED TO MAKE THESE CLEVER BAUBLE-SHAPED CARDS

SUPPLIES

Colourful card

9–10cm bowl or other circular shape to use as a template

Pencil

Washi tape

Glitter tape

Scissors

Hole punch

Ribbon, twine or string

Glue (optional)

1 Fold a piece of card in half. Trace around the bowl carefully, leaving

approximately 1.25cm of space by the fold. Apply a strip of metallic washi tape to fill the space between the fold and the top of the circle shape.

2 Cut out your ornament shape, keeping inside the pencil outline all the way round – you don't want any lines to be visible on your finished card. Cut a straight line down each side of the metallic tape to shape the top of the ornament.

3 Decorate the card with strips of glitter and washi tape. To make small glitter dots, use a hole punch. You can decorate both sides of the card if you like.

4 To create a slightly different look, get inspired by the swirls of peppermint lollipops. Mark the centre on your circle, then position triangular-shaped strips of glitter tape so that the points meet in the middle. Trim tape ends.

5 Open up the card and punch a small hole in the centre of the tab. Cut a piece of twine or ribbon approximately 25cm long. Fold the length in half, tie the loose ends together, then feed the looped end through the hole at the fold of the card. The knotted end will be hidden neatly inside the card when it's closed.

6 To make them into ornaments, decorate both sides, add the string, then dab a bit of glue in the centre to fix the two sides together. Allow to dry before hanging on your tree.

7 Make it mini: handmade gift tags are a sweet finishing touch. Punch or cut circles out of card before decorating them with glitter tape.

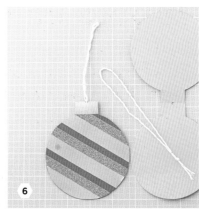

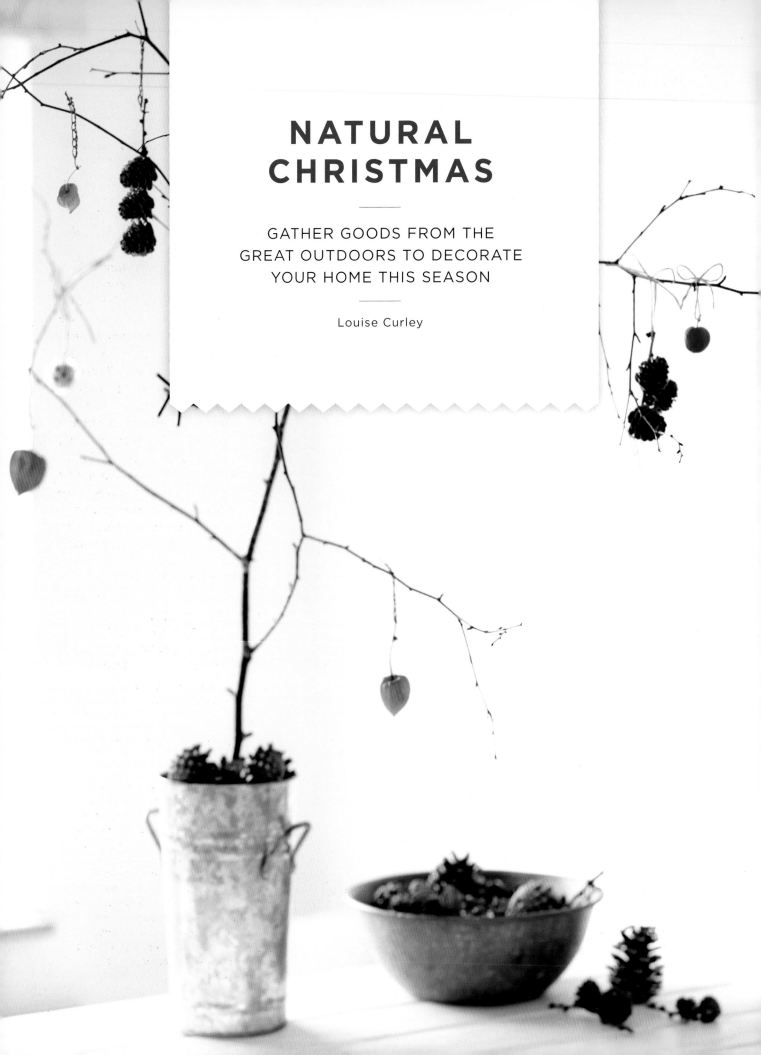

NATURAL
CHRISTMAS

GATHER GOODS FROM THE
GREAT OUTDOORS TO DECORATE
YOUR HOME THIS SEASON

Louise Curley

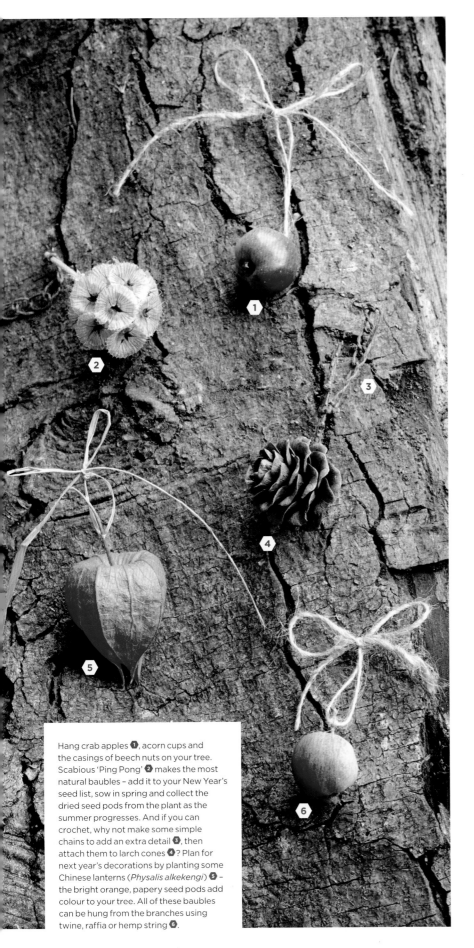

Hang crab apples ❶, acorn cups and the casings of beech nuts on your tree. Scabious 'Ping Pong' ❷ makes the most natural baubles – add it to your New Year's seed list, sow in spring and collect the dried seed pods from the plant as the summer progresses. And if you can crochet, why not make some simple chains to add an extra detail ❸, then attach them to larch cones ❹? Plan for next year's decorations by planting some Chinese lanterns (*Physalis alkekengi*) ❺ – the bright orange, papery seed pods add colour to your tree. All of these baubles can be hung from the branches using twine, raffia or hemp string ❻.

We love Christmas and we're not adverse to a bit of sparkle, but it can be easy to overdose on tinsel and glitter at this time of year. We've come to prefer something a little more natural and rustic, with a nod to the Scandinavians for their simpler approach to Christmas décor.

Taking inspiration from nature and the seasons is where it's at. A spot of foraging in the hedgerows and woods while out for a Sunday afternoon walk, and making your own homemade baubles and wreaths, is all part of the fun. Early winter storms are likely to have brought a windfall of cones and branches – great for creating your own miniature Christmas tree. Keep your decorations very natural by attaching them using jute twine, raffia and hemp string, or add colour with crab apples, Chinese lanterns and winter berries. Once you've caught the natural decorating bug, there are all sorts of plants you can grow in your garden or on your allotment with future Christmas decorations in mind.

Christmas tree

A BRANCH TREE IS A GREAT ALTERNATIVE IF SPACE AND BUDGET ARE TIGHT. DECORATE WITH FORAGED BAUBLES

SUPPLIES
One attractively shaped branch (birch, alder or hazel)

1 Keep a look out for branches with a good shape and lots of smaller branching stems, which are nice for hanging decorations. Birch makes a good natural tree, as does alder with its pretty tiny cones. You could also try a few stems of contorted hazel gathered together.
2 If necessary, prune to fit your space, but be careful not to spoil the natural shape.
3 Select a container, place the stems into it, fill the base with some stones to weigh it down and then wedge some newspaper in around the stems to hold in place.

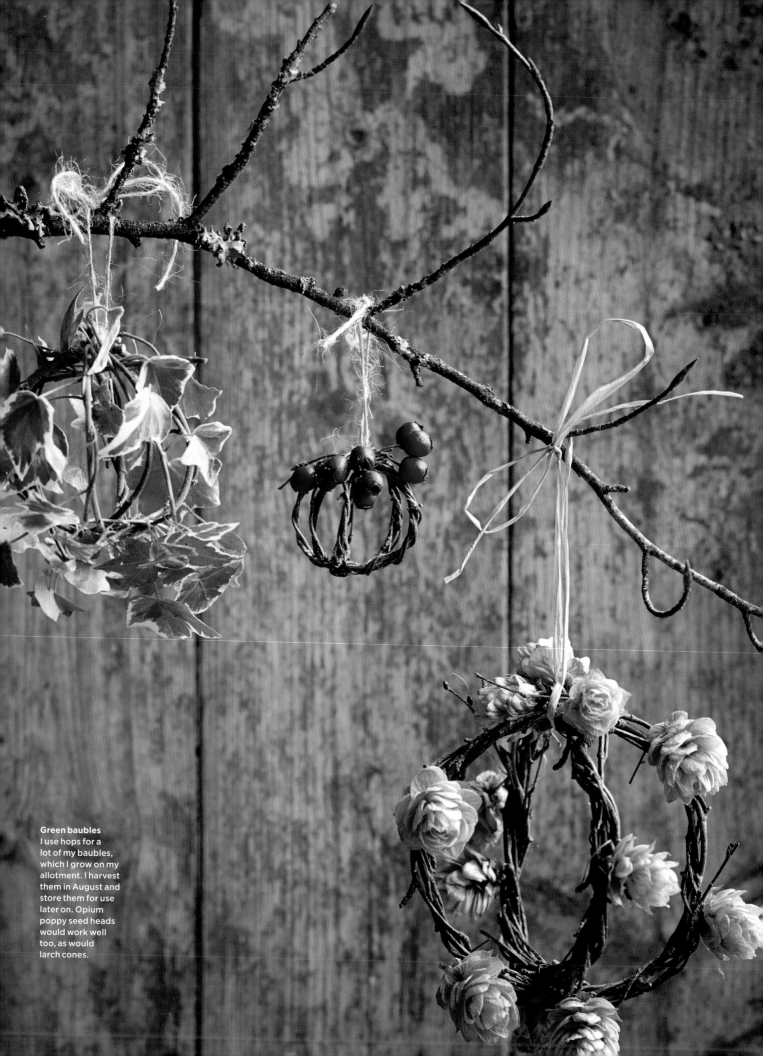

Green baubles
I use hops for a lot of my baubles, which I grow on my allotment. I harvest them in August and store them for use later on. Opium poppy seed heads would work well too, as would larch cones.

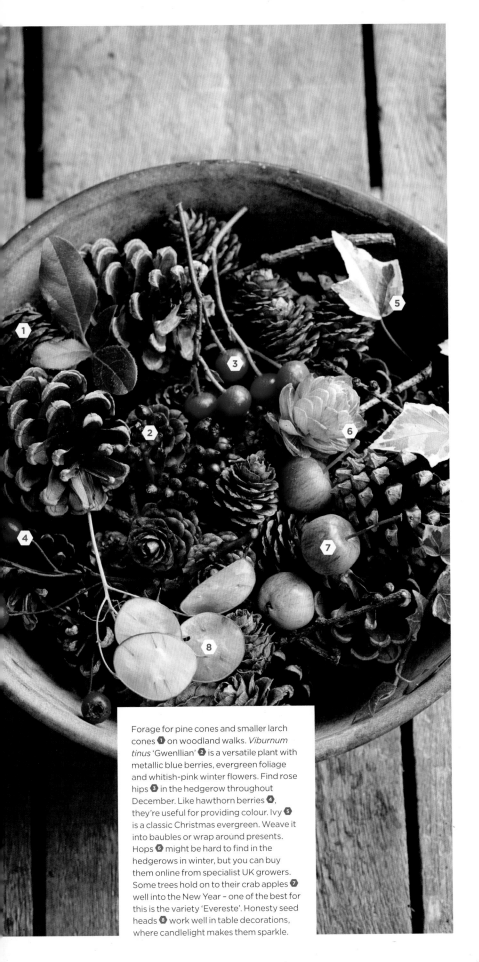

Keeping your last-minute homemade decorations simple is the key, and a spot of foraging is a nice excuse to take a break and get some fresh air.

Forage for pine cones and smaller larch cones **1** on woodland walks. *Viburnum tinus* 'Gwenllian' **2** is a versatile plant with metallic blue berries, evergreen foliage and whitish-pink winter flowers. Find rose hips **3** in the hedgerow throughout December. Like hawthorn berries **4**, they're useful for providing colour. Ivy **5** is a classic Christmas evergreen. Weave it into baubles or wrap around presents. Hops **6** might be hard to find in the hedgerows in winter, but you can buy them online from specialist UK growers. Some trees hold on to their crab apples **7** well into the New Year – one of the best for this is the variety 'Evereste'. Honesty seed heads **8** work well in table decorations, where candlelight makes them sparkle.

Garden baubles

RUSTIC DECORATIONS ADORNED WITH IVY, HOPS AND BERRIES. HANG IN COLOURFUL CLUSTERS

SUPPLIES
Birch, willow or hazel stems and wire

Decorations such as ivy and berries

Raffia, twine or hemp string to hang

1 Make two or three circles of the same size from birch, willow or hazel, securing each with wire.
2 Put them together to form a globe and secure the circles together at the base and top with wire.
3 Decorate with natural material, weaving in ivy or wiring in berries, and hang from a length of raffia.

119

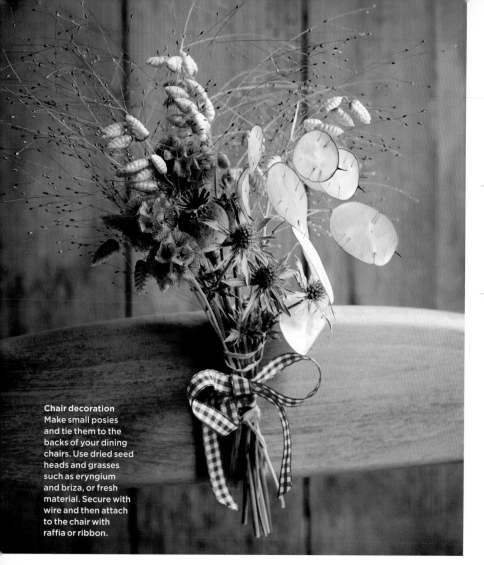

Chair decoration
Make small posies and tie them to the backs of your dining chairs. Use dried seed heads and grasses such as eryngium and briza, or fresh material. Secure with wire and then attach to the chair with raffia or ribbon.

Wrapping presents

SWAP GAUDY FESTIVE PACKAGING FOR SIMPLE BROWN OR WHITE PAPER, EMBELLISHED WITH NATURAL ORNAMENTS

SUPPLIES
White or brown packing paper
Ribbons, twine or raffia
Holly, seed heads or larch cones

1 If you feel guilty at the mountain of rubbish generated once presents have been unwrapped, there is an alternative. Wrap presents in neutral white and brown packing paper, both of which are easily recycled.
2 Adorn them with pretty ribbons, natural twine and raffia.
3 Rather than shiny, plastic-looking bows, top your gifts with a sprig of holly, seed heads or tiny larch cones.

Table decorations

PREPARE THE TABLE FOR A CHRISTMAS FEAST WITH VASES OF LARCH CONES, CRAB APPLES AND WINTER BERRIES

SUPPLIES
Jars; ribbon; natural decorations from the garden and hedgerows

1 Keep hold of empty jars in the run-up to Christmas, as they can be recycled into vases.
2 Tie some ribbon around the necks to add a festive touch and fill with pickings from the garden and hedgerows. Evergreen herbs such as rosemary and bay work well, providing a lovely aroma.
3 Add a few stems of hawthorn berries or pyracantha for a shot of Christmassy colour.
4 Even more simple is to fill a few jars with larch cones and crab apples. On crowded Christmas tables smaller decorations like this work much more effectively, taking up less space and allowing guests to chat without being obscured by plant material.

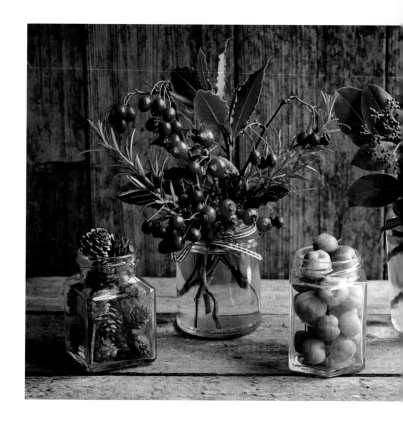

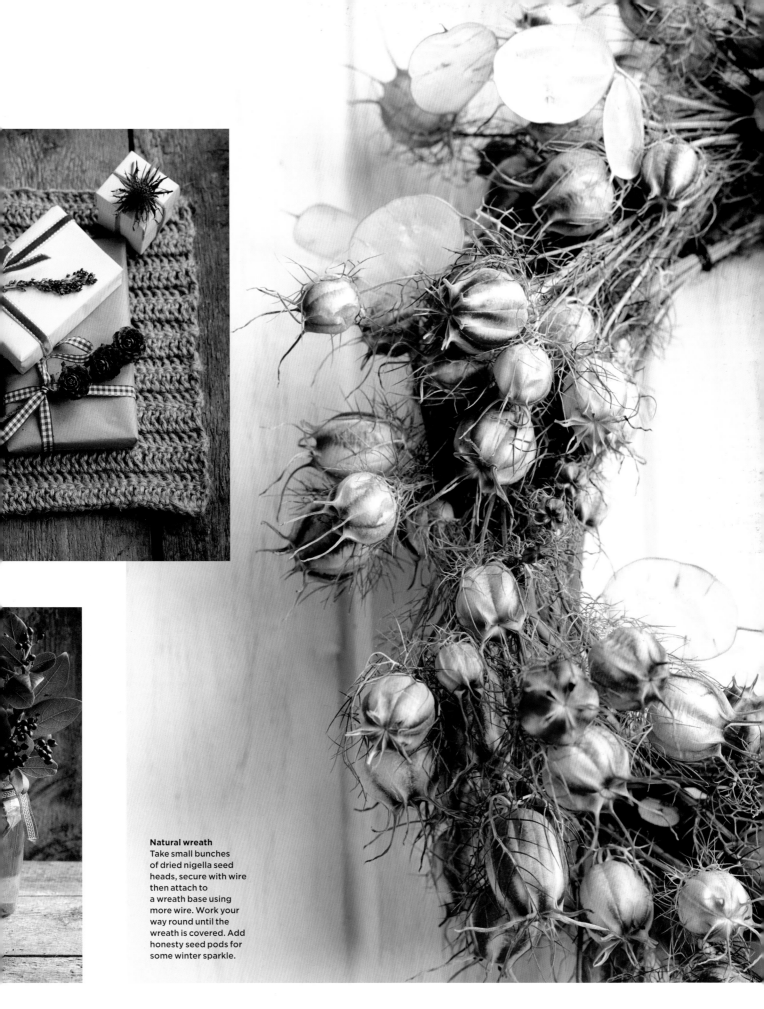

Natural wreath
Take small bunches
of dried nigella seed
heads, secure with wire
then attach to
a wreath base using
more wire. Work your
way round until the
wreath is covered. Add
honesty seed pods for
some winter sparkle.

Woodland wreaths

DRESS SUSTAINABLE
WREATHS OF
HAZEL, WILLOW OR
BIRCH STEMS WITH
LEAVES, BERRIES
AND PINE CONES

SUPPLIES

Florist's wire – thin green wire
for wiring in berries and seed
heads and thicker wire on a
roll for securing stems

Natural jute twine

Raffia

Hemp string – a completely
natural material that comes in
several neutral colours and is
easy to crochet into simple
chains, which you can use to
hang your decorations

1 For hazel or willow, start with
one stem about 1.2m in length and
bend into a circle, securing the
ends tightly with florist's wire.
2 Take another stem and weave
this around the circle. Repeat with
another 3 stems until you have
a sturdy woven wreath base.
3 The stems of weeping birch
are super bendy and excellent
for creating wreaths.
4 Take 2 or 3 stems and, holding
them at their fattest end where
they've been removed from the
tree, wrap some wire around to
hold them together.
5 Then wind their whippy
branches together as if you were
plaiting hair, working your way
along the length of the stems.
Join both ends together to form
a ring and secure with some wire.
6 Don't worry if some stems poke
out, as this adds to the charm and
creates a more relaxed shape.

FORAGING
**Going out foraging is fun, but there
are a few rules you should observe:**

- Don't take from other people's
 gardens, nature reserves or
 protected places.
- Ask the landowner's permission first.
- Only take small amounts, leaving
 plenty for wildlife and others to enjoy.
- Never uproot plants.
- Look out for windfall, ask tree
 surgeons for any leftover material
 or seek out your local woodland
 coppicer for branches to create
 natural trees and wreaths.
- It can be easy to mistake safe
 plants for poisonous ones.
 If in doubt, don't pick.
- Be careful which plants you
 bring indoors and where you
 place them if you have young
 children or pets around.

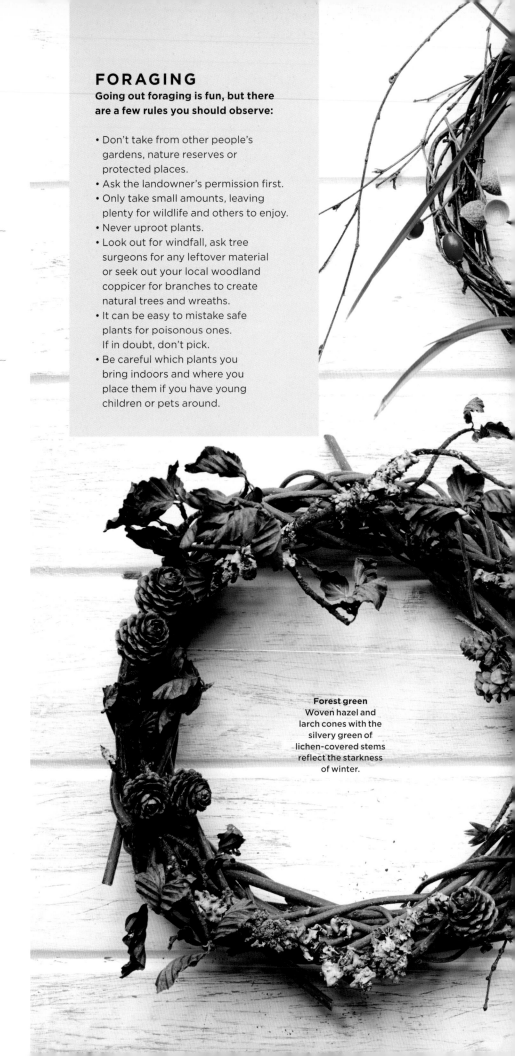

Forest green
Woven hazel and
larch cones with the
silvery green of
lichen-covered stems
reflect the starkness
of winter.

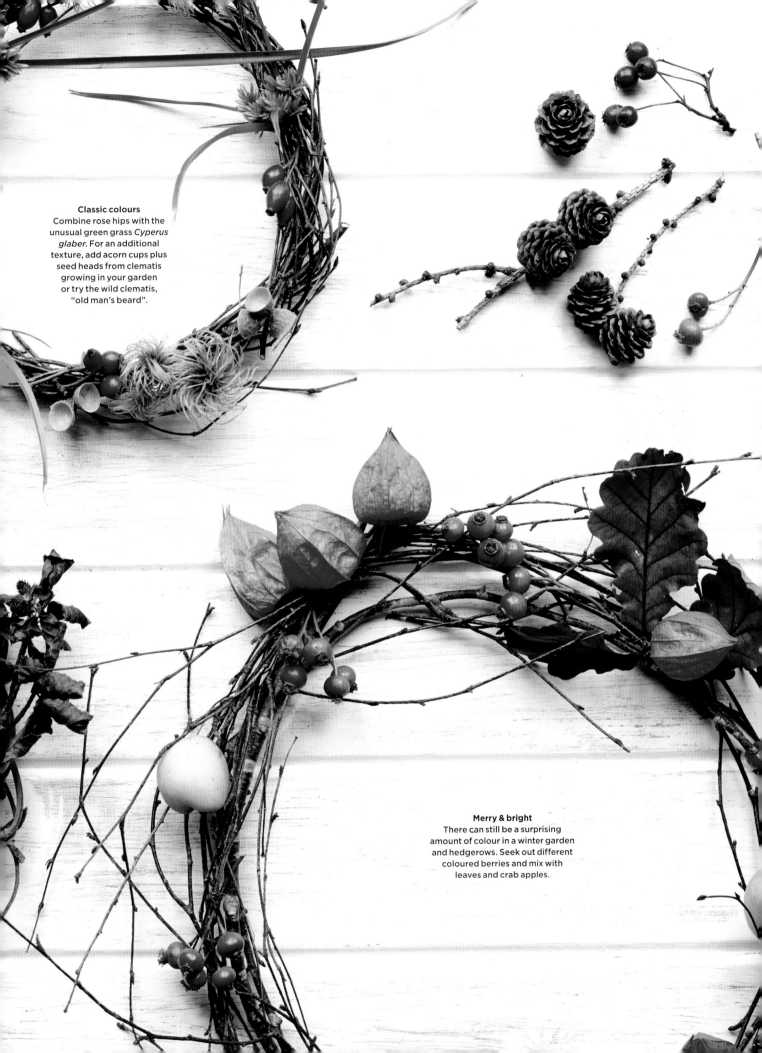

Classic colours
Combine rose hips with the unusual green grass *Cyperus glaber*. For an additional texture, add acorn cups plus seed heads from clematis growing in your garden or try the wild clematis, "old man's beard".

Merry & bright
There can still be a surprising amount of colour in a winter garden and hedgerows. Seek out different coloured berries and mix with leaves and crab apples.

GATHERING

At the very heart of *The Simple Things* is the idea that there's nothing better than **sharing good food with friends and family**. But what used to be called 'entertaining' is now a less formal affair and doesn't have to involve hours in the kitchen. It might take the form of an **impromptu picnic**, or **having a go at something new**, making the most of **a long weekend**, marking a **festival** or feast day. It will always involve people **gathered at a table,** abuzz with conversation, and the glow of good living on contented faces.

MENU

Pumpkin coconut
curry with split peas,
chickpeas & leek

*

Nutmeg-spiced
tomato chutney

*

Roasted whole carrot with
cumin & mustard seeds

*

Spiced Jerusalem artichoke
crisps & red lentil dip

*

Sautéed chard with peas
& hazelnuts

LIGHT UP, LIGHT UP

LET THE HINDU FESTIVAL OF LIGHTS BE YOUR EXCUSE FOR AN INDIAN-THEMED FEAST

Menu: Julia Gartland

From Jaipur to Leicester, Diwali is literally the most dazzling of all the world's ancient festivals. The Hindu festival of lights, which is celebrated each year in October or November, is an explosion of spice-coloured lanterns, crowds of candles flickering in glass holders, vibrant rangoli (floor paintings), the shiniest, spangliest saris, gaudiest deities, mountains of sweets and lavish pyro-technics. The celebration of victory of good over evil, light over darkness and knowledge over ignorance: it's the ultimate feel-good event.

So what better time to organise your own Indian feast for friends? Brooklyn-based photographer, food stylist and cook Julia Gartland did just that for her boyfriend Joe and a trio of their favourite people. Diwali – it's the ideal marriage of food and photons.

The word 'Diwali' means 'a line of oil lamps' – time to make use of that bumper bag of tealights in the cupboard!

Pumpkin coconut curry with split peas, chickpeas & leek

THIS LIGHT, SUNSHINE-HUED CURRY PROMISES NOT TO MAKE YOUR EYES WATER – JUST YOUR MOUTH

Serves 4-6

2 tbsp olive oil

1 medium onion, roughly chopped

1 leek, roughly chopped

1 litre vegetable stock

1 can coconut milk

230g kabocha squash/pumpkin

65g yellow split peas

1 can chickpeas, rinsed and drained

2½ tsp curry powder

1 tsp cumin seeds

⅛ tsp allspice

⅛ tsp nutmeg, freshly grated

⅛ tsp red pepper flakes

65g kale, chopped small

1 Add onion, garlic, leek and olive oil to a frying pan over medium heat. Sauté for 5-10 mins or until it starts to brown. Add vegetable stock, kabocha or pumpkin, split peas and salt. Bring mixture to a boil, then simmer and cover for 20-25 mins.
2 Once pumpkin and split peas are tender, add chickpeas, all spices and kale. Stew for 10-15 mins until well combined and tasty. Top with shredded coconut or natural yoghurt.

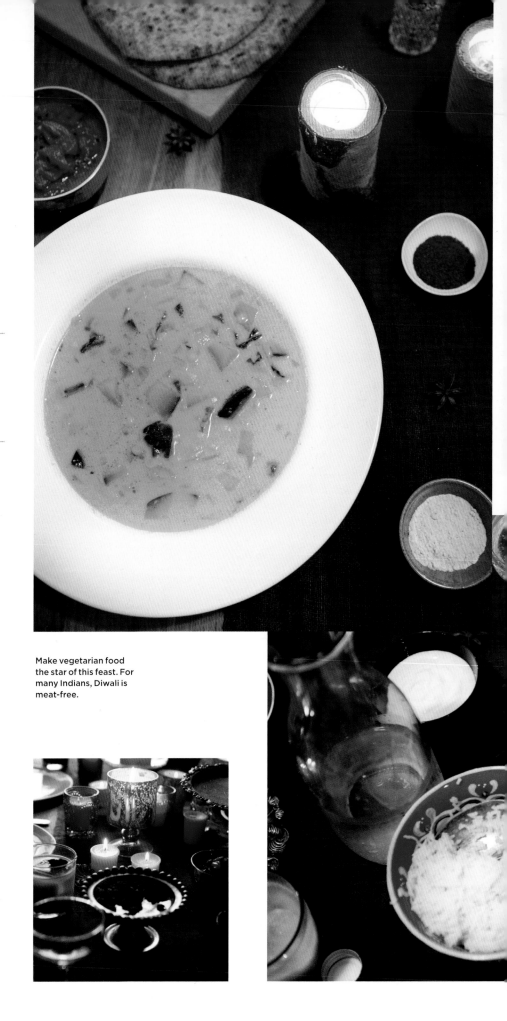

Make vegetarian food the star of this feast. For many Indians, Diwali is meat-free.

From cauliflower
to coconut, via
prawns and
peanuts, Indian
cuisine is packed
with inventive
chutney recipes
and flavours.

Nutmeg-spiced tomato chutney

SWEET AND EARTHY
WITH A NICE NUTMEG
KICK – DOLLOP, DIP
AND SAVE A BIT FOR
CHEESE TOMORROW

Serves 4-6
560g heritage tomatoes
1 garlic clove, minced
1 shallot, minced
1 tsp mustard seeds
¼ tsp allspice
½ tsp nutmeg, freshly grated
2 tbsp olive oil
1¼ tsp salt
2 tsp brown sugar
Freshly ground pepper

1 Heat oil and mustard seeds
over medium heat until seeds
begin to pop. Add shallot
and garlic and stew over
medium heat.
2 Add tomatoes, and cook over
med-low heat until tomatoes
begin to burst and thicken,
usually after about 20-25 mins.
3 Add spices, sugar, salt and
pepper to taste. Remove
from heat, cool and chill.

Roasted whole carrot with cumin & mustard seeds

THIS CRISPY, FLAME-COLOURED SIDE DISH BRINGS OUT THE SATISFYING NATURAL FLAVOUR OF CARROTS

Serves 4-6

450g-675g whole carrots, scrubbed and with the tops cut off

1 tsp mustard seeds, freshly ground

2-3 tbsp olive oil

1 tsp cumin seeds

1 shallot, minced

2 garlic cloves, minced

1 tsp salt

Freshly ground pepper

1 Preheat oven to 200°C/Fan180/400°F, gas 6. In a large mixing bowl, add carrots and coat well with olive oil, spices, salt, garlic and shallot. Make sure all the carrots are coated well and evenly.
2 Spread carrots out on a foil-lined baking sheet. Season with salt and pepper to taste. Bake for 30-35 mins or until crisp and browned.

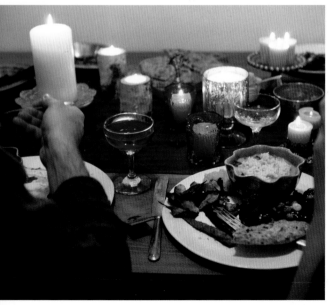

This light, smooth and tangy dip is a great partner for Jerusalem artichoke crisps.

Spiced red lentil dip

RAID YOUR STORE CUPBOARDS FOR THIS COOL, SMOOTH, MODERN SPIN ON THE CLASSIC INDIAN DHAL

Serves 4-6
200g red lentils, rinsed
1 garlic clove, minced
1 tsp ginger, minced
1 tsp sea salt
⅛ tsp cumin seeds
¼ tsp lemon zest
2 tbsp yoghurt
Freshly ground pepper

1 Add lentils, 350ml water, salt, ginger and garlic to a medium saucepan. Boil, then simmer and cover for 10-15 mins or until lentils are tender.
2 Use a hand blender to purée the mixture well until smooth. Set aside to cool.
3 Once cooled, whisk in yoghurt, lemon zest, cumin seeds, salt and freshly ground pepper to taste.
4 Chill before serving.

Spiced Jerusalem artichoke crisps

BAKE THESE SLICED
SUNFLOWER TUBERS
INTO CRUNCHY,
EARTHY MOUTHFULS
OF GOODNESS

Serves 4-6

225g Jerusalem artichokes,
scrubbed

2 tbsp olive oil

⅛ tsp sumac

½ tsp garlic powder

⅛ tsp allspice

⅛ tsp cardamom

1 tsp salt

⅛ tsp cumin seeds

Freshly ground pepper to taste

1 Preheat the oven to 180°C/
Fan160/350°F, gas 4. Slice
Jerusalem artichokes paper-thin
with mandoline or paring knife.
Lay out on paper towels for
10-15 mins, pressing down to
drain excess liquid from the Jeru-
salem artichokes.
2 In a large bowl, mix together
all spices and seasonings. Add
Jerusalem artichokes and toss
to coat. Drizzle in olive oil and
mix until all are covered well.
3 Add Jerusalem artichokes to
a parchment-lined baking tray,
spread evenly over one layer.
Bake for 30-35 mins or until crispy
and brown. Set aside to cool.

Jerusalem artichokes
are similar in taste and
texture to Indian root
vegetable *arbi*.

If cooking with whole
cardamom pods, bash
them first to release
the aromatic seeds.

Sautéed chard with peas & hazelnuts

TENDER, TOOTHSOME GREENS TO OFFSET THE TABLE'S HOTTER COLOURS AND HEARTIER FLAVOURS

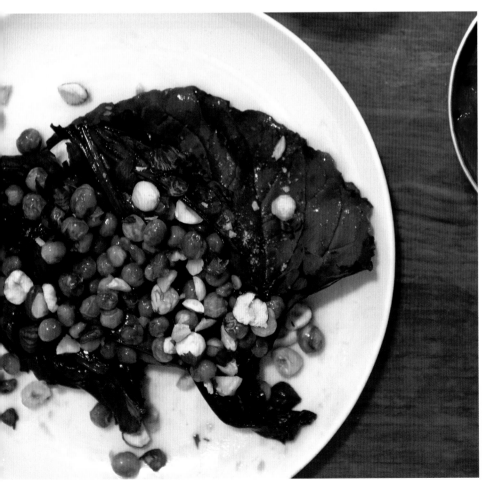

Serves 4-6

2 tbsp olive oil

120g green peas

1 bunch Swiss chard (around 500g), de-stemmed and chopped roughly

½ tsp garlic powder

⅛ tsp nutmeg

⅛ tsp sumac

TO SERVE

60g hazelnuts

1 tbsp mint, minced

Sea salt

Freshly ground pepper

1 Add olive oil and green peas to a frying pan over medium heat. Sauté until peas begin to brown and become tender.
2 Add Swiss chard leaves, using tongs to move around and cook evenly. Add spices and garlic powder. Make sure chard leaves are well coated with spices. Cook over medium heat until tender.
3 Place greens on a large serving plate. Garnish with chopped hazelnuts, mint, and freshly ground pepper and sea salt to taste. Serve warm.

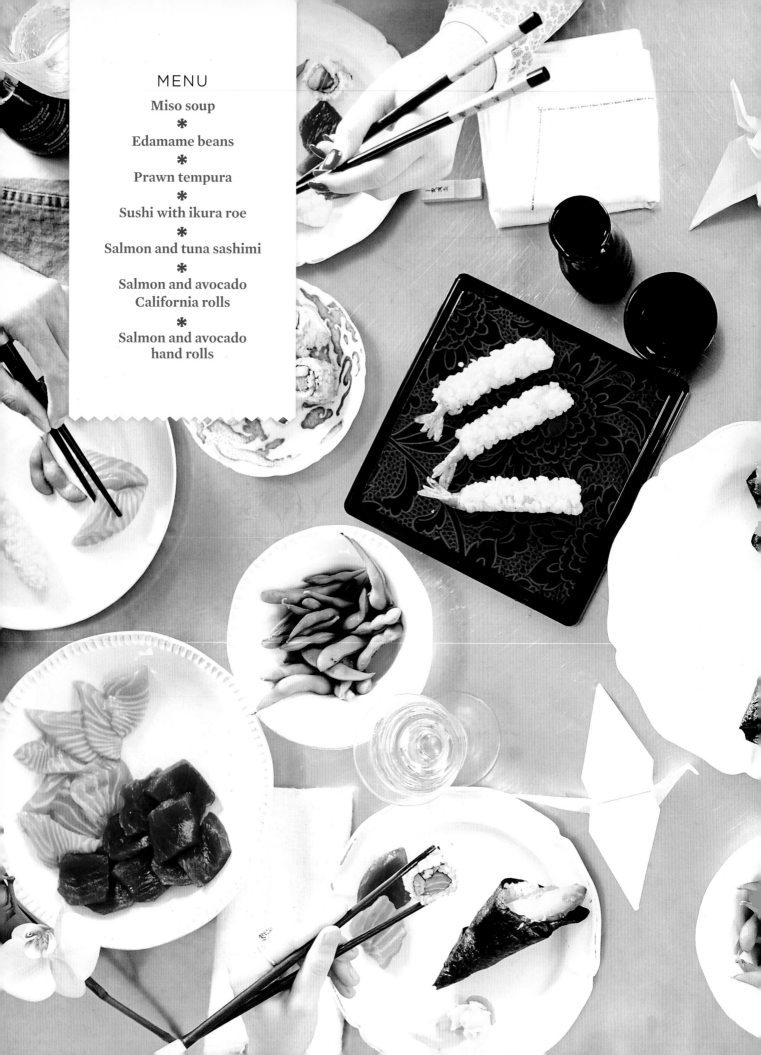

MENU

Miso soup

✳

Edamame beans

✳

Prawn tempura

✳

Sushi with ikura roe

✳

Salmon and tuna sashimi

✳

Salmon and avocado
California rolls

✳

Salmon and avocado
hand rolls

ROLL YOUR OWN

SUSHI NEEDN'T BE TRICKY – WITH
OUR GUIDE TO THE FRESHEST FISH AND
THEIR JAPANESE ACCOMPANIMENTS,
YOU'LL BE MASTER OF THE ROLLS

Menu: Mowie Kay

Sushi* has a reputation for being difficult to make at home. The truth is that it's actually one of the easiest meals to prepare, as long as you have all the right ingredients, the freshest fish you can find and a little help from sushi-making videos online. All the other ingredients are easily sourced from the 'world' aisle of most supermarkets and with a little practice, it's easy to prepare a Japanese feast for sharing at home.

All recipes serve six and can be dished up with soy sauce, pickled ginger or wasabi paste.

** Sushi is now officially more popular than tuna sandwiches.*

Sushi with ikura roe

GLISTENING, BERRY-RED
ROE ATOP A WRAP OF
FLUFFY RICE

1 sheet sushi nori (dried seaweed)

200g sushi rice, prepared according
to pack instructions

100g ikura (salmon roe)

1 Cut the nori into 8 long strips and
place shiny side down.
2 Using wet hands, take a teaspoon of the
sushi rice and roll into a bite-size portion.
Place it in the corner of one of the nori strips
and roll up, keeping the rice at the bottom.
3 Join the ends of the nori together by
dabbing a little water on the inside and
sticking them closed.
4 Scoop a heaped tsp of ikura on top
of the rice. Repeat for the remaining strips.

Salmon and avocado hand rolls

A SEAWEED WRAP WITH
AUTHENTIC JAPANESE MAYO

3 sheets sushi nori (dried seaweed)

400g sushi rice, prepared according
to pack instructions

3 tbsp Kewpie (Japanese mayonnaise)
or plain mayonnaise

1 salmon fillet, cut into 12 slices

1 avocado, cut into 12 slices

1 Cut each square nori sheet in half so
you have 6 long rectangles of nori.
Lay them shiny side down.
2 Place 1–2 tbsp sushi rice on one half of
the nori and flatten it into a square shape,
leaving the other half of the nori empty
(this is important for rolling later).
3 Spread 1 tsp Kewpie over the rice and
add 2 slices salmon and 2 slices avocado.
4 Start rolling from the bottom right-
hand corner, into a cone shape.
Repeat for all the others.

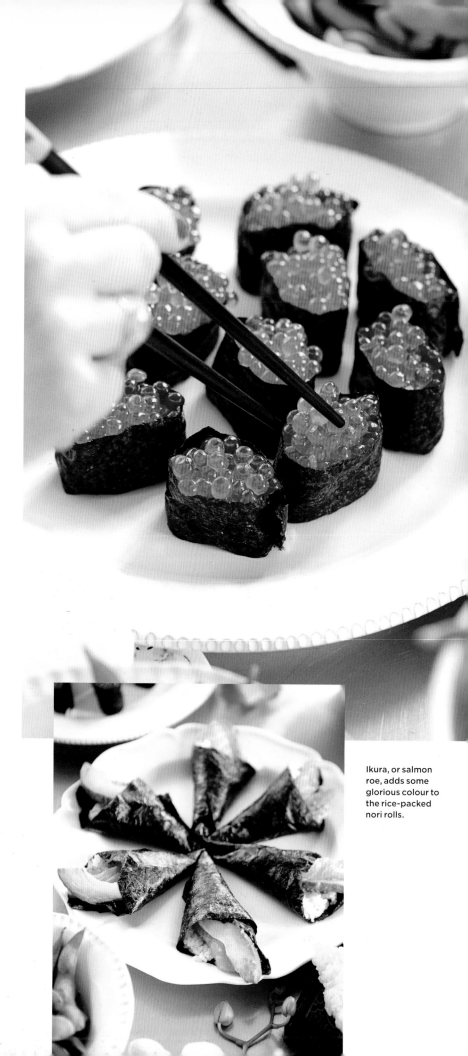

Ikura, or salmon
roe, adds some
glorious colour to
the rice-packed
nori rolls.

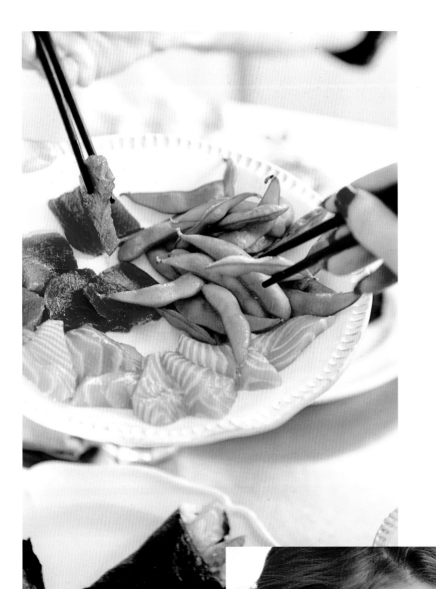

Salmon and tuna sashimi

THE SIMPLEST DISH OF ALL – JUST SHOP, SLICE AND SERVE

1 salmon fillet
1 tuna fillet

1 The key to great sashimi is freshness. Go to a fishmonger that you trust and check the fish to make sure there are no missing scales, the eyes are bright, the gills pink and the body quite firm. Keep it refrigerated until it is needed for preparation.
2 It helps to have cold utensils. Using the sharpest knife you have, cut the fillets on the diagonal into medium slices, then arrange on a plate.

Miso soup

6 cups water
2 tsp dashi granules
3-4 tbsp miso paste
1 sheet nori, cut into long strips
250g tofu, cubed
3 green onions, chopped

Pour the water into a pot and bring to the boil. Reduce heat to medium and whisk in the dashi and miso. Add the nori and simmer until it is soft. Then add cubed tofu and spring onions and simmer for a further 5 mins.

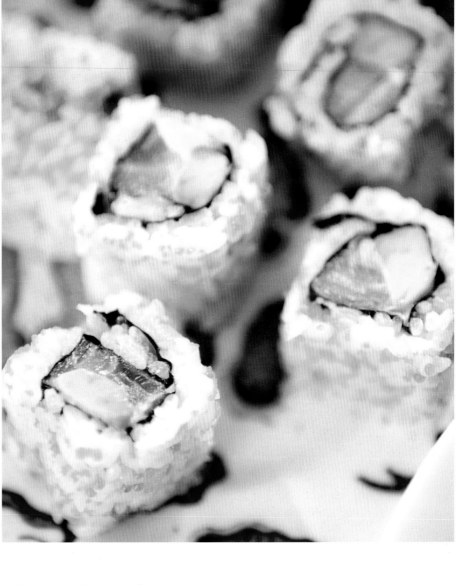

Edamame beans

TRADITIONAL SUSHI
ACCOMPANIMENT:
BEANS WITH SEA SALT

600g edamame beans
2 tbsp sea salt flakes

1 Bring a large pot of water to
the boil, add the edamame beans
and boil for about 5 mins without
covering the pot.
2 Drain the beans and sprinkle
with the sea salt flakes.
3 Serve in small bowls. Squeeze
the beans out of their pods and
onto your plate or directly into
your mouth, discarding the pods.

Salmon and avocado California rolls

THE 'INSIDE OUT' ROLL
HAS A ROE COATING
AND SALMON CENTRE

1 sheet sushi nori
300g sushi rice, prepared
according to pack instructions
50g tobiko (flying fish roe)
250g salmon fillet, cut into slices
1 avocado, cut into slices

1 Cover your sushi mat with cling film.
2 Cut the square nori sheet in half to
get two rectangles. Place one of
these on the lower half of the mat.
3 Scoop some rice onto the nori
sheet and, with wet fingers, gently
spread the rice to cover it. Sprinkle
about a tsp of tobiko on top of the
rice and spread gently and evenly.
4 Flip the nori and rice so that the
nori is on top and the rice is at the
bottom (touching the cling film).
5 Place a few slices of salmon and
avocado along the bottom half of
the nori – not too much, otherwise
the roll won't close properly.
6 Lift the edge of the mat with your
thumbs, and place your fingers
evenly over the filling to hold it
in place. Roll until the rice touches
the nori.
7 Now unroll the mat and cling
film. Use the mat to squeeze the
roll to ensure it's tightly packed.
8 Place your cylindrical roll on a chop-
ping board and use a very sharp
knife to cut through the centre first,
then slice on either side to give
you 6 pieces.

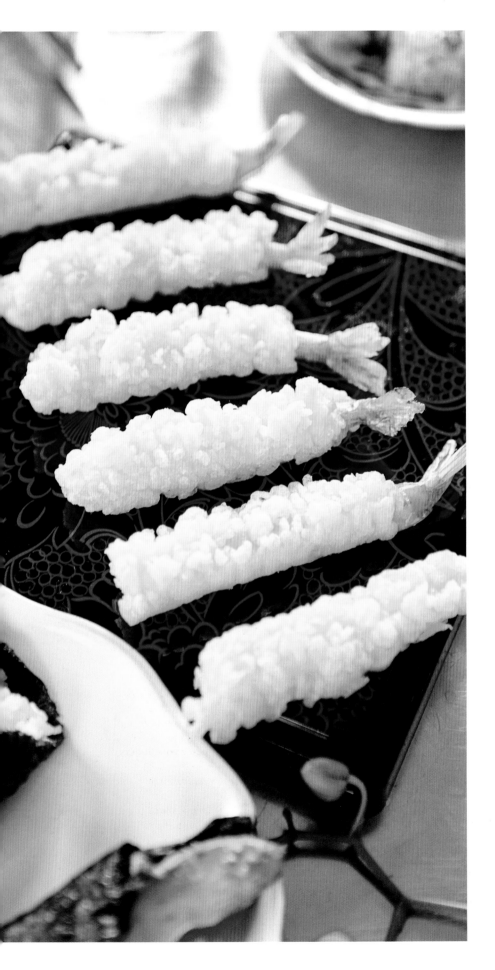

Prawn tempura

JUICY PRAWNS
TRAPPED IN DELICIOUS
BATTER JACKETS

250g plain flour, sifted
500ml water
1 egg
Oil, for frying
1kg large prawns, peeled,
with tails left on
250g plain flour, for
coating prawns

1 In a bowl, mix the flour, water and
egg until a light batter is formed.
2 In a large pot or deep fryer, pour
some oil to a depth of about
10–15cm and heat until a little batter
dropped into the oil crisps up and
floats to the top.
3 Coat prawns in the remaining
flour, then dip into the batter.
Fry in batches of threes, turning
gently, until evenly golden brown.
4 Remove from the oil and drain
on kitchen paper.

139

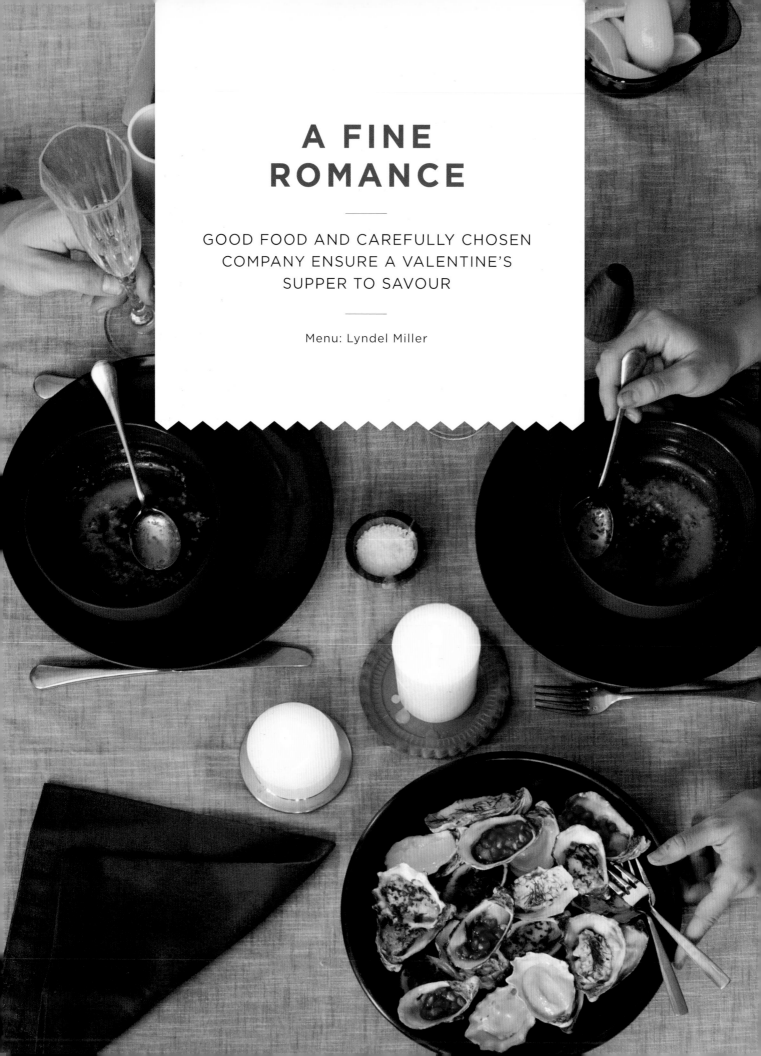

A FINE ROMANCE

———

GOOD FOOD AND CAREFULLY CHOSEN
COMPANY ENSURE A VALENTINE'S
SUPPER TO SAVOUR

———

Menu: Lyndel Miller

MENU
Mushroom soup
*
**Green salad with
maple vinaigrette**
*
Herbed butter oysters
*
Wasabi oysters
*
Dill salsa oysters
*
**Pomegranate
mignonette oysters**
*
Chocolate tart

Being in love doesn't need to be complicated. Sometimes it's as simple as meeting someone for the first time, falling head over heels with them and spending a lifetime together.

Every romance has its own plot twists and near-misses, leading to one serendipitous moment for two people to collide. But Valentine's Day, with all its clamour and high hopes, can threaten the steadiest of hearts. Sometimes the best way to preserve the intimacy is to eschew the over-priced menus and enforced closeness of restaurants in town, and stay in to cook a special meal for two.

Certain foods exude romance – for their rumoured aphrodisiac qualities or seductive earthiness. Mushroom soup is the first thing on the menu, using portobellos or other varieties from your local market. Oysters are an easy choice, prepared four ways and teamed with bubbly for extra decadence. And a chocolate tart with a hint of spice that will linger on the tongue. Divine.

Green salad with maple vinaigrette

TART CAPERS AND
SWEET CHERRIES WILL
ENGAGE ALL YOUR
TASTE BUDS IN THIS
LIVELY GREEN SALAD

Serves 2

500g mixed lettuce leaves,
washed and strained

12 pitted cherries, halved

10-12 caper berries

50ml maple syrup

50ml olive oil

50ml balsamic vinegar

1 Place lettuce mix on salad platter
to serve. Scatter cherries.
2 Combine capers, maple syrup,
olive oil and vinegar in a jar.
3 Shake dressing and pour over
salad just before serving.

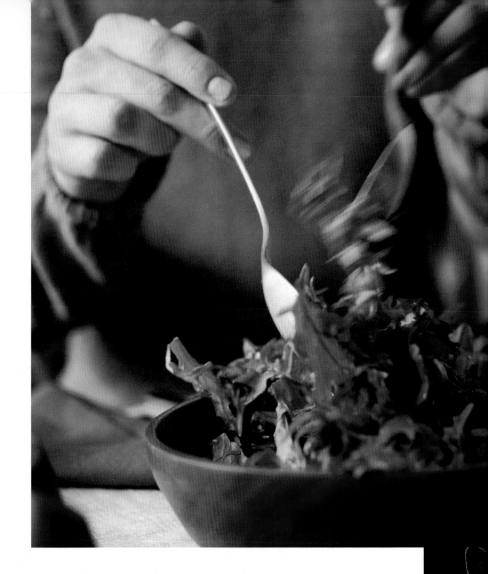

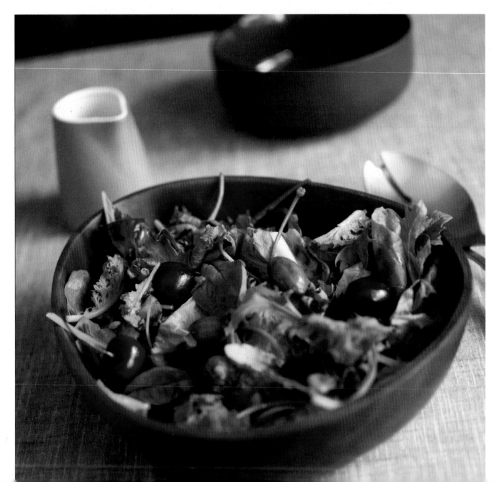

The bite of crisp
greenery adds fresh
textures as well as
tastes to balance out
a sensuous meal.

Choosing the
mushrooms for your
soup is a hands-on
job – opt for ones that
are firm to the touch.

Mushroom soup

MAKE YOUR FAVOURITE
MUSHROOM VARIETY
THE STAR OF THIS
COMFORTING AND
LUSCIOUS SOUP

Serves 2

20ml olive oil

1 large onion, chopped

350g portobello, brown
button or cremini mushrooms,
cleaned and chopped

2 cloves garlic, crushed

Fresh or dried thyme to taste

1 tbsp unsalted butter

Freshly ground black pepper
and salt to taste

600ml basic vegetable stock

80ml single cream

10g fresh dill, chopped

10g parsley, coarsely chopped

1 Place a large frying pan on medium
heat. Add olive oil, chopped onion
and pinch of salt. Sauté for 15 mins
or until the onion is soft.
2 Add mushrooms, garlic, thyme,
butter and black pepper to taste
and cook for a further 5 mins or
until the mix starts to turn a lovely
golden brown.
3 Add stock and simmer, covered,
for 15 mins. Remove from heat.
Puree soup to desired consistency
with cream and serve. Garnish
with fresh herbs.

Herbed butter oysters

FRAGRANT HERBS, A DASH OF PAPRIKA AND SUCCULENT OYSTERS

Serves 2

6 oysters

A handful fresh herb leaves
(such as flat-leaf parsley, chives
and tarragon)

1 garlic clove

50g unsalted butter, at room
temperature

¼ tsp finely grated lemon zest

Paprika to taste

Salt and pepper to taste

Lemon wedges to serve

1 Pulse herbs and garlic in a food
processor until well combined.
Add butter and lemon zest, and process
until smooth. Season with paprika,
salt and pepper to taste.
2 Spoon a tsp of the butter mixture
onto each oyster and grill for 1-2 mins
on a medium grill.
3 Remove from heat and serve with
lemon wedges.

Wasabi oysters

THE TASTE OF SEA SPRAY WITH A HINT OF EXOTIC EASTERN HEAT

Serves 2

6 oysters

1 tsp wasabi paste

4 tbsp of soya or Japanese
mayonnaise

1 tsp of mirin or white wine vinegar

Lemon wedges to serve

1 Combine wasabi paste, mayonnaise
and mirin, and mix to a smooth paste.
2 Spoon mixture on top of each oyster
and place under a grill on medium heat
for 1-2 mins or until lightly golden.
3 Remove from heat and serve with
lemon wedges.

KNOW YOUR OYSTERS

• Always keep oysters
refrigerated.

• Never eat an oyster that won't
open when cooked or close
when tapped. These two tests
are common ones to establish
whether the oyster is still alive
and ready for eating.

• Oysters with a closed shell will
last up to 10 days refrigerated.
Oysters in half shell will last
approximately four days if fresh.

• Oysters are high in mineral
zinc, calcium and vitamin A.

When buying your
oysters from a
fishmonger, ask for
them to be shucked
and cleaned.

BEST OF THE SIMPLE THINGS

Dill salsa oysters

OYSTERS WITH DILL, YOGHURT AND PEARLY SHARDS OF CUCUMBER

Serves 2

6 oysters

50ml distilled vinegar

1 tbsp sugar

2 tbsp finely chopped shallots

2 tbsp finely chopped cucumber

2 tsp sliced chives

2 tbsp chopped dill, plus fronds for garnish

Salt and pepper to taste

5 tbsp Greek yoghurt

1 tbsp lemon zest

Lemon wedges to serve

1 Combine the vinegar and sugar in a small saucepan. Bring to a simmer. Remove from the heat, add the shallots and set to cool.

2 Strain the shallots and mix the syrup with the cucumber, chives, dill and yoghurt. Season to taste with salt and pepper. Spoon the yoghurt onto each oyster.

3 Place the oysters under a grill on medium heat for 1-2 mins.

4 Serve with a garnish of dill fronds, lemon zest and lemon wedges.

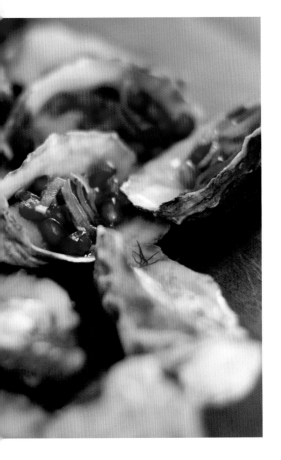

Pomegranate mignonette oysters

A SWEET MOUTHFUL OF ANTIOXIDANT-RICH POMEGRANATE SEEDS

Serves 2

6 oysters

2 tbsp shallot, finely chopped

2 tbsp pomegranate juice

2 tbsp pomegranate seeds

Pinch of salt

Lemon wedges to serve

1 Combine all ingredients and spoon onto oysters.

2 Place oysters under grill for 1 min on a medium heat to warm through.

3 Serve with lemon wedges.

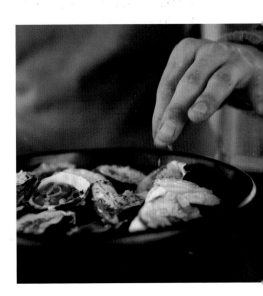

Chocolate tart pastry case

FEW DESSERTS MAKE A DINNER GUEST'S
EYES LIGHT UP LIKE A RICH CHOCOLATE
TART. SERVE IN LAVISH QUANTITIES

Serves 12
200g chilled, unsalted butter,
chopped into small cubes
250g plain flour
20g icing sugar
125g sour cream

1 Place butter, flour and icing sugar
in a food processor and pulse until
the mixture looks like breadcrumbs.
2 Add the sour cream and pulse in
short bursts until the mixture forms
a ball. Take your time so you don't
over-process the dough.
3 Remove the ball of dough from
the food processor and wrap it in
cling film, then place in the fridge
and leave to rest for around 15 mins.

4 Dust your work surface with flour.
Remove dough from fridge and
unwrap. Roll out until it's roughly
3mm thick and place over a 25cm
tart tin with a removable base.
5 Use a fork to prick the pastry all
over. Place the pastry-lined tin in
the fridge and chill for 20 mins.
6 Preheat oven to 200°C/Fan180/
400°F, gas 6. Line the pastry
case with baking paper and rice
or pastry weights.
7 Blind bake for 15 mins, then
remove the baking paper and rice
or weights and bake for a further
5 mins. Allow to cool. The cooked
pastry shell will last 2-3 days in the
fridge before the filling is added.

To make life a little easier, you could buy a ready-made pastry case as the base for your tart. We promise we won't tell...

Chocolate tart filling

CLOVES, CARDAMOM AND CINNAMON MAKE FOR A GROWN-UP TAKE ON A GOOEY, SWEET-TOOTHED PUD

375ml double cream
1 tsp ground cardamom
3 tsp cinnamon powder
3 tsp ground cloves
1 tsp black pepper
150g dark chocolate, chopped
150g milk chocolate, chopped
A few whole cherries with stems for garnish

1 Prepare and bake the pastry case in a 25cm tart tin, as shown on the previous page.
2 Take a small saucepan, add the double cream and spices and place over a medium heat.
3 Bring to the boil and then immediately remove and set aside. Leave for about 30 mins.
4 Place chopped chocolate in a mixing bowl and set aside.
5 Place saucepan back on the heat and bring to the boil. Remove immediately and then pour over the chopped chocolate. Stir until the mixture is lovely and glossy.
6 Pour the chocolate mix into the prepared pastry case. Transfer to the fridge and leave to set for approximately 2 hours.
7 Serve tart at room temperature topped with the whole cherries.

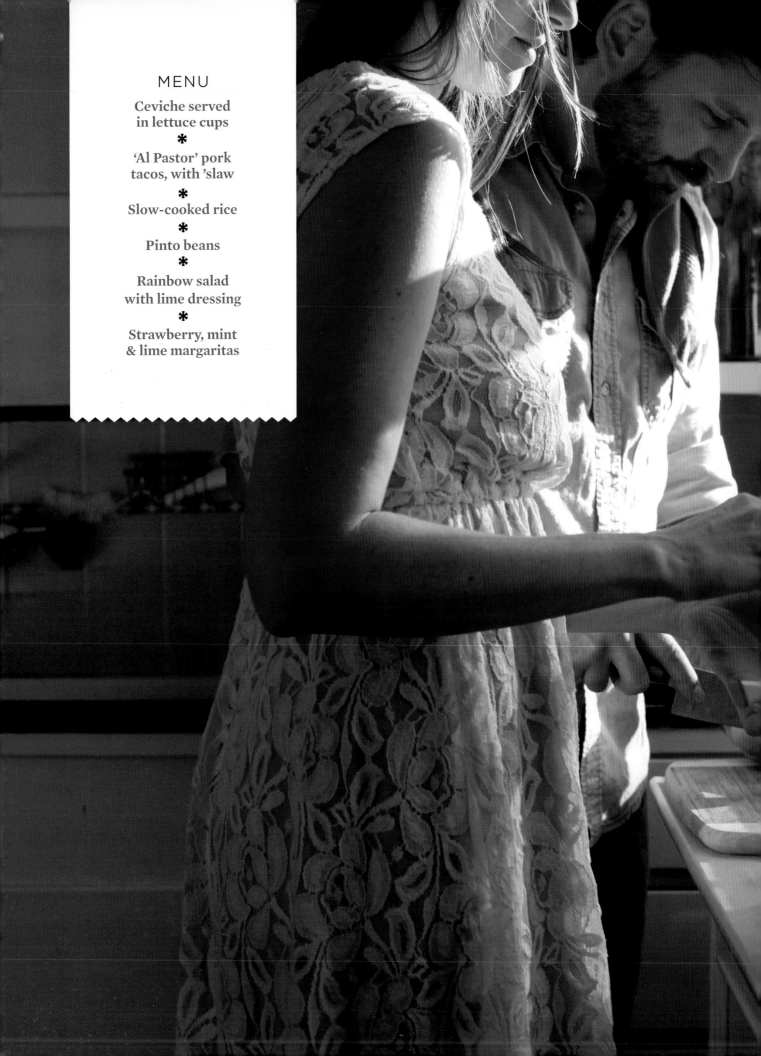

MENU

**Ceviche served
in lettuce cups**

❋

**'Al Pastor' pork
tacos, with 'slaw**

❋

Slow-cooked rice

❋

Pinto beans

❋

**Rainbow salad
with lime dressing**

❋

**Strawberry, mint
& lime margaritas**

BUEN APETITO

GATHER YOUR COMPADRES, ADD A TWIST OF LIME AND DIVE INTO A COLOURFUL MEXICAN BUFFET

Menu: John Lee Simpson

Authentic Mexican food is hard to find in restaurants, even those located relatively close to the source. "A lot of the time it's this watered-down, Americanised version," says California-based chef John Lee Simpson. "So I love making it because I get to give it the flavour and care I think it deserves.

"I suggest making a whole day of it, if you can, and having many helpers. That makes it more fun and less work. Mexican food for me is all about enjoying family and savouring flavours, so relax, take your time and have fun.

"For this evening we gathered at my old friend Thea's house. It's always a pleasure to get together a bunch of friends for a lazy afternoon of cooking and catching up while the kids run around and play. Great food, and a chance to chill with a few margaritas. We had loads of fun."

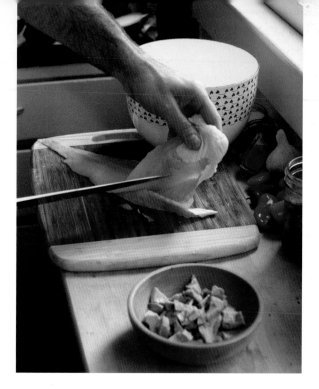

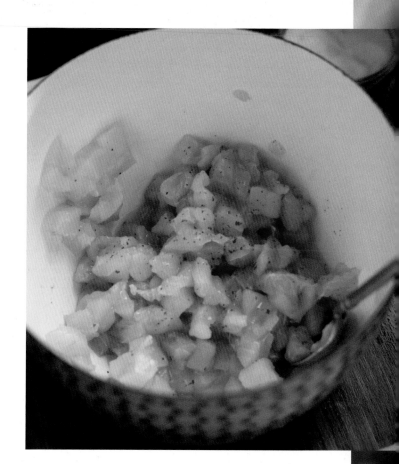

Peruvians claim
to have invented ceviche,
but then so do the
Ecuadorians and
probably the French.
Just about everybody
has a similar dish.

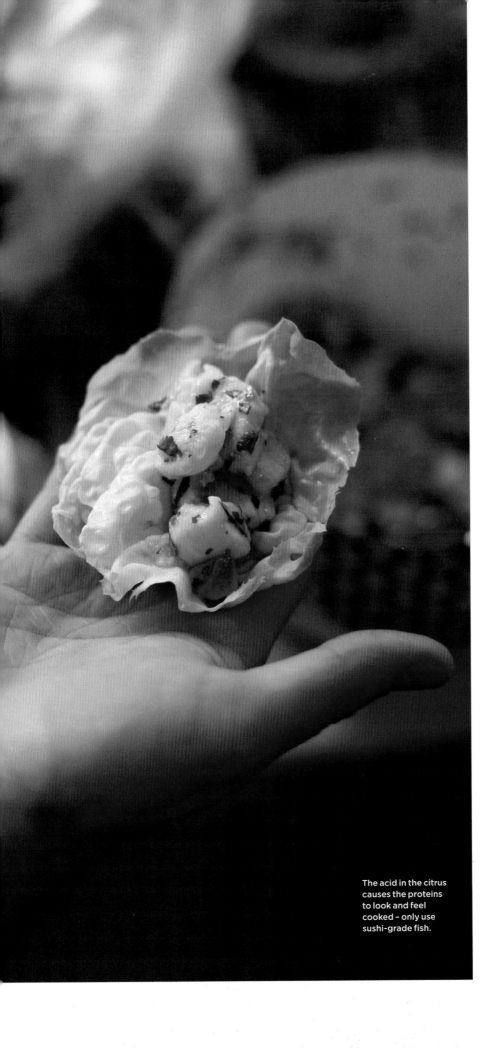

The acid in the citrus causes the proteins to look and feel cooked – only use sushi-grade fish.

Ceviche

TRADITIONALLY MADE WITH COOKED SHRIMP, OUR VERSION USES QUALITY FISH 'COOKED' IN LIME JUICE

Serves 6

900g fresh white fish
(We used sea bass – in season in the UK until April. Or ask your fishmonger to suggest an alternative round white fish)

120ml freshly squeezed lime juice

60ml freshly squeezed lemon juice

60ml freshly squeezed orange juice

1 habenero pepper, seeds removed and minced

Salt and pepper to taste

2 diced ripe avocados

Butterhead lettuce leaves, washed and separated

Coriander leaves for garnish

1 Cut fish into bite-size pieces and place in a bowl.
2 Blend all the other ingredients together then pour onto the fish.
3 Mix thoroughly, cover and place in the fridge to marinate for about 15 minutes.
4 Mix in the avocado.
5 Scoop out and serve on lettuce leaves with a little coriander on top.

Tacos Al Pastor

SALTY, SPICY, CHEWY
PORK PILED HIGH IN WARM
TORTILLAS WITH RICE,
'SLAW AND RADISHES

Serves 6

FOR THE PORK

1.4kg pork roasting joint

⅓ of a pineapple cut in thick slices
or 227g can pineapple slices

3 tbsp freshly squeezed orange juice

3 tbsp tomato paste

4-6 garlic cloves, peeled

1 small onion

30ml fresh oregano or 15ml dried

15ml ground cumin

15ml smoked paprika or chipotle

5ml ground black pepper

5ml ground cinnamon

Corn tortilla wraps to serve

FOR THE 'SLAW

¼ head of red cabbage

4 spring onions

6 radishes*

Mayonnaise, cider vinegar, olive oil,
salt and pepper, coriander

1 Set aside half of the pineapple slices to
grill later.
2 Blend all the other marinade ingredients in
a food processor, or mince and mix them as
best you can.
3 Slice the meat into thick slices. Rub the
marinade all over, cover in a bowl and refrigerate
for at least a few hours, preferably overnight.
4 Ensure the grill is clean and well-oiled, then
heat to medium hot. Dust the pineapple slices
with salt and pepper, then brush with olive oil.
5 Grill the slices on each side until they have
charred grill marks, then set aside. Grill the pork
on a medium heat until it's thoroughly cooked.
6 Chop up and mix the pork and pineapple.
Cover and leave for a few minutes so the
flavours can mingle.
7 Thinly slice the 'slaw ingredients and toss
together with a dollop of mayo, a few dashes
of cider vinegar, 1 tbsp olive oil and coriander,
plus salt and pepper to taste.
8 Serve on the tortillas.

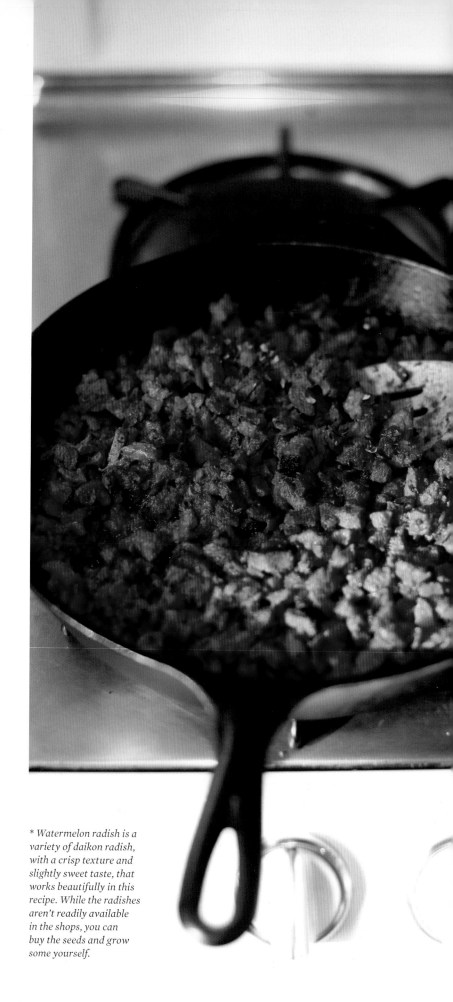

** Watermelon radish is a
variety of daikon radish,
with a crisp texture and
slightly sweet taste, that
works beautifully in this
recipe. While the radishes
aren't readily available
in the shops, you can
buy the seeds and grow
some yourself.*

Slow-cooked rice

RICE COATED IN
BUTTER AND SPICES
THEN SIMMERED FOR
AN HOUR IN CHICKEN
BROTH. DELICIOSO

Serves 6

Brown rice, up to the 240ml
level of a measuring jug

500ml chicken stock

One medium onion, diced

4 garlic cloves, minced

½ tsp salt

½ tsp ground black pepper

1 tsp paprika

1 tsp dried oregano

1 tsp tomato purée

1 Sauté onions in butter in a heavy-
based pan until translucent. Add
garlic and sauté until golden.
2 Add all other ingredients except
stock and stir until rice is coated in
spices and butter. Add stock, bring
to a boil then reduce to as low a
simmer as you can get.
3 Cover and let cook without
disturbing for at least 40 minutes.

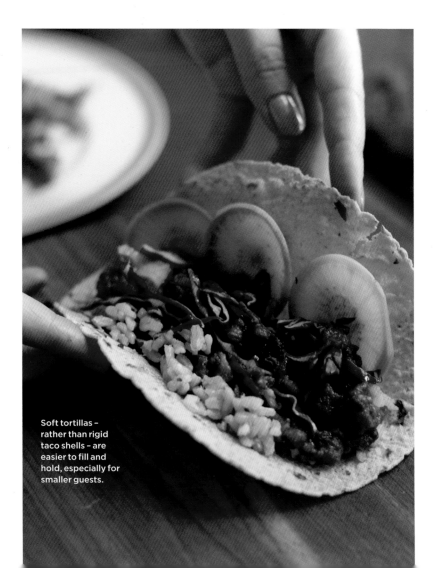

Soft tortillas –
rather than rigid
taco shells – are
easier to fill and
hold, especially for
smaller guests.

Squeeze oranges, and squirts of lemon and lime, into fizzy water and add a little brown sugar for homemade, tangy orangeade.

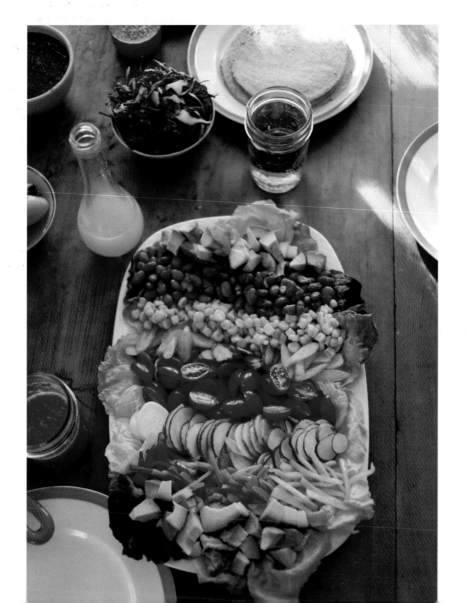

Rainbow salad

A SIMPLE SALAD THAT'S AS NUTRITIOUS AS IT IS PRETTY. DON'T EXPECT IT TO STAY NEAT FOR LONG

Serves 6
FOR THE SALAD
7 or 8 large lettuce leaves
500g cherry tomatoes
500g radishes
500g carrots
500g fresh sweetcorn
500g orange peppers
500g avocado
400g can of black beans

FOR THE DRESSING
5 tbsp olive oil
5 tbsp lime juice
2 tbsp minced shallots
Honey, salt and pepper to taste

Spread the lettuce leaves across a large platter. Slice and shred the other salad ingredients into fun shapes and arrange on top of the lettuce as the muse dictates.

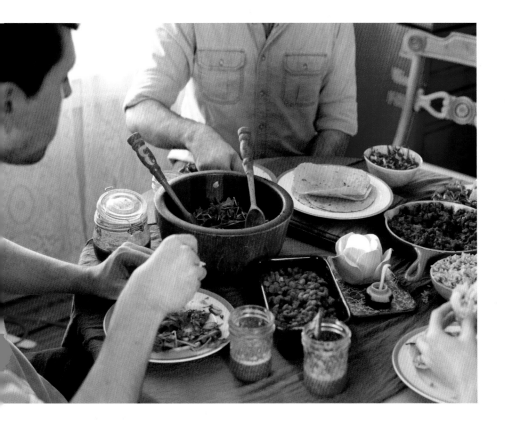

Pinto beans

NO MEXICAN DINNER TABLE IS COMPLETE WITHOUT THIS NATIVE BEAN, COMFORTING AND GENTLY SPICED

Serves 6

450g tinned pinto beans (or 225g dried pinto beans, soaked according to the instructions on the pack)

One small to medium yellow onion, diced

A pinch each of salt, pepper, and chilli powder

1 Sauté onion in a heavy-based pan with a little oil or butter until translucent. Add seasoning and beans and stir.
2 Cover with water until just above the beans.
3 Bring to a simmer, stirring occasionally, for about 3 hours. You may need to add water as you go along. The longer you cook, and the wetter it is, the softer the beans.

'Pinto' means painted and describes the speckled look of this Mexican staple. Use canned to save time.

Strawberry & mint margaritas

A FRUITY FAVE, NICE AS AN APERITIF OR AN ACCOMPANIMENT TO THE MEAL. CHEERS!

Serves 6

300g fresh or frozen strawberries

2 tbsp honey

240ml tequila

Half a bunch of mint leaves

1 Fuse the honey, tequila and strawberries in a blender – add a little ice if using fresh, or a splash of water if using frozen.
2 Garnish with chopped mint and strawberry slices.

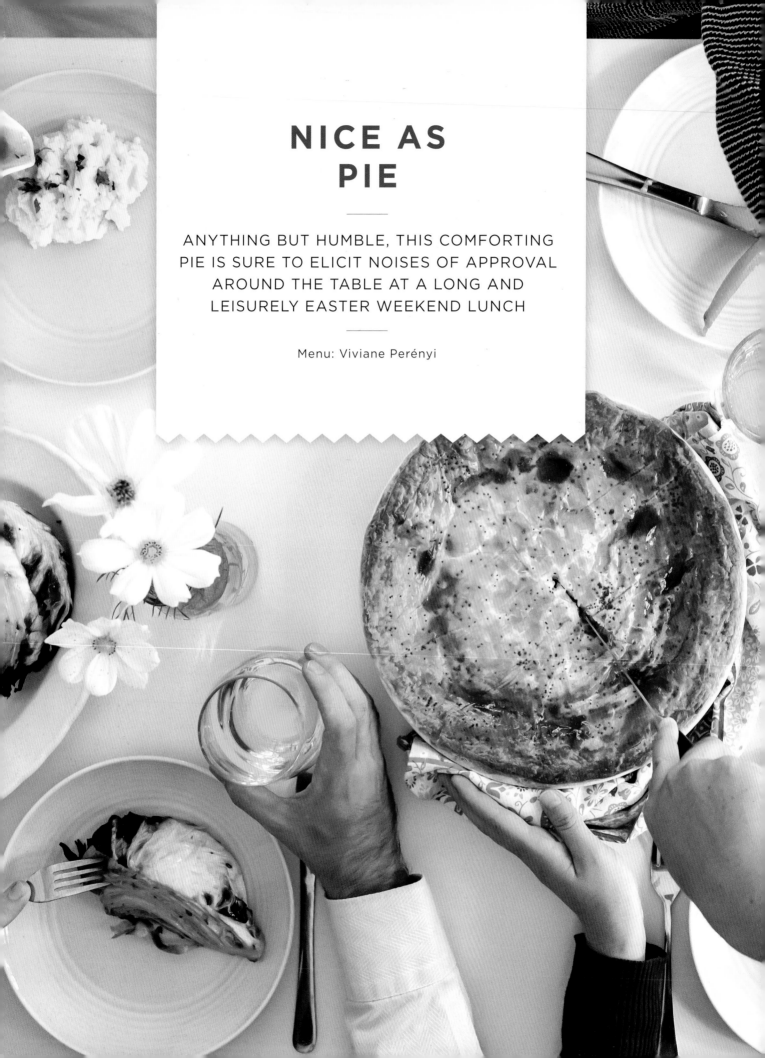

NICE AS PIE

ANYTHING BUT HUMBLE, THIS COMFORTING
PIE IS SURE TO ELICIT NOISES OF APPROVAL
AROUND THE TABLE AT A LONG AND
LEISURELY EASTER WEEKEND LUNCH

Menu: Viviane Perényi

MENU

Chicken and mushroom pie

*

**Honey and thyme
glazed carrots**

*

Roasted cabbage wedges

*

Herbed potato mash

*

**Chocolate mousse with
candied orange peel**

This holiday means blissful time for hanging out with family and friends. Why can't they all be this long? If you're gathering a lunch gang, a pie you can make beforehand is a simple, steaming gift to bring to the table. Fill it with spring chicken (or rabbit for the less squeamish*). Then run it off afterwards with an Easter egg hunt in the garden. There's got to be chocolate for the adults, too – how about a mousse with candied orange peel?

** Poach rabbit pieces in milk on a low heat with the same flavours, but lose the lemon as it would curdle the milk. Remove bones and make sauce from filtered milk.*

It is the law that any pie must be always be served with hearty veg and an over-generous dollop of buttery mash.

Chicken and mushroom pie

A CLASSIC FILLING
FOR A SPRING PIE,
TOPPED WITH
GOLDEN PASTRY

Serves 4–6

2 large chicken breasts
(around 550g), each cut into
4 equal pieces

1 litre vegetable stock

2 fresh thyme sprigs

1 bay leaf

1 lemon slice

1 small garlic clove, smashed

300g small mushrooms (swiss
button or baby portobello),
thickly sliced

Half a small brown onion,
finely sliced

Vegetable oil

200ml milk

200ml vegetable stock

25g butter

25g flour

4-5 thyme sprigs

Salt and pepper

1 sheet puff pastry (to fit your
pie dish)

1 egg, yolk and white separated

1 tbsp milk

½ tsp poppy seeds (optional)

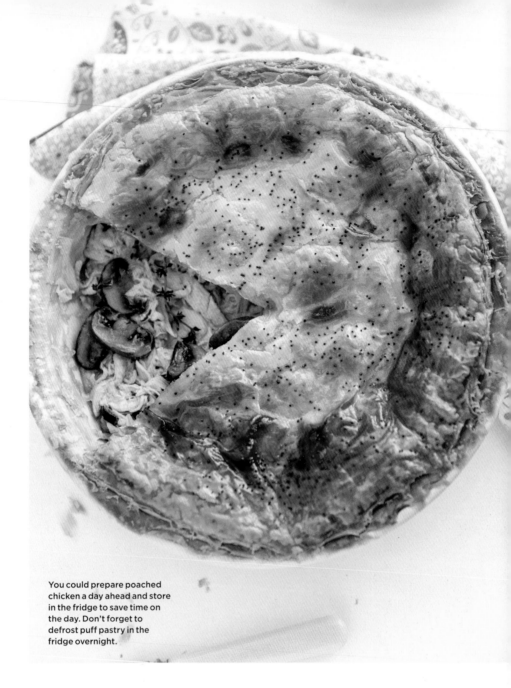

You could prepare poached
chicken a day ahead and store
in the fridge to save time on
the day. Don't forget to
defrost puff pastry in the
fridge overnight.

1 Preheat oven to 200°C/Fan
180/400°F.
2 Pour the stock into a saucepan
and add bay leaf, thyme, garlic
and the lemon slice, and bring to
a boil. Add chicken and, as soon
as it comes back to a boil, lower
the heat, cover and simmer
for 15 mins.
3 Remove from the heat and let it
sit for 5 mins. Shred chicken with
two forks and set aside.
4 Heat 1½ tbsp vegetable oil in
a large non-stick pan and fry

onion until soft and translucent.
Add mushrooms and season
with salt and pepper. Cover and
cook for 3–5 mins or until mush-
rooms have rendered some of
their juice.
5 Add shredded chicken, sprinkle
with thyme and cook for 1–2 mins,
then set aside.
6 Melt butter in a saucepan
over a low heat, then add flour
and mix constantly for a minute
or two. Remove from heat and
pour in stock slowly, whisking
after each addition to obtain a
smooth batter.
7 Add milk and stir. Place

saucepan over a low-medium heat
and stir constantly until sauce
starts to thicken. Pour sauce into
mushroom and chicken pan
and mix. Season to taste.
8 Spoon filling into pie dish. Brush
edges of dish with egg white and
cover with puff pastry, pressing
lightly all around the edge to seal.
Make a small hole in pie centre
with a sharp knife to allow the
steam to escape while baking.
9 Mix 1 tbsp milk with egg yolk and
brush top of pie. Sprinkle poppy
seeds on top and bake for 25–30
mins, or until pastry is puffed and
golden. Serve with chicken gravy.

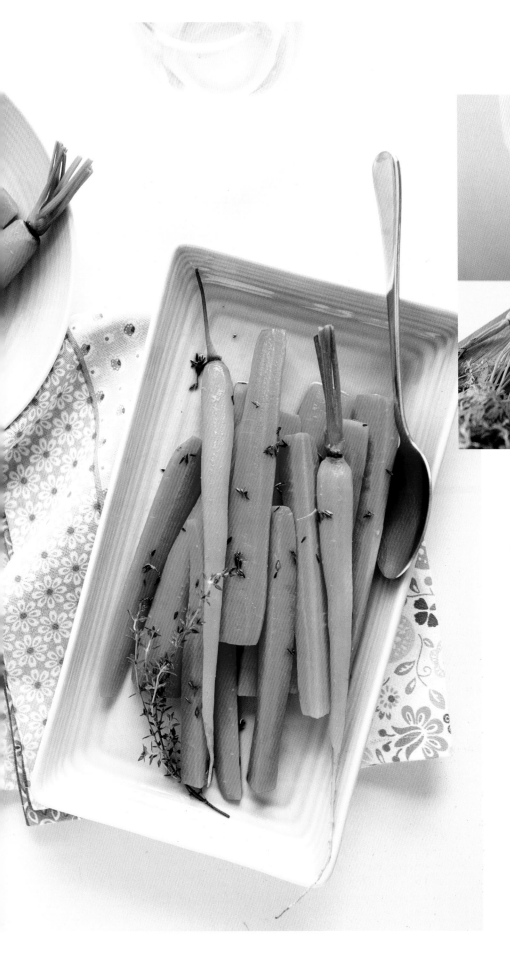

Honey and thyme glazed carrots

WHOLE CARROTS, SIMPLY ENROBED IN STICKY, SWEET HONEY

Serves 4 as a side dish
400g carrots, peeled
20g unsalted butter
4 sprigs thyme, leaves only
1 tbsp liquid honey

1 Place carrots in a large saucepan, fill with water and bring to the boil. Cook for 5–10 mins or until the carrots are just tender.
2 Drain and cool under cold running water.
3 Heat butter in a skillet until completely melted. Stir in honey. Sprinkle with thyme, salt and pepper, then add carrots.
4 Stir to coat carrots evenly and season to taste. Serve warm.

Herbed potato mash

WHAT ELSE TO SERVE
WITH PIE BUT HERBY,
CREAMY MASH?

Serves 4 as a side dish

800g potato

40g butter

80ml warm milk

Salt, pepper

2–3 sprigs chervil

2 sprigs tarragon, leaves only

5 stems chives

1 Peel, wash and cut potatoes
into four equal pieces and place
in a large saucepan with water.
Bring to the boil and cook for
10 mins or until potatoes are soft.
2 Drain, return potatoes to
pan and shake gently. Use
a potato masher or ricer
to mash the potatoes.
3 Add butter and warm milk and
stir until mash is light and fluffy.
Season with salt and pepper.
Finely chop fresh herbs and
sprinkle them on top. Serve warm.

After lunch, retire to the
garden for a rowdy Easter
egg hunt to run off your
meal. Cheating and Easter
egg sabotage are both to
be encouraged.

Roasted cabbage wedges

JAZZED-UP CABBAGE WITH SEEDS, SALT AND A DRIZZLE OF OIL

Serves 4 as a side dish
¼ large cabbage
Olive oil
Fennel seeds
Salt and pepper
Balsamic vinegar

1 Preheat oven to 200°C/Fan180/ 400°F and line a large oven tray with baking paper.
2 Remove outer leaves of cabbage, rinse and cut into 4 equal wedges.
3 Place wedges on the oven tray and brush each one with olive oil, then sprinkle with salt, pepper and fennel seeds. Place a small piece of baking paper on top of each wedge and flip them over. Coat equally with oil and season as before.
4 Bake wedges for 40–45 mins. After 30 mins, remove tray from oven and flip each wedge with the baking paper, then return tray to oven and bake for another 15 mins.
5 Remove from oven and drizzle with balsamic vinegar before serving.

Chocolate mousse with candied orange peel

BECAUSE ADULTS NEED EASTER TREATS, TOO

Makes 4 portions
FOR THE MOUSSE
140g dark chocolate
135ml milk
2 tbsp sugar
200ml whipping cream

FOR THE CANDIED ORANGE PEEL
1 orange
Sugar water
Unsweetened cocoa powder

1 Cut chocolate into chunky pieces and place in a saucepan.
2 Warm milk and pour over chocolate. Let it sit for a minute, then whisk gently until chocolate is fully melted and combined with the milk. Allow to cool completely.
3 Pour cold cream into a medium bowl and sprinkle with sugar. Whip cream to a soft peak with a hand mixer on high. The cream should stay in the bowl when turned upside down.
4 Pour over the cool chocolate sauce and fold into the whipped cream using a spatula. Lift from the bottom, up around the sides and toward the middle, trying to retain as much air as you can. When chocolate is fully incorporated, pour into 4 ramekins and chill in fridge for at least 4 hours.
5 Meanwhile, cut orange into wedges and remove flesh and pith. Place orange peel in a pan, cover with water, bring to a boil and drain. Repeat this step a second time. Drain and finely slice each orange peel.
6 Weigh the peel and pour the same weight of sugar in a saucepan. Add just enough water to cover sugar, then place peel in the pan. Let the syrup simmer over a low heat until all the water has evaporated.
7 Carefully spoon out the candied peel and let it cool on baking paper.
8 Sprinkle the top of each mousse with cocoa powder and garnish with candied orange peel to serve.
9 Put cream in a bowl in the freezer for 5 mins before whipping. The chill makes it whip quicker and hold better.

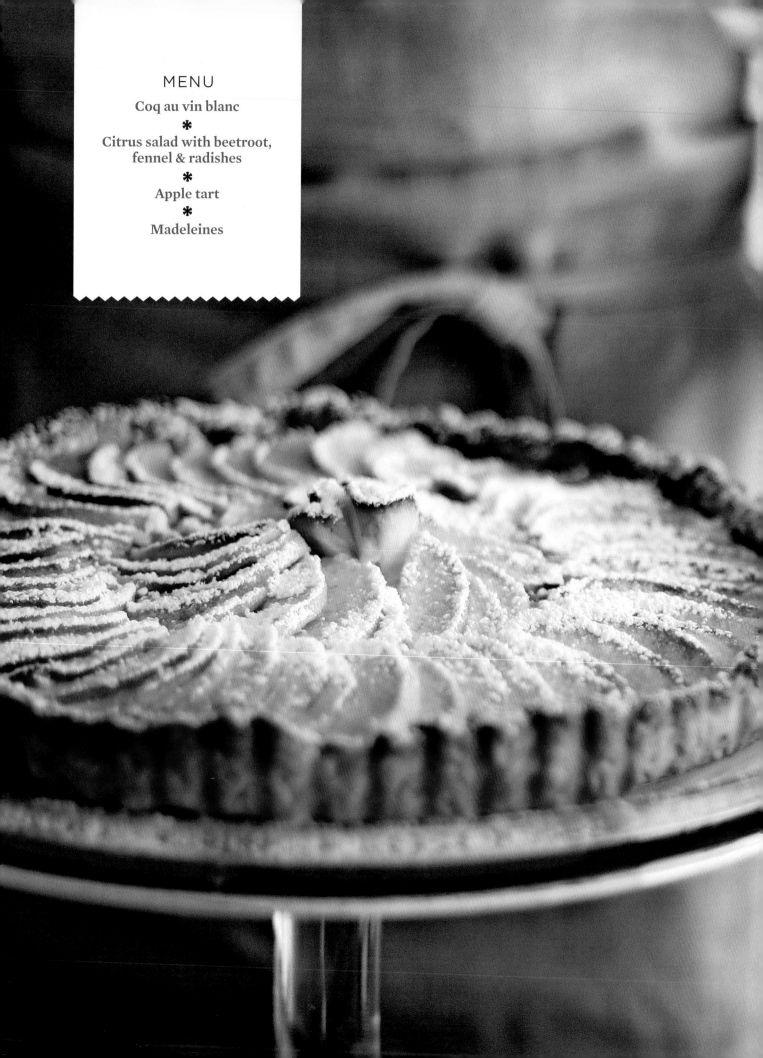

MENU

Coq au vin blanc
*
Citrus salad with beetroot,
fennel & radishes
*
Apple tart
*
Madeleines

LADIES DO LUNCH

MAKE YOUR MOTHER'S DAY (AND EVERYBODY ELSE'S) WITH A DELECTABLE AND FUSS-FREE FAMILY FEAST

Menu: The Cook's Atelier

Do you remember the first time you cooked with your mum (or indeed dad)? Maybe it was that perennial childhood favourite, butterfly cakes – or maybe you were the Sunday sous-chef tasked with crumbling the stock cube or keeping an eye on the spuds. It was a time of discovery, anticipation and a dash of fear – were they really letting you stand so close to a naked flame? And how did you know when water was boiling?

As adults, however, cooking alongside a parent is perhaps a less appealing prospect – at least initially. We have our own kitchens now, with our own wooden spoons in them. We're convinced Jamie's fish pie trumps Delia's and know what harissa is. It's been a long time, for most of us, since mother knew best. But roll back the years, roll up your sleeves, permit gentle ribbing on both sides and cooking together – Mothering Sunday being the ideal occasion – is a rare chance to bring the generations together, exchange ideas and laugh about days gone by. It'll even make light work of the washing up. During which she'll point out that, actually, she bought that wooden spoon you're using back in '72...

Coq au vin blanc

SWITCH RED WINE
FOR WHITE IN A LIGHT
TWIST ON THE ONE-
POT FRENCH CLASSIC.
SMASH THAT GARLIC!

Serves 6

1 tbsp extra-virgin olive oil

170g thick-cut bacon slices, cut
into lardons (rectangles 0.5cm
across and 2.5cm long)

2 chicken drumsticks, 2 thighs,
2 wings with top quarter of
adjoining breast, 2 breasts

2 cloves garlic, smashed

1 medium onion, chopped

6 carrots, peeled and sliced

500ml dry white wine

1 bouquet garni (4 sprigs thyme,
a small bunch of parsley and
1 bay leaf)

500ml chicken stock, preferably
homemade

Chopped fresh flat-leaf parsley

FOR THE MUSHROOMS

2 tbsp butter

2 tbsp extra-virgin olive oil

450g assorted fresh wild
mushrooms

1 Heat oil in a large heavy pot (wide enough to hold the chicken in a single layer) over medium-high heat. Add the bacon and sauté until crisp. Using a slotted spoon, transfer the bacon to a small bowl. Pat the chicken dry and season with salt and pepper. Sauté, skin side down, in 2 batches until golden (do not turn), about 10 mins. Transfer to a plate.
2 Pour off all but 2 tbsp of fat from the pot. Cook the garlic, onion and carrots over medium heat, stirring frequently, until golden and just beginning to soften, about 5 mins.
3 Add the wine and boil, uncovered, until reduced by about half, 3 to 5 mins. Return the chicken to the pot, skin side up, add the bacon and the bouquet garni. Cover with stock and simmer, partially covered, until cooked through, 20 to 25 mins.
4 While the chicken is cooking, prepare the mushrooms. Place a skillet over high heat with the butter and olive oil. As soon as the butter foam has begun to subside, which indicates it's hot enough, add the mushrooms. Toss and shake the pan for 4 to 5 mins until lightly browned.
5 Add the mushrooms to the pot and bring to a simmer, basting the chicken with the sauce. Cover and simmer slowly for 4 to 5 mins to incorporate the flavours. Adjust the seasoning and sprinkle with chopped parsley.

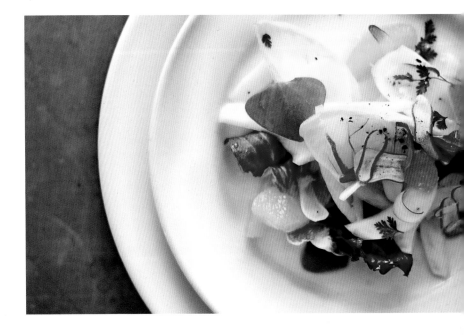

Citrus salad with beetroots, fennel & garden radishes

SALAD AS IT SHOULD BE: AN EXPLOSION OF COLOUR, CRUNCH AND ALL-ROUND GOODNESS

Serves 4 to 6

1 medium red beetroot, top trimmed

1 medium golden beetroot, top trimmed

2 blood oranges, supremed

1 medium navel orange, supremed

1 fennel bulb, sliced very thin

1/2 bunch of radishes, sliced very thin

1 small shallot, sliced very thin

A handful of watercress leaves

Extra-virgin olive oil (for drizzling)

Sea salt and freshly ground black pepper

A small handful of fresh chervil leaves

1 Preheat the oven to 200°C/Fan180/400°F, gas 6. Wash the beetroots. Wrap individually in foil, place on a rimmed baking sheet and roast until they're tender when pierced with a paring knife, about 1 hour. Allow to cool.
2 Supreme the oranges. Using a sharp knife, cut the stem and blossom ends from the blood and navel oranges. Place the oranges cut side down. Following the contour of the fruit, working from top to bottom with your knife, remove the peel and white pith. Over a bowl, cut along each side of the membrane to separate the segments.
3 Quarter the fennel bulbs lengthwise. Using a mandoline or sharp knife, cut lengthwise into thin slices. Set aside. Using a mandoline or sharp knife, slice the radishes into thin slices.
4 Slice the beetroots crosswise into thin rounds. Arrange the sliced beetroots in the centre of the plate. Toss the fennel, radishes, sliced shallot and watercress in a bowl with a couple of tbsp of the orange juice. Season with salt and pepper.
5 Arrange the fennel and radishes over the beetroots and place the blood orange and navel orange segments in and around the salad. Garnish with chervil leaves and a drizzle of olive oil.

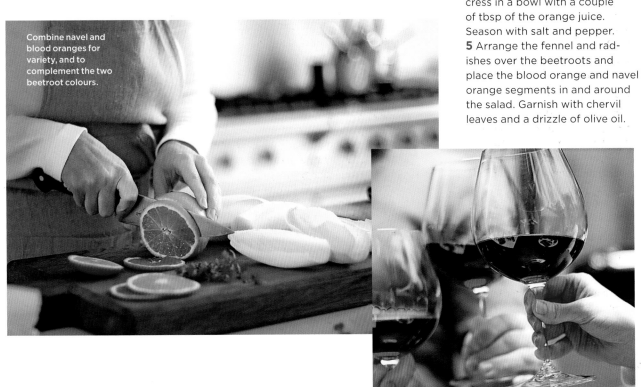

Combine navel and blood oranges for variety, and to complement the two beetroot colours.

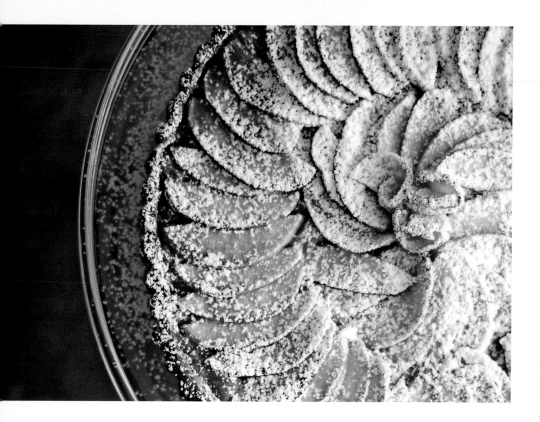

Apple tart

DELIVER A DOUBLE
DOSE OF GOLDEN
DELICIOUS IN
THIS TIMELESS
CROWD-PLEASER

Serves 6 to 8

1 recipe pâte sucrée (opposite)

3 Golden Delicious apples,
peeled, cored and sliced into
even 1cm-thick slices

2 tbsp unsalted butter

2 tbsp sugar

FOR THE APPLE PURÉE

3 Golden Delicious apples, peeled,
cored and diced

1 vanilla bean pod, split lengthwise

2 tbsp sugar

2 tbsp butter

1 Preheat the oven to 190°C/Fan170/
375°F, gas 5. Line the tart pan with
the pâte sucrée. Prick the bottom with
a fork and line the shell with parch-
ment. Fill the lined tart with dried
beans or pie weights and bake for
15 mins until the edges are set and

lightly browned. Take the tart out of
the oven and carefully remove the
parchment paper and dried beans.
2 To make the apple purée, put the
diced apples, vanilla bean pod, sugar
and butter in a saucepan with 3 to 4
tbsp of water. Cook gently, stirring often
until soft, adding more water if neces-
sary, for about 10 to 15 mins. Use the
tip of a knife to scrape the seeds out
of the vanilla bean, then discard the
pod. Transfer the mixture to a food
mill or mash with a fork until smooth.
3 Heat the butter in a sauté pan and
then gently sauté the apple slices to
coat them in the butter until they're
just softened.
4 Spread the purée evenly in the par-
tially baked tart shell. Carefully arrange
the apple slices in a neat circle around
the edge. They should be tightly over-
lapping but not squished together.
Depending on the size of your tart pan
and the apples, you can repeat to create
an inner circle or just fill in the centre in
a decorative pattern. Sprinkle over
a tablespoon or two of sugar.
5 Bake in the preheated oven until
just browned and tender, about
25 to 30 mins. Serve the tart warm
or at room temperature with a dollop
of crème fraîche or Calvados-spiked
whipped cream.

Pâte sucrée

DOUBLE CREAM LENDS
A LITTLE LUXURY TO
THIS RICH, SWEET AND
BISCUITY PASTRY BASE

Makes enough for 2 tarts

60ml double cream

2 large egg yolks

325g plain flour

60g granulated sugar

A pinch of sea salt

230g unsalted butter,
cut into pieces

1 Whisk the cream and the
eggs together in a small bowl
and set aside. In a large bowl,
combine the flour, sugar, salt
and butter. Using your fingers,
incorporate the butter until
you have a coarse meal.
2 Gradually add the cream and
yolks, and mix until just com-
bined. Be careful not to overwork
the dough. Bring the dough
together with your hands to
incorporate completely. Divide
the dough in half, shape into
disks, and wrap one of them
to freeze and use later.
3 If the dough is soft, put it
into the fridge for a few minutes
prior to rolling. Place it on a
lightly floured work surface,
and sprinkle with a little flour.
Roll it into a 1/2cm-thick circle,
flouring as needed.
4 Starting at one side, roll and
wrap the dough around the
rolling pin to pick it up. Unroll
the dough over the 23cm tart
pan. Gently press the dough into
the pan, being careful not to
stretch it as this will cause it
to shrink when baking.
5 To remove the excess dough,
work your way around the edge
pinching off the excess dough
with your fingers. Chill for
1 hour before baking.

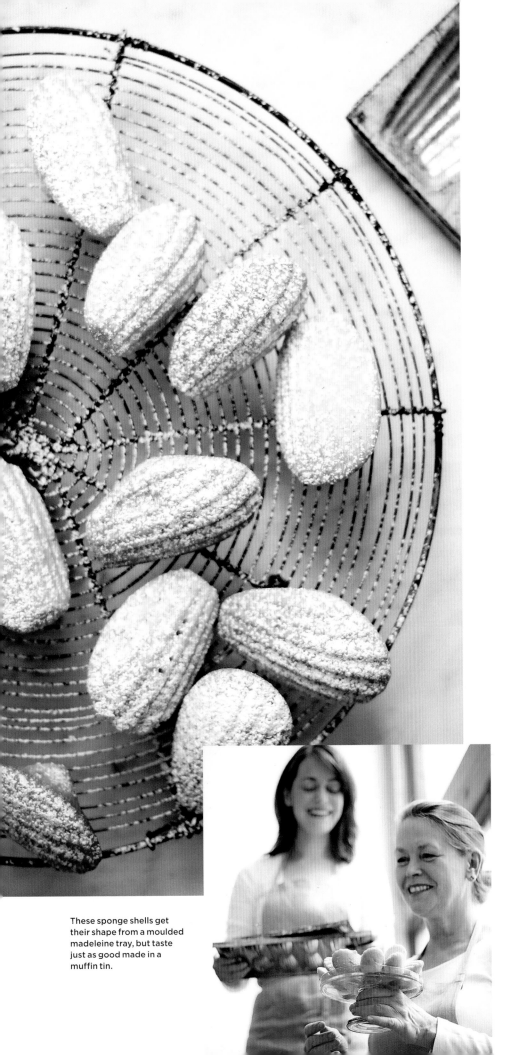

These sponge shells get their shape from a moulded madeleine tray, but taste just as good made in a muffin tin.

Madeleines

FEW CAKES SAY FAMILY AND MEMORY AS STRONGLY AS THESE LITTLE BAKED BEAUTIES

Makes about 24
130g unsalted butter
3 eggs, at room temperature
1 egg yolk
120g granulated sugar
Pinch of sea salt
175g flour, plus extra for dusting
1 tsp baking powder
Zest of 2 medium oranges

1 Melt the butter in a small saucepan on medium heat until it just starts to turn golden brown. Be careful not to overheat. Set aside to cool.
2 Using a pastry brush, generously grease the madeleine tin with a little of the melted butter. Dust with flour and place the tins in the fridge to set.
3 With a stand mixer, whisk the eggs, egg yolk, sugar and salt until the batter starts to thicken, about 5 mins.
4 Sift the flour and baking powder and use a spatula to fold the flour into the batter mixture. Add the orange zest to the cooled butter, then slowly drizzle the butter into the batter until you've incorporated all of the butter in the mixture.
5 Cover the bowl and place in the refrigerator for at least 1½ hours.
6 Preheat the oven to 220°C/Fan200/425°F, gas 7. Drop the batter in the middle of each mould until about three-quarters full without spreading it. Bake for 8 to 9 mins in the upper third of your oven until slightly brown and set to the touch.

A LONG WEEKEND

—

SPRING HOLIDAYS CALL FOR GOOD
FRIENDS, OPEN DOORS AND CASUAL
COOKING. GARDEN GAMES OPTIONAL,
BUT HIGHLY RECOMMENDED

—

Menu: Awen McBride

MENU

Panzanella

✱

Falafel with flatbreads

✱

**Hummus, Tahini
sauce and Harissa**

✱

Piquant vegetable salad

✱

**French lemon tart
with berry coulis**

✱

Mojitos

Long, light days full of the promise of spring holiday weekends that top and tail the month – isn't May just the best? This is no time for slaving over the stove, though. What you need is food that's high in flavour and low on fuss to allow maximum time for chatting and quaffing. Fresh and colourful dishes with a Mediterranean influence will keep any post-lunch slump at bay, should the afternoon call for an impromptu game of ping-pong or boules. Opt for an informal table with terracotta plant pots holding the cutlery and fresh herbs replacing flowers. Vintage crockery finishes the rustic, playful feel, while a freshly mixed mojito delivers a touch of holiday decadence. Holiday weekends – we'll drink to that.

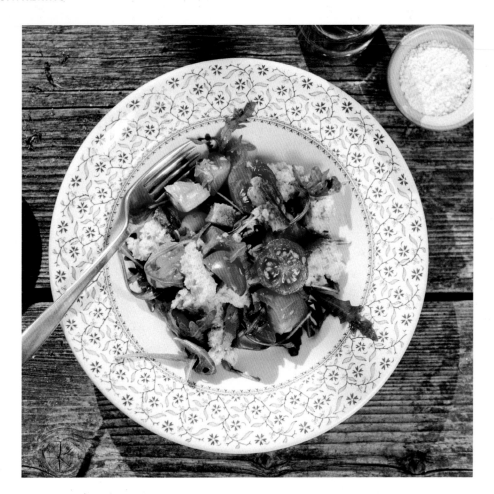

Panzanella is great for using up stale bread and ripe tomatoes.

Panzanella

AROMATIC AND PRETTY,
THE BREAD SOAKS UP
THE FLAVOURS IN THIS
CLASSIC ITALIAN DISH

Serves 4

500g mixed tomatoes

A large pinch of salt

200g stale sourdough bread

A handful of wild garlic

A handful of rocket

2 tbsp olive oil

2 tbsp balsamic vinegar

Chop the tomatoes and season
with salt. Tear bread into bite-sized
pieces. Just before serving, stir
all the ingredients together.

Falafel

THESE UNEXPECTEDLY MOIST, SAVOURY BITES TASTE WONDERFUL ACCOMPANIED BY FRESH FLATBREADS

Serves 4

400g dried chickpeas, soaked over night in water

2 tsp ground cumin

3 cloves garlic, peeled

Herbs such as parsley, chives or thyme, roughly chopped

Salt and black pepper

Splash of olive oil

200g dried breadcrumbs

1 Blitz all the ingredients together, except the breadcrumbs.
2 Roll the mixture into balls or patties – these are your falafels. Roll the falafels in the breadcrumbs.
3 Shallow-fry the falafels in a frying pan until golden brown.

Flatbreads

100g strong bread flour

2 eggs

300ml milk

2 tsp agave syrup

6 stalks of wild garlic, finely chopped (chives if out of season)

Pinch of salt

1 tbsp olive oil, for frying

Mix all ingredients together, then cook in a frying pan, as you would when making pancakes. Eat warm.

With its mix of spicy and earthy flavours, falafel provides a meat-free feast to satisfy even the most devout carnivore.

Sauces and relishes

FEW THINGS SAY LAID-BACK SUMMER DINING MORE THAN AN ARRAY OF DIPS FOR DUNKING FOOD INTO

Harissa
Serves 4 (with plenty left over)

2 tsp cumin seeds

2 tsp coriander seeds

1 red onion, peeled and quartered

4 chillies, tops sliced off

250g tomatoes, quartered

3 red peppers, deseeded and roughly chopped

4 cloves garlic, peeled

1 tsp black onion seeds

Salt to taste

Olive oil to drizzle

1 Grind the cumin and coriander seeds in a pestle and mortar.
2 Place all the vegetables in a roasting tray, sprinkle with the ground spices, garlic, onion seeds, salt and olive oil. Toss together well.
3 Roast in oven for about 40 mins at 200°C/Fan180/400°F, gas 6. Allow to cool a little, then blitz ingredients together in a blender. Season to taste with a pinch or two of salt.

Hummus
Serves 4

200g chickpeas

3 cloves garlic

Juice of 1 grapefruit

4 tbsp olive oil

3 tbsp tahini sauce (see below)

Salt to taste

Blitz all the ingredients together in a blender until smooth. Season with salt to taste.

Tahini sauce
Serves 4 (with plenty left over)

1 small jar of tahini

1 lemon, juiced

Salt to taste

3 tbsp olive oil

Blitz all the ingredients together in a blender. If the sauce starts to thicken, loosen it with a little water.

Harissa (above) is a fiery North African sauce – you can reduce the heat by deseeding the chillies before adding them.

Piquant vegetable salad

A SHREDDED VEGGIE
SALAD ADDS A POP
OF FLAVOUR AND A
BURST OF COLOUR

Serves 4 as a side salad
Half a cauliflower, finely sliced
2 carrots, peeled and grated
1 beetroot, peeled and grated

FOR THE DRESSING
1 tbsp balsamic vinegar
2 tbsp olive oil
Salt and black pepper to taste
1 tsp agave syrup

Combine all ingredients in a bowl.
Add the dressing before serving.

You'll love the buttery, light shortcrust pastry. Serve the tart with plenty of crème fraîche to complement the berry coulis.

French lemon tart

THE MIXED BERRY COULIS DELIVERS AN EXTRA FRUITY KICK TO THIS DELICIOUS LEMON TART

Serves 8

FOR THE PASTRY

225g plain flour

25g icing sugar

3 tbsp ice-cold water

150g butter

A pinch of salt

1 Sift the flour and icing sugar. Blitz pastry ingredients in a blender. Chill in the fridge for 30 mins.
2 Grease a 20cm flan dish. Roll out the pastry, then bake blind in a moderate oven for about 10 minutes.

FOR THE FILLING

4 eggs, beaten and sieved

150g caster sugar

275ml double cream

3 lemons, zest and juice

1 Beat the eggs and sugar together, then beat in the cream, then add the lemon juice and zest.
2 Pour the mixture into the baked tart case; bake at 170°C/Fan150/325°F, gas 3 for 30-40 mins. Chill.

BERRY COULIS

2 handfuls of mixed berries such as redcurrants, blackcurrants, raspberries and strawberries

1 tbsp agave syrup

Warm the berries in a pan until they start to mush slightly. Add the agave syrup and a touch of water. Chill.

Hailing from the island of Cuba, the mojito has gained popularity worldwide, and who are we to argue?

Mojito

AS THE HAZY EVENING LIGHT IMBUES THE SKY, BRING OUT THE FINISHING TOUCH TO A TERRIFIC AFTERNOON

Serves 1

3 limes, juiced

2 sprigs of mint

50ml white rum (optional)

2 tsp agave syrup (optional)

Soda water, enough to top up the glass

Ice to serve

Mix the lime, mint, rum and syrup together, top up with soda water to taste, stir well and serve with ice.

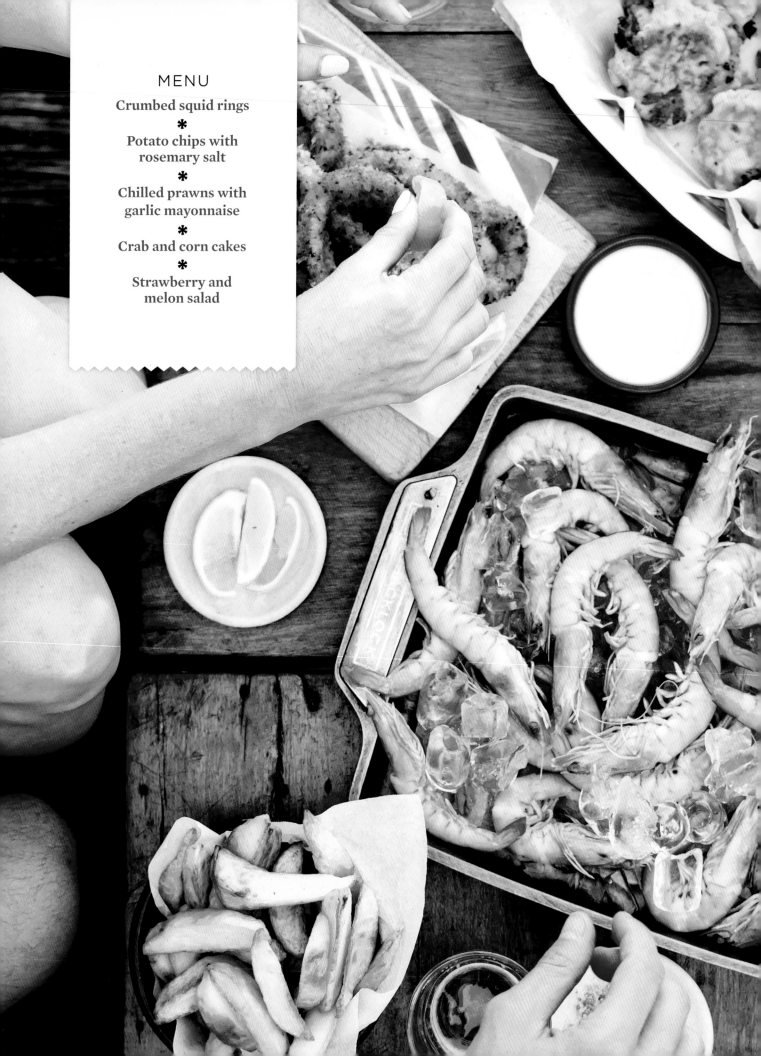

MENU

Crumbed squid rings

✳

Potato chips with
rosemary salt

✳

Chilled prawns with
garlic mayonnaise

✳

Crab and corn cakes

✳

Strawberry and
melon salad

SURF & MIRTH

WHERE BETTER TO ENJOY FOOD
FROM THE SEA THAN BESIDE THE SEA?
WHETHER IT'S A DAY TRIP TO THE
COAST OR A BEACH BARBECUE,
CHILL THE BEERS, CHUCK OUT THE
CUTLERY AND TUCK IN

Menu: Viviane Perényi

Eating in the fresh sea air from a newspaper wrapper is fish and chips at its best. So, too, with any kind of seafood – savouring it on the coast will elevate it to a feast to remember. OK, so your prawns and squid may not hail from the English Channel, but trust us, this finger-lickin' fare is extra special when devoured to a soundtrack of breaking waves, the (hopefully) far-off caw of gulls, and the occasional crunch of an escapee grain of sand. Sign up family and friends and bag your spot on the shoreline.

It'll be a casual, jolly affair. Squid rings, whole prawns, crab cakes – even a jewel-pretty fruit salad – all call for digging in with your hands, a napkin or two, and not so much as a fork. Add a bucket of ice-cold beers and let the fun begin.

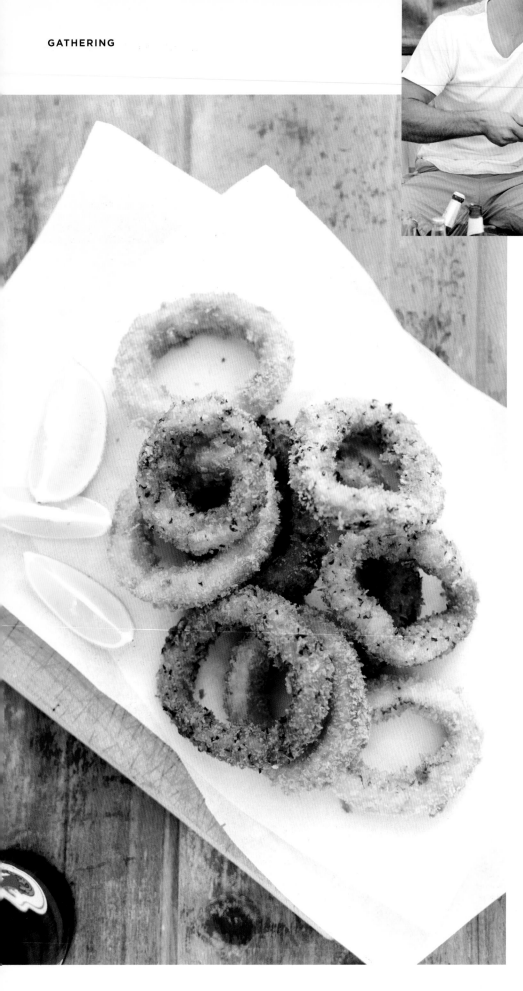

Crumbed squid rings

HOMEMADE CALAMARI:
SQUIRT WITH LEMON,
DUNK IN TARTARE
SAUCE, SCOFF...

Makes 20–22

70g plain flour

100g panko* breadcrumbs

Chopped leaves of 1 small bunch
flat-leaf parsley

1 extra-large egg

2 large squid, cleaned and sliced in
½–1 cm thick rings

Approx 350ml vegetable oil

Lemon wedges, to serve

1 Place flour on a shallow plate.
On another, mix panko and finely
chopped parsley. In a small bowl,
lightly beat the egg and season
with salt and pepper.
2 For each squid ring: coat with
flour, shaking off excess; dip floured
ring into egg and drain well before
coating evenly with parsley panko.
3 Pour oil into a cast-iron or heavy
bottomed saucepan, so that it is
at least 2cm deep (you may need
more than 350ml, depending on
pan size). Heat on a medium-high
heat and test oil temperature by
sprinkling a pinch of panko into oil.
When there's an instant sizzle,
you're ready.
4 Fry squid rings for a minute
on each side or until nicely golden.
Drain well and place on paper
towel. Serve with freshly cut
lemon wedges.

** Find panko breadcrumbs – they're
crunchy and Japanese – in the speciality
foods section at the supermarket.*

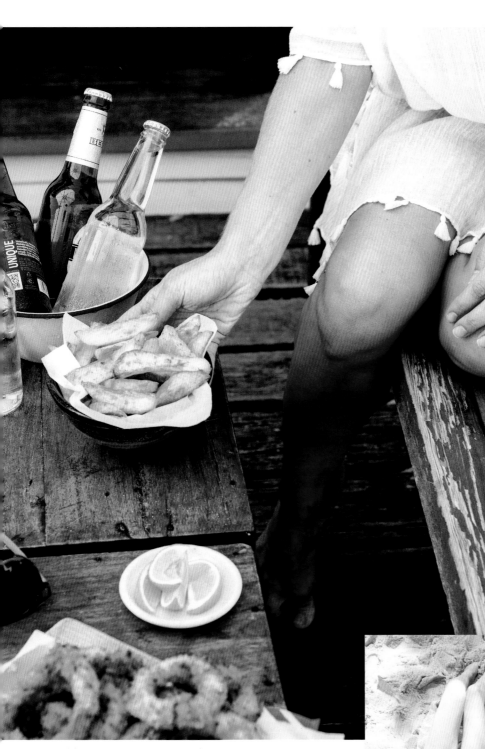

Chips with rosemary salt

COOK AHEAD, THEN REHEAT OVER A BEACHSIDE BARBECUE

Serves 4 as a side dish
2 tsp sea salt
½ sprig rosemary leaves
1kg floury potatoes
2 tbsp vegetable oil

1 With a pestle and mortar, pound together salt and rosemary to a fine powder. Preheat oven to 200°C/Fan 180/400°F.
2 Wash and peel potatoes. Cut them into equal-size wedges, place in a pan and cover with water. Bring to a boil and parboil for 5 mins.
3 Drain and place spuds in a large bowl. Sprinkle a tsp of rosemary salt and add oil. Gently shake the bowl for an even coating.
4 Line a baking tray with baking parchment and arrange potato wedges on top. Bake in the oven for 20–30 mins or until nicely golden. Serve with the remaining rosemary salt.

Even the chips get a seaside upgrade, with chunky hand-cut wedges seasoned with aromatic rosemary salt.

179

Chilled prawns with garlic mayonnaise

THE FINEST OF FINGER
FOODS, ESPECIALLY
DIPPED IN AÏOLI

Makes 20

20 large whole prawns
1 fresh egg yolk at room temperature
1 tsp Dijon mustard
100ml vegetable oil
1 tsp vinegar
1 large garlic clove, peeled
and mashed

1 Rinse prawns and place half of
them into a steamer over a pan of
boiling water. Steam, covered, for
3–4 mins or until prawns turn
pink and opaque and curl.
2 Prepare a large bowl filled with icy
water. Remove prawns from heat and
pour them into the icy water to stop
cooking. Steam the second batch of
prawns in the same way.
3 To make the garlic mayo: in a bowl,
mix together egg yolk and mustard.
Measure oil into a jug. With an electric
hand mixer, whisk egg yolk and, very
slowly, pour a trickle of oil into the
egg as you whisk. Whisk until all the
oil is used and the mayonnaise firm.
4 Mix in vinegar and season with salt.
Add garlic and stir. Serve with the
iced prawns and a bowl for discarded
prawn shells and heads.

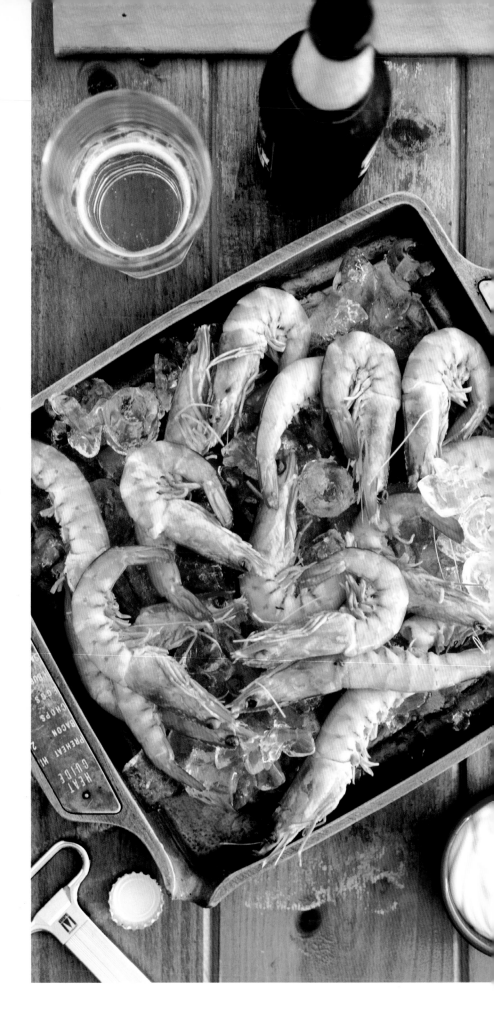

Crab and corn cakes

THE FRESHER THE
BATTER THE BETTER
WITH THESE FLAVOUR-
PACKED FRITTERS

Makes 10

90g plain flour

240g sweetcorn

170g cooked crab meat
(fresh*), drained

Handful fresh coriander
leaves, chopped

2 eggs

Vegetable oil

FOR THE SAUCE

1 tbsp olive oil

Juice of ¼ lime

1 red chilli, finely sliced

1 In a large bowl combine flour, sweet-
corn, crab meat and chopped cori-
ander leaves. Add eggs and stir well to
combine. Season with salt and pepper.
2 Heat a tbsp of vegetable oil in a
frying pan on a medium-high heat.
When the oil is hot, ladle 3–4 tbsp
batter into the pan for each cake.
Fry on each side for 1–2 mins or until
golden. Remove from the pan and
drain on paper towel. (You may need
to add more oil/repeat this stage,
depending on size of pan.)
3 In a small bowl, mix together oil,
lime juice, a pinch of salt and the
chilli and serve with still-warm cakes.

** Buy prepared fresh crabmeat (not
a shell in sight) from the fishmonger
or fish counter. You can use tinned
instead, but it has less flavour.*

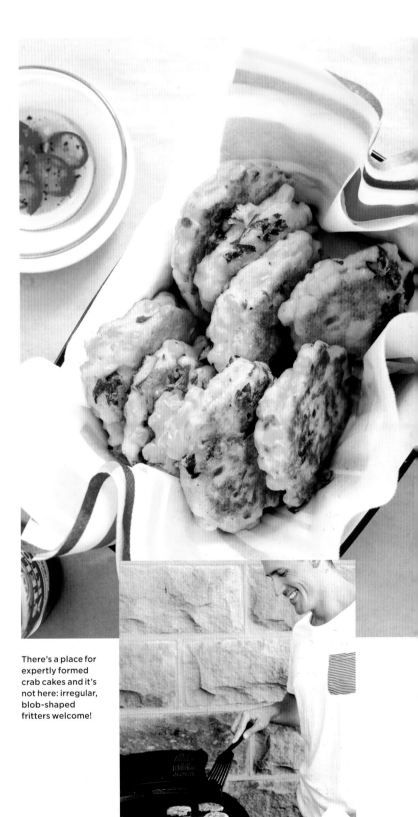

There's a place for
expertly formed
crab cakes and it's
not here: irregular,
blob-shaped
fritters welcome!

Strawberry and melon salad

IT'S THE PERKY
PRESENTATION
THAT MAKES THIS
COLOURFUL COMBO
FIT FOR A PARTY

Serves 4

1 large cantaloupe melon

250g strawberries, washed
and hulled

2 tbsp runny honey

Juice of 1 lime

Handful fresh mint leaves

1 Cut melon in half. With a
spoon, remove seeds and use a
melon baller to carve spheres/
curls of flesh. Scoop out
remaining flesh with a spoon so
you're left with even, hollow
melon halves. Set aside.
2 Cut strawberries lengthways
into wedges and add to melon
balls. Mix together honey and
lime juice. Pour over fruit
salad and stir to coat evenly.
3 Place dressed salad into
reserved melon halves or bowls
and top with mint leaves.

Leave out of the fridge before serving to
allow flavours to develop. Mix different
types of melon for a colourful salad (say,
cantaloupe, honeydew, water melon).

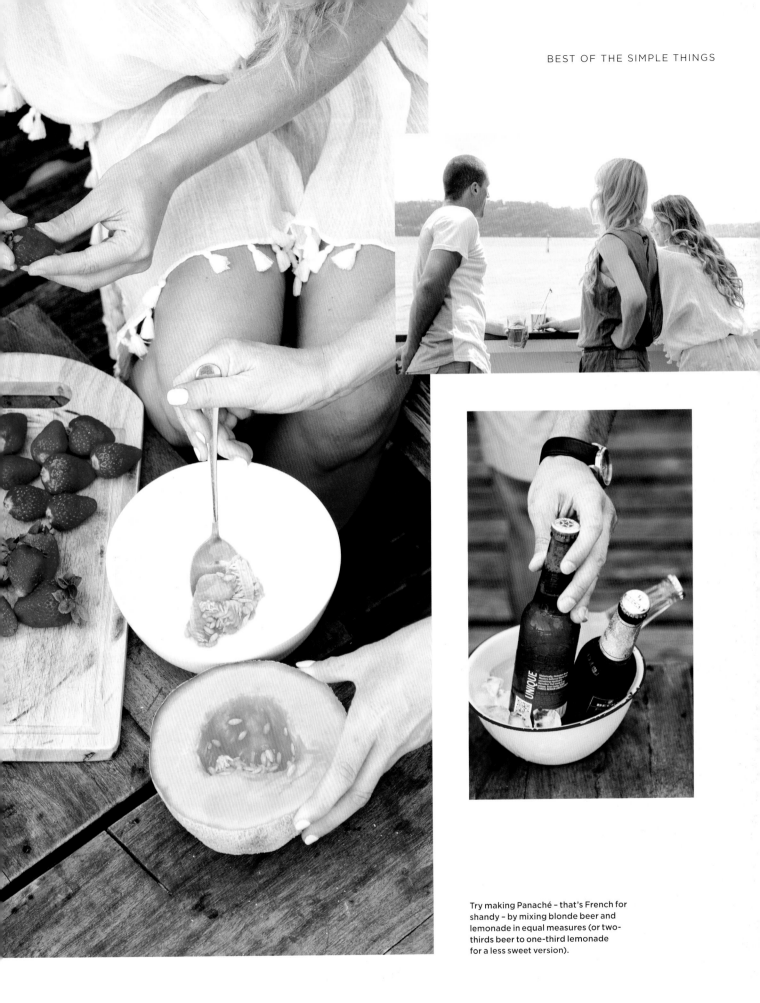

Try making Panaché – that's French for shandy – by mixing blonde beer and lemonade in equal measures (or two-thirds beer to one-third lemonade for a less sweet version).

THE SPICE OF LIFE

IT'S A GARDEN PARTY, BUT NOT AS WE KNOW IT: FAMILY, FRIENDS – FIREWORKS OPTIONAL – AND DELICIOUSLY WARMING, AUTUMNAL FOOD TO ENJOY AROUND THE FIRE

Menu: Marina Akonas

MENU
Pumpkin soup

*

Vegetable skewers

*

**Chicken and chorizo
jambalaya**

*

**Salted caramel
toffee apples**

*

**Buttered bourbon
apple cider**

Getting together with friends and family happens so easily in summer – good weather and that holiday feeling being the natural allies of socialising. Yet there's plenty to celebrate come bonfire season: autumn's fiery canopy, the crisp, cold air and fast-falling dusk lend themselves to gathering outdoors, wrapping up, wellies donned, and feasting around the fire. If the brazier doesn't warm you, our chillproof menu will: aromatic pumpkin soup, hot-in-a-good-way jambalaya, and the family favourite, toffee apples, updated with salted caramel. All can be made over the fire outdoors, or prepared ahead and finished over the flames. We'll raise a glass of mulled cider to that. Why wait till Christmas to throw a family party?

Pumpkin soup

NUTMEG AND
CINNAMON BRING OUT
THE NUTTY SIDE OF
TASTY AUTUMN SQUASH

Serves 6–8

4kg pumpkin, cut into wedges

4 cloves of garlic

Olive oil

2 onions, finely chopped

1.7 litres vegetable stock

1 tsp cinnamon

Pinch freshly ground nutmeg

Pumpkin seeds, to garnish

1 Preheat oven to 200°C/
Fan180/400°F. Arrange the
pumpkin wedges and garlic
cloves evenly on a baking tray,
brush with olive oil and sprinkle
with salt and pepper. Roast for
25–30 mins until tender.
2 Meanwhile, add 2 tbsp olive oil
to a large pot, add the onions
and cook gently on a low heat for
10–15 mins, until soft and golden.
3 Remove the skin from the
roasted pumpkin and garlic
cloves and add the peeled veg
to the stock with the onion,
cinnamon and nutmeg. Season
to taste and bring to the boil.
4 Remove from the heat and
allow to cool slightly, then
carefully transfer the soup in
batches to a food processor
and blend until smooth.
5 At this point you can return
the soup to its pot to reheat
either on the stove or outdoors
over the fire. Serve topped with
a sprinkling of pumpkin seeds.

Like a good sweetcorn,
pumpkin has an
inherently sweet
flavour that appeals to
all ages. Alternatively,
you could use
butternut squash.

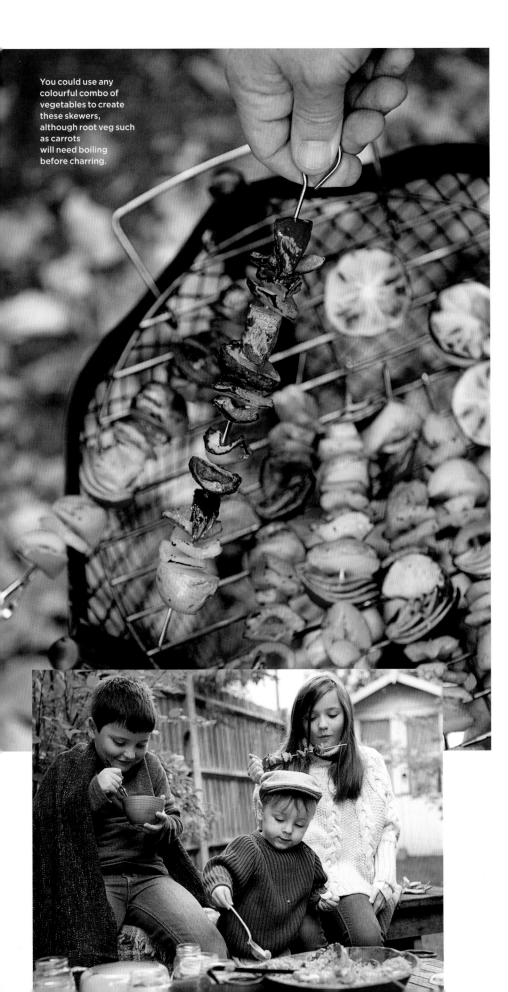

You could use any colourful combo of vegetables to create these skewers, although root veg such as carrots will need boiling before charring.

Vegetable skewers

QUICK TO PREPARE, EASY TO COOK, COLOURFUL TO BEHOLD

Makes 6

500g waxy potatoes, washed and cut into chunks

1 small sweet potato, peeled and cut into chunks

2 red onions, cut into eights

½ yellow pepper

½ green pepper

Parsley to garnish

3 tbsp olive oil

1 Boil the potatoes in salted water until tender, around 12 mins; the sweet potato cooks more quickly, so add to the water a few mins into the cooking time, or boil in separate pans.
2 Drain the potatoes and allow to cool. Prepare your red onions and peppers and thread the veg onto your skewers.
3 Mix salt and pepper into the olive oil and brush prepared skewers liberally.
4 Cook on the fire, rotating until browned on all sides, or place under your oven's grill. Sprinkle with parsley and serve.

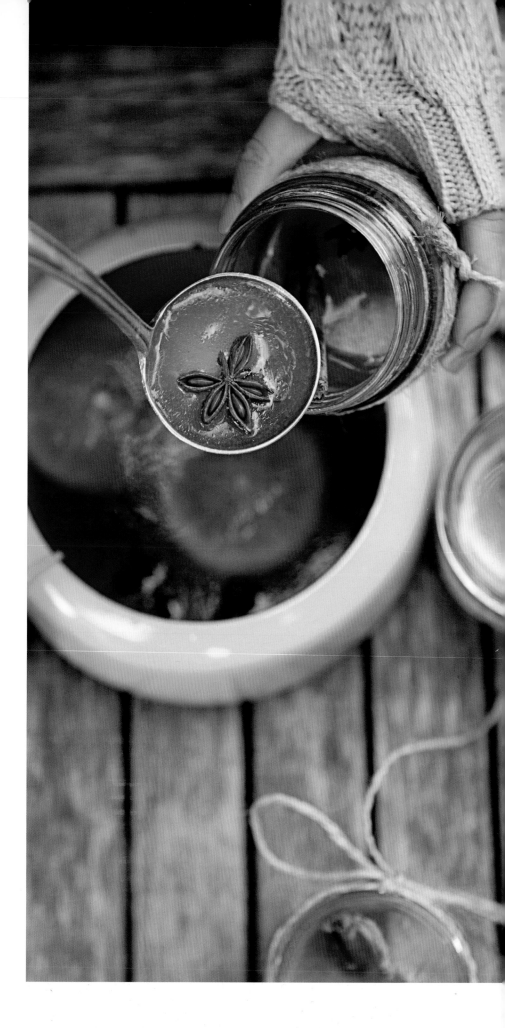

Buttered bourbon apple cider

MAKE TWO BATCHES – ONE BOOZY, ONE KID AND DRIVER-FRIENDLY

Serves 6–8

500ml apple cider*

100ml apple juice

1 tbsp light brown sugar

Cinnamon sticks (one, plus some to use as stirrers)

Cloves

Star anise

1 tsp ground nutmeg

1 tsp ground cinnamon

Pinch of ginger

Sliced fresh fruit (orange, apple)

3 tbsp unsalted butter

150ml bourbon

1 In a large pot add the cider, apple juice and sugar; heat until it starts to simmer.
2 Add all other ingredients except for the butter and bourbon.
3 Let the spiced cider simmer for 10 mins, then add the butter and bourbon, stirring gently until the butter has melted.
4 Remove from the heat, pour into glasses, add a cinnamon stick to each glass and serve. You can strain the mixture before pouring, if you don't want 'bits'.

** To make a children's version, replace the bourbon and cider with apple juice (600ml in total).*

Cooking eyecatching, cockle-warming fare such as jambalaya and vegetable skewers over the fire only adds to the spectacle.

Chicken and chorizo jambalaya

EVER A SUNNY COMBO, SPANISH MEETS CREOLE IN THIS SPICY RICE DISH

Serves 6–8

Olive oil

2 chicken breasts, chopped

8 chicken drumsticks and thighs, skinned

1 onion, diced

½ yellow pepper, sliced

½ red pepper, sliced

4 garlic cloves, crushed

½–1 fresh chilli, deseeded and finely chopped

150g chorizo, thickly sliced

1 tbsp cayenne pepper

500g basmati rice

800g tinned chopped tomatoes

700ml chicken stock

3 bay leaves

Spring onions and parsley, to garnish

1 Heat 2 tbsp of olive oil in a large pot and brown the chicken. Once golden all over, remove and set to one side.
2 Add the onion and cook until soft, around 4 mins. Add the peppers, garlic, fresh chilli, chorizo and cayenne pepper and cook for 5 mins more, stirring occasionally.
3 Return the chicken to the pot and also add the rice, tomatoes, stock and bay leaves. Stir, cover and simmer for around 25 mins (until the rice is cooked). Or, at this stage, you can put your pot on the fire and finish the cooking outdoors.
4 Season with salt and pepper and garnish with chopped spring onion and fresh parsley.

189

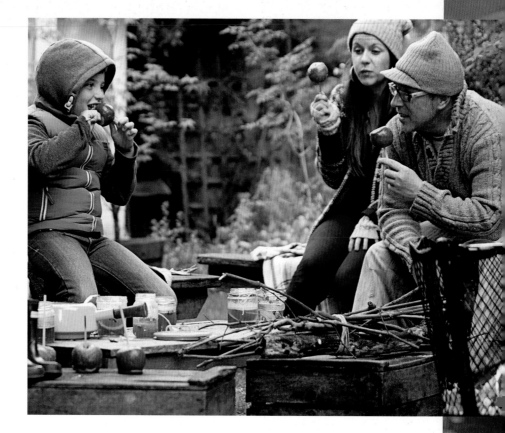

Salted caramel toffee apples

STICKY, SUGARY
HEAVEN FOR CHILDREN
– AND A SALT-LACED
CARAMEL TREAT
FOR GROWN-UPS

Makes 10

10 apples (Granny Smiths
work well)

Toffee apple sticks*

300g light brown sugar

3 tbsp maple syrup

6 tbsp golden syrup

220g butter

1 tsp vanilla extract

1 heaped tsp flaked salt

Note: Unlike traditional toffee
apples, getting a caramel sauce
to stick to the apples is a little
more tricky. You need a sugar
thermometer and to work really
quickly when dipping the apples.
It may require a little more effort
but the result is worth it! The
apples can be made in advance;
keep in Cellophane bags for
2–3 days.

1 Wash apples, dry thoroughly,
remove stalks and replace with
sticks. Place the fruit in the fridge
(washing and chilling helps the
sauce to stick).

2 Line a baking tray with parch-
ment. Into a large pan, add the
sugar, maple syrup, golden syrup,
butter and vanilla, and stir over a
medium heat until the sugar has
dissolved – around 15 mins.

3 Add the thermometer,
increase the heat, bringing the
mixture to a rolling boil, stirring
slowly but constantly until the
temperature reaches 113°C/236°F
(around 10 mins).

4 Carefully pour the caramel into
a glass bowl and stir in the salt. Add
the thermometer and allow the car-
amel to cool to 99°C/210°F (this
should take around 10–15 mins).

5 Have your apples and baking
tray ready and, working really
quickly, submerge each apple into
the caramel, twist, ensuring all but
the top is covered and place on
your baking tray.

6 Continue until all the apples are
done. You can then go back and
tidy up the bottom of each apple:
either press into shape or scrape
off excess caramel if you so wish.

7 If the temperature cools too
much the caramel will slide
straight off, so you may need
to reheat and recool the remain-
ing caramel to finish coating
your fruit.

8 Allow the coated apples to
set (2–3 hours) before placing
in Cellophane bags; store in
the fridge.

** Toffee apple sticks are a seasonal
supermarket buy, or surf online for
confectionary or lolly sticks; skewers
work, too.*

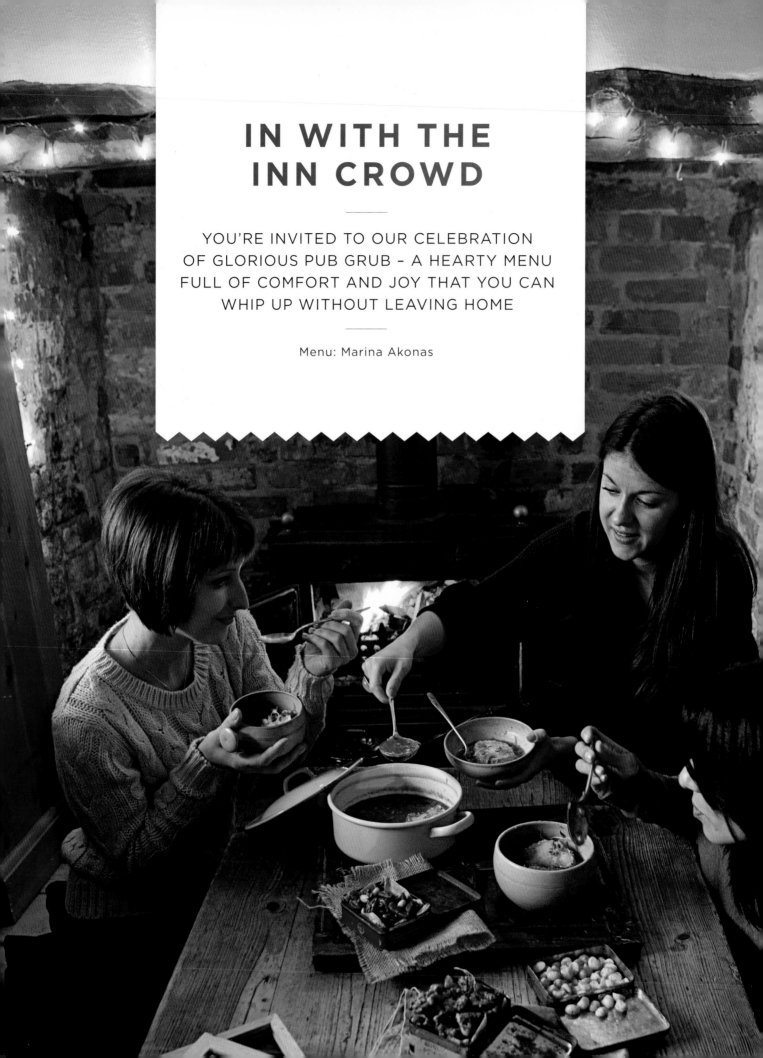

IN WITH THE INN CROWD

YOU'RE INVITED TO OUR CELEBRATION
OF GLORIOUS PUB GRUB – A HEARTY MENU
FULL OF COMFORT AND JOY THAT YOU CAN
WHIP UP WITHOUT LEAVING HOME

Menu: Marina Akonas

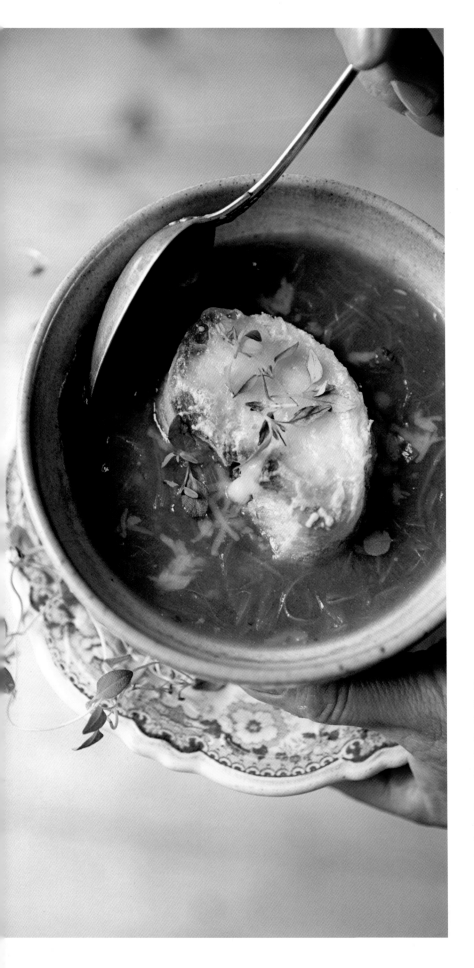

MENU
Home-pimped nuts
*
French onion soup
*
**Baked sausages, leeks
& red onions**
*
**Berry chocolate
brownies**
*
Easy pear tart
*
**Orange & cardamom
hot chocolate**

Short days and cool climes invite you to make like a hedgehog and hibernate – although unlike our prickly friends, this needn't involve solitude. Instead, make a desire to hunker down indoors your excuse to light the fire, rustle up some hearty food, and gather good friends.

It's this kind of relaxing sentiment that draws people together at the pub, so we thought we'd bring the pub to you this winter with a line-up of warming dishes worthy of any chalkboard menu. Sausages, French onion soup – even the top-it-all-off hot chocolate – every dish is the stuff of satisfying soul food.

Home-pimped nuts

A TRIO OF NIBBLES TO
PLEASE SWEET TOOTHS
AND SAVOURY FANS

Walnut & parmesan nuts

150g walnuts

40g parmesan, grated

Knob of butter, melted

Sprig of rosemary, chopped

1 Preheat oven to 180°C/
Fan160/350°F.
2 In a bowl, add melted butter,
salt, pepper and rosemary.
Mix thoroughly.
3 Add walnuts and parmesan, stir
until the nuts are evenly coated.
4 Spread onto a baking tray, and
bake in the oven for 8–10 mins.

Honey and cinnamon pecans and peanuts

100g pecans

100g peanuts

2 tbsp butter, melted

2 tbsp honey

½ tsp cinnamon

½ tsp sea salt

1 Preheat oven to 180°C/
Fan160/350°F.
2 In a bowl, add all the
ingredients, and mix thoroughly
until the nuts are evenly covered.
3 Spread onto a baking tray, and
bake in the oven for 10 mins.

Paprika macadamias

Knob of butter

150g macadamias

1 tsp smoked paprika

1 tsp sea salt

1 Melt the butter in a frying pan.
2 Add the nuts and paprika and
toss until evenly coated. Warm
for 2–3 mins; don't let the nuts burn.
3 Remove from the heat, place
in a bowl and add the sea salt.

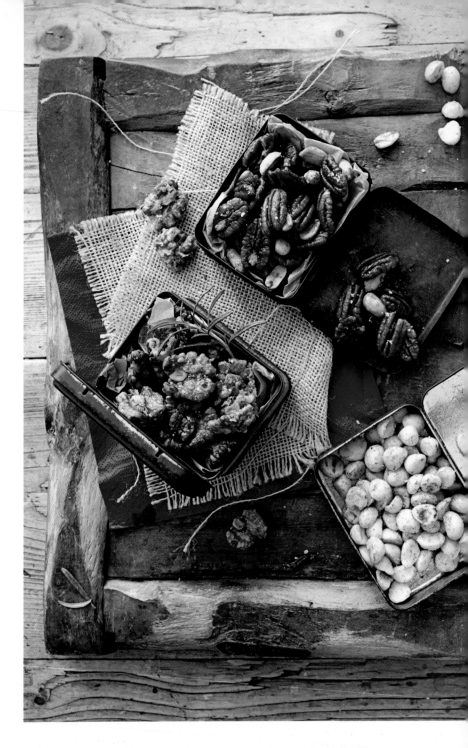

French onion soup with gruyère croutons

A RICH BROTH WITH
DECADENT, CHEESY
SUPER-CROUTONS

Serves 4

50g butter

2 tbsp olive oil

1kg white onions, thinly sliced

1 tsp sugar

4 garlic cloves, crushed

2 tbsp plain flour

250ml dry white wine

1.25 litres beef stock

French bread, sliced

150g gruyère, grated

Fresh thyme

1 In a large pan, melt the butter and oil. Add the sliced onions, cover and sweat for 10 mins until they are soft.
2 Add the sugar, stirring frequently for about 20 mins until the onions caramelise. Next, add the garlic and cook for a further few mins.
3 Add the flour; stir thoroughly.
4 Increase the heat and add the wine and stock. Stir well, bring the soup to the boil and then reduce the heat and simmer for 20 mins. Season well with sea salt and freshly ground black pepper before serving.
5 Meanwhile, slice the French bread, toast in a toaster, then cool before covering generously with gruyère.
6 Ladle the soup into bowls, if they are grillproof; add 1-2 French bread slices per bowl and place under the grill until the cheese is bubbling and melting into the soup. (Or, grill croutons on a baking tray before adding to each bowl of soup.)
7 Top with fresh thyme and serve.

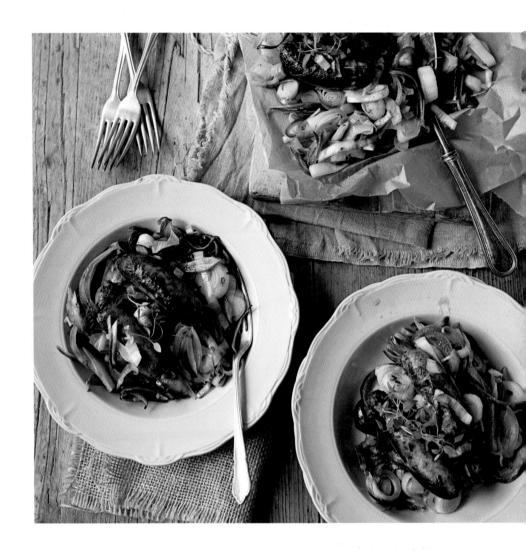

Baked sausages, leeks and red onions

A 'ONE-TRAY' BAKE
THAT OOZES FLAVOUR
AND SIMPLICITY

Serves 4

8 good quality sausages

4 leeks, trimmed and sliced into rings

4 red onions, sliced

Fresh thyme, chopped

Olive oil

Sour cream

1 tbsp wholegrain mustard

1 Preheat the oven to 200°C/ Fan180/400°F. In a frying pan, heat a little oil and brown the sausages.
2 In a large bowl toss the onions and leeks in olive oil, salt and pepper, then spread out on a large baking tray.
3 Place the browned sausages on top of the onions and leeks. Place in the oven for 30–40 mins or until the sausages are cooked through, turning 3–4 times during cooking.
4 Sprinkle with the fresh thyme.
5 Place the sour cream in a bowl, add a heaped tbsp of wholegrain mustard and mix thoroughly.
6 Serve the sausages, onions and leeks in a bowl and top with a dollop of sour cream and mustard mix.

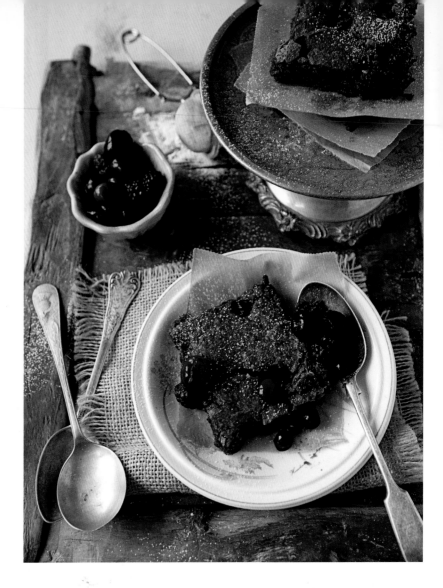

Easy pear tart

AS TASTY AS TATIN
WITH HALF THE WORK

Per skillet

100g caster sugar

1 tsp vanilla extract

3 pears, peeled, cored and cut
into eighths (rub with lemon
juice to prevent browning)

20g unsalted butter

½ tsp cinnamon

½ tsp ground ginger

Ready-made puff pastry

1 Preheat the oven to 200°C/
Fan180/400°F.
2 In a large frying pan, add 100ml
water, sugar and vanilla. Bring to
the boil then simmer until it
becomes caramel coloured.
3 Add the pears and butter
and stir until the butter has
melted and the pears are
thoroughly coated.
4 Continue to simmer for another
5 mins or so, then add the spices.
5 Grease your skillet with butter,
then line with rolled-out pastry.
6 Add the pears and caramel
sauce to your skillet, arrange the
fruit evenly then place in the
oven for 20 mins or until the
pastry is golden brown.
7 Remove from the oven,
and allow to cool a little
before serving.

Berry chocolate brownies

COCOA-LADEN TREATS
WITH SURPRISE POPS
OF TANGY BERRIES

200g milk chocolate, roughly
chopped/broken into pieces

100g dark chocolate, roughly
chopped/broken into pieces

250g unsalted butter

400g golden caster sugar

4 large eggs

150g plain flour

50g cocoa powder

200g frozen berries (we used
a Black Forest mix of cherries,
grapes, blackberries and
blackcurrants), taken out of
the freezer 15 mins ahead

1 Preheat the oven to 200°C/
Fan180/400°F. Line a baking
tray with greaseproof paper.
2 Put a large pan on a low heat
and gently melt the chocolate,
butter and sugar.
3 Remove from the heat and add
the eggs, then the flour and
cocoa powder. Mix thoroughly.
4 Add half of the berries and stir.
5 Tip the mixture into your baking
tray and scatter the rest of the
fruit over the top.
6 Bake for 25–30 mins, until the
top is firm and cracking but the
inside remains moist and gooey.
7 Allow to cool, before slicing
into squares and serving.

Orange and cardamom hot chocolate

CARDAMOM AND CINNAMON ADD EXTRA WARMTH AND FLAVOUR

Serves 4

1 litre milk

200g milk chocolate, roughly chopped/broken into pieces

10 cardamom seeds crushed, outer shell removed

Zest of 1 orange – reserve some to use as a garnish – plus juice of half

½ tsp vanilla extract

Optional, to serve: marshmallows, ground cinnamon, cinnamon sticks

1 Put the milk, chocolate, cardamom, orange juice and most of the zest into a milk pan.
2 Heat gently; keep stirring until the chocolate is melted and the milk hot.
3 Stir in the vanilla, divide between 4 cups, top with marshmallows, ground cinnamon, and the reserved orange zest and add a cinnamon stick as a stirrer.

GARDENING

There's a wise saying we like very much at *The Simple Things*: 'If you have a garden and a library, you have everything you need'. **Tending your patch** (however big or small) brings the reward of **homegrown fruit and veggies**, the joy of **spring flowers** and the scent of **summer roses** — but that's far from all. **Being outdoors**, digging, planting and getting your hands dirty are **good for mind, body and soul**. The bonus is a chance to **watch nature at work** up close and hang out with the birds and the bees. We like to **make the most of each season**: winter planning, spring planting, the summer harvest, autumn colour – and rain never stops play.

POSTCARDS FROM THE HEDGE

GROWING TO EAT STARTS AS SPRING REALLY BEGINS TO SHOW ITS COLOURS

Mark Diacono

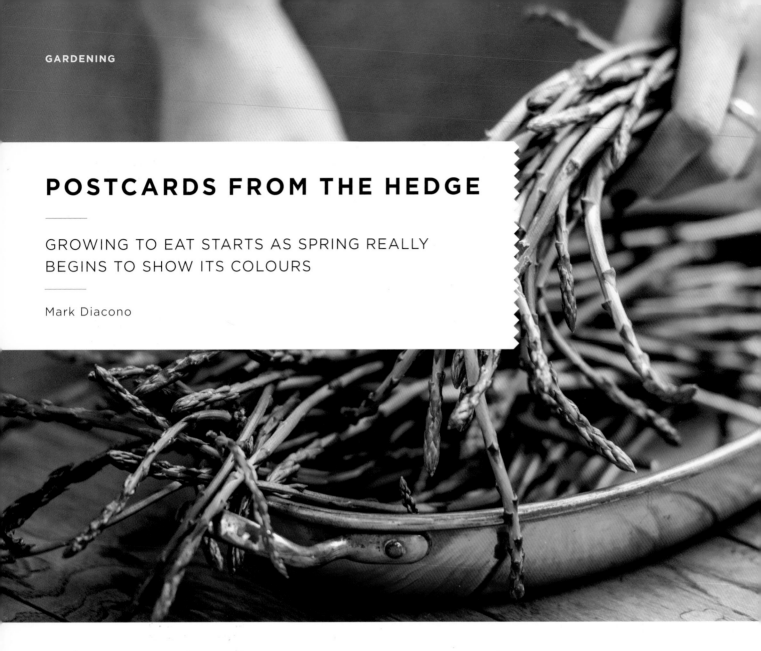

In April, I always think 'this is my favourite month.' I admit that I say the same about May and June, but hey, for four weeks, I'm in heaven. It's coat on/coat off, sunshine and showers, and the dawn chorus almost beside itself with excitement. April is full of scents too: fruit trees in blossom, the broad beans in flower and the early spicy leaves of the Szechuan pepper.

It's a month of muddy knees and elbows, caused by getting down low to look for shoots. First up, it's along the lines of asparagus for the earliest shoots, more in hope than expectation in early April. Even in the coldest years I've picked some by the end of the month; in warmer years, three weeks earlier. Waiting for Asparagus Day, as I call it, is a bit of a torture but there are consolations in the weeks while I wait.

The two bamboos I planted a few years ago suddenly took off last spring, with dozens of shoots flying up early in the month – they'll grow a few inches a day in that typical mix of April rain and sun. I cut them crisp and fresh, before they've reached 30cm tall, to get them at their succulent best. The outer layers come away to reveal the tender pale green to white flesh. Steamed for 10 minutes or so, their subtle, courgette-like flavour is delicious.

And even before the bamboo appears, Good King Henry makes its entrance. I love a plant that gives me two harvests, and the leaves and spears of GKH are both delicious – it's known as 'poor man's asparagus' and 'Lincolnshire spinach' for good reason. The flower buds are wonderful, sautéed briefly in butter and garlic – ideal to take over from the end-of-season sprouting broccoli. And all three love hollandaise and the usual asparagus dressings. Yep, April is my favourite month. At least for a few weeks.

Asparagus, Good King Henry, boiled egg and spring herb salad

THIS SIMPLE RECIPE
IS SURPRISINGLY
SUBSTANTIAL

Serves 2 as a light lunch

3 just-hard boiled eggs

A handful asparagus
(or bamboo or GKH shoots)

A handful GKH leaves
(or sprouting broccoli)

A handful sweet cicely,
roughly chopped

A few chive flowers, torn into florets

A good, pokey, honey-
mustard dressing

Salt and freshly ground black pepper

1 Steam the asparagus until it just takes the point of a sharp knife. Steam the GKH or sprouting broccoli until just cooked.
2 Quarter two of the just-cooked eggs and roughly chop the third. Lay a base of the GKH, and arrange the asparagus spears (cut into large pieces) and egg quarters on top.
3 Sprinkle over the chopped egg, chive flowers and sweet cicely.
4 Spoon the dressing on top and sprinkle on salt and plenty of black pepper. Serve warm.

WISH YOU WERE HERE...

• To lie in the veg patch in one of those glorious April sunny spells, alongside the broad beans in full blossom – the finest scent in the garden.
• To welcome the weaners – the piglets that arrive in April and spend the first few days running around in irregular patterns, getting to know their patch.

• For the joys of Asparagus Day. The first of the year's asparagus – a sadly short season – is delicious griddled on the barbecue, with just butter, lemon juice, salt and pepper.
• To nibble the early sweet cicely seeds, picked when tiny and full of the most delicious sweet, gentle aniseed flavours.

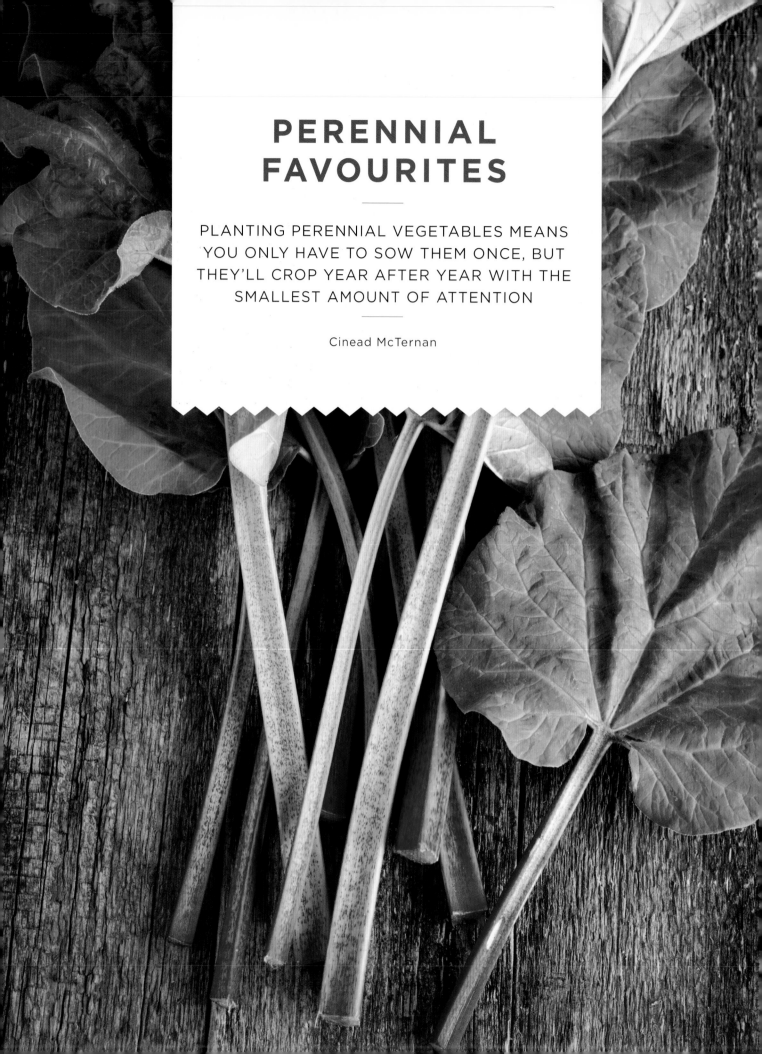

PERENNIAL FAVOURITES

PLANTING PERENNIAL VEGETABLES MEANS YOU ONLY HAVE TO SOW THEM ONCE, BUT THEY'LL CROP YEAR AFTER YEAR WITH THE SMALLEST AMOUNT OF ATTENTION

Cinead McTernan

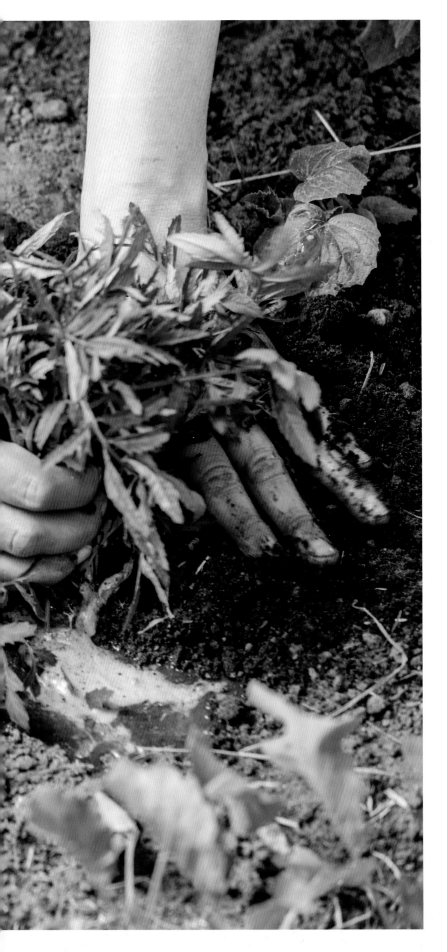

My veggie seeds have arrived. It's a good moment. For a start, it means re-painting the kitchen wall and hand-washing my knit-wear will have to wait. It's finally time to get outside. Digging, in preparation for a spot of sowing, is at last my top priority. And I'm going to try something new: this is the year of perennial vegetables.

Think of the advantages. Number one: you'll save precious time. Anyone with a kitchen garden knows that their plot, however small, needs far more looking after than the rest of their green space put together. Growing a crop in the same spot calls for less weeding, digging and mulching. There's an eco angle here, too: because they're low maintenance, it makes them a low-carbon alternative to annuals. According to London's City University, com-mercially produced annual crops take around 10 times the energy to produce as the energy they give us. It's also a chance to plug the 'hungry gap' that occurs in early spring, as many perennial veg varieties crop earlier than annuals.

This sounds like a no-brainer, so why has it taken a while for the penny to drop? Think back to those dark nights of midwinter when you failed to resist the urge to order five vari-eties of tomatoes from the seed catalogue. Pages of beautiful salad leaves and varieties you haven't tried before easily lead to over-am-bition. But the reality of a busy working week, family-centred weekends and a plot that needs regular care can mean unsatisfactory results. You start with a great flurry of enthusiasm in spring, but by summer a combination of weather (too wet, too hot, too windy) and not having enough time means the veg patch isn't looking, or producing, quite as you'd hoped.

I can't helping thinking that if a significant chunk of my plot can be left to its own devices and still provide a good harvest, it will have an impact on my gardening morale as well as my larder. It's a win-win proposition.

1 A great option for busy families, perennial veggies mean less time weeding and more time harvesting.

7 TO TRY AT HOME...

Seed companies are cottoning on to this trend – buy from one that flags up perennial vegetable varieties, so you don't need a certificate from the Royal Horticultural Society to decode what can and can't be left in the ground each year.

2 Rhubarb has many uses and is a cinch to tend. 3 Bright green sorrel has a sharp flavour that works really well in salads. Think of it as an alternative to spinach.

Sorrel

A great alternative to spinach, you can eat young, succulent sorrel leaves in salads as well as using the larger, tougher leaves to make a delicious soup. One of the earliest crops to start in spring, it has a tangy flavour.

WHAT, WHERE & WHEN? 'Red-Veined' is a beautiful addition to both the veg patch and the plate, but the common broad-leaved variety with its vibrant green colour is tempting too.

All varieties prefer a bit of shade, if possible, and they'll need watering in a long hot spell, otherwise they'll run to seed. Sow seeds from March to May, thinning seedlings out to about 30cm apart to give them plenty of room as they bulk up over the years. You'll need a few plants if you're cooking it as sorrel reduces down a lot.

Rhubarb

I love rhubarb. I remember picking big long stems from an old rhubarb patch in my parents' garden when I was a child and dunking them in bags of sugar. These days I'm a bit more discerning and go for the young, tender

stems, or the pale pink forced stems that appear a little earlier than those left to face the elements.

WHAT, WHERE & WHEN? 'Timperley Early', 'Champagne' and 'Victoria' should be planted in the autumn. If you prefer a little acidity to the flavour, go for 'Victoria'. 'Champagne' produces sweet stems whether forced or not. As its name suggests, 'Timperley Early' can give you a harvest in February if forced, when there's little else in the veg patch. 'Fulton's Strawberry Surprise' can't be planted as early as the Early, but does well if started in March. In a few years the plants will look a bit unruly – simply dig them up in the autumn and divide the roots (or corms) into two or three chunks by splitting with a fork.

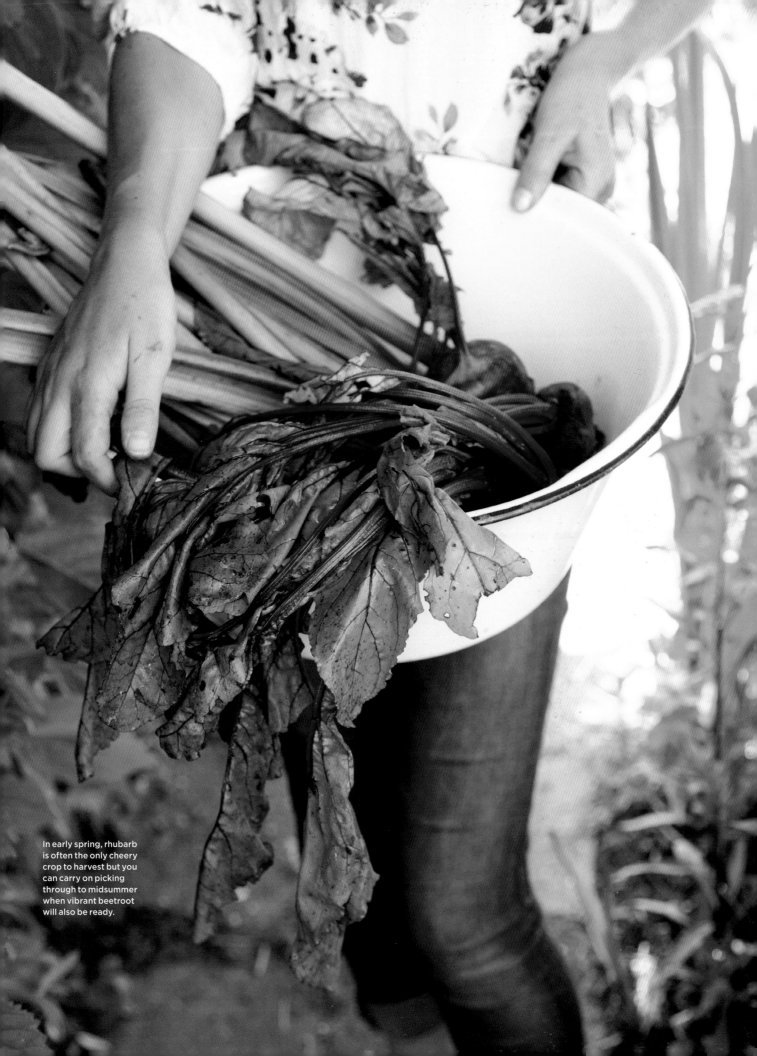

In early spring, rhubarb
is often the only cheery
crop to harvest but you
can carry on picking
through to midsummer
when vibrant beetroot
will also be ready.

Asparagus

Once you've harvested your first spears, you'll wonder why you didn't try growing asparagus before. It's a short-seasoned crop that really is best eaten fresh, but what could be more satisfying than harvesting this expensive-to-buy crop from your own plot?

A well-known restaurateur once told me a lovely story about a friend who adored asparagus but was incredibly particular about its freshness. Each April, he would take a small camping stove and a saucepan of water to his patch, set up the stove at the end of a row and wait for the water to boil. Then he'd dash off to cut some spears and sprint back to immediately plunge them into the boiling water – plot to plate in just a few minutes!

WHAT, WHERE & WHEN? You do need to show a bit of patience before you can harvest your first spears, giving them three years to get established. The good news is that you can speed the process up and buy two-year-old corms. This enables you to enjoy a modest-sized snack after the first growing season, with the promise of much more to come the following year. Choose a sunny spot, but don't worry too much about the soil type. Plant out in March, placing the 'crowns' on a peaked-shaped trench (think an upturned 'V'), covering the roots with soil and leaving the bud tips just showing. 'Backlim' and 'Gijnlim' are recommended by the RHS and widely available. For something a little more unusual, go for 'Ariane' and 'Stewart's Purple', which, as the latter's name suggests, are attractive purple varieties.

Globe artichoke

A great choice for the veg patch if, like me, your enthusiasm for this delectable vegetable is put to the test when you get it into the kitchen – unless you're an adept cook, it's a complete faff to prepare artichokes. But as the plant is wonderfully architectural (growing up to 1.5 metres), with silvery-green leaves and large purple flowers, it easily earns its keep in the garden even if you don't bother to harvest it. If you're game, however, pick the buds when they're the size of golf balls from July

1 When it comes to flavour, few garden veggies can match fresh asparagus and globe artichokes.

2 Want something a bit different? Oca can be boiled and buttered just like a new potato.

3 Skirret provides two crops: the shoots can be picked in spring and the roots in autumn.

4 In smaller gardens, horseradish is best grown in a container. Pick it little and often.

5 If you plant Egyptian walking onions, don't expect them to stay put – they can 'walk' between one and three feet each year and might eventually wander out of your garden plot.

onwards, and keep an eye out for a second flush later in the summer. If left, the flowers last well into autumn, providing a seed supply for hungry birds during winter. **WHAT, WHERE & WHEN?** The best varieties to go for are 'Green Globe' and 'Violetta di Chioggia'. Sow seeds in early spring either directly in the soil or in seed trays – or you can buy young plants from garden centres. Water if there's a dry spell or feed in the spring with a general fertiliser. It's a good idea to protect plants during winter by covering them with straw or well-rotted manure.

Oca

Never heard of it? I must confess, I haven't grown oca yet either, but will give it a try. It looks truly beautiful – somewhere between a small knobbly Jerusalem artichoke and a new potato, but with a pink blush skin. It's said to have the same waxy texture as a potato and a delicious lemony aftertaste. **WHAT, WHERE & WHEN?** Plant tubers in the ground in late May when the soil has warmed up, and mulch with a layer of well-rotted compost to help retain moisture during the summer months. They're a great alternative to potatoes because they don't suffer from blight, which causes growers no end of angst, obliterating potato and tomato crops almost overnight. Great for December harvests, this little tuber can be eaten raw or boiled and smothered with butter – could be something new to try for this year's Christmas lunch to impress your family?

Skirret

An old-fashioned root vegetable, skirret was widely grown when men wore togas and spuds hadn't yet arrived from the Andes. Thanks to the renaissance of growing your own and the interest in heritage varieties, skirret is making something of a comeback – though I expect most of us would need to double-check in a seed catalogue before we could describe it to a fellow grower. **WHAT, WHERE & WHEN?** Sow seed in pots in early

spring, leaving in a cold frame or with a little protection, potting on as needs be and planting out in the summer. It's worth tracking down as it provides a double harvest – the shoots can be picked in spring and taste delicious tossed in butter and garlic, while the clusters of long, white roots can be harvested in autumn (preferably after a light frost to improve its flavour) and cooked just as you would a parsnip. It's hardy, too, so you really can plant it and then pretty much forget about it until you want to eat it. Skirret likes moisture, though, so cover with mulch and do water it if it's a dry, hot summer to prevent the roots from going too woody.

Horseradish

Freshly grated or made into a sauce, horseradish is delicious with beef and mackerel. **WHAT, WHERE & WHEN?** If you don't have oodles of space to let it romp away, it's a good idea to grow horseradish as a container crop. Just find a sunny spot in well-drained soil (or add a few handfuls of horticultural grit if you're planting in pots) and horseradish plants will happily thrive year after year. It's hard to find seed, so plant root cuttings from March to May at about 30cm deep on an angle. By October it'll be ready for harvesting. Try to pick little and often to enjoy young, tender roots – you can store horseradish in your fridge for up to three months. It's thought that the roots taste at their best after frosts, so if you can wait until you see leaves die back, all the better.

...and one amazing onion

Egyptian walking onions quite literally walk through your vegetable patch. OK, perhaps it's more of a topple on closer inspection, but they look fantastic and it's quite fun to have a crop start in one area of your veg bed and end up in another without any help. They produce a cluster of little bulbs at the tip of the plant. These bulbs develop roots when they mature and, because they're supported on a thin, chive-like stem, they fall over. Once they hit the soil, they root and begin to grow and so the process continues. They appear very early on in spring, enlivening home-cooked dishes with fresh flavour. You can plant them all year round, too.

THE
HERBAL LIST

WHETHER IT'S IN A POT OR ON A PLOT, WE
CAN ALL GROW HERBS. ESPECIALLY
WITH SOME EXCELLENT ADVICE FROM
'QUEEN OF HERBS' JEKKA MCVICAR

Cinead McTernan

Winter savory's white
flowers are tinged
pink in summer.

Jekka attributes her success to her passion for herbs.

"I couldn't be without herbs," says Jekka McVicar. "And even if I didn't have them on my doorstep in the nursery, I'd grow a selection on my windowsill so I could enjoy picking fresh, tasty leaves and flowers to use in the kitchen."

It's largely due to herb-supremo Jekka's enthusiasm for herbs that we so readily pick homegrown basil or mint leaves to rip à la Jamie Oliver to add to our quick supper or summery drinks. Jekka has worked hard over the past 25 years to put herbs not only on the map, but on our dinner plates. Her knowledge and enthusiasm is unrivalled and fellow horticulturists, supermarket buyers and chefs regularly consult with her on all things herby. It's not surprising that Jamie crowned her the 'Queen of Herbs'.

This title is well-deserved: since setting up her 2.5-acre herb farm in south Gloucestershire with her husband Mac (a former spacecraft engineer now devoted to the business) in 1987, she has been awarded more than 60 gold medals for her herb-garden exhibits at RHS flower shows, as well as publishing five books about growing and cooking with herbs, and appearing on TV gardening shows from *Rick Stein's Food Heroes* to the recent *The Great British Garden Revival*. A member of the RHS council, she is also president of the Herb Society.

Jekka puts her success down to a true passion for the plants, rather than years of formal horticultural training. A beacon of light to working mums, she started the herb nursery with two very young children playing in the borders while she sowed seeds and took cuttings. "Dreams can come true if you're prepared to work hard enough," she says. Those early years – though hectic, and more often than not, exhausting – were happy times for Jekka and were clearly rather idyllic for her son and daughter, too, as the business still remains a family affair. Hannah, a successful

211

> *"With a bit of planning and regular picking, you'll be rewarded with a supply of edible treats year round"*

botanical illustrator and printmaker (see her illustrations on these pages), still finds time to work with her mum designing brochures, seed and herbal tea packets, while Alastair can still be tempted away from his career as an environmental analyst to help during the RHS Chelsea Flower Show.

In the last few years, Jekka's vision for her business has evolved and she has scaled down the nursery to realise a long-held ambition of creating a Herbetum to display more than 300 different varieties of native and tropical culinary herbs. She describes it as "an environment where visitors can see the herbs and learn how to use them in their own kitchens, as well as understand their medicinal uses". Her hope is that it will be somewhere future generations can discover the significance of herbs.

The Herbetum is a winning combination of raised beds beautifully planted with an inspiring collection of herbs, and a teaching school where Jekka runs a series of master-classes about growing and using herbs. For the more casual visitor, she also holds a number of open days and garden tours throughout the year.

"As well as being flavoursome, herbs are versatile too," says Jekka with typical enthusiasm. "They add structure and interest to a herbaceous border, creating eye-catching and scented displays in containers and pots, as well as being a haven for pollinating insects in summer. In the autumn, the seeds you haven't harvested for use in the kitchen are a source of food for birds. And they are easy to grow, given the right conditions. With a bit of planning and regular picking, you'll be rewarded with a supply of edible treats all year round."

JEKKA'S KNOW-HOW

• **Oregano is the easiest herb to grow** in poor, dry conditions. It is happy to be planted in the type of soil that other herb varieties wouldn't put up with.

• **Supermarket herbs are best on window sills.** Amazing as it sounds, they're actually raised to cope with indoor conditions. Pick leaves regularly and don't let them dry out or, indeed, overwater them.

• **Contrary to what you might think,** coriander is a bit of a tricky customer. It needs shade as well as a rich, fertile soil that doesn't dry out.

• **The easiest herbs to grow from seed** are rocket, purslane or dill. They will put on a good show whether sown in trays or directly into the ground.

• **Mint is easy to propagate.** It's the best herb to try if you're new to taking cuttings.

• **Plant parsley all summer.** Sow directly into the soil by the end of August for fresh pickings through winter.

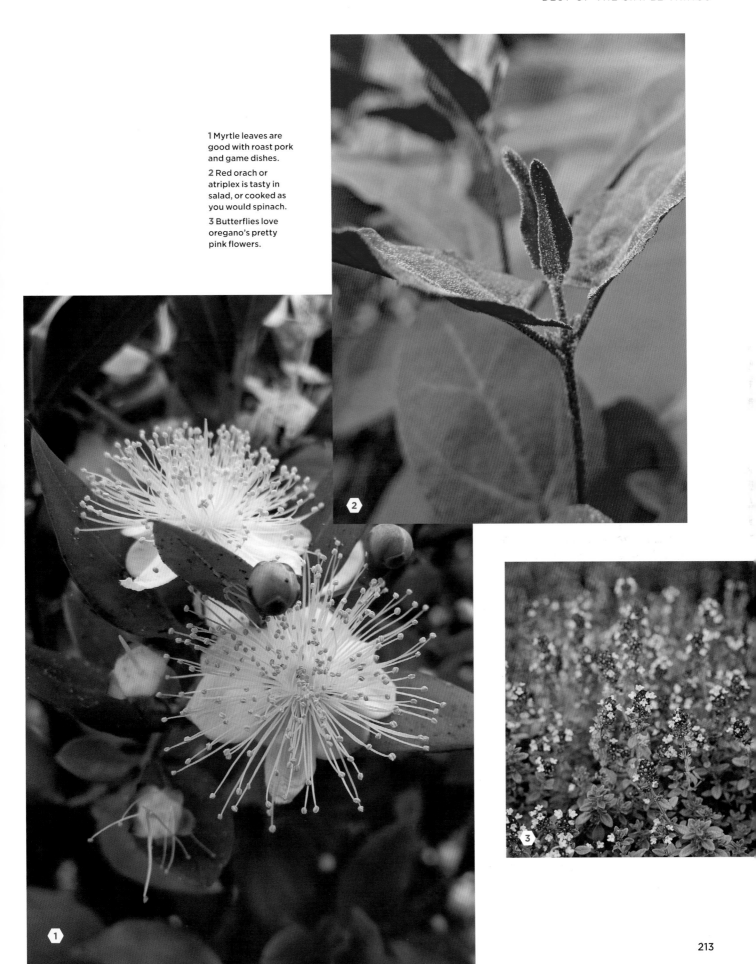

1 Myrtle leaves are good with roast pork and game dishes.

2 Red orach or atriplex is tasty in salad, or cooked as you would spinach.

3 Butterflies love oregano's pretty pink flowers.

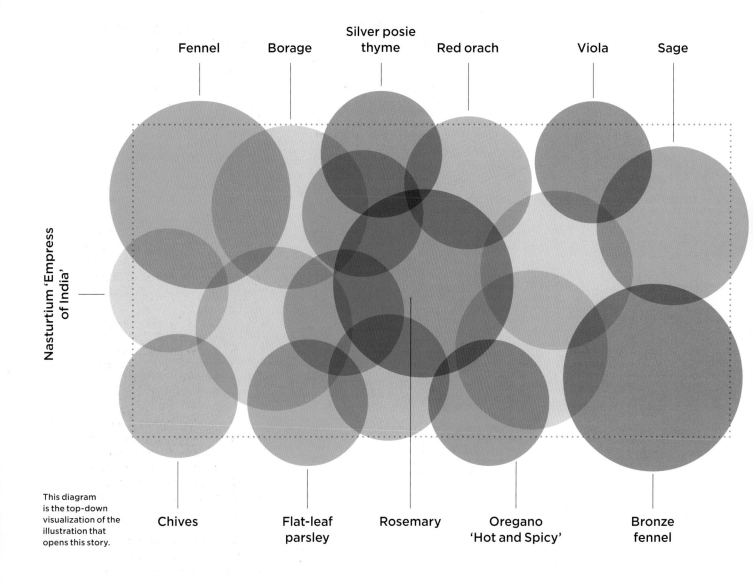

Fennel

Borage

Silver posie
thyme

Red orach

Viola

Sage

Nasturtium 'Empress
of India'

This diagram
is the top-down
visualization of the
illustration that
opens this story.

Chives

Flat-leaf
parsley

Rosemary

Oregano
'Hot and Spicy'

Bronze
fennel

A HERB GARDEN
OF YOUR OWN

"Here is a planting plan I've designed for a small space. I've created this 1 x 0.5m border using a selection of well-known and lesser-known herbs to give a long season of interest, as well as a variety of flavours and textures (leaves, flowers and seeds) to liven up your cooking.

"The herbs in this design like well-drained soil, so if you have heavy clay you'll need to add plenty of horticultural grit and organic matter to try to open up the structure and create the right environment for the plants. When it comes to planting, think about the size of the plants in two years' time, and space accordingly – you should find guides to the plant's eventual size on its label from the nursery.

"If you can't create a border, a large trough will do the trick. I've also ensured that this display works as an 'island', where you can see all sides, or positioned against a wall with the three sides visible."

IF YOU ONLY GROW SIX HERBS...

1 Thyme (*Thymus vulgaris*)
Hardy evergreen perennial, height: 20cm. Mauve flowers in summer and small, mid-green leaves. Tasty in stews, salads and sauces. Cut back after flowering to encourage new growth for winter.

2 Chives (*Allium schoenoprasum*)
Hardy perennial, height: 30cm. Purple, globe-shaped flowers in spring with tubular leaves and flowers, both of which have mild onion flavour. Cut back after flowering to encourage new growth. Add to salads, egg and cheese dishes.

3 Sage (*Salvia officinalis*)
Hardy perennial, height: 60cm. Blue, mauve flowers in summer and aromatic, oval, grey-green, textured leaves. Its fresh leaves torn up over fresh pasta are delicious.

4 Rosemary (*Rosmarinus officinalis*)
Hardy evergreen perennial, height: 1m. Small pale-blue flowers in spring and summer with short, dark-green, needle-shaped aromatic leaves and an upright habit. Rosemary has both culinary and medicinal uses.

5 Parsley (*Petroselinum crispum*)
Hardy biennial, height: 40cm. Flat umbels of small, creamy white flowers in the summer of the second season. Bright green, serrated, curly leaves. Culinary, a rich source of vitamins and iron. Grow in a rich soil in partial shade.

6 Oregano (*Origanum vulgare*)
Hardy perennial, height: 45cm. Clusters of small mauve, purple flowers in summer and oval, dark green hairy aromatic leaves. Strongly flavoured, it suits both meat and vegetables.

POSTCARDS FROM THE HEDGE

EARLY SUMMER IS MARKED BY THE ARRIVAL
OF SWEET STRAWBERRIES AND LOADS
OF LOVELY LETTUCES

Mark Diacono

In June, even if the spring has been wet and cold, the leaves, shoots, herbs and fruit know it's June and somehow grow through it. There are hearting lettuces such as Reine de Glace and Buttercrunch, plenty for cut-and-come-again harvesting, such as Green Oak Leaf and Australian Yellow Leaf, and – in a tribute to my laziness – there's also quite the jungle of self-sown leaves springing up in pathways, under bushes and in the vegetable beds themselves. No two salads need be the same at this time of year.

It seems I'm not so sharp about not letting oriental leaves, Mexican tree spinach or erbette go to seed. In June I'm glad of it, with these free, self-sown beauties brightening the salad bowl. Mexican Tree Spinach, a relative of Fat Hen and Good King Henry, even reflects the weather, turning increasingly pink in the sun.

June means strawberries. The first serves of Wimbledon kick off a long season of strawberries, with Mara de Bois and Flamenco usually first out of the traps. I eat dozens daily, warm from the plant, but try to keep plenty back for granita, fools and the tart (opposite) that works so well with midseason rhubarb.

With so much going on, I really ought to be in the vegetable patch, but despite the action in the garden, I'm more drawn to the far field, where the buzzards climb in lazy spirals on the early summer thermals. These warm evenings mean mayflies, and mayflies hatching means trout will be rising for a nibble.

All I need is the promise of still air, a little of the day's warmth left and cold beers to lower into the water to stay cool, to forget even the pleasures of the veggie patch.

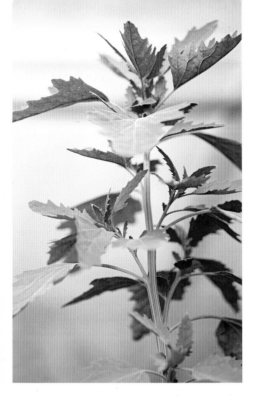

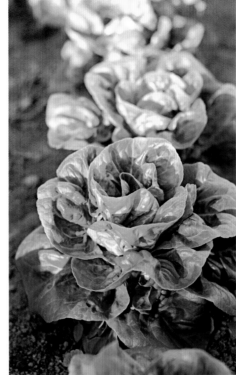

Strawberry and rhubarb tart

Serves 6–8

180g rhubarb, trimmed
into 3cm pieces

200g strawberries, hulled and
halved

40ml white wine

100g caster sugar

1 tbsp cornflour

1 tsp lemon juice

1 egg yolk

½ tsp grated fresh ginger

300g pastry – your own
or readymade

1 Combine the fruit, wine, sugar,
cornflour, lemon juice and ginger
in a large bowl and leave to
macerate.
2 Preheat oven to 180°C/
Fan160/350°F.
3 Roll out the pastry to around
3mm. Gently press it into the base
and sides of the tart tin. Prick the
base a few times with a fork and
bake for 10 mins.
4 Lightly beat the egg yolk, brush
over the pastry and bake for a
further 10 mins.
5 Take the tart out of the oven,
trim off any overhanging pastry
and fill with fruit. Add 5–6 tbsp of
the fruity liquid, too.
6 Place the tin on a baking sheet
in the bottom of the oven. Bake
for 45-60 mins.
7 Remove tart from oven and let
it cool. Serve with double cream.

WISH YOU WERE HERE...

• To cast the first flies towards the river
in hope of an early- season trout, to
cook on the bank with just-harvested
fennel and garlic scapes.
• To sip warm evening cocktails of rose
syrup (made from the early petals)
topped up with sparkling wine.

• To catch frequent June glimpses of the
kingfishers shooting a foot or two above
the surface of the river.
• To take the first warm/chilly dip in the
river, at the sharp bend that marks its
deepest point.

SEED *to* STOVE
FLOWER POWER

PRETTIFY SALADS, DESSERTS AND EVEN DRINKS WITH EDIBLE FLOWERS

Lia Leendertz

May is the month when my plot shakes itself free of its winter dourness and starts to feel fun again. Spending time here is now less hard labour and more sunlit pottering. Things really start to move this month: the soil is warming up and, given a few sunny days, growth romps away as if a shotgun has been fired. It's the first blast of summer and a glorious feeling. Everything is fresh and green and there's plenty of work to be done. As the chills of early spring melt away, it's time for sowing straight into the ground: beetroot, carrots, peas, radishes, spring onions, spinach and more. Just make a drill, sow the seeds into it, water and go. This is also the moment to sow delicate courgettes and winter squashes indoors for planting outside next month, when the weather should be even warmer.

Despite all this action and warmth, produce is still pretty scarce. New sowings are only getting settled in and even overwintered plants, such as broad beans, are all flower and no bean... yet. Happily, edible flowers are just coming into bloom – the quickest edible off-the-blocks, though it has to be admitted they won't exactly fill you up. Mine were sown in late summer directly into the soil, and as they are fully hardy they have overwintered well and are ready to go now. The first few roses join them in late May, ahead of the rose explosion in June. Edible flowers are a beautiful addition to many dishes all summer long, but are particularly welcome strewn over salads and desserts, and there is still plenty of time to sow cornflowers, pot marigolds and borage for flowers later this year if you missed the autumn sowing window.

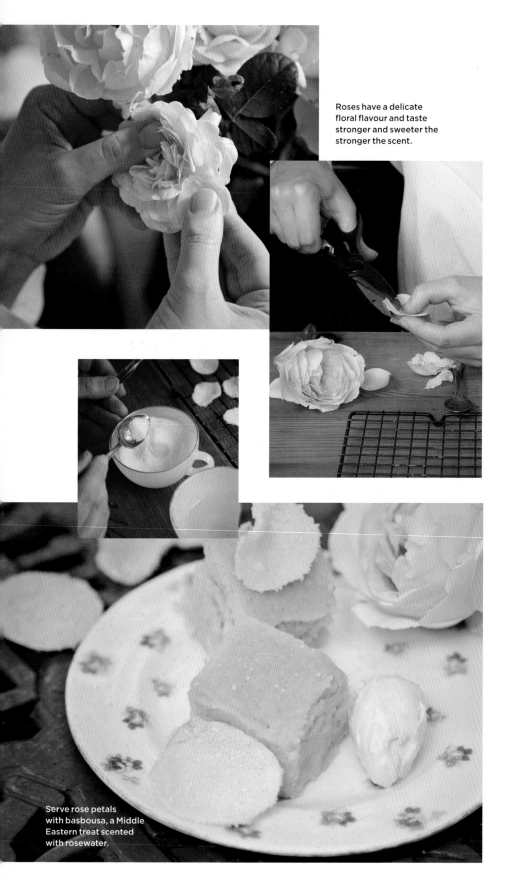

Roses have a delicate floral flavour and taste stronger and sweeter the stronger the scent.

Serve rose petals with basbousa, a Middle Eastern treat scented with rosewater.

Crystallised roses

SPRINKLE OVER CAKES, ICE-CREAM OR DESSERT

Rose petals
1 egg white
Granulated sugar

Snip the base off each petal and discard before you start as it tastes slightly bitter. Dip the remaining petal in the egg white then into the sugar, using a teaspoon to make sure it is covered. Transfer each petal to a wire rack and leave to dry overnight. They should be dry and encrusted in sugar, ready for scattering.

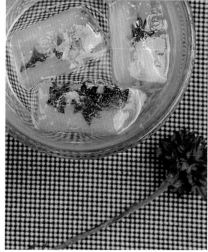

Ice cubes

Floral ice cubes make a great addition to home-made lemonade or a jug of Pimm's. There is just one trick you need to know: fill the ice cubes with water halfway first, drop in your chosen flower or petal, and freeze. Only when it's frozen solid should you fill the ice cube tray right to the top and freeze again. The two stages help to anchor the flowers in the centre of the cube – without it they would float to the top.

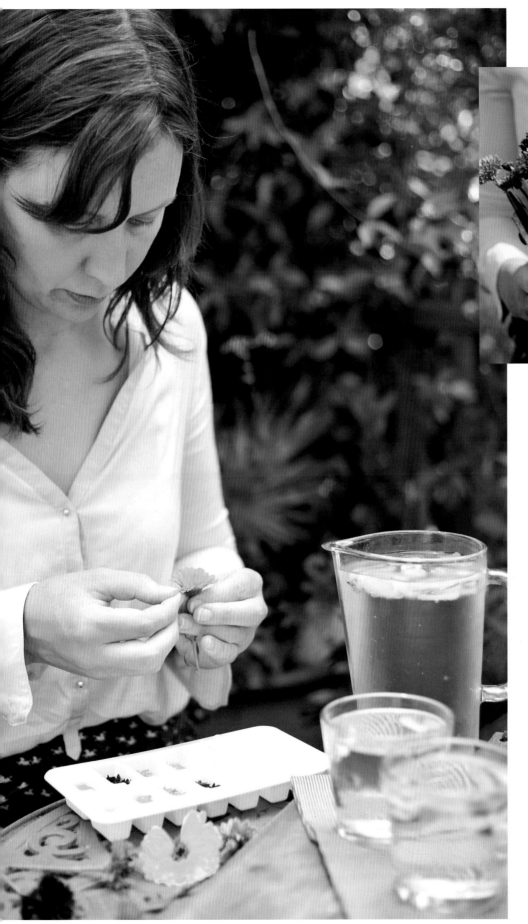

LIA LOVES

Not all flowers are edible, so make sure you know what you're picking. Here are three that look and taste utterly delicious

CORNFLOWER 'BLUE BOY'

I grow this lovely bold blue cornflower every year. It looks great on the plot, but also makes a wonderful cut flower and adds a beautiful splash of colour to salads and ice cubes.

POT MARIGOLD 'ART SHADES'

This is the first year I have grown this particular marigold and it has proved a winner – in all shades of orange, from palest apricot to free-range yolk. Marigolds also attract bees that help to pollinate your fruit and veg flowers.

ROSE 'HERITAGE'

This is one of David Austin's English roses and has beautiful ruffles of pale pink petals and a delicate fruity scent with a touch of honey – a lovely rose for creating pastel-coloured, crystallised petals.

Fresh borage and cucumber salad

BORAGE IS AN
EDIBLE FLOWER
WITH A DELICATE
CUCUMBER TASTE

Serves two for lunch, with bread, or four as a side salad
1 cucumber
Small bunch of dill
A splash of extra virgin olive oil
A splash of white wine vinegar
A handful of borage flowers
A few dill florets

1 Use a mandoline or a peeler to snake long, thin ribbons of cucumber into a large bowl. Finely chop the dill and sprinkle it over the cucumber ribbons, then add the oil and vinegar. Use your hands to carefully turn the ribbons in the herbs and dressing.
2 Arrange the cucumber ribbons in a bowl. Scatter over the borage and dill florets and serve.
3 Alternatively, change the method to make an easy fridge pickle. First, salt the ribbons and leave them to drain for an hour. Pat them dry, brush off the salt and lay them in a Tupperware box. Sprinkle over the dill, then pour in enough vinegar to cover. Leave in the fridge overnight. Just before serving, remove from the vinegar and sprinkle with the flowers and a little extra dill.

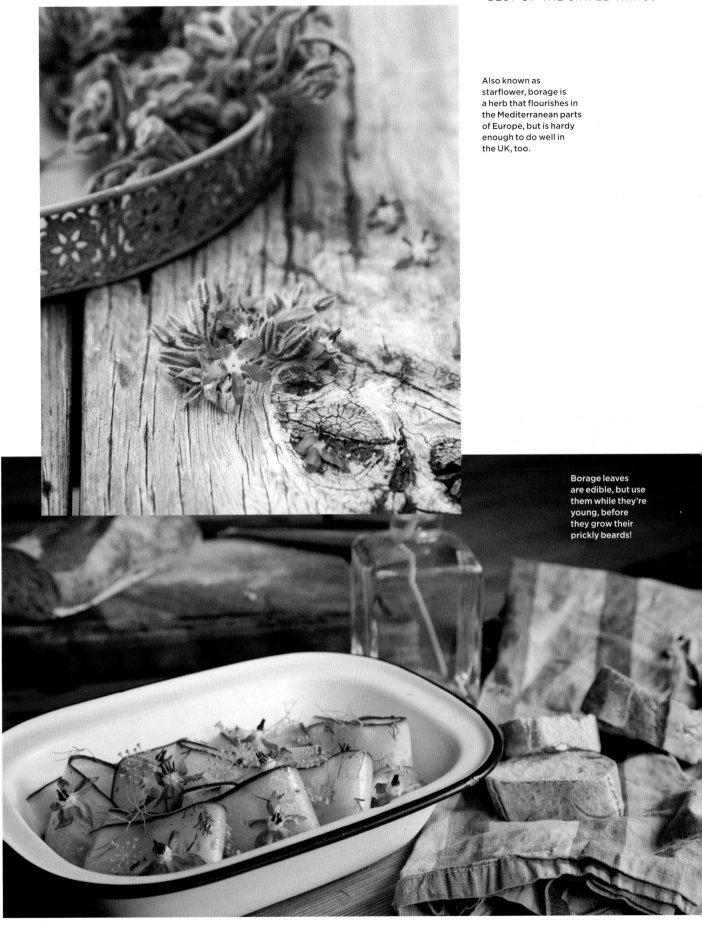

Also known as
starflower, borage is
a herb that flourishes in
the Mediterranean parts
of Europe, but is hardy
enough to do well in
the UK, too.

Borage leaves
are edible, but use
them while they're
young, before
they grow their
prickly beards!

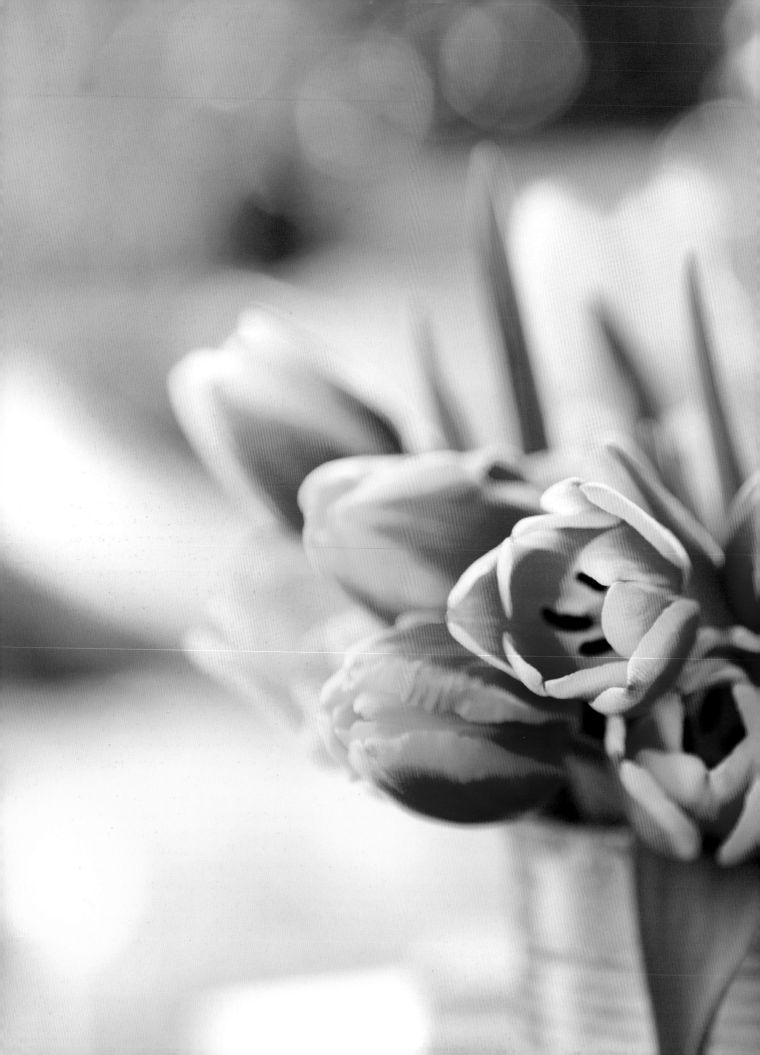

TULIP LOVE

THEIR BEAUTIFUL COLOURS AND SHAPES BRIGHTEN EVEN THE SMALLEST SPACE. PLANT IN THE AUTUMN AND MAKE TULIPS THE CENTRE OF YOUR SPRING DISPLAY

Cinead McTernan

For a splash of spring colour in your backyard, patio containers or, perhaps, roof garden, tulips are just the ticket. They come in a variety of colours, shapes and heights, so there's plenty of choice to suit your style. There are even scented types – and, of course, they make beautiful cut flowers, so you can enjoy them both indoors and out.

Ideally they like a combination of well-drained soil and full sun, but will still put on a show in poorer soil and a bit of dappled shade. They won't cope, however, if they're sitting in sodden soil, so it's worth adding some horticultural grit or sand along with plenty of organic matter to the flower bed or container before planting. Keep them sheltered from strong winds, too, which will wreak havoc with their elegant, tall stems. If it's difficult to find a protected spot, go for the more sturdy Triumph varieties, such as the burnt-orange 'Jimmy', burgundy 'Ronaldo' or deep plum 'Black Knight'.

While most spring-flowering bulbs can go in the ground in early autumn, it pays to wait until November before planting tulips to avoid the dreaded tulip fire, Botrytis tulipae. A fungal disease, it's rife during warm, humid weather. By late autumn the weather has cooled, and so the risk of infection reduces, too. If leaves emerge in late winter looking distorted and you see brown spots on the plants, it's best to lift and burn the bulbs to prevent further infection and then leave the spot tulip-free for at least three years.

HOW TO PLANT

As a rule of thumb, plant tulips at least twice the bulb's width apart and at a depth of about two to three times the bulb's height. If you're planting in containers, you can layer with other bulb varieties that flower at different times to help extend your spring displays. Just place the latest flowering plants on the bottom layer, covering with about two inches of compost, and work upwards so the earliest flowering varieties are on the top layer.

If you have spare storage space, plant some tulips in aquatic baskets and use them to fill gaps in your borders during the spring. Simply plunge the baskets in the soil where there's an empty spot, lifting the baskets again after the tulips have finished flowering.

If you're looking for a natural display of tulips in long grass, throw a handful onto the ground and plant them where they fall using a bulb planter – an essential tool if you're planting more than half a dozen.

Always try to plant in drifts or swathes in a border to get a ripple of colour. For container displays it's often best to stick to one variety, though if you're a colour addict perhaps group a number of single-coloured containers together to create an eye-catching display.

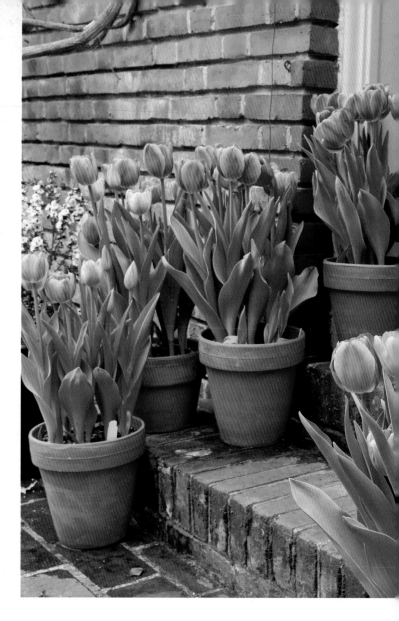

LEAVE OR LIFT?

Though you can leave some tulip varieties (such as Tulipa kaufmannia, T. fosteriana and T. greigii) in the ground, all other varieties can't be relied upon to flower in the same numbers year after year. There are two options for annual displays – either replace with new bulbs each year or lift and dry bulbs after they've flowered. It's a bit time-consuming, but the satisfaction that comes with not having to buy so many bulbs again next year makes it worthwhile. About six weeks after the tulips have flowered, the leaves should have turned yellow.

Lift and clean the soil off the bulbs, throwing away any you think look damaged or diseased, and leave to dry in a cool, dark spot, like a shed or under the stairs.

That said, if your display is in a prominent spot or is planned for a special occasion, it's a good idea to add a few new bulbs as a belt-and-braces approach to ensuring a good spring show.

If you're happy to try your luck, simply cut back yellow and brown foliage and stems once at least six weeks after they flowered and see what happens next year.

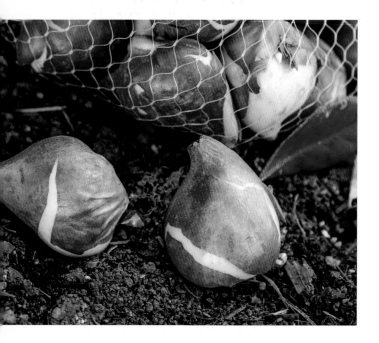

ABU HASSAN

Plan ahead! Plant tulip bulbs in pots in the fall to dress your garden for a spring party or special occasion next year.

GOLDEN ARTIST

BEST VARIETIES FOR COLOUR

From fiery reds to sunny yellows, there's a tulip to suit every palette. Choose from these elegant varieties for a garden worthy of a Monet painting

ANTRACIET
One of the most glamorous varieties, these peony-shaped flowers initially form a dark red bud and then burst open to reveal a sumptuously crimson bloom. Height: 40cm

GOLDEN ARTIST
An unusual tulip, its petals are a striking mix of yellow, orange and green. Given their interesting colour combination, they look great in cut-flower displays, too. A reliable variety that will last well if you lift and dry after flowering. Height: 20cm

ABU HASSAN
Good for exposed sites, the sturdy tall stems hold aloft goblet-shaped, burnt-orange flowers with bright yellow edges. Height: 50cm

HAVRAN

"If you're planting in containers, layer with other bulb varieties that flower at different times to extend your displays"

BEST VARIETIES FOR SCENT

We love the sweet, heady perfume of these three beautiful orange blooms. Bury your nose in their petals (mind the pollen!) or enjoy from afar

BALLERINA

Sweetly scented, this orange lily-flowered variety has elegant long, pointed petals. Flowering in May, it's good at the front of a border planted with deep plum varieties such as 'Victoria's Secret', 'Negrita' and the classic favourite, 'Queen of the Night'. Height: 35cm

PRINSES IRENE

Soft orange petals are embellished with purple flame-shaped markings. Highly scented, it also has attractive silvery green leaves, which make this April-flowering tulip a great all-rounder. Height: 35cm

CAIRO

An exotically coloured, scented tulip that's a burnished orange on the inner petal and a bronze-caramel on the outer petal. A relatively new variety, combine with vibrant green euphorbia for a bold contrast in the border. It also works well planted with bright orange or deep plum flowers. Height: 45cm

BEST VARIETIES FOR A CONTAINERS

Create a big display in a small space with these pot-friendly varieties. Go for two-toned petals, or mix and match for colourful patios and balconies

COULEUR CARDINAL

An early April-flowering variety, it's reliable and long-lasting. Two-toned petals (crimson-scarlet on the inside, plum-crimson on the outside) make it eye-catching enough for a single-colour display. Keep an eye out in junk shops for galvanised dolly tubs or baths for a stylish container. Height: 35cm

HAVRAN

Three flowers on each stem, these make ideal plants for large terracotta pots positioned as a seasonal focal point in your garden. As these deep purple flowers put on a show from April, a little earlier than 'Queen of the Night' – another similarly coloured variety – planting both types will ensure a long display of springtime colour. Height: 45cm

BURGUNDY

An elegantly shaped flower with vibrant purple petals. Its unusual flower-form makes it a good choice for a container display where it can be positioned near a door or window. Looks pretty with lighter purple shades, such as 'Ballade'. Height: 40cm

BALLERINA

BURGUNDY

PRINSES IRENE

229

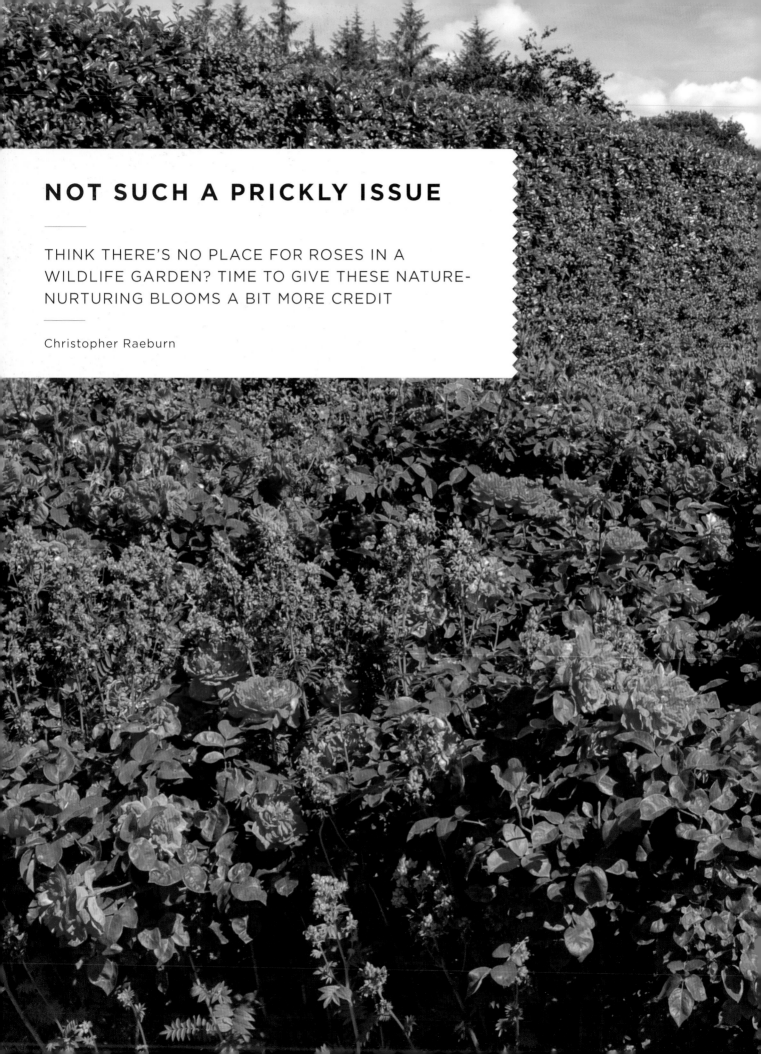

NOT SUCH A PRICKLY ISSUE

THINK THERE'S NO PLACE FOR ROSES IN A
WILDLIFE GARDEN? TIME TO GIVE THESE NATURE-
NURTURING BLOOMS A BIT MORE CREDIT

Christopher Raeburn

Now that the first flush of roses is fading, I am reaching for the secateurs for a quick clean-up. The better roses drop everything neatly, but one or two always insist on displaying their dead only too proudly. We all know that prompt deadheading encourages lots more flowers, and I know many more of these luscious blooms will be welcomed by visitors to the garden. Wildlife-friendly planting guides place garden roses low down on the useful list, if at all. Double-flowered and 'un-friendly' as they may be, while working on your roses at close quarters, you will probably see plenty of evidence of the many creatures that have been making the most of the stars of your summer garden.

As I snip and trim, there is much to distract me from the task in hand. These 'wildlife un-friendly' bushes are, surprisingly, crawling. The seething mass of spring's aphid extravaganza, left unsprayed, has already reduced to a few scattered clusters. The survivors are hurriedly producing summer-generation winged daughters and, as I work, those that can take to the air around me in a fairy flurry. Among the foliage, Two-spot and Harlequin ladybird larvae patrol determinedly. The soft translucent grubs of hoverflies and caliper-jawed lacewing nymphs join them in the hunt for the hapless, wingless remainder.

Bushes are scattered with leaves stripped to herring-bone skeletons – jaws bigger than an aphid's have been at their leaves. Only too familiar to those who lose sleep over 'prize' roses, Rose Sawfly produce ravenous broods of leaf-eating caterpillars, which can defoliate whole branches in serious infestations. The infestation here is ongoing from year to year and it bothers neither me, nor my roses, one jot. From the eggs laid in slits cut into spring-soft stems by the females' saw-tipped genitalia, communally feeding grubs have hatched. Arrayed to feed around the edge of a single leaf, a puff of breath will cause them all to arch into a characteristic S-shape defensive pose, momentarily replacing the missing leaf veins with their bodies. A defence that seems to be lacking a certain something, as eager wrens happily harvest them by the beakful.

One may think that largely nectar-and pollen-free roses, with their luxuriantly double flowers, have little to offer the bees, but there are other reasons for some to visit. There is no mistaking the neat scallops cut from the leaves as arising from anything other than the nest-building activities of leafcutter bees (Megachile spp). Solitary bees that construct nests from pieces of leaf, they rather favour roses. The female, and it is only the female who builds, grips the edge of her chosen leaf with her legs and chews around herself, cutting a neat, bee-sized oval. She carries the piece back to her chosen nest site – a hollow stem, an old beetle hole, a hole in your bee-box – and uses it to create a succession of cells, each provisioned with nectar and pollen, rather like mini hand-rolled cigars. The single egg laid in each will develop into next year's generation.

Small, brownish and hairy, leafcutter bees are relatively easily identified by the females' flat-bellied shape. Unlike bees with pollen baskets on their legs, leafcutters collect pollen on a belly-wide brush and this is easily seen when fully laden. The males hang out on promising flowers to wait for foraging females to visit. A cute teddy-bear countenance belies a less than chivalrous approach to courting – unsuspecting females are pounced upon, 'blind-folded' by the males' hairy mittens and unceremoniously mated. Oh, l'amour.

Traditional rose-growing calls for an armoury of sprays to deal with all their 'pests'. I would suggest that there is another way. Tough, deep-rooted and self-reliant, roses grown as part of a mixed planting provide a food source for many species and yet continue to produce a lavish display. Planning the ideal wildlife garden, you could probably manage without them at all, but as I stand nose-deep in Felicia's addictively nostalgic sweetness, I wonder, could I?

SEED *to* STOVE
SUMMER HARVEST

EARLY-SEASON CROPS AND HERBS PROVIDE A FIRST TASTE OF SUMMER

Lia Leendertz

You don't need to wait for high summer to harvest your plot. Picking little and often is a surefire way to make sure you don't miss anything at its peak. If you don't have a dedicated space for growing veggies, you can still pack your food full of summer flavours by growing a few pots of herbs.

Mint is easy to grow; I have several pots on my back doorstep, which leap into growth in spring and die back in winter. Basil is a different ball game, an old foe. I often cheat and buy a few supermarket pots, then transfer them to terracotta pots to make it look as if I grew them from seed. Thyme can be green all year, but the best leaves are found in summer. If you haven't discovered lemon verbena, then make procuring a plant your new resolution. The leaves taste like sherbet and make the best herb tea.

Some crops such as courgettes and peas are already producing, while cut-and-come-again salads are designed to be picked early, middle and late season. Baby carrots are a particular favourite – you need to thin out the rows anyway in order to let some carrots grow large; keep the thinnings for a salad. Courgettes get going quickly and keep going. If by mid-summer you haven't resorted to leaving bags of them by your neighbours' doors, you're doing something wrong. You can stem the flow by picking tiny courgettes while they are sweet and firm.

Unlike winter produce, which needs painstaking preparation, so much summer produce is pick-and-eat, and I love to see kids grazing on it. My earliest gardening memory is of picking peas in the garden and popping them into my mouth, and it makes me happy to see my kids doing the same.

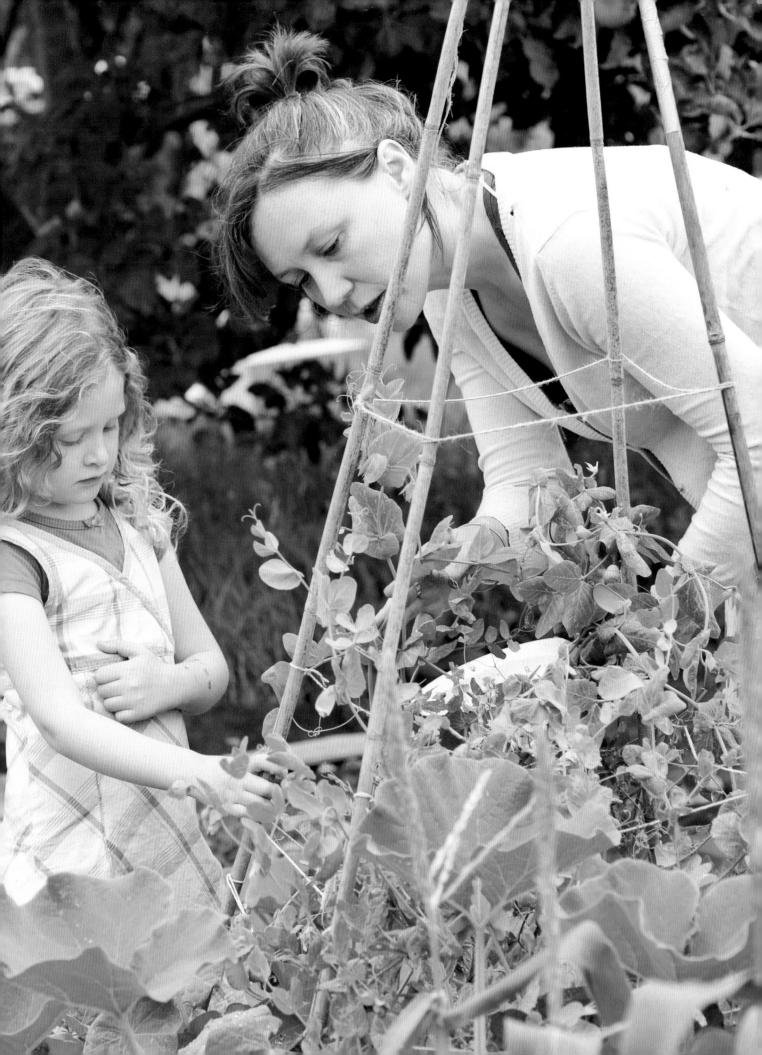

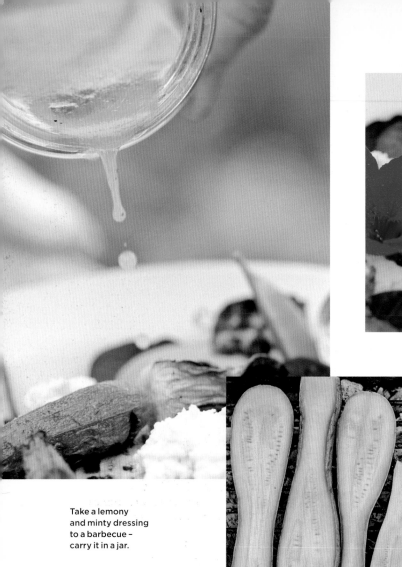

Take a lemony
and minty dressing
to a barbecue –
carry it in a jar.

Barbecued courgettes and ewe's curd salad

THE KEY INGREDIENTS
ARE COURGETTES AND
A MINT DRESSING —
THE REST CAN COME AND
GO WITH THE SEASON

Serves 2

3 medium courgettes, sliced
lengthways, about 1cm thick

A little olive oil

Handful of freshly picked peas

Handful of mangetout

A few nasturtium leaves & flowers

50g ewe's curd (or soft goat's cheese)

FOR THE DRESSING

6 tbsp extra virgin olive oil

Zest and juice of 1 lemon

Small bunch of mint, chopped

Pinch each of sugar and salt

Freshly ground pepper

1 Put dressing ingredients in a lidded
jam jar, shake and store in the fridge.
2 Brush courgettes with oil and cook on
the barbecue for a few mins until lightly
scorched; turn and repeat on other side.
Pile up courgettes with the other veg
and leaves, add the curd and top with
nasturtium flowers. Drizzle over
dressing and serve.

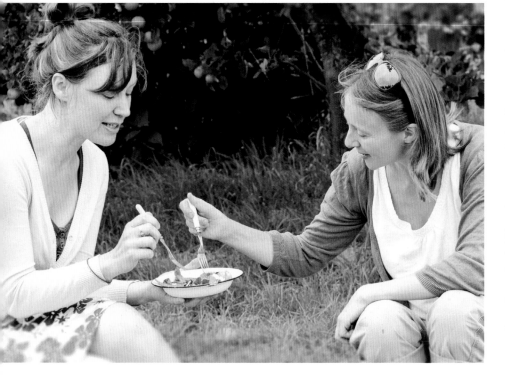

LIA LOVES
Here are my three favourites for the herb garden

ORANGE THYME AND LEMON THYME
These are delicately different versions of common thyme, each with its own sweet, citrussy edge. Look out for golden and silver-variegated thymes, too. All are excellent for cooking.

GREEK BASIL
I always struggle to grow the usual type of basil, but Greek basil works better for me. It is less temperamental as a plant. It grows into a little bush of tiny leaves, but they are as pungent as the larger ones.

MINT
There are so many variations of mint that you could fill a whole (shady) garden with them, and a very lovely garden it would be, too. Moroccan mint is one of the better known ones and a good place to start, with a bright spearmint flavour that's good for Moroccan mint tea.

Dip strawberries or ice lollies into your own homemade sherbet – magic!

Orange thyme syrup

EXPERIMENT WITH OTHER HERBS (MINT, BASIL AND LEMON VERBENA) AND USE AS A CORDIAL OR POUR OVER ICE CREAM

Makes 250ml
1 cup water
1 cup sugar
1 cup orange thyme

1 Put all ingredients in a saucepan and bring slowly to the boil. Allow to simmer gently for a few mins, then switch off and leave to cool.
2 When it is cool, fish out the thyme leaves and pour into a sterilised bottle, using a tea strainer to remove any remaining leafy bits. (Will keep in the fridge for a few weeks.)

Lemon verbena sherbet

THE FIZZINESS COMES FROM THE TONGUE-TINGLING COMBO OF CITRIC ACID AND BICARBONATE OF SODA

Makes about 70g
Pared peel of 4 lemons
About 8 lemon verbena stems, hung up to dry for a few days
60g icing sugar
¼ tsp citric acid (from chemists)
1 tsp bicarbonate of soda

1 Roast lemon peel on a baking tray in a low oven for 30 mins until crispy.
2 Strip the leaves from the stems (they must also be crispy) and whizz peel and leaves together in a blender.
3 Sift sugar, citric acid and bicarb into a bowl and add the ground leaf and peel. Serve with sliced fruit.

Mint & basil gremolata

MAKE MORE THAN YOU NEED AND STORE IN A JAR IN THE FRIDGE

Makes around 50g
1 lemon
Large handful of basil
Large handful of mint
3 tbsp granulated sugar

1 Pare the zest off the lemon, taking as little white pith as possible. Using a sharp knife, finely slice the peel strips one way, then turn and finely chop the other way to create tiny squares.
2 Pull the basil and mint leaves off the stalks and chop the leaves finely. Mix in the sugar and lemon zest. You can serve the gremolata as it is or blast it in a small spice blender.

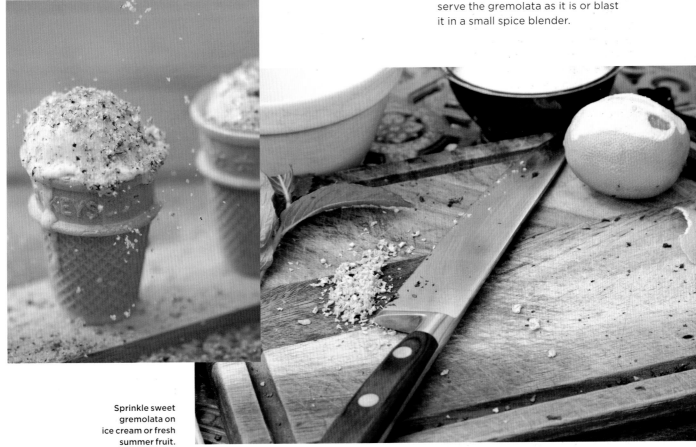

Sprinkle sweet gremolata on ice cream or fresh summer fruit.

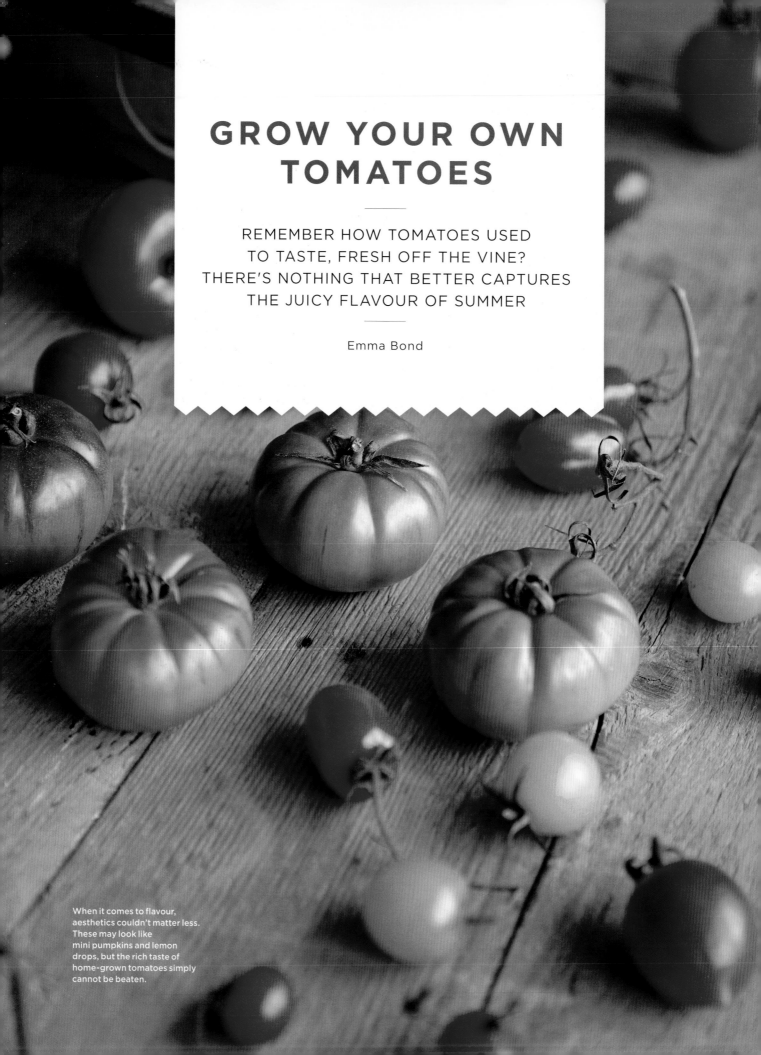

GROW YOUR OWN TOMATOES

REMEMBER HOW TOMATOES USED
TO TASTE, FRESH OFF THE VINE?
THERE'S NOTHING THAT BETTER CAPTURES
THE JUICY FLAVOUR OF SUMMER

Emma Bond

When it comes to flavour, aesthetics couldn't matter less. These may look like mini pumpkins and lemon drops, but the rich taste of home-grown tomatoes simply cannot be beaten.

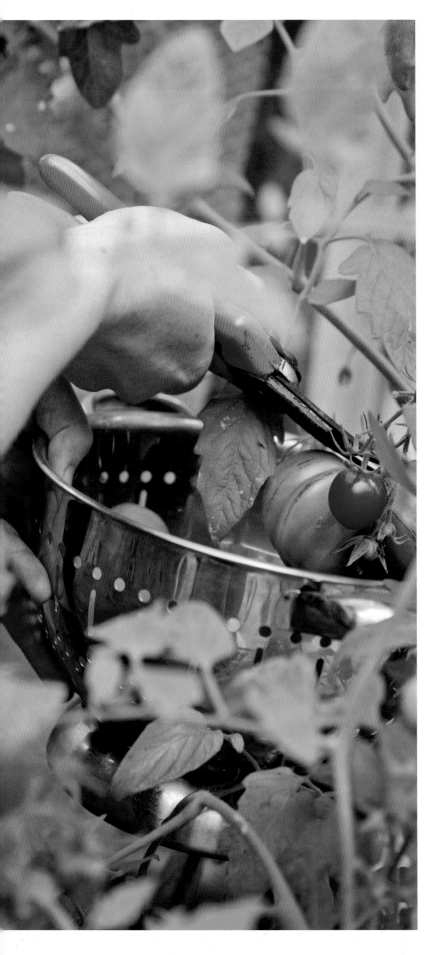

The rest of the crop may be for the pantry, but the first ripe tomato of the year is just for me. I scoff it like an apple, sun-warmed and straight from the plant, savouring the tenderness of the fire engine-red skin and the familiar sweetness of the flesh. I love everything about growing tomatoes, from the herbal perfume of the leaves in the summer through to the satisfaction of teasing plump fruits from the vine – but the highlight, every year, is the sense of anticipation as I bring the harvest back to my kitchen.

This year I'm growing 'Bloody Butcher' and 'Brandywine', which I chose because of their flavour and lack of uniformity – it sets them apart from the bland flawless specimens you find in supermarkets. I'm also growing a plum tomato and two types of cherry. The best part is deciding how I'm going to cook and preserve them for eating during the rest of the year.

The larger tomatoes are used in passata and pasta sauces, and also slowly dried in the oven with thyme and preserved in olive oil in jars to be used over winter for sauces and stews. I also make vats of chutney using my chillies and a mixture of cherry tomatoes and larger varieties. I make a tomato jam, too – a rich, flavoursome preserve that keeps for several months and is delicious with smoked meats and cheeses. This is made in the same way as fruit jam, only using spices including cardamom, juniper, cloves and star anise. It's a real favourite in our house.

In the late summer we eat gazpacho made from our own tomatoes in a heavenly soup heavy with chopped boiled eggs from our hens, sliced peppers and cucumber, and my own fresh basil and crisp croutons.

But before the first fruits of the year arrive, there's the pleasure of planting. If you want to grow your own tomatoes from seed, mid-spring is a good time to start. The usual growing rules apply and they'll need warmth this early in the year. They'll also need to be

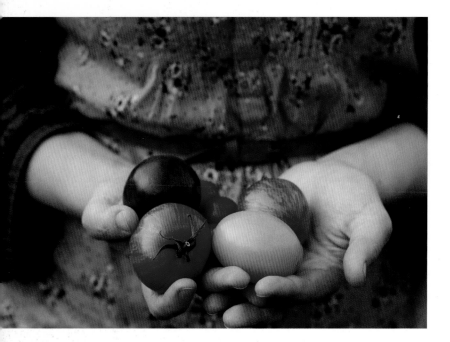

Passata

IF YOU'VE GROWN A GLUT,
TURN THE SURPLUS INTO
THIS RICH TOMATO PUREE –
A GREAT BASE FOR SAUCES,
SOUPS AND STEWS

Makes around 600ml

800g tomatoes, any variety
or a mix, skinned and deseeded

1 medium onion, peeled
and finely chopped

1 tsp sugar

Splash olive oil

Basil (optional)

Pinch of sea salt

Pinch of black pepper

1 garlic clove, finely chopped

1 Very slowly and gently fry the onion
and garlic in a splash of olive oil in a
frying pan with a lid, until translucent
and tender.

2 Add the tomatoes and remaining
ingredients and cook for a further
20 minutes with the lid on. Taste and
adjust seasoning according to your
preference.

3 Allow to cool a little and use a
blender or stick blender to whizz
the mixture until smooth. Divide
into batches and freeze or use
in sauces at once.

properly hardened off by putting them outside for three or four
days and bringing them in at night before they go outside or into
your greenhouse.

They'll grow in grow bags, in the ground or in pots, but the main
thing is to give them as much sun and shelter as possible and, for the
cordon varieties, plenty of sturdy staking to grow up. The bush types
will also need some support, but won't grow as tall. Regularly water,
but not too much or the fruit will split, and regularly feed with a stan-
dard liquid feed. Water the roots rather than the leaves, as they're
not keen on getting wet.

With either type I make sure I pick off any leaves around the
emerging tomatoes to give them more light and air, as blight can be
a real problem if the leaves get too crowded. It's also a good idea to
pinch out any developing shoots between the main stem and each
of the main branches, as they take energy from the plant. I lop off
the top of the plants once they have around six sets of trusses, as
this also contains the plants' efforts.

If you don't have the space to grow from seed, then do as I do and
cheat. You can buy tomato plants ready-grown pretty much every-
where, but you'll be limited on variety. I like to combine some of my
own grown from seed with a few bought plants.

If you find all the fiddling of picking off leaves and pinching out
too much of a faff, then don't worry – some years I simply leave my
plants to get on with it and they don't seem to suffer too much;
sometimes it's just a matter of trial and error.

I hope you enjoy growing your own tomatoes and allow yourself
the unparalleled pleasure of picking and eating your first ripe fruit.

Gazpacho

HONOUR THE PICK OF THE CROP WITH THIS COLD SPANISH SOUP. TOP WITH CROUTONS AND SERRANO HAM FOR A LOVELY LUNCH

Serves 6

6 large tomatoes

2 red peppers, deseeded and chopped

2 yellow peppers, deseeded and chopped

1 small cucumber, peeled and chopped

3 spring onions, chopped

1 large garlic clove

1 tbsp sherry vinegar, or a splash to suit your taste

A splash garlic olive oil

1 tbsp good olive oil

1 tsp sugar

½ tsp smoked paprika

1 Put the tomatoes into a bowl of boiling water, with small crosses cut into them to help the skins to peel off. Remove the skins, wait until the tomatoes are cool and chop finely.
2 Chop everything up, removing the green part of the spring onion and deseeding the cucumber. If you have a blender or food processor, add all of the vegetables and blitz. Otherwise, just carry on chopping until a paste-like consistency is reached.
3 Add the oils, sugar, sherry and paprika and taste. Add additional seasoning if it needs it. Serve toppings in separate bowls so people can help themselves.

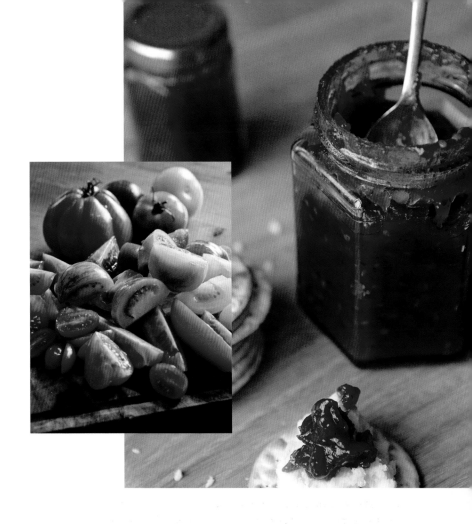

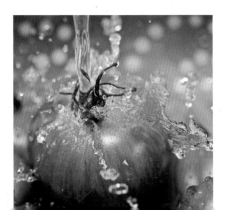

Tomato jam

RESIST OPENING THE JAR AND IT WILL KEEP IN THE DARK FOR SEVERAL MONTHS

Makes enough for three jars

1.5kg mixed tomatoes, the more variety the better

300g caster sugar

½ tsp salt

1 tsp juniper berries

1 tsp coriander seed

1 tsp black peppercorns

2 star anise

Juice and zest of an orange and a lemon

1 In a heavy-based pan or jam pan add the tomatoes, halved, deseeded and chopped roughly. Meanwhile, put all the spices in a small frying pan and dry fry them until they release their fragrance. Allow to cool and grind with a pestle and mortar until fine.
2 Place two or three saucers in the fridge to cool, ready to test the set of your jam. Add the spices, orange and lemon zest and juice, sugar and salt to the tomatoes and gently cook until the sugar has melted. Simmer for another 30 minutes and keep stirring. Then test a teaspoon of the mixture on one of the cold saucers. If it forms a skin and doesn't run off the saucer, it's ready – if it's still too runny, return to the heat for 5 minutes then test it again. You don't want the tomatoes to have completely cooked down, so they retain some of their shape in the jam.
3 Carefully pour into your sterilised jars; I love using Kilner jars for this. Label and leave to cool, and store somewhere dark.

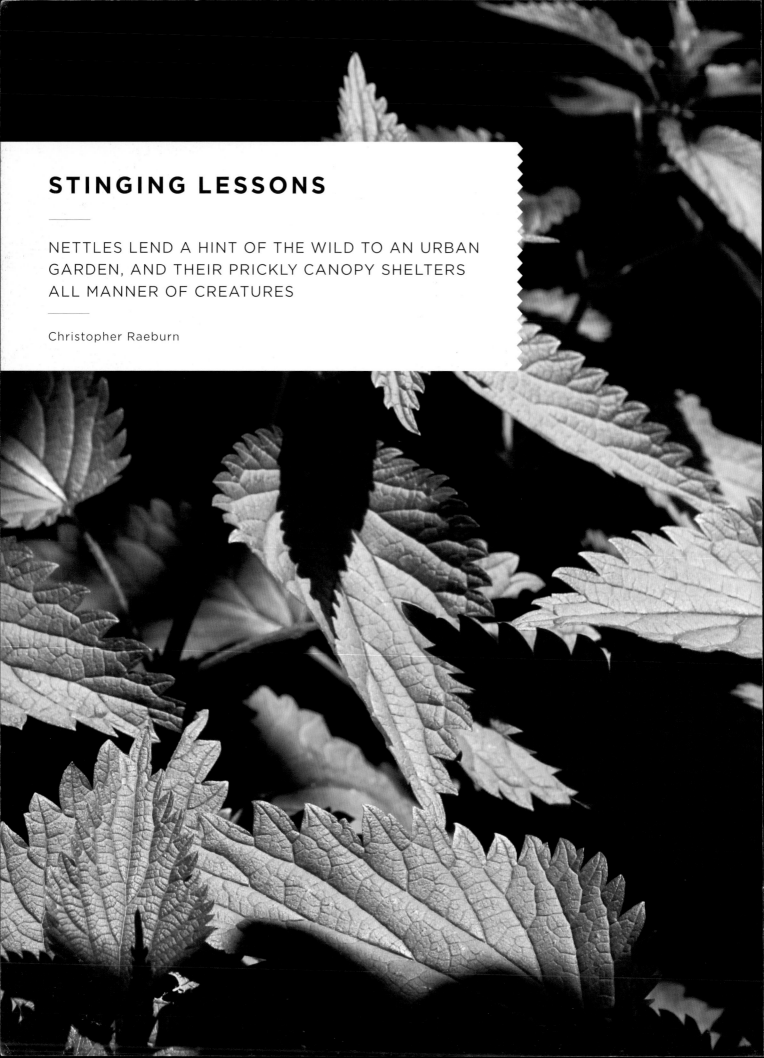

STINGING LESSONS

NETTLES LEND A HINT OF THE WILD TO AN URBAN
GARDEN, AND THEIR PRICKLY CANOPY SHELTERS
ALL MANNER OF CREATURES

Christopher Raeburn

For some visitors, the grandstands of stinging nettles adorning the community garden here at the Phoenix Garden, where I manage the plant life, are a wildlife-friendly step too far. As I politely refuse their offers to help with 'all the weeding that needs doing', I wax lyrical about nettles' aesthetic qualities. They make it quite clear that they believe I garden well beyond the pale and cut me short. So they never get to hear all about stinging nettles' superb habitat-boosting benefits.

Supremely adapted to hold their ground in the hurly-burly of the hedgerow, nettles, with their dense, overlapping foliage that's up early and to bed late, are extremely efficient at shading out competitors. Well-defended, covered with stinging 'hypodermic' hairs – all ready to lick the lips of hungry herbivores with a potent cocktail of irritant chemicals – they're left largely un-grazed. As a result, they steadily increase with rapidly growing rhizomes to form majestic stands of tassel-topped, lush foliage.

However, as effective as the burning stings are against larger mammalian browsers (and gardeners' ungloved hands), they're no defence against smaller jaws. Stands of nettles are microcosms; structured like forests in miniature they provide numerous niches, from a sunlit canopy to cool shade, for myriad smaller creatures. In the UK, more than 30 species are solely dependent on nettles, with a further 100 or so found in close association with them.

Four popular butterfly species, Red Admiral, Peacock, Small Tortoiseshell and Comma, all use nettles as caterpillar food. Moths likewise: Snout, Spectacle, Mother-of-Pearl, Burnished Brass. Angle Shades caterpillars migrate vertically to feed on nettle tops at night before returning to the base at first light – a torchlight search can reveal them in all their tubby greed. Nettle flowers crawl with the gleaming bodies of mating nettle capsids. Tiny adult weevils gnaw the edges of leaves, while their larvae tunnel between the leaf surfaces along with leaf-mining fly grubs. Even smaller, primitive psyllids* and thrips pierce the leaves to suck the sauce from individual cells, leaving a pale stippling in their wake. Stalking through the dense foliage, assassin bugs drain their victims dry. Comb-footed spiders criss-cross stems with networks of web. Robber flies pounce on the unwary. Parasitic flies touch down momentarily to lay single eggs on caterpillars, the hatching larvae burrow deep into the living host to feed on its juicy insides. Bugs, beetles, aphids, flies, moths and butterflies feast here in the thousands. Tits, great and blue, bounce from stem to stem in eager hunts, and shy wren forage, secure from cats in the stinging canopy.

Unlike the usual 'allow to grow in a hidden corner' advice so often pertaining to nettles, I would argue that these plants are best grown proudly. Few plants bring such an instant air of wildness to this urban garden – the regular tiered foliage topped with great tufts of dangling catkin flowers are unmistakably uncultured. Grown in island beds alongside ornamental plants of equal ground-holding vigour – Geranium 'Claridge Druce', Japanese anemones and caucasian comfrey – management is simple. A quick whizz round the edges with a lawn mower keeps these thugs contained (none can withstand regular mowing), while cutting sections of nettle to the ground in rotation encourages the fresh vigorous regrowth that egg-laying butterflies favour. The result? Luxuriant, habitat-boosting beds with absolutely no bother.

Of course, such gardening leaps of faith are not to everyone's taste, but there are coloured-leaf forms of nettle that may be more palatable. Here I grow two. Well mannered, 'Good as Gold' has vivid golden foliage – bright throughout spring, it softens to lime-green in summer – lovely. The other, 'Brightstone Bitch', a beauty, is strongly variegated in cream and white, but lives up to its name with a vicious long-lasting sting. The welts it raises will remind me, even days later, just how much I love it.

*Aka jumping plant life, these small plant-feeding insects are almost entirely host-specific, meaning that those that feast on nettles won't stray.

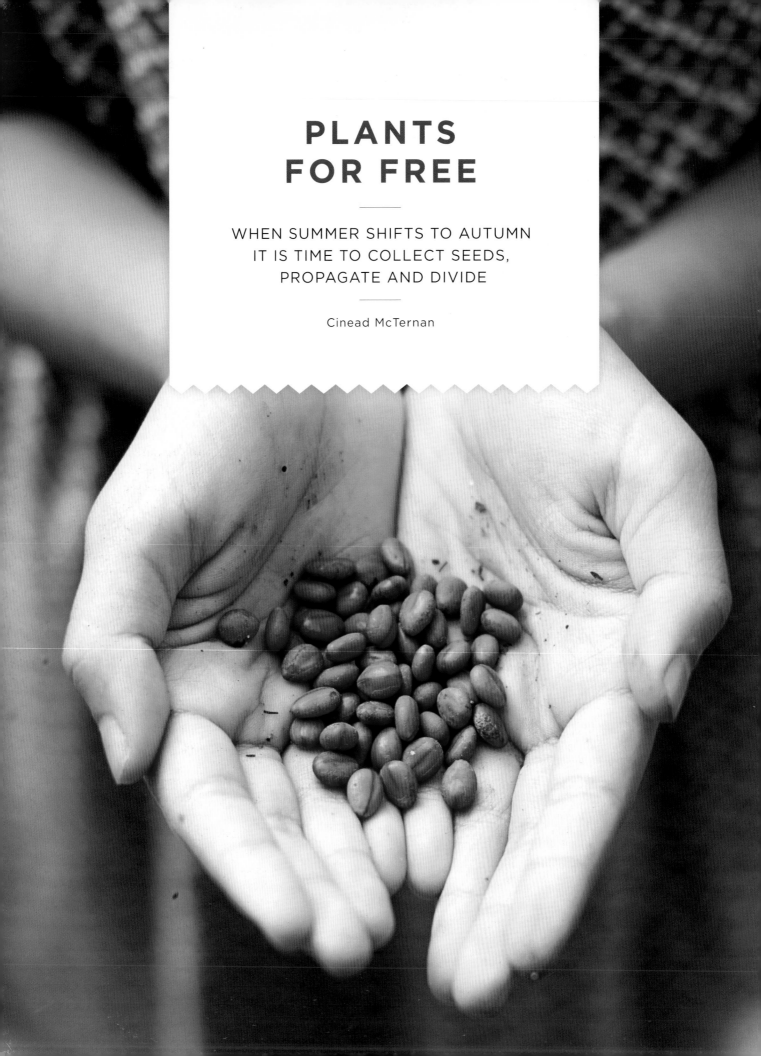

PLANTS
FOR FREE

WHEN SUMMER SHIFTS TO AUTUMN
IT IS TIME TO COLLECT SEEDS,
PROPAGATE AND DIVIDE

Cinead McTernan

All the seasons have something glorious to offer in the garden: winter allows you to hang up your spade and enjoy some quiet time while browsing seed catalogues and gardening books in front of a roaring fire. Spring bounds in with all its freshness and splashes of yellow and promise, while summer is a frenzy of colourful profusion and bounty. But for me autumn is best, a wonderful mixture of them all, as the garden puts on one last show, thanks to late-flowering plants like sedum, crocosmia and helenium. Ornamental grasses look their frothy best, while other plants fade delicately to create a skyline of seed heads against greyer skies.

The veg plot no longer groans with produce but pumpkins, cabbages and even salads provide a welcome crop as spent beds are refuelled with freshly sown green manures like phacelia, winter tares and crimson clover. This is the time to slow down and plan for the year ahead, and to take care of your plot so that it can do its thing all over again next spring. It's also a good time to evaluate the performance of your beds, borders and containers and decide what worked well this year and what might benefit from a tweak or two next year. And, finally, it's the time to harvest a different sort of crop: seeds, cuttings and divided plants to fill the garden with colour next year.

COLLECT YOUR OWN SEEDS

Set off with a brown paper bag, a pair of scissors and a skip in your step

If you want to bulk up stocks of a favourite plant or ensure new supplies of an annual, autumn is the time to collect their seeds. Foxgloves (Digitalis purpurea), love-in-a-mist (Nigella damascena), cosmos (Cosmos bipinnatus) and honesty (Lunaria annua) are ideal for beginners and will easily store and germinate the following spring. However, there are many other annuals as well as perennials, biennials, alpines, ornamental grasses, vegetables, herbs and some trees and shrubs that can all be grown from seed that you've collected.

CHOOSE YOUR PLANTS CAREFULLY

Go for strong, healthy ones as they're likely to have good-quality seed. However, be aware if they're hybrids (specially bred plants that are unlikely to have the same qualities as the parent plant) rather than species, as the plant won't "come true" from seed. In the case of hybrids, either buy new plants the following year or be prepared for the collected seeds to produce something completely different from this year's plants.

COLLECT THE SEEDS

Once you've decided which plants you're saving seed from, the trick is to collect it just before it has dispersed. It's a bit of a waiting game, but once the seed head has ripened and changed colour (from green to brown, black or red) and is dry and crisp, it's time to spring into action. Pick individual seed heads and use separate paper bags for each species or, if they'll come away easily, place a paper bag over the seed head and gently shake.

DRY THE SEEDS

Once you've gathered all the seeds you want, lay them out on a warm windowsill or a greenhouse bench – you can even find a spot in the airing cupboard. You need to give them time to dry out so you can get to the seed more easily. Clean away the 'chaff' or casing until you're left with just the seed. Check to see which seeds you've collected and if they need to be sown straight away. Hellebores, for example, can be stored to sow next spring when the weather warms up.

PLACE THE SEEDS IN INDIVIDUAL PACKETS

You'll be surprised how satisfying this is. Keep them in an airtight container and, if you have any sachets of silica gel from new shoes or bags, place a couple in with the seeds to absorb excess moisture, which would otherwise cause the seeds to rot. If not, add a handful or two of rice to the container and find a spot for the container in the fridge.

A WORD ABOUT BERRIES

Collecting berries is a bit more messy than seeds, but it is worth the effort. Harvest the berries before the birds have a chance to eat them all, then mash them in a fine sieve. Rinse away the pulp and dry the seeds over a day or two by laying them on paper towel. Seeds and berries are, of course, an important food source for birds during the cold winter months, so don't forget to leave some on the plants – there's plenty to go around.

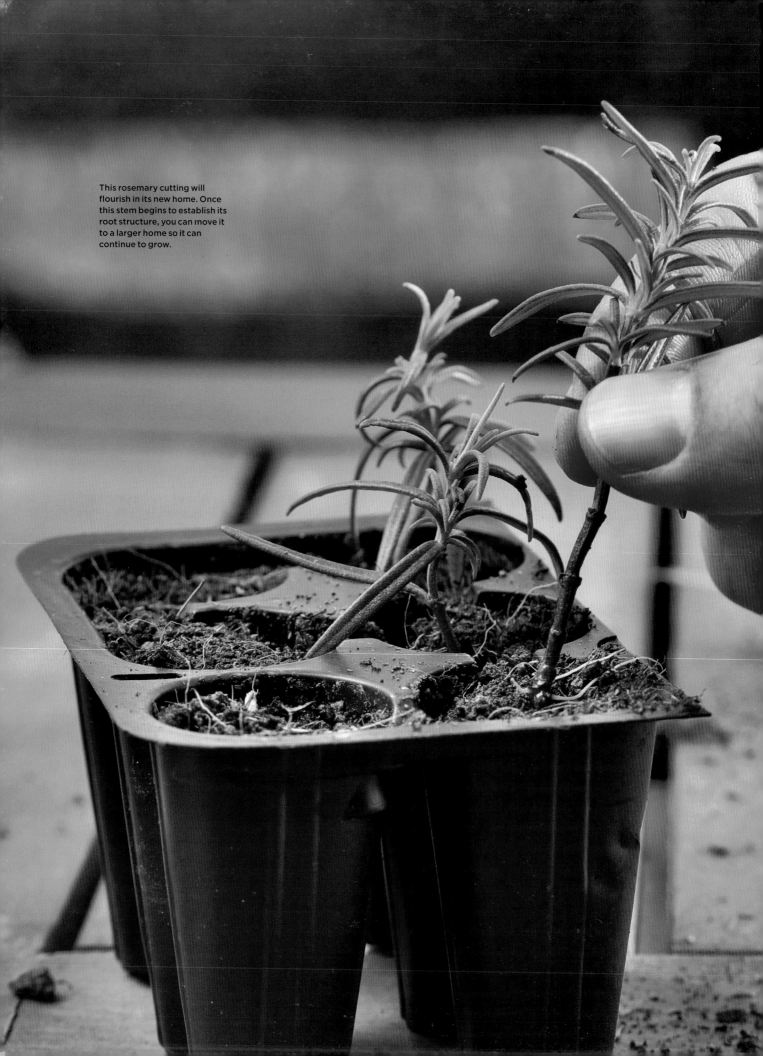

This rosemary cutting will flourish in its new home. Once this stem begins to establish its root structure, you can move it to a larger home so it can continue to grow.

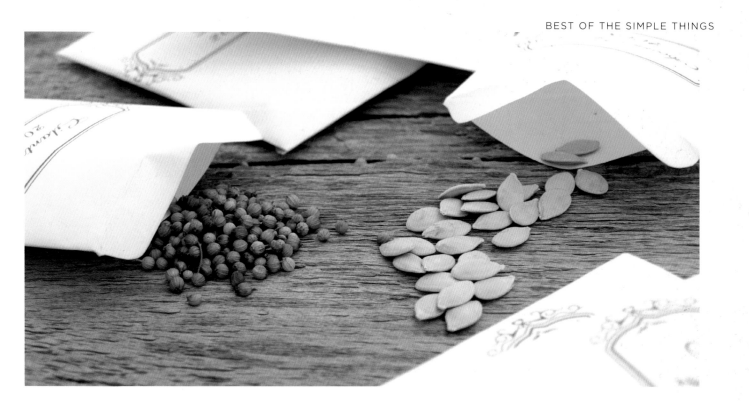

Seeds parceled into their own envelopes makes for easy sorting.

TAKE CUTTINGS

A snip, a dip and you're away...

Saving seed is an easy way to get new plants for free, but for some shrubs, climbers and trees, you'll need to take cuttings from the parent plant. It may sound more complicated, but it's a surprisingly easy way to bulk up plant stocks or have them on hand to give to friends and family, so it's well worth having a go.

At this time of year you can take cuttings from dogwood, willow, roses, honeysuckle, jasmine, gooseberries and black, red and white currants. You can also do cuttings from herbs like bay, lavender, rosemary, sage and thyme, as well as shrubs including box, Lonicera nitida and privet – which is really useful for creating evergreen hedges without buying large numbers of shrubs to get it going (although this will take a while).

1 Cut a healthy stem from a suitable plant using a sharp pair of secateurs and remove the soft, new leaf growth at the tip.
2 Chop the stem into about 15cm sections for herbs and smaller shrubs, and 25cm lengths for larger shrubs, snipping cleanly above a bud at the top (cut at an angle to help water run off).
3 Make a straight cut at the bottom of the cutting, just below a pair of buds.
4 Dip the cutting in hormone rooting powder. This will help promote root growth and prevent it from rotting. Insert into a pot filled with soil. Keep one third of the cutting above the soil.
5 Allow about 10cm between cuttings and place somewhere sheltered until the following autumn when they can be potted on.
6 Keep an eye on them, particularly over the summer, making sure the pot doesn't dry out.

LIFT AND DIVIDE

Grab your bread knife and employ a bit of elbow grease

To ensure perennials like Michaelmas daisies, Japanese anemones, heuchera and stonecrop remain strong and healthy so that they can put on a show year after year, it's a good idea to lift and divide them every four to five years.

1 Loosen the soil around the root system, taking care not to damage any roots, and lift the plant.
2 Gently brush the soil away from the roots to reveal the root system and any buds forming. If the root ball isn't too big, use a bread knife to halve it (see previous page). If it's too big, use two garden forks, back to back, to tease roots apart.
3 Repeat the process, if you can divide it into more sections, but you'll need to make sure there's a healthy bud in each division.
4 Remove the old woody growth from the divisions and then replant at the same depth as the original plant. Make sure you water well straight after planting to help roots re-establish. If you don't want all the divisions in your garden, pot them up in containers, tie a bow around them and give them away to friends.

POSTCARDS FROM THE HEDGE

REAPING THE LAST REWARDS FROM THE GARDEN

Mark Diacono

With Christmas and New Year – which I love – looming, the weather is about all that gets me down in December. I'm in Devon and the soil, roads and even the air is wet. Happily, there's little to do outside. The pigs have gone, there's nothing to sow, and while the chickens need feeding, eggs are for months with more light. There's only the daily raid of the veg patch, where chickens peck between the frosted greens, clearing up the leather-jackets and weed seeds.

Among the greens, January King (the best of the Savoy cabbages), green and purple Brussels sprouts and two of my favourites from the veg patch at any time of year: Romanesco and cime di rapa. The first, a beautiful, almost luminous, cone of spiralling mini-spirals, with a sweet nuttiness that blows easily ruined cauliflowers and hard-to-perfect calabrese out of the veg patch. Hugely popular

in Italy, cime di rapa is the leafy, bulbless sister of turnips, as chard is to beetroot. Mustardy, nutty and full of fresh, green flavour, it's a cut-and-come-again treat that lasts right into winter from a late-summer sowing. Shredded and sautéed with garlic and chilli in olive oil, it is about the quickest (and probably the tastiest) pasta sauce I know.

The cabbage-like tops at the summit of each Brussels sprout plant are their equal: gently sweet, lightly hazel-nutty and with just enough mustard to set that sweetness off. Shredded, steamed, and dressed with a little oil and lemon juice, I'd grow sprouts for these tops alone.

Apart from those quick raids, I'm pretty much indoors by the fire at this time of year, deciding what to plant next year and revelling in last autumn's sloe gin and this winter's mulled cider.

Kiwi and elderflower fool

THE KIWIS AND
ELDERFLOWER
MAKE A GORGEOUS
HAND-HOLDING
ACROSS THE SEASONS

Serves 4
6 kiwis
2 tbsp caster sugar
4 tbsp elderflower cordial
300ml double cream

1 Peel and whizz up the kiwis
in a blender until smooth.
Add the sugar and cordial
and blend briefly.
2 Whisk cream until it forms
soft peaks, then fold it into the
kiwi purée but don't completely
combine – leave it as a ripple.
3 Refrigerate for at least an
hour before serving.

WISH YOU WERE HERE...

• To push the polytunnel door hard
open against the thick carpet of fallen
kiwi leaves to get at the ripe fruit.
From early summer flowers, the fruit
hang in strings, firm until the cold
and short-day light softens them
just right.
• To pick the very last of the aromatic
Szechuan peppers from the leafless

bushes to keep to add to the brine
for the Christmas hams.
• To peel the bark from the Carolina
allspice plants. Heady and full of
cinnamon, a few inches of this turns
any apple crumble, mulled cider or
wine and five spice – not to mention
the maturing hams – into something
truly extraordinary.

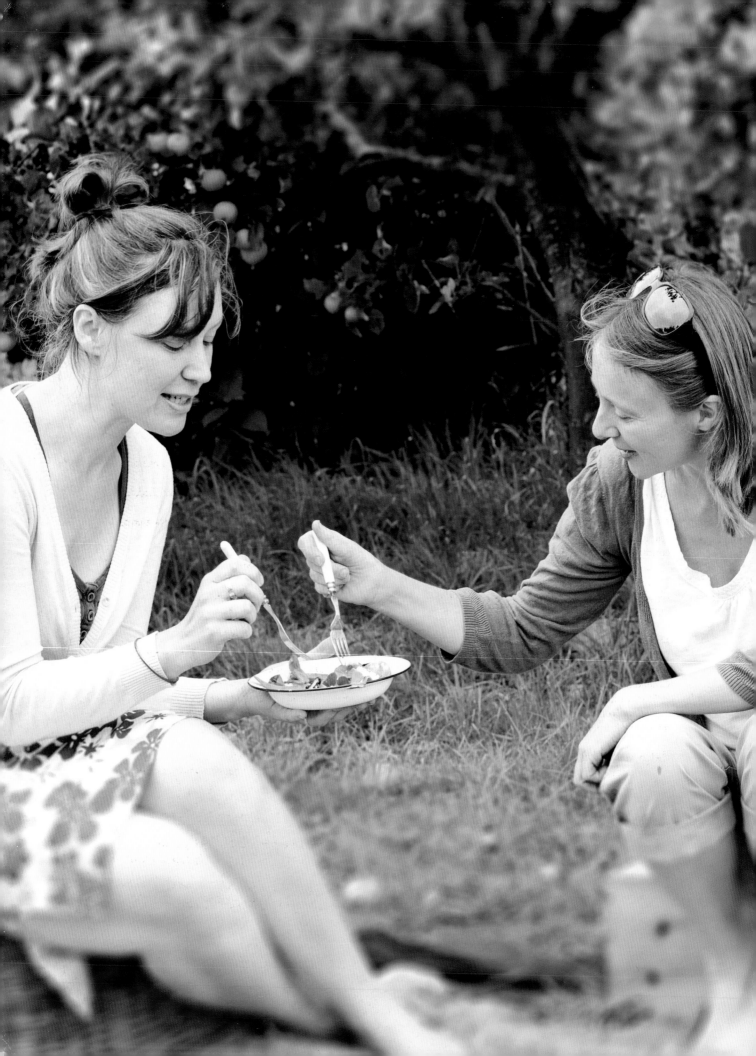

FEATURED CONTRIBUTORS

The Cook's Atelier's Marjorie Taylor, Kendall Smith Franchini and Selden Koolman run a French cooking school, epicurean destination, culinary boutique and Wine Shop in the center of historic Beaune, France. **thecooksatelier.com**

Louise Curley is a freelance writer and lover of flowers, food and the great outdoors. She is also the author of *The Cut Flower Patch*. **wellywoman.wordpress.com**

Mark Diacono is a green-fingered foodie and author who grows, cooks and eats the best of the familiar, forgotten and climate change foods on his Devon smallholding. **otterfarm.co.uk**

Julia Gartland is a photographer and self-taught cook and baker who runs the food blog Sassy Kitchen. **sassy-kitchen.com**

Alex Gooch is a baker extraordinaire who supplies restaurants, sells at markets and runs bread-making courses. **alexgoochbaker.com**.

Lia Leendertz is a freelance gardening writer and a regular contributor to *The Guardian, The Telegraph* and *Gardens Illustrated*. **lialeendertz.com**

Awen McBride is the chef at The Potager Garden and Glasshouse Café in Cornwall. **potagergarden.org**

Cinead McTernan is The Simple Things' Gardening Editor, author of several books on growing your own and blogs from her urban garden in Bristol **athoeandhum.wordpress.com**

Gillon Meller is head chef at River Cottage. He contributes to River Cottage cookbooks and shows and at the Cottage's school. **rivercottage.net**

Lyndel Miller is a cookbook author and food stylist, her books include *Naked Cakes* and *Wild Sugar Desserts*. **lyndelmiller.com**

Viviane Perényi is a French food photographer and writer based in Australia. **vivianeperenyi.com**

Helen Powell is the co-founder of Obsessionistas, a website "about the things that people choose to love and collect." **obsessionistas.co.uk**

Christopher Raeburn is the gardener at The Phoenix Garden – the last Covent Garden community garden. **thephoenixgarden.org**

Lottie Storey is The Simple Things' Digital Editor, in charge of our newsletters and blog at thesimplethings.com/blog. She also has her own blog at **oysterandpearl.co.uk**

Kirstie Young is a Bristol-based food photographer who shoots the magazine's regular Seed to Stove series in Lia Leendertz' allotment plot and kitchen. **kirstieyoungphotography.com**

Crafters

Denim runners: Heather Young, **growingspaces.net**

Candlesticks: Erin Loechner, **designformankind.com**

Centre pieces: Jen Huang, **greenweddingshoes.com**

Cushion cover: Victoria Haynes, **theowlandtheaccordian.com**

Pompom cushion cover: Lana Red, **lanaredstudio.com**

Colour block cushion: Kelly Cheesley, **aplaceofmyown.co.uk**. This tutorial first appeared on **growingspaces.net**

Hanging plant holder: Laetitia Lazerges, **vertcerise.com** and **doityvette.fr**; Etsy, **vertceriseshop.etsy.com**

Marbled paper: Mollie Costley, **molliecostley.com** This project first appeared in Mollie Makes magazine.

Pencil case: Harri Wren, **vanillacraftblog.com**

Envelopes: Ruth Bleakley, **ruthbleakley.com** Tutorial created first for Poppytalk (**poppytalk.com**)

Ornament cards: Marisa Edghill, **omiyageblogs.ca**; Instagram @omiyage_ca

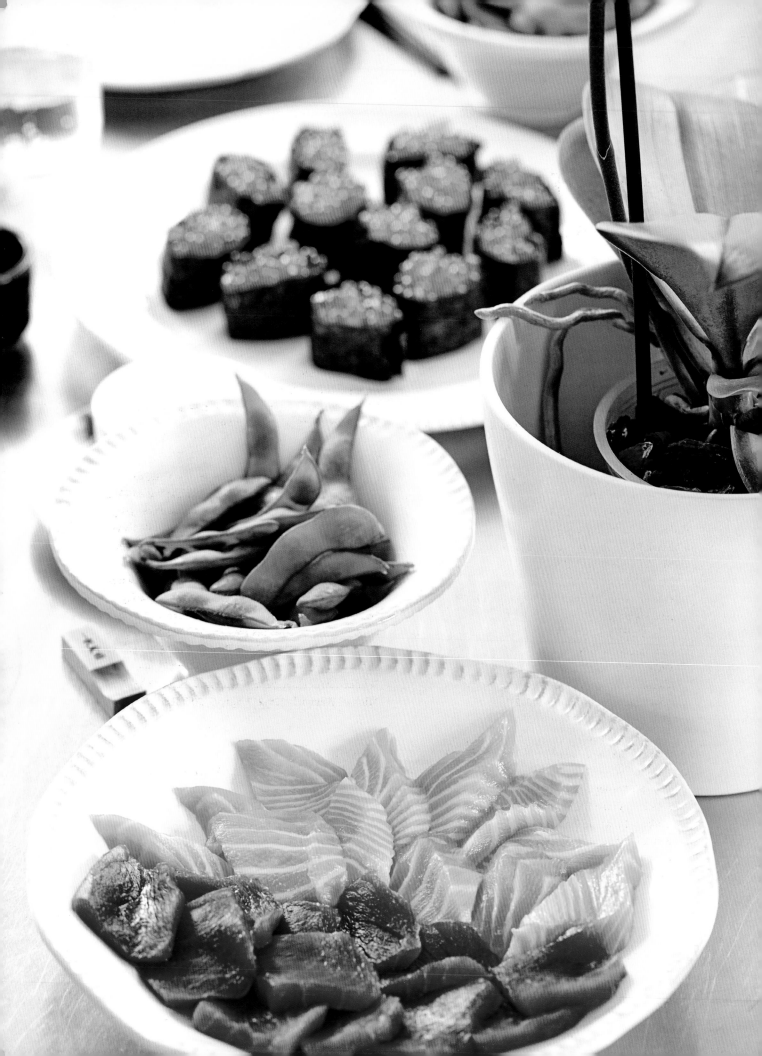